PELICAN BOOKS

FIVE HUNDRED YEARS OF PRINTING

S. H.
studied
of art,
Univers
Courta
Master , and during
the war did Intelligence work for
SHAEF. He was Assistant Editor of
Chambers's Encyclopaedia, and Editor of
Cassell's Encyclopaedia of Literature, and
edited *The Statesman's Year-Book* after
1946. His books include *Historical Tables,
A New Dictionary of British History* and
The 'Thirty Years War', and he contri-
buted to *History, The Monotype Recorder,
The Library*, and various other journals.
He was a Fellow of the Royal Historical
Society. S. H. Steinberg died in 1969.

Steinberg was born in 1865. He
studied history, literature, and the history
becoming a Reader of Typog-
and later did research at the
Institute. He was Assistant
at Sotheby's and became

FIVE HUNDRED YEARS OF
PRINTING

BY

S. H. STEINBERG

WITH A FOREWORD BY BEATRICE WARDE

*

*Typographia, ars artium omnium
conservatrix*

THIRD EDITION

PENGUIN BOOKS

Penguin Books Ltd, Harmondsworth, Middlesex, England
Penguin Books, 625 Madison Avenue, New York, New York 10022, U.S.A.
Penguin Books Australia Ltd, Ringwood, Victoria, Australia
Penguin Books Canada Ltd, 41 Steelcase Road West, Markham, Ontario, Canada
Penguin Books (N.Z.) Ltd,
182–190 Wairau Road, Auckland 10, New Zealand

—

First published 1955
Second edition 1961
Reprinted with revisions 1966
Reprinted 1969
Third edition, revised by James Moran, 1974
Reprinted 1977
Copyright © the Estate of S. H. Steinberg, 1955, 1961
Copyright © James Moran, 1974

—

Made and printed by Richard Clay (The Chaucer Press) Ltd,
Bungay, Suffolk
Set in Monotype Times

Contents

5

Foreword

THESE were the five hundred years of the Printer. These were the centuries in which there was his way, but no other way, of broadcasting identical messages to a thousand or more people, a thousand or more miles apart. This was the epoch that we have been calling 'modern times'.

We gave it that name because we have imagined ourselves as standing on this side of the deep cleft-in-history that opened up midway of the fifteenth century: the cleft into which Johann Gutenberg and his followers drove those leaden wedges that are called printing types, and split us clean away from that almost inconceivable world in which there was no such thing as printing.

But what if another such cleft proves to have been opening just behind us, in this very century? It is not easy for our children now to imagine a world in which there were no loud-speakers. Already the demagogues have almost forgotten how handicapped they were in that day-before-yesterday when there were no *soft*speakers: no radio-waves to carry a stage-whisper of scorn or passion into ten million susceptible ears at the same instant. The children, as they grow to maturity, will become increasingly familiar with such phrases as 'the year 2000', 'the Third Millennium'. The mysterious power that is in round numbers will impel them to look with fresher, more far-sighted eyes upon those thousand years that will have passed in some night before they are sixty. They will be as convinced as we are that something ended and something else began with Gutenberg's invention. But I think that they will find other names for the epochs on either side of the cleft.

Whatever they call the one on the farther side, it will no longer be the *middle* ages. Whether or not they name these past five centuries the Epoch of Gutenberg, they will at least come to look upon it as another 'middle' section of human history: that in which only the *graphic* word – the word that has to be wrested from conventional signs by the acquired power of literacy – had yet attained the enormous strength of mechanical multiplication. They will scarcely be able to stretch the phrase 'modern times' so far back, over a period that has suddenly become so different and remote from the one that began with Edison and Marconi.

Printing – graphic communication by multiplied impressions – will go on as long as civilization goes on. Its presses have trundled serenely across the new cleft in history. Necessity built the bridge. All that the printers have had to leave behind is their singularity as disseminators of ideas on a vast scale. But that is, on the whole, a beneficial loss. Who can perceive what a thing really *is* (and so judge its value) without first noticing what it most obviously and particularly is *not*? No wonder Kipling's famous question has been so often paraphrased. *What do they know of [any thing], who only [that thing] know?* It was by peering back into the age of the manual copyist that we came to realize that what Gutenberg gave us was first and foremost the means of correcting texts in advance, and then making sure that whatever errors crept past the proofreader could be located at a given point on a given page, in any one of a thousand copies struck off from the same forme of type. From that new possibility stemmed the concept of the 'edition', with all that it has meant to scholarship, to invention, and hence to our daily lives. That much we have been able to see all along. But the contrast between the scribe and the press only shows us that printing is the safer (and of course the speedier) way of getting messages into many people's heads through their eyes. There remained the far more dramatic and fundamental contrast between the graphic and the oral word: between the emotional impact of the human voice and the cold, silent precision of the graphic message:

between the exciting evanescence of the spoken word and the special, frightening power which the written one has of keeping on saying the thing long after any knave or liar would wish it to do so.

The contrast was there, but it told us less than we needed to know about the importance and virtue of printing, because it was too easy to discount the influence of even the most hypnotic human voice as long as it had to struggle to be audible to as few as a thousand listeners at one time. Today we have a fairer comparison of means. It is revealing to us the glory and dignity of the three great privileges that the printed word allows to its recipients, which the spoken word cannot offer even now when it has the use of its own vast multiplication-process.

We have the privilege of turning back from the page on which we have found something debatable, in order to find and re-read that point where the argument started (as every argument must start) with an assumption. Was it perhaps a false assumption that we were being hurriedly begged to accept 'for the sake of argument'? We can find out then and there, without having to lose the thread of what is to follow.

And we can turn forward to the end, or far enough ahead to see what conclusion the fellow is driving toward. If he is 'selling' us anything, we can find out what he wants us to 'buy' some time before he has come around to mentioning it.

And the third privilege is that of stopping short at any word or statement that seems to call for meditation, verification, or resort to the dictionary.

Printing is on the side of the people who still have the courage to say 'Stop, I want to think about that', or 'Surely that wasn't what you said before?' or 'What are you getting at?' It does take courage to say such things, even to the amenable printed page, let alone to the vocal spellbinder: and there is no way whatever of saying such things to the reproduced-voice that comes to us through the loudspeaker.

But the future of any form of democratic government depends on keeping that sort of courage alive.

*

In the year forty of each century there are celebrations of the Invention of Movable Type. The printers turn out handsome broadsheets and booklets in honour of the *ars conservatrix artium*, and Providence arranges the appropriate pageant. In 1840 it showed us how recent inventions – the power-driven printing machine, the paper-making machine, and others – had at long last made possible the dream of universal literacy, hence the universal franchise. For the demi-millennial celebration it chose Fireworks, and ironically allowed a German to set them off – to the deep and permanent embarrassment of the noble city of Mainz and the shade of Gutenberg. For those Fireworks began with book-bonfires, and blazed up into white explosions which very clearly lit up the new cleft in history.

To me as the editor of a paper concerned with typography it seemed a good moment to call upon Mr Steinberg for a summary of what had really happened as the result of the invention of type and the press. You are not likely to come across the number of the *Monotype Recorder* which contains the 30,000-word gist and promise of this present book. What with the paper famine and the bombs, few copies survive. But those that do have been worn shabby in passing from hand to hand. In this book you have the fuller story. Here are the five hundred years of printing as a creator of changes in human lives. It will continue to bring changes into our lives; but its greatest task will be to help keep something intact which we were a long time earning – something too precious to be stolen from us by the hypnotic chanting of slogans.

<div style="text-align: right">BEATRICE WARDE</div>

Introduction

Discourse was deemed man's noblest attribute,
And written words the glory of his hand.
Then followed printing with enlarged command
For thought – dominion vast and absolute
For spreading truth and making love expand.

<div align="right">WORDSWORTH</div>

THE history of printing is an integral part of the general history of civilization. The principal vehicle for the conveyance of ideas during the past five hundred years, printing touches upon, and often penetrates, almost every sphere of human activity. Neither political, constitutional, ecclesiastical, and economic events, nor sociological, philosophical, and literary movements can be fully understood without taking into account the influence which the printing press has exerted upon them. As a business proposition the printing trade has its share in the economic development of all other branches of industry and commerce. Being based on a technical process, it is closely linked up with the growth of the applied sciences. The history of printing types is but a side-issue. That is to say, the change of type-faces must be traced back to new needs necessitated, or new possibilities opened, by technical improvements; to commercial considerations on the part of printers or publishers; or, lastly, to sociological changes, including those of taste and fashion, on the part of the reading public.

As 'adventure and art' Gutenberg described his epoch-making invention in 1439; and 'adventure and art' have ever since remained the characteristic features of the printed book,

from its inception in the mind of the author to the finished product in the bookseller's shop and on the book-lover's shelves.

The history of printing from movable types can roughly be divided into the following periods: (1) 1450–1550, the creative century, which witnessed the invention and beginnings of practically every single feature that characterizes the modern printing piece; (2) 1550–1800, the era of consolidation which developed and refined the achievements of the preceding period in a predominantly conservative spirit; (3) 1800 to the present, the period of tremendous technical advances, which has radically changed the methods of production and distribution as well as the habits of producers and readers.

THE FIRST CENTURY OF
PRINTING

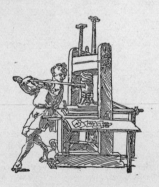

Overleaf: Drawing of one of Koberger's presses, by Dürer, 1511 (original in the Musée Bonnat, Bayonne). See page 25

Chapter One

THE FIRST CENTURY OF PRINTING
1450–1550

1. THE INCUNABULA PERIOD

ALL historical periods are makeshift expedients: people did not go to bed in the Middle Ages and wake up in modern times. Few of these arbitrary breaks, however, can have been more detrimental to a real understanding of an important section of human progress than the restriction of the term *incunabula* to the time from Gutenberg's first production to 31 December 1500. This date cuts right across the most fertile period of the new art, halving the lives of some of its greatest practitioners such as Anton Koberger (1445–1513), Aldus Manutius (1450–1515), Anthoine Vérard (d. 1512), Johannes Froben (1460–1527), Henri Estienne (1460–1520), and Geofroy Tory (1480–1533).

The word *incunabula* was first used in connexion with printing by Bernard von Mallinckrodt, dean of Münster cathedral, in a tract, *De ortu et progressu artis typographicae* (Cologne, 1639), which he contributed to the celebration of the second centenary of Gutenberg's invention. Here he describes the period from Gutenberg to 1500 as '*prima typographiae incunabula*', the time when typography was in its swaddling-clothes. The French Jesuit, Philippe Labbé, in his *Nova bibliotheca librorum manuscriptorum* (1653), already equated the word *incunabula* with 'period of early printing up to 1500'. In

the course of the eighteenth century men whose Latin was considerably shakier applied the term to the books printed during this period, and nineteenth-century writers with no Latin at all eventually coined the singular 'Inkunabel', 'incunable', 'incunabulum', to denote the individual item that emanated from the printing presses of the fifteenth century.

The delimination of the incunabula period has for a long time made research workers everywhere concentrate on the fifteenth century to the grievous neglect of the early sixteenth century. Thus the impression has been created that the turn of the century signified the end of one and the beginning of another era in the history of printing, publishing, and the trade in general. Nothing can be farther from the truth.

The main characteristics which make a unit of the second half of the fifteenth and the first half of the sixteenth centuries are these: the functions of typefounder, printer, publisher, editor, and bookseller are little differentiated; the same man or the same firm usually combines all or most of these crafts or professions. Claude Garamond of Paris (d. 1561) and Jacob Sabon of Lyon and (from 1571) Frankfurt were the first to gain fame for specializing in type-designing, punch-cutting, and type-founding, while Robert Estienne (d. 1559) consummated the era of the great printer-scholars. Moreover, by 1540 printing and publishing had barely outgrown the restlessness of the early practitioners to whom knowledge of the craft and an adventurous spirit had sufficed to set up shop anywhere and to move about with the ease permitted by a small equipment and a smaller purse. The number of printers is increasing, but the day of the small, itinerant man is past. Printing, publishing, and bookselling had become established industries requiring stability and capital and foresight. The German Diet of 1570 only tried (in vain, of course) to put into a legal straitjacket what had become an economic fact when it limited the setting up of printing presses to the capitals of princely states, university towns, and the larger imperial cities, and ordered all other printing establishments to be suppressed. For by this time, business concentration had

advanced so far that the French book-trade can almost be equated to that of Paris, Lyon, and Geneva; the Italian to that of Venice, Rome, and Florence: that of the Low Countries to Antwerp, Amsterdam, and Leiden, while the edict of the German Diet faithfully reflects the anomalous conditions prevailing in the Holy Roman Empire.

From the typographical point of view, too, the first half of the sixteenth century is still part and parcel of the creative 'incunabula' period when the appearance of printed letters was still in the experimental stage, before settling down to accepted conventional forms.

In the middle of the sixteenth century the geography of printing also underwent a change. Both Germany and Italy ceased to be of much importance in the printing and publishing world. At the same time France entered upon her heyday of fine printing and publishing; and Christophe Plantin, a Frenchman by birth, inaugurated the golden age of Netherlands book production. The charter granted to the Stationers' Company in London (1557) may be taken as an outward sign that by then the shades of restrictive planning had fallen across the path of hitherto unfettered expansion.

2. GUTENBERG

THE available evidence about the invention of printing with movable types cast from matrices is unfortunately less conclusive than might be wished; but the following facts may be considered well established.

Johann Gensfleisch zum Gutenberg (born between 1394 and 1399), a Mainz goldsmith of a patrician family, began experimenting with printing work towards 1440 when he was a political exile at Strasbourg. At that time other people too were engaged in discovering some method of producing an 'artificial script' as it was called. Avignon, Bruges, and Bologna are mentioned as places where such experiments were carried out, and the names of a goldsmith and a book-illuminator are extant who thus tried their hands. The general

climate of the age was undoubtedly propitious for Gutenberg's achievement. He returned to Mainz between 1444 and 1448 and by 1450 had perfected his invention far enough to exploit it commercially. For this purpose he borrowed 800 guilders from the Mainz lawyer, Johannes Fust. In 1452 Fust advanced another 800 guilders and at the same time secured for himself a partnership in the 'production of books'. In 1455, however, the financier foreclosed upon the inventor. The bulk of Gutenberg's presses and types went to Peter Schöffer of Gernsheim, who was in Fust's service and later married his daughter (and her dowry). Another printer of unknown name obtained a number of inferior types with which he printed calendars, papal bulls, Latin grammars, and similar works. Gutenberg himself seems to have saved very little from the wreck of his fortune – perhaps only the type in which the 42-line and 36-line Bibles and the *Catholicon* were printed.

The *Catholicon*, compiled by Johannes Balbus of Genoa in the thirteenth century, deserves mention for three reasons. Its type is about a third smaller than that of the 42-line Bible; it is therefore considerably more economical and thus marks an important step towards varying as well as cheapening book-production by the careful choice of type. Secondly, the *Catholicon* was a popular encyclopedia, and with its publication Gutenberg pointed the way towards a main achievement of the art of printing, namely the spread of knowledge. Lastly, the book contains a colophon which it is difficult to believe to have been written by anybody but the inventor of printing himself. It therefore affords the solitary, precious glimpse of Gutenberg's mind, and reads as shown on the page opposite.

After 1460 Gutenberg seems to have abandoned printing – possibly because of blindness. He suffered further loss in the sack of Mainz in 1462 but received a kind of pension from the archbishop in 1465. He died on 3 February 1468 and was buried in the Franciscan church which was pulled down in 1742. A humanist relation later dedicated an epitaph 'to the immortal memory of Johannes Gensfleisch, the inventor of the art of printing, who has deserved well of every nation and language'.

Altissimi presidio cuius nutu infantium lingue fi
unt diserte. Qui og nuosepe puulis reuelat quod
sapientibus celat. Hic liber egregius. catholicon.
dnice incarnacionis annu OD cccc lx Alma in ur
be maguntina nacionis indite germanice. Quam
dei demencia tam alto ingenu lumine. dono og g
tuitu. ceteris terrau nacionibus preferre. illustrare
og dignatus est. Non calami. stili. aut penne suffra
go. ß mira patronau formau og concordia ypor
cione et modulo. impressus atog confectus est.
Huic tibi sancte pater nato cu flamine sacro. Laus
et honor dño trino tribuatur et uno Ecclesie lau
de libro hoc catholice plaude Qui laudare piam
semper non linque mariam DEO. GRACIAS

Colophon of the *Catholicon*, printed by Gutenberg in Mainz, 1460

With the help of the Most High at whose will the tongues of
infants become eloquent and who often reveals to the lowly what
he hides from the wise, this noble book *Catholicon* has been
printed and accomplished without the help of reed, stylus or pen
but by the wondrous agreement, proportion and harmony of
punches and types, in the year of the Lord's incarnation 1460 in
the noble city of Mainz of the renowned German nation, which
God's grace has designed to prefer and distinguish above all other
nations of the earth with so lofty a genius and liberal gifts. There-
fore all praise and honour be offered to thee, holy Father, Son
and Holy Spirit, God in three persons; and thou, Catholicon,
resound the glory of the church and never cease praising the Holy
Virgin. Thanks be to God.

Only one major work can confidently be called a product of
Gutenberg's own workshop – the 42-line Bible which was set
up from 1452 and published before August 1456. Moreover,
there is no doubt that Peter Schöffer was superior to Gutenberg
as a typographer and printer; the quality of his work made
amends for the equivocal practices which made him reap
where he had not sown.

What is perhaps Gutenberg's greatest claim to fame is the

fact that, after the early experimental stage of which we know nothing, he reached a state of technical efficiency not materially surpassed until well into the nineteenth century. Punch-cutting, matrix-fitting, type-casting, composing, and printing remained, in principle, for more than three centuries where they were in Gutenberg's time. Technical changes to the press suggested by Leonardo da Vinci remained in the drawing-board stage and were never put to the test. Minor alterations were made by Dutch printers in the sixteenth century, usually attributed to Willem Janszoon Blaeu (1571–1638) on the sole authority of Joseph Moxon's *Mechanick Exercises* (1683–4); and in the late eighteenth century a number of inventors tried to improve the wooden press by substituting other methods of pressure than the screw, but Gutenberg's basic design continued in commercial use well into the nineteenth century.

To nine out of every ten readers the sentence that 'Gutenberg invented printing' is a shortened form of 'Gutenberg invented the printing of books'. The inevitable association of Gutenberg's name with the 42-line Bible tends to strengthen this fallacy. For it is not – certainly not primarily – the mechanical production of books which has made Gutenberg's invention a turning point in the history of civilization.

Books were printed before Gutenberg, and there is no reason why printing from wood-blocks, engraved metal plates, drawings or photographs on stone, and other media should not have gone on with ever greater refinement – as it has actually done. The books 'printed' by William Blake and, now, filmsetting come readily to mind as examples of printing without movable type. What was epoch-making in Gutenberg's process was the possibility of editing, sub-editing, and correcting a text which was (at least in theory) identical in every copy: in other words, the uniform edition preceded by critical proof-reading. The identity of each copy of each edition extends even to the misprints which, in turn, can be atoned for by identical 'errata' slips.

Moreover, it was not the production of books that was revolutionized by the use of movable types or its applictaion to the

Quod cū audisset dauid:descendit in
presidiū.Philistiĩm autem venientes
diffussi sunt in valle raphaim.Et cō=
suluit dauid dūm dicens.Si ascendā
ad philistiĩm·et si dabis eos ī manu
mea? Et dixit dūs ad dauid. Ascende:
qa tradens dabo philistiĩm in manu
tua.Venit ergo dauid ad baalphara=
sim:et percussit eos ibi et dixit.Diuisit
dūs inimicos meos corā me:sicut di=
uidunt aque.Propterea vocatū ē no=
men loci illi9 baalpharasim.Et reliq=
runt ibi sculptilia sua:q tulit dauid et
viri ei9. Et addiderunt adhuc philisti=
im ut ascenderent:et diffussi sūt ī valle
raphaim.Cōsuluit autē dauid dūm.
Si ascendā cōtra philisteos:z tradas
eos in manus meas?Qui rūdit. Nō
ascendas cōtra eos sed gira post tergū
corū:z venies ad eos exaduso pirorū.
Et cū audieris sonitū clamoris gra=

Part of a column of the 42-line Bible (II Sam. 5:17–24),
printed by Gutenberg in Mainz, 1452–6

machine-made edition. In fact, printed books were at first hardly distinguishable from manuscripts, and the title-page is virtually the one feature which printers have added to the products of the scribes – and one which scribes, too, would sooner or later have hit upon, as did Vespasiano da Bisticci. It is in two vastly different spheres that Gutenberg has changed the aspect of reading matter in its widest sense. When he and Fust preceded and accompanied their great adventure of book-printing with the issue of indulgences, calendars, and pamphlets on ephemeral topics, the proto-typographers created what came to be known as job-printing. With it they laid the foundations of modern publicity through the printed word, which is dependent on the identical mass-production of freely combinable letter-units in almost infinite variety of composition – the very characteristics of Gutenberg's invention.

At the same time, when Gutenberg made it feasible to put on the market a large number of identical copies at any given time, he thereby foreshadowed the possibility of ever increasing the number of copies and ever reducing the length of time needed for their issue. The principle once established, it was a matter of technical progress to develop the turning out of ten thousand identical indulgences within a month into the turning out of a million identical newspapers within a few hours. Thus Gutenberg can also be acclaimed as the progenitor of the periodical press.

Again, while it is easy to say that 'Gutenberg invented printing', it requires a long treatise to say what actually constituted Gutenberg's 'invention'. Down to Moxon's *Mechanick Exercises*, that is to say, for 250 years, the literary allusions to the 'mystery' are vague or ambiguous, and the representations of printers at work are rarely accurate about technical details. The only tangible sources therefore are the products of Gutenberg's press, from which the process by which he achieved them must be inferred.

In order to remove popular misunderstandings, we may perhaps proceed by a series of negative propositions.

Gutenberg was not the first to grasp the need for, and the

potentialities of, large-scale production of literature. On the contrary, his invention was largely prompted by the fact that the multiplication of texts was not only a general want but had, by the middle of the fifteenth century, become a recognized and lucrative trade. Professional scribes catered for the wealthy collector of classical manuscripts as well as for the poor student who needed his legal and theological handbooks. The Florentine bookseller Vespasiano da Bisticci employed up to fifty scribes at a time; in the university towns, of which Paris was the most important, the copyists of learned texts were numerous enough to form themselves into guilds. The religious congregation of the Brethren of the Common Life in Deventer specialized in copying philosophical and theological books for which they established a market all over northern Europe. Diebold Lauber ran a veritable 'book factory' in the Alsatian town of Hagenau; he, like any later publisher, produced books for the open market; 'light reading' was Lauber's speciality, and illustrations, also produced by rote, added to the popular appeal.

Nor was 'printing' from a negative relief a new invention. The Chinese had practised it for about a thousand years (the legendary date of its inception is A.D. 594), and their method of rubbing off impressions from a wood-block had spread along the caravan routes to the west, where block-prints and block-books were well known at the time of Gutenberg.

From China, too, had come the invention of paper, which was to prove the ideal surface for printing. Vellum, it is true, was and still is occasionally used for luxury printing; but paper had, and has, the advantage over vellum of being available in virtually unlimited quantities and thus allows mass-production which is the distinguishing feature of printing.

Again, Gutenberg followed precedent when he replaced wood by metal, and the block by the individual letter. In this respect he stood in the tradition of his own trade of goldsmith, for goldsmiths and kindred artisans had always cut punches for their trade-marks or the lettering with which they struck inscriptions on cups, bells, seals, and other metalware.

Gutenberg also found at hand an instrument suitable for compressing and flattening a moist and pliable substance (such as printing paper), namely the screw press, used for a variety of purposes for at least a thousand years.

Gutenberg's achievement, then, lies first in the scientific synthesis of all these different trends and trials. He fulfilled the need of the age for more and cheaper reading matter by substituting machinery for handicraft. Drawing upon the technical experience of the writing-master, the wood-engraver, and the metal-worker, he produced movable types which could be combined at will. Here at last comes the point where we can speak of at least two genuine 'inventions' made by Gutenberg. Types had to be available in large numbers even for the setting of a single sheet; they would be required by the thousand for the composition of a whole book. How could they be multiplied from the one model produced by the letter-designer and punch-cutter? Gutenberg overcame this difficulty by applying the principle of replica-casting. A single letter, engraved in relief and struck or sunk into a slab of brass would provide the intaglio or 'matrix' (female die) of that letter in reverse; from this matrix any number of mechanical replicas of that letter could be cast by pouring molten lead into it. The replica-letters, the types, had to be cast with a long enough shank to permit finger and thumb to grasp them securely while they were being fitted together into words and lines. Whatever character was being cast, this shank or 'body' had to be of precisely the same length so that the composed lines and columns of type, standing on the level bed of the press, would present a uniformly flat printing surface. It is not certain how far Gutenberg himself developed the principle of the typecaster's 'mould' – the instrument of which the two interlocking parts provide an orifice roughly an inch deep, sealed at one end by the intaglio matrix, open at the other end for the molten metal, and adjustable to any specific width of letter from broad W to narrow I. Tradition assigns its invention to Schöffer. But Gutenberg, before he arrived in Mainz and joined forces with Fust and Schöffer, must have worked

out some practicable method of replica-casting from matrices unlimited quantities of metal types that would combine in optical alignment to create a flat composite printing surface. In doing so he had not only established the main principle of letterpress printing but also introduced to Europe, more than three centuries ahead of its general adoption by industry, the 'theory of interchangeable parts' which is the basis of all modern mass-manufacturing technique.

Gutenberg's second invention without which printing as we understand it would have been impossible was the preparation of an ink which would adhere to the metal types and therefore had to have chemical properties very different from those of the ink with which impressions were taken from woodblocks. His solution was to adapt the discoveries of Flemish painters by using an ink made from a pigment ground in linseed-oil varnish. Gutenberg also needed paper and this was available, having been manufactured in Europe for some years. It was, however, a paper made from macerated linen and cotton cloth, treated with gelatine to give it a hard, opaque surface for writing on with a quill pen. It was unlike the thin, soft, pliable, and absorbent paper used with water-based ink in rub-printing. The constitution of both ink and paper therefore demanded a different method of printing, whereby a sharp but decisive impact could be made between paper and type.

Apart from this consideration, if full value was to be obtained from Gutenberg's mass-production of type, he needed a faster way of manufacturing printed texts than rub-printing. The answer was found in the screw press, well known in Europe since the first century A.D. The tale that Gutenberg was inspired by the heavy winepress at a wine festival is apocryphal, and it is more likely that he instructed Konrad Saspach, a wood-turner, to alter a small domestic screw press – one for pressing linen, or extracting oil from olives. As continuous, squeezing pressure was not needed, the pressing board (or platen) no longer travelled down guides at the sides of the frame, but was detached and hung on hooks at the

end of a box-like contrivance, known as the hose, in which the screw turned. This provided the resilient pressure suitable for printing from type.

At some point, a projecting table was added, along which the forme of type could be slid under the platen. The earliest known illustration of a printing press, dated 1499, shows not only how small the press was but indicates the addition of the table and the box carrying the type. The first circumstantial report on the art of printing, which Koelhoff embodied in his *Chronicle of Cologne* (1499) pays scant attention to technicalities. Dürer's drawing of 1511 is not accurate: there is no way of running in the type under the platen and the screw is wrongly cut. But other artists, particularly those who drew the press marks of Josse Bade of Paris from 1509 onwards, give us a more accurate impression, and the first simplified description of the printing process was published by Christopher Plantin in 1567 in *Dialogues français pour les jeunes enfans*, nearly a hundred and twenty years earlier than that of Joseph Moxon in his *Mechanick Exercises*. But it is to Moxon that posterity owes the most comprehensive book on the practice of type-cutting, casting and composing, ink-making, press manufacture, printing, and correcting. It has remained an indispensable mine of information about every aspect of the technical processes of printing as they were practised from Gutenberg to the invention of the cylinder printing machine.

Gutenberg's press remained in use without any very radical improvement for more than three centuries. Its working required a great deal of muscular force; the pull and weight of the machine made presswork toilsome; and it was incapable of printing a full sheet of paper at one pull. But it sufficed for its day, and for the then limited section of the public which could read its products.

However, as these very products had the effect of continuously enlarging the number of literate people, the old press eventually failed to cope with the demand it had created. It thus was the principal agent in superseding itself.

3. TYPE-DESIGN

WITHIN fifteen years after Gutenberg's death in 1468 print-ing presses had been set up in every country of western Christendom from Sweden to Sicily and from Spain to Poland and Hungary. Less than a century later, in the middle of the sixteenth century, the western comity of nations had made up their minds as to the outward form in which they wanted to have printing matter presented to them. Whereas it is possible to examine country by country the intellectual contributions made to European civilization by the printers of each nation, the development of type-design was intrinsically a supra-national affair and shall therefore be surveyed briefly in chronological order.

It was the penetration of western Europe by the spirit of humanism that brought about the victory of 'roman' and 'italic' types; and it was the resistance to the spirit of human-ism that made the Germans, Russians, and Turks cling to the isolationism of the Fraktur, Cyrillic, and Arabic types. The recent transition to the 'Latin' alphabet by the Germans and Turks is a major step towards the unity of world civilization; just as the refusal of post-Lenin Russia to abandon the Cyrillic letter – nay, its progressive imposition on the Soviet colonials – is a significant omen of the deep cleavage between East and West.

In outward appearance the books printed between 1450 and 1480 are almost indistinguishable from contemporary manu-scripts. The printers took over virtually the whole range of scripts used in mid-fifteenth-century Europe: the *textura* of liturgical works, the *bastarda* of legal texts, the *rotunda* and *gothico-antiqua*, both Italian compromises between Carolin-gian and late-medieval scripts, the formal *lettera anticha* and the cursive *cancelleresca* favoured by Italian humanists, and so on. Neither manuscript nor printed book had a title-page or page-numbers; when coloured initials and other illustra-tions were wanted, they had to be inserted by a specialist

other than the scribe or printer. The same material, from the roughest to the finest paper and from the coarsest to the smoothest parchment, was used for the same sizes which had become fairly settled, with quarto and folio easily leading.

Why did the printers thus follow so closely the scribes? It is sometimes said that they wished to deceive the public by making their 'substitute' look as near as possible like the 'real' thing. The true explanation, however, is to be found in the attitude of the consumer rather than the producer. Extreme conservatism as to the presentation of reading matter has always been the outstanding characteristic of the reading public. 'The typography of books requires an obedience to convention which is almost absolute'; and 'for a new fount to be successful, it has to be so good that only very few recognize its novelty' – these are amongst the 'first principles of typography' as abstracted by Stanley Morison from the study of five centuries of printing. The same rules apply to the shape of individual letters and to the look of a whole page or an opening. William Morris would have been deeply mortified, had he but known it, that a contemporary of Gutenberg or Caxton would hardly have recognized a product of the Kelmscott Press as a 'book' but more likely have marvelled at it as a kind of purposeless curio. A book which, in some way or other, is 'different', ceases to be a book and becomes a collector's piece or museum exhibit, to be looked at, perhaps admired, but certainly left unread; the fate of virtually all productions of 'private presses'.

The incunabula printers were artisans and craftsmen, without any of the arty-crafty ambitions or illusions that haunted English, French, and German 'reformers' from 1880 to 1910. In other words, while they were proud – and justifiably proud – of the quality of their handiwork, they had to make their living by it and therefore sell goods which their customers would be willing to buy. The regularity of each letter, the compactness of each line, the closely woven pattern of each page, comparable to a latticed gothic window or an oriental carpet – these rather than clarity and legibility were the effects

a well-trained scribe sought to produce. The printer un-hesitatingly accepted this convention. The lawyer who needed a copy of the Decretals knew exactly what the Decretals ought to look like because he had handled it all his life. Schöf-fer's, Richel's, Wenssler's, Koberger's, or Grüninger's editions, with the commentary printed on the margins round the text, without spacing or leading, teeming with ligatures and abbre-viations, without title-page, table of contents, and index – these a fifteenth-century lawyer would instantly have been familiar with, whereas any modern annotated *Codex juris canonici*, with footnotes and appendices, would have left him completely bewildered.

The wish to make a printed book look like a hand-written one has by no means become extinct, but it must now be regarded as a romantic aberration rather than a legitimate variety of the printer's craft. This stricture, of course, does not apply to the use of script-types for display and advertisements where they fulfil the legitimate function of arresting the reader's eye by their very strangeness.

It was the recognition of the basic difference between the effects created by the metal-worker and those produced by the quill-driver which brought about the victory of the punch-cutter over the scribe and with it the supersession of the imita-tion-manuscript by the authentic book. By 1480 the second generation of printers had become conscious of the intrinsic autonomy of their craft.

It is precisely in the lucid arrangement of a given text that the printers have achieved the greatest advantage over the scribes. The value of an accurate and uniform text made possible by the printing press has already been alluded to. This gain is enhanced further by the skilful use of graduated types, running heads at the top and footnotes at the bottom of a page, tables of contents at the beginning and indices at the end of a tract, superior figures, cross-references, and other devices available to the compositor – all identical and there-fore quotable by any reader. They are so many aids to the easier understanding not only of scholarly treatises but even

more of time-tables, dictionaries, travel guides, manuals of every description, and much else.

An important by-product of this development was the gradual reduction of the contents of the compositor's case. Gutenberg used nearly 300 different letters, ligatures, and abbreviations. These have now been brought down to about 40 in the 'lower case' and even fewer in the 'upper case': the surviving ligatures are restricted to ff, fi, fl, ffi, ffl, æ, œ, and the ampersand & is the sole existent abbreviation.

Handwriting, type-founding, and printing were discussed together in the *Dialogues pour les jeunes enfans* which Plantin published in 1567. The author, Jacques Grévin, first talks about penmanship with the writing-master Pierre Hamon, and then about the tools and procedure of the printing shop with a second interlocutor, 'E.', who may be Robert Estienne or the Dutch type-founder Laurens van Everbroeck. Although the usefulness of the booklet for 'young children' of any period may be doubted, it still makes pleasant reading for any master-printer who wants to sample the flavour of sixteenth-century craftsmanship.

Within about fifty years after Gutenberg's death the original profusion of types had sorted itself out into two streams: on the one hand, the 'antiqua' founts of 'roman' and 'italics'; on the other, the 'gothic' founts of 'Fraktur' and 'Schwabacher'. All these names are fanciful inventions of later writers. In fact, 'roman' types were cut first in Strasbourg in 1467 and brought to perfection in Venice by the Frenchman Nicolas Jenson, in 1470. The origin of 'italics' is the cursive humanist script which was made serviceable for printing by the punch-cutter Francesco Griffo who worked for Aldus Manutius in Venice about 1500, and the script of the Papal chancery which was adjusted to printing by the Roman writing-master Ludovico Arrighi and the Roman printer Antonio Blado, about 1520. 'Fraktur' grew out of the various types used all over Europe during the fifteenth century. Its English name 'gothic' still points to this origin, whereas the French term *caractères allemands* alludes to the

fact that it received its final form in Augsburg and Nürnberg about 1510–20. 'Schwabacher', also one of the many 'gothic' types then in use, appears from about 1480 in Nürnberg, Mainz, and elsewhere; it certainly did not originate in the little Franconian town of Schwabach.

ROMAN TYPE

The victory of the 'antiqua' type over its 'gothic' rival was mainly due to the business genius of the printer Aldus Manutius. He was backed, it is true, by the powerful tradition in which his most influential customers had been brought up since the days of the Florentine humanists, Coluccio Salutati, Poggio, and Niccolò Niccoli. They had established the principle that the 'littera antiqua' was the proper medium for the transmission of ancient texts.

It was therefore quite natural that the very first book printed in Italy should appear in a type which more nearly approximated the 'round hand' of the renaissance scribes than the 'gothic' textura of the Mainz printers: for it was a classical text, Cicero's *De oratore*, printed by Sweynheym and Pannartz in Subiaco, 1465. Similarly, the first printers in France used an 'antiqua' fount, for their employers, two dons of the Sorbonne, wanted to utilize the printing press for the spread of humanism, and an instruction in the art of elegant Latin composition, Gasparinus Barzizius's *Epistolarum libri*, was the first text printed in Paris (1470). Sweynheym and Pannartz's round type, in the slightly varied form it was given by the Roman printer Ulrich Han, remained popular with Roman presses for a long time, until this Roman roman of a German typographer was ousted by the Venetian roman of the Frenchman, Nicolas Jenson. It was, however, pleasant enough to cause St John Hornby, a fastidious typographer, to revive it for his Ashendene Press in 1902.

Jenson, one of the greatest type-designers of all time, too, cut his 'roman' fount for the printing of a 'Roman' text, Cicero's *Epistolae ad Brutum* (1470). Nicolas Jenson, born

Illis qppe promisisse mercedem falsumq̃
iurasse phibet̃. Miror Apollinem noiatũ
diuinatorem:in tanto opificio laborasse
nescietẽem:qp Laomedon fuerat promissa
negaturus. Quáq̃ nec ipsum Neptunum
patruũ eius fratrem Iouis regem maris
decuit ignarum esse futuroȝ. Nam hunc
Homer9 de stirpe Aeneȝ de posteris cui9
roma est:cum ante illam urbem cõditam
idem poeta fuisse dicatur: inducit magnũ
aliqd diuinãtem qué etiã nubes rapuit ut
dicit ne ab Achille occideretur:cuperetq̃
cõuertere ab imo quod apud Virgilium
confitetur. Structa suis máibus periurȩ
mȩnia troiȩ. Nescientes igitur tanti dii et
Neptunus & Apollo Laomedontem sibi
negaturũ esse mercedé:structores mȩniũ
troianoȝ gratis & igratis fuer̃t. Videãt
ne grauius sit tales deos credeȓ q̃ diis ta-
libus peierare. Hoc.n.nec ipsȩ Homerus
facile credit.qui Neptunũ quidem contra
troianos Apollinem auteȝ pro troianis
pugnantem facit:cũ illo periurio ambos

Augustinus, *De civitate Dei*, printed by Sweynheym and Pannartz
with their first type at Subiaco, 1467

Sed plane íplestí remeanſ pie uictor olympi.
Tartera preſſa iacent.nec ſua iura tenent.
Inferuſinſaturabiliter caua guttura pãdenſ
Qui raperet ſemper:fit tua preda deuſ.
Eripiſ innumerũ populũ de carcere mortiſ.
Et ſequitur liber quo ſuuſ auctor abiſ.
Euomit abſorptam pauide fera belua plebẽ.
Et de fauce lupi ſubtrahit agnuſ oueſ.
Hinc tumulũ repetēſ poſt tartara carne reſũpta.
Belliger ad celoſ ampla trophea referſ.
Quoſ habuit penale chaoſ:iam reddidit iſte:
Et quoſ morſ peteret:hoſ noua uita tenet.
Rex ſacer ecce tui radiat parſ magna trophei:
Cum puraſ animaſ ſacra lauacra beant.
Candiduſ egreditur nitidiſ exercituſ undiſ.
Atqʒ uetuſ uitium purgat in amne nouo.
Fulgenteſ aiaſ ueſtiſ quoqʒ candida ſignat.
Et grege de niueo gaudia paſtor habet.
Additur hac felix concorſ mercede ſacerdoſ:
Qui dare uult domino dupla talenta ſuo.
Ad meliora trahenſ gentili errore uaganteſ:
Beſtia ne raperet munit ouile dei.
Quoſ priuſ eua nocēſ infecerat:hoſ modo reddit
Eccleſie paſtoſ ubere lacte ſinu.

Hoc Conraduſ opuſ ſuueynheym ordine miro
Arnolduſqʒ ſimul pannartſ una ede colendi
Gente theotonica:rome expediere ſodaleſ.

In domo Petri de Maximo.M.CCCC.LXVIII.

Lactantius, *Opera*, second edition printed by Sweynheym and Pannartz
with their second type in Rome, 1468

GVILLERMVS Fichetus parisiensis
theologus doctor, Ioanni Lapidano Sor/
bonensis scholæ priori salutem ;
Misisti nuper ad me suauissimas Gaspa/
rini pergamensis epistolas, nõ a te modo
diligent emẽdatas? sed a tuis quoqz ger//
manis impressoribus nitide & terse trã/
scriptas. Magnam tibi gratiã gasparinus
debeat • quem pluribus tuis uigiliis ex
corrupto integrz fecisti. Maiorẽ uero cæ/
tus doctorz hoim? qz nõ tm saccis litteris
(quæ tua prouicia est)magnopere studes?
sed redintegrãdis etiã latinis scptoribus
insegnem operam naual. Res sane te uiro
doctissimo & optimo digna•ut qz cũ lau//
de & gloria sorbonico certamini dux p̃//
fuisti? tum latinis quoqz lris(quas ætatis
nostræ ignoratio tenebris obumbrauit)
tua lumen effundas industria• Nam præt
alias complures lrãrz grauiores. iacturas,
hanc etiã acceperũt? ut librariorz uitiis,
effectæ pene barbaræ uideant • At uero

Gasparinus Barzizius, *Epistolarum libri*, the first book printed
in France, by Freiburger, Gering, and Kranz at the
Sorbonne in Paris, 1470

P.VIRGILII MARONIS BVCOLICA.
AEGLOGA PRIMA:INTERLOCVTORES
MELIBOEVS ET TITYRVS AMICI. ME.

ITYRE TV PATVLAE RECV
BANS SVB TEGMINE FAGI
Siluestrĕ tenui muſā meditaris auena.
Nos pr̃iæ fines:& dulcia lĩqmus arua.
Nos pr̃iā fugĩus:tu Tityre lĕtus ĩ ũbra
F ormoſam reſonare doces amaryllida ſiluas. TI.
O meliboee deus nobis hæc ocia fecit.
N anq; erit ille mihi ſemper deus:illius aram
S æpe tener noſtris ab ouilibus imbuet agnus.
I lle meas errare boues(ut cernis)& ipſum
L udere quæ uellem calamo permiſit agreſti. ME.
N on equidem inuideo:miror magis:undiq; totis
V ſq; adeo turbatur agris:en ipſe capellas
P rotinus æger ago:hanc etiam uix Tityre duco.
H ic inter denſas corylos modo nanq; gemellos .
S pem gregis ah ſilice ĩ nuda cõnixa reliquit.
S æpe malum hoc nobis:ſi mens non leua fuiſſet:
D e cælo tactas memini prædicere quercus.
S ed tamen iſte deus qui ſit da Tityre nobis. TI.
V rbem quam dicunt romam Meliboee putaui
S tultus ego huic noſtræ ſimilĕ:quo ſæpe ſolemus
P aſtores ouium teneros depellere fœtus.
S ic canibus catulos ſimiles:ſic matribus hædos
N oram:ſic paruis componere magna ſolebam.
V erũ hæc tantum alias inter caput extulit urbes:
Q uãtum lenta ſolent inter uiburna cupreſſi. ME.
E t quæ tanta fuit romam tibi cã uidendi? TI.
L ibertas quæ ſera tamen reſpexit inertem
C andidior:poſtq̃ tondenti barba cadebat.
R eſpexit tamen:& longo poſt tempore uenit.

Virgil, *Bucolica*. printed by Nicolas Jenson in Venice, 1475

about 1420 at Sommevoire near Troyes, was a die-cutter by profession, and is said to have been sent by King Charles VII to Mainz to spy out the new mystery of printing – an early instance of industrial espionage. It seems certain that he actually learned printing in Germany, perhaps in Mainz, before he settled in Venice shortly before 1470; he was in any case the first non-German printer of whom we know. We no longer share the exaggerated enthusiasm of William Morris, who maintained that 'Jenson carried the development of roman type as far as it can go', but the strength and nobility of this first true 'roman' at once set the highest standard for every subsequent roman face. However, Jenson himself later reverted to the use of 'gothic' types, and at least vernacular printing matter continued for a while even in Italy and France to be composed in non-antiqua founts. The gothic cursive, called *lettre bâtarde*, which was designed in Paris in 1476, remained for some decades the type normally used for French texts.

The turn of the tide came with the publications of Aldus Manutius. He was extremely fortunate in the choice of his type-designer, Francesco Griffo of Bologna. Above all, Griffo supplied a novel fount which Jenson had not thought of. It was based on the 'cancelleresca corsiva' of the papal chancery, which humanists had taken over for their informal writing, and later received the name of 'italics'. It is pleasant to find, though, that the Spaniards call it *letra grifa*. It proved to be the ideal companion, in print as it had been in handwriting, to the formal 'roman' type. Griffo also cut several founts of the latter; these are particularly important in that Griffo went for his models beyond the hands of humanist scribes (who had mistaken the Carolingian script for a product of the classical era) to the inscriptional lettering of imperial Rome. Griffo's most satisfactory roman founts are his first – used initially for Pietro Bembo's *De Aetna*, 1495 – and third – used for the curious *Hypnerotomachia Poliphili* in 1499. Both these types exerted their fascination upon successive generations of typographers from Simon de Colines

and Robert Estienne in the sixteenth century to van Dyck and Grandjean in the seventeenth century, Caslon in the eighteenth, and Stanley Morison in the twentieth century.

But the typographical qualities of Griffo's founts would hardly have had the effect of finally ousting the black-letter as well as Jenson's roman types, had they not been sponsored by the greatest publisher of the time. Aldus Manutius chose Griffo's italics for his popular series of classical authors not because it was beautiful but because it suited his commercial intentions in that it was condensed and narrow and therefore made the most economic use of the type area.

Backed by the international prestige of the printer-publisher Aldus, there was henceforth no doubt that 'antiqua' was to be the common European type. As in the sixteenth century France took over from Italy the leading role in typography, it was of importance that French printers should presently adopt the Aldine pattern even for the printing of Books of Hours and other liturgical works for which the medieval textura had been customary longest. Thielmann Kerver, tentatively, and Geofroy Tory, as a matter of principle, took this decisive step.

Printer's device used by Geofroy Tory from 1524:
a broken vessel (Ps. 31 : 2) on a clasped book;
motto 'Non plus'

Tory crowned his work as a practising printer by writing the first theoretical treatise on the designing of types: *Champfleury, au quel est contenu Lart & Science de la deue & vraye Proportion des Lettres Attiques, quon dit autrement Lettres Antiques, & vulgairement Lettres Romaines proportionnees selon le Corps & Visage humain* (1529). The author was rewarded by François I with the title of *Imprimeur du roi* (1530). Tory also advocated the use of the accent, apostrophe, and cedilla in French printing, and was a poet in his own right and an able translator from the Greek. An additional claim to glory has now been disproved; it was not Tory, but the Parisian printer Antoine Augereau (d. 1534) with whom Garamond was apprenticed in 1510 and who thus became the teacher of one of the greatest typographers.

Claude Garamond (1480–1561) was the first to confine himself to the designing, cutting, and casting of types, which hitherto had formed part of the printer's training and profession. Garamond was not himself a printer, but from 1531 onward created a series of roman founts (commissioned and first used by the publishing firm of Estienne) which have influenced the style of French printing down to the end of the eighteenth century.

The last effort to create a really 'new' fount to take its place beside 'roman' and 'italic' was made by Robert Granjon. He was the son of a Paris printer and himself combined the professions of punch-cutter, founder, printer, and publisher. From 1556 to 1562 he lived in Lyon, having previously supplied the Lyonese printer de Tournes with various founts. For his own firm Granjon in 1557 designed a special fount, called *Civilité*, which he intended to become the French national type. This was an adaptation of gothic cursive handwriting and received its name from its frequent use in children's books entitled, e.g., *Civilité puérile*. But by this time Griffo's 'italic' had established itself too firmly in the favour of printers and readers to admit any rival as the subsidiary antiqua fount. Moreover, the idea of a 'national' type ran counter to the whole development of printing as a vehicle of international

Dialogue de la vie et d

La Mort, Composé en Toscan par
Maistre Innocent Ringhier
Gentilhomme Boulongnois.

✣

Nonvellement traduit en Francoys par Jehan
Louvtan Recteur de Chastillon & Jembes

A Lyon.
De L'Imprimerie de Robert Granjoy.
Mil. D. Lvij.

First use of Robert Granjon's *Civilité* type in Jean Louveau's
French translation of Innocent Ringhier's Italian
Dialogue de la vie et de la mort (Lyon, 1557)

understanding. Although *Civilité* kept its place in the specimen sheets of French, Dutch, and German printers for more than 200 years, it was never used as an everyday type. For, unbeknown to himself, Granjon had created in his *Civilité* the first display fount, admirably suited for a diversity of jobbing matter, such as business circulars, high-class advertisements, and the like – not a rival but a valuable supplement to the ordinary book types.

GOTHIC TYPE

By the time of Aldus's death (1515) Germany had set out on the way towards a typographical style of her own. About 1510 the Augsburg printer Johann Schönsperger had cut some founts for which the clerks of the imperial chancellery had supplied the designs. Ten years later, about 1520–2, this proto-Fraktur was disciplined and given its final shape by the Nürnberg writing-master Johann Neudörffer (1497–1563) and the Nürnberg punch-cutter Hieronymus Andreae. 'Fraktur' was to remain the typical German letter for 400 years.

The Neudörffer-Andreae type of Fraktur owes its ascendancy as the dominant German type largely to the favour it found with the Frankfurt publisher Sigmund Feyerabend (1528–90). He began as a type-cutter and designer of book ornaments and worked in Augsburg, Mainz, and Venice before he settled in Frankfurt in 1560. Here he soon became the head of a rapidly expanding publishing company which eventually employed nearly every Frankfurt printer for its numerous and variegated production. Faithful to his artistic upbringing, Feyerabend secured for his firm the services of some of the best book-illustrators, such as Virgil Solis (1514–1562) and Jost Ammann (1539–91), whose popularity in turn increased the familiarity of the public with the Fraktur letterpress accompanying their woodcuts.

Neudörffer's Fraktur superseded the 'Schwabacher' type which from 1480 to 1530 was the most popular face of German presses. Or rather should it be said, Fraktur relegated

Oratio ad suū ꝓpriū angelū.
Deus ꝓpicius esto mihi
peccatori·Et sis mihi cu
stos omnibus diebus vite mee·
Deus Abrahā·Deus Ysaac·
Deus Jacob miserere mei Et
mitte in adiutoriū meum pro-
prium angelū gloriosissimū:
qui defendat me hodie:et pte-
gat ab omnibus inimicis meis
Scte Mihael archangele·De-
fende me in ꝓlio:vt non pereā
in tremendo iuditio·Archan-
gele christi·Per gratiā quam

Prayer-book of the Emperor Maximilian I, limited edition of ten copies
printed on vellum by Johann Schönsperger in Augsburg, 1512–13;
type-design by Vinzenz Rockner, the emperor's secretary

Schwabacher to a subsidiary place as a kind of 'italic' beside the dominant fount. But Schwabacher, although more rounded and open than Fraktur, is on the whole so little distinguished from Fraktur that it cannot actually be considered an independent second face. This shortcoming is one of the reasons which render Fraktur so much inferior to antiqua. In addition, Fraktur has no small capitals, and its own capitals cannot be combined to make a legible word.

The original reason for the prevalence of the black-letter in Germany and the Scandinavian and Slavonic countries in cultural dependence on her may be found in the preponderance of theological over humanistic writings in Germany. This was backed first by the strictly Thomist teachings of Cologne and later by the Lutheran theology of Wittenberg, two university towns which at the same time were busy centres of printing.

However, it seems that non-German texts – classical as well as modern – were always set up in antiqua type; and down to the end of the eighteenth century, 'foreign words' (*Fremdwörter*) were frequently printed thus even in an otherwise black-letter text.

4. THE SPREAD OF PRINTING

IN view of the fact that printing from movable type was a German invention and first practised in the German city of Mainz, it is not surprising that the first practitioners of the new art in every country of Europe and even in parts of the New World should have been German nationals. It is no exaggeration to describe Gutenberg's invention as Germany's most important single contribution to civilization. However, the printers who, from about 1460 onward, went on their travels from Mainz were little concerned with German culture. They were craftsmen and business men; they wanted to make a living; and they readily adapted themselves and their art to the conditions of

international trade. Until printing had firmly established itself as an everyday commodity, that is to say, until well into the beginning of the sixteenth century, a map showing the places where printers had settled down is virtually identical with a map showing the places where any commercial firm would have set up an agency.

It is quite purposeless to enumerate the dozens of one-horse towns in the Abruzzi or Savoy which can boast of one or perhaps even two early presses or to trace the steps of these wandering printers in their quest for patrons and customers. Fascinating though the study of some of these men and their productions is for the student of incunabula, the history of printing is too much bound up with the history of 'big business' to mention here more than one of these small fry. Except for the high quality of his work, the career of Johann Neumeister of Mainz is typical of that of many of his fellow-craftsmen. Perhaps a direct pupil of Gutenberg, Neumeister was invited to Foligno by a humanist scholar and there produced the first edition of Dante's *Divina Commedia* in 1472; he then returned to Mainz and later on set up a press at Albi in Languedoc. In both places he drew upon his familiarity with Italian art when he produced Turrecremata's *Meditationes* (1479, 1481) with illustrations cut after the mural paintings in S. Maria sopra Minerva in Rome. Finally Neumeister was called by the cardinal d'Amboise to Lyon where he printed the magnificent *Missale secundum usum Lugduni* (1487).

Individual patrons, however, were not enough to guarantee the printer a livelihood and to secure the sale of his books. Right from the beginning, the printer (who, be it remembered, was his own publisher and retailer) was faced by the alternative, unchanged ever since, of basing his business on the support of organized institutions or of relying on the fairly stable market of a literate, book-loving, and book-buying clientele of sizeable dimensions. Official backing was (and is) provided mainly by governments, churches, and schools; private patronage, by the educated urban middle class.

The aristocracy, which in the following centuries was to

build up those magnificent libraries, most of which have eventually found their last refuge in public libraries, greeted the new invention with little enthusiasm if they did not condemn it outright. The attitude of the Duke Federigo of Urbino, as reported by Vespasiano da Bisticci, was at the time, about 1490, shared by most connoisseurs. In his splendid library 'all books were superlatively good and written with the pen; had there been one printed book, it would have been ashamed in such company'. It is in keeping with this contempt of the mechanically produced book that Cardinal Giuliano della Rovere (later Pope Julius II) had Appian's *Civil Wars* copied by a superb scribe in 1479 from the text printed by Wendelin of Speier in 1472. The calligrapher even adopted the printer's colophon; he only changed 'impressit Vindelinus' to 'scripsit Franciscus Tianus'. As late as the second half of the eighteenth century a voluptuary aesthete, the cardinal Rohan, used only hand-written service books when he celebrated mass.

It was, then, people of moderate means who could not afford to be squeamish about the outward appearance of the tools of their profession, to whom the early printers had to look for custom. It was the binders rather than the printers who overcame the reluctance of highbrow connoisseurs in admitting printed books to their stately shelves; and down to the present the sumptuousness of choice bindings frequently contrasts oddly with the shoddiness of printing and the worthlessness of contents thus bound.

It is quite in keeping with the well-organized and world-wide net of international trade at the end of the Middle Ages that printing by no means spread in ever-widening circles from Mainz over southern Germany, central Europe, and to the fringes of the then known world. On the contrary, the ease of firmly established communications all over the Continent permitted the printers to reach out at once to those places which offered the brightest prospects, that is to say the flourishing centres of international trade. So it came about that printing presses were established in quick succession in Cologne (1464), Basel (1466), Rome (1467), Venice (1469),

Paris, Nürnberg, Utrecht (1470), Milan, Naples, Florence (1471), Augsburg (1472), Lyon, Valencia, Budapest (1473), Cracow, Bruges (1474), Lübeck, Breslau (1475), Westminster, Rostock (1476), Geneva, Palermo, Messina (1478), London (1480), Antwerp, Leipzig (1481), Odense (1482), Stockholm (1483). University towns as such had no attraction for printers: learning and diligence is no substitute for ready cash. Cologne, Basel, Paris, Valencia, Seville, and Naples acted as magnets because they were thriving centres of trading, banking, and shipping, and seats of secular and ecclesiastical courts.

The only university town which seems to be an exception was Wittenberg; but there it was one professor only who made printing a success, and before and after Martin Luther's connexion with Wittenberg university the place does not occur in the annals of printing. In fact, Wittenberg can be said to owe its fame partly to the one blunder the shrewd Nürnberg printer, Anton Koberger, ever committed when he turned down Luther's offer to become his publisher.

The church, and especially the monastic orders and congregations with their far-flung connexions, too, provided easy ways of transmitting the art regardless of political frontiers. When, in 1463, the two printers, Sweynheym and Pannartz, went to the Benedictine abbey of Subiaco near Rome to set up the first press outside Germany, they most probably travelled via Augsburg. For the Augsburg abbey of SS. Ulric and Afra maintained the closest relations with Subiaco (which, incidentally, was manned chiefly by German monks). Both abbeys excelled in the zeal and quality of their scriptoria, and it was in SS. Ulric and Afra that a few years later the first Augsburg press was established. As Subiaco abbey was under the supervision of the great Spanish cardinal, Torquemada, it was a natural step for the two printers to move very soon to Rome itself. Later, their literary adviser, Giovanni Andrea dei Bussi, was rewarded with a bishopric in Corsica; and Sweynheym received a canonry at St Victor's in Mainz (1474).

However, the shelter of a monastery and the patronage of a prince of the church were not sufficient to maintain a steady

output and sale. Intellectual impetus and economic power had long since become the property of the laity. It was the big towns and the world of industry and commerce which became the mainstay of book-production.

In northern Europe the net of international trade which the Hanse towns had spun from Russia to England and from Norway to Flanders now provided easy openings for the printer's craft. The trade routes which the south German merchants had established to Milan and Venice, Lyon and Paris, Budapest and Cracow were now trodden by printers and booksellers. The very first printer next to Gutenberg, Johann Fust, died in 1466 in Paris where he had gone on business. The 'Great Trading Company' of Ravensburg, which had a virtual monopoly in the trade with Spain, was instrumental in establishing presses in Valencia, Seville, Barcelona, Burgos, and elsewhere; and one of their emissaries, Juan Cromberger of Seville, introduced printing in the New World, when in 1539 he dispatched a press to the capital of the then Spanish colony of Mexico.

GERMANY

By the end of the fifteenth century printing presses had been established in about sixty German towns. But only a dozen of them rose to eminence in this field, and their attraction to printers was entirely based on their position in the economic life of the empire. Mainz and Bamberg, which had seen the glory of the earliest presses, soon dropped out of the race; although no mean episcopal sees, they were economically unimportant. Their place was taken in south Germany by Basel, Augsburg, Strasbourg, and, above all, Nürnberg, the wealthiest German centres of international banking and trade; and in north Germany by the towns which were members of, or affiliated to, the German Hanse, with Cologne, Lübeck, and Bruges in the forefront.

STRASBOURG. Strasbourg seems to have profited by the presence of the earliest workmen with whom Gutenberg had

conducted his first experiments before he returned to Mainz about 1445. That would explain certain primitive features of the productions brought out by the first Strasbourg printer, Johann Mentelin. He was a careless printer but obviously a smart business man. His first publication was a Bible, issued in 1460–1 in direct competition with Mainz; but whereas the 42-line Bible occupied 1,286 pages, Mentelin succeeded in squeezing the work into 850 pages, thus saving almost a third of the paper. His next book again shows his sound commercial instinct. It was the first Bible printed in German or in any vernacular and, although full of schoolboy howlers, it nevertheless remained the standard text of all German Bibles before Luther.

Mentelin was the first professor of the new art to cater deliberately for the laity, and other Strasbourg printers followed his lead. He published Wolfram von Eschenbach's *Parzival* and *Titurel* epics (both in 1477), probably at the instigation of his patron, Bishop Rupert, who earlier on had ordered similar romances of chivalry from the writing establishment of Diebold Lauber in Hagenau. But both these epics proved a flop; no reprint was called for until the nineteenth century when they were relegated to university seminars. After Mentelin's death (1478) other medieval and contemporary poetry, folk legends, Bible translations, sermons, and similar popular books and pamphlets continued to leave the Strasbourg presses. Adolf Rusch, one of Mentelin's sons-in-law – who were all printers – introduced roman types into Germany. The early Strasbourg firms flourished until the middle of the sixteenth century: Johann Prüss, who printed from 1482 to 1510, was succeeded by his son of the same name who carried on until 1546. Most of their books were meant for popular consumption, but Martin Flach, who printed from 1487 to 1500, preferred theological works in Latin. His widow brought the business to her second husband, Johann Knoblauch, who by the time of his death in 1528 had printed some 300 books; their son, Johann the younger, carried the press on until 1558. Martin Schott, another son-in-law of Mentelin, who printed from 1481 to 1499, was followed by his son, Johann, who continued the

firm until 1548. The second quarter of the sixteenth century was a heyday for the Strasbourg printers as they threw themselves vigorously into the religious warfare on the side of the Lutheran Reformation. Johann Schott published also two English tracts by the ex-Franciscan William Roy, 'A lytle treatous or dialoge between a Christian father and his stubborn son' (1527) and 'The burying of the Mass' (1528), each in an edition of 1,000 copies as Schott testified on oath. But the one printer who remained faithful to the old church, Johann Grüninger, brought out the one great scoop of the Catholic camp, Thomas Murner's *Exorcism of the Great Lutheran Fool* (1522).

BASEL. Whereas Strasbourg was from the very beginning in the forefront of popular publishing, Basel earned its fame as a centre of printing through the high quality of its scholarly output. Here, the art was introduced by an immediate pupil of Gutenberg, one Berthold Ruppel, who in 1467 completed the *editio princeps* of St Gregory's *Moralia super Job*, the most popular commentary on any book of the Bible. Within a few years printing became a recognized part of Basel industry so that a strike of the printers' journeymen in 1471 – the first recorded in the trade – caused a minor sensation; it was happily settled by arbitration on Christmas Eve.

The glory of Basel started when Johann Amerbach (1443–1513) set up his press in 1477. A pupil of Johann Heynlin at the Sorbonne, where he obtained his degree as Master of Arts, Amerbach made the press the vehicle of the Christian humanism of his teacher. A scholar and aesthete himself, he saw to it that his editions were not only printed with fastidious taste but also edited with care and accuracy. His main adviser was Heynlin who had left Paris for Basel. His relation with Amerbach was very much that of the 'literary director' of a modern firm, advising the policy of the house and seeing its major publications through the press. Other professors of Basel university also served Amerbach as editors and proof-readers.

The tradition of the Amerbach press was maintained by Johann Froben (1460–1527) who had learned the trade in Amerbach's shop and from 1491 to 1513 worked in partnership with

Amerbach and Johann Petri (a native of Mainz, who appears first as a printer in Florence in 1472). Johann Froben and, after him, his son Hieronymus (d. 1563) were the standard-bearers of

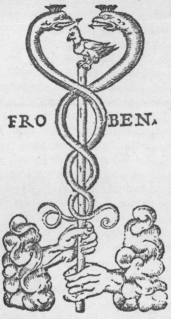

FRO BEN.

Printer's device used in various forms by Johann Froben
from 1516: two crowned snakes, twined round the
caduceus on which a dove is perched (Matt. 10: 16)

humanism in Germany. Their chief literary adviser was Erasmus of Rotterdam. Whereas Heynlin inclined towards supporting the *via antiqua* of the schoolmen, Erasmus was the leader of the *via moderna* of the new learning; but as both men avoided narrow partisanship, the firm of Amerbach and Froben was able to produce over a period of sixty years books which, in their judicious selection, careful editing, and fine workmanship, satisfied the needs and desires of scholars all over Europe.

Amerbach's 11-volume edition of St Augustine (1506) and Froben's 9-volume edition of St Jerome (1516) and Erasmus's Greek New Testament (1516) are the outstanding monuments of Basel printing. The last-named paved the way for biblical criticism, although Erasmus's text was amazingly bad even in the light of contemporary philological knowledge. Its fame is chiefly based on the fact that Erasmus was the first to treat critically the text of the Vulgate and that his Greek version was the source of Luther's translation (which has thus perpetuated some of Erasmus's errors down to the present). Froben was the first publisher to launch a collected edition of Luther's Latin tracts (four editions between October 1518 and July 1520), which he sold in France, Spain, Italy, Brabant, and England. But he stood by Erasmus when the two reformers parted company over the problem of free-will (1524).

The learned disposition of the Basel printers was carried on by Johannes Oporinus, who in 1541 began setting up a Latin translation of the Koran. But it took the personal intervention of Luther to overcome the prejudices of the Basel city council against the dangerous book – only a few years earlier the Pope had ordered a Venice edition of the Arab original to be burned. Luther, on the other hand, emphasized that the actual acquaintance with the Koran could only resound to 'the glory of Christ, the best of Christianity, the disadvantage of the Moslems, and the vexation of the Devil'. So the Latin Koran eventually came out in 1542 with prefaces by Luther and Melanchthon – without justifying either the fears of its opponents or the hopes of its sponsors.

ZÜRICH. As long as the houses of Froben, Petri, and Oporinus flourished, that is to say, until about 1560, the European importance of Basel as a centre of printing and publishing could not be challenged by any other Swiss town. However, from 1521 to the end of the century the Swiss market, or at least that of the Protestant cantons, became the domain of the Zürich printers Christoph Froschauer, uncle (d. 1564) and nephew (d. 1590). The elder Froschauer was a keen partisan of Zwingli all of whose writings appeared under

ΡΧΗ τῶ ἐυαγγελίȣ ΙΗΣΟΥ
ΧΡΙΣΤΟΥ ὑιȣ τῶ θεοῦ,ὡς γέ
γραπται ἐν τοῖς προφήταις,
ἰδοὺ ἐγὼ ἀποςέλλω τὸν ἄγ
γελόν μου πρὸ προσώπου σου, ὃς κατασκευ
άσει τὴν ὁδόν σου ἔμπροσθέν σε. φωνὴ βοῶν
τος ἐν τῇ ἐρήμῳ. ἑτοιμάσατε τὴν ὁδὸν
κυρίȣ,ἐυθείας ποιεῖτε τὰς τρίβȣς αὐτῶ.
ΕΓένετο ἰωάννης βαπτίζων ἐν τῇ ἐρήμῳ. κỳ
κηρύσσων βάπτισμα μετανοίας,ἐις ἄφεσιν
ἁμαρτιῶν. κỳ ἐξεπορέυοντο πρὸς αὐτὸν
πᾶσα ἡ ἰουδαία χώρα κỳ ὁι ἱεροσολυμῖται.
κỳ ἐβαπτίζοντο πάντες ἐν τῷ ἰορδάνη
ποταμῷ ὑπ'αὐτοῦ,ἐξομολογούμβνοι τὰς
ἁμαρτίας αὐτῶ. ἦν δὲ ὁ ἰωάννης ἐνδε
δυμῶ τρίχας καμήλου κỳ ζώνην δερ
ματίνην περὶ τὴν ὀσφὺν αὐτοῦ, ᾳ ἐσθίων
ἀκρίδας κỳ μέλι ἄγριον, ᾳ ἐκήρυσσεν λέ
γων. ἔρχεται ὁ ἰχυρότερός μȣ ὀπίσω μȣ
ȣ ȣκ ἐιμὶ ἱκανὸς κύψας λῦσαι τὸν ἱμάρτα
ᾷ τῶ ὑποδημάτων αὐτοῦ. ἐγὼ μὲν ἐβάπ
τισα ὑμᾶς ἐν ὕδατι. αὐτὸς δὲ βαπτίσει ὑμᾶς
ἐν πνέυματι ἀγίῳ. καὶ ἐγένετ ἐν ἐκείναις
ταῖς ἡμέραις, ἦλθεν ΙΗΣΟΥΣ ἀπὸ ναζαρὲθ
ᾷ γαλιλαίας. κỳ ἐβαπτίσθη ὑπὸ ἰωάν
νȣ ἐν τῷ ἰορδάνη. κỳ ἐυθέως ἀναβαίνων ἀπὸ ὕδα
τος, ἔιδεν χιζομένȣς τοὺς ὀυρανοὺς, κỳ τὸ
πνεῦμα ὡσεὶ περιστερὰν καταβαῖνον ἐφ'αὐτόν.
κỳ φωνὴ ἐγένετ ἐκ τῶ ὀυρανῶν,σὺ ἔι ὁ ἱός μȣ ὁ
ἀγαπητός,ἐν ᾧ ἐυδόκησα.κỳἐυθέως τὸ πνεῦμα
αὐτὸν ἐκβάλλʹᾶ ἐις τὴ ἔρημον.κỳ ἦν ἐκεῖ ἐν τῇ ἐρή
μω ἡμέρας

Nitiũ euãgelij Iesu Chri/
sti filij dei, sicut scriptum
est iii prophetis.Ecce ego
mitto nunciũ meum ante
faciem tuam,qui præparabit uiam tuã
ante te,uox clamantis in deserto,para
te uiam domini, rectas facite semitas
eius.Erat baptizãs in deserto Ioannes,
& prædicans baptismũ pœnitentiæ in
remiſſionem peccatoᵣ.Et egrediebã
tur ad eum tota Iudææ regio, & hie
rosolymitæ,& baptizabantur omnes
ab illo in Iordane flumine , confiten
tes peccata sua. Erat aũt Ioannes uesti
tus pilis cameli & zona pellicea circa lũ
bos suos,& uescebatur locustis,ac mel
le syluestri , & pdicabat,dicens.Veniet
qui fortior est me post me, cuius non
sum idoneus, ut procumbens soluam
corrigiam calciamentoᵣ.Ego quidem
baptizaui uos in aqua,ille uero bapti
zabit uos in spiritu sancto.Et factñ
est in diebus illis,uenit Iesus a Naza
reth Galilææ,& baptizatus est a Ioãn
ne in Iordane.Et statim cum ascende
ret ex aqua uidit discindi cœlos,& spm
quasi columbã descendentè super illũ.
Et uox facta est de cœlis.Tu es filiꝰ
meus,dilectus , in quo mihi bene com
plácitum est.Et continuo spiritus illum
emittit in desertum , & erat illic in deser
G to dies

MARTINI
DORPII SACRAE THEO
logiæ profeſſoris Oratio in
prælectionem epiſto-
larum diui Pauli.

De laudibus Pauli, de literis ſa-
cris ediſcendis, de eloquétia,
de pernicie ſophiſtices,
de ſacrorũ codicum
ad Græcos caſti
gatione, &
lingua-
rum peritia.

Epiſtola ERASMI ad Dorpiũ.

Title-page, with woodcut-frame by Hans Holbein, of Martin van
Dorp's commentary on St Paul's Epistles, introduced by Erasmus,
printed by Johann Froben in Basel, 1516

his punning imprint of the 'frog on the meadow'. He also brought out the first complete Protestant Bible (6 vols, 1524–9) and a monumental Latin Bible annotated by the Reformed scholar, Conrad Pellikan (7 vols, 1532–7). Among the 900 titles issued by the Froschauers some 500 were of a religious character; these include 28 German, 10 Latin, and one English Bibles, and 26 German, 18 Latin, 4 Greek, and one English New Testaments. With Johannes Stumpf's *History of the Swiss Confederation* with 4,000 illustrations (1548) Froschauer scored a deserved popular success in a different field. The younger Froschauer is noteworthy for his gothic cursive type, not dissimilar to Granjon's *Civilité*; but it failed to gain a permanent place in the range of gothic founts.

The firm was eventually, in 1760, bought up by Conrad Orell, the publisher of J. J. Bodmer, J. J. Breitinger, and Wieland, and thus lives on in the present-day house of Orell, Füssli & Co. of European reputation.

AUGSBURG. A characteristic feature of the Augsburg presses was their early and successful attempt to amalgamate letterpress and illustration, or rather to continue the tradition of the illuminated manuscript in the novel medium of print. It is not without significance that the first printer – Günther Zainer, probably trained in Mentelin's shop in Strasbourg – was called to Augsburg by the abbot of SS. Ulric and Afra, which had for a long time been the seat of a famous scriptorium. By its side the abbey now set up a press which produced three large-scale books of moral instruction in 1472–6. From 1475 Anton Sorg, originally a *Briefmaler* who had learned printing in Zainer's shop, worked on the abbey premises. He soon turned to the publication of vernacular texts, first biblical and theological, but from 1480 to his death in 1493 mainly historical and travel books. These include Marco Polo's and Breydenbach's realistic descriptions of the Near and Far East as well as the fabulous exploits of St Brandan and John de Mandeville, and above all the history of the Council of Constance by Ulrich von Richental, magnificently illustrated with forty-four woodcuts.

Zainer himself (d. 1478) produced the first illustrated book on a large scale, Jacobus de Voragine's *Legenda aurea* in 2 volumes with 131 woodcuts (1471–2), and together with Jodocus Pflanzmann, the first illustrated Bible (1475). It is characteristic of the popular trend of Augsburg publishing that both these books were German translations. Zainer was also the first (after the magnificent but solitary trial by Schöffer in the Mainz *Psalter* of 1457) to use a specially de-signed set of initials instead of leaving blanks which illumina-tors were later to fill in by hand. The ornamentation of books by means of initials, borders, and woodcuts reached an aesthetic height, rarely surpassed, in the prints of Erhard Ratdolt (1447–1527 or 28). When he returned to his birth-place in 1486, he had already gained renown as a printer in Venice where, among other books, the first edition of Euclid's *Elementa geometriae* (1482) stands to his credit. He intro-duced in Augsburg an italianate style of printing skilfully adapted to mathematical and astronomical works as well as to missals and other liturgical books, in which he specialized. Ratdolt was, moreover, the first to produce a real title-page and the first to issue a type-specimen; about these achievements something will be said elsewhere.

Johann Schönsperger the Elder (1481–1523) was the first printer to receive official recognition as imperial court printer by appointment to the Emperor Maximilian I. The emperor was the earliest monarch to realize the potential value of the printing press for political propaganda. [He was the first ruler to issue a 'White Book' in 1509 which published a number of state papers to vindicate his aggressive war against Venice.] He drew up an ambitious programme of 130 books which were to broadcast the glories of the house of Habsburg and especially of Maximil-ian himself. For the sumptuous illustrations of these tomes Maximilian employed the foremost artists of the time, in-cluding Hans Burgkmair and Albrecht Dürer, and special types were cut for each volume. But only two volumes (and a 'picture book' with captions only) were finished by the time of Maximilian's death, both printed by Schönsperger. The Emperor's Prayer-Book, begun in 1513, was never completed;

Aue maria gr̄a plena dominus tecū bene dicta tu in mulierib' et benedictus fruct' uentris tui : ihesus christus amen.

Glozia laudis resonet in oze omniū Patri genitoq̄ zpzoli spiritui sancto pariter Resul tet laude perhenni Laborib' bus dei uendunt nobis om nia bona. laus: honoz: virtuſ potētia: ⁊ gratiaz actio tibi christe. Amen.

Hinc deū sic ⁊ vites per secula cūc ta. Prouidet ⁊ tribuit deus omnia nobis. Proficit absque deo null'in ozbe laboz. Illa placet tell'in qua res parua beatū. He facit ⁊ tenues luxuriantur opes.

Si fortuna volet fies de rhetoze consul. Si volet hec eadem fies de cōsule rhetoz. Quicquid amoz iussit nō est cōtedere tutū Regnat et in dominos ius habet ille suos Vita dara è yrēda data è sine fenere nobis. Mutua: nec certa persoluenda die.

Usus ⁊ ars docuit quod sapit oīnnis homo Ars animos frangit ⁊ firmas dirimit vzbes Arte cadunt turres arte leuatur onus Artibus ingenijs quesita est glozia multis Pzincipijs obsta sero medicina paratur Cum mala per longas conualuere mozas Sed propera nec te venturas differ in horas Qui non est hodie cras minus aptus erit

Non bene pzo toto libertas venditur auro Hoc celeste bonum pzeterit ozbis opes Pzecautis animi est bonis veneranda libertas Seruitus semper cunctis quoque despicienda Summa petit liuoz perflant altissima venti Summa petit dextra fulmina missa ionis In loca nonnunqz am siccis arentia glebis De prope currenti flumine man at aqua

Quisquis ades scriptis qui mentem forsitan istis Ut noscas adhibes pzotinus istud opus Nosce: augustensis ratolir germanus Erhardus Litterulas istos ordine quasqz facit Ipse quibus venera libzos impzessit in vzbe Multos ⁊ plures nunc pzemit atqz pzemet Quique etiam varijs celestia signa figuris Aurea qui pzimus nunc monumenta pzemit Quin etiam manibus pzopzijs vbicunqz figuras Est opus: incidens dedalus alter erit

Nobis benedicat qui ⁊ trinitate vnit ⁊ regnat Amen: Honoz soli deo est tribuendus Aue regina celoz mater regis angelo= rum o maria flos virginum velut rosa velisilium o maria: Tua est potentia tra regum: domine tu eo super omnes gen tes da pacem domine in diebz nostris mirabilis deus in sanctis suis Et glozi osus in maiestat: sua orbi panthon kyr

Quod prope sacce diem tibi sum conuiua futurus forsitan ignotas vt fote ne dubites Ergo para cenam non qualem flozidus ambu Sed lautam sane more cinenaco Namque duas mecum flozente etate puellas Adducam quarum balsama cunnus olet Vernula sola domi fedeat quam nuper habebas Sinondum cunnus vepibus hozzuerit Sunt quinsimulent ⁊ auari crimen amici Dicant facio rumoz vristi cadat Hec Pobiclebus

Hanc ades mira quicunqz volumina querns Arte uel ex animo pzessa fuisse tuo Seruiet ille nibmobis iure sorores Incolumen seruet vis zogare licet

Est homini virtus fuluo preciosior auro: aenzas Ingenium quondam fuerat preciosius auro. Miramurqz magis quos munera mentis adornātu Quam qui corporeis emicuere bonis. Si qua virtute nites ne despice quenquam Ex alia quadam forsitan ipse nitet

Nemo sue laudis nimium lętetur honore Ne uilis factus post sua fata gemat. Nemo nimis cupide sibi res desiderat ullas Ne dum plus cupiat perdat & id quod habet. Ne ue cito verbis cuiusquam credito blandis Sed si sint falsi respice quid moneant Qui bene proloquitur coram sed postea praue Hic erit inuisus bina qz ora gerat

Pax plenam virtutis opus pax summa laborum pax belli exacti pzaecium est praeciumque pericli Sidera pace vigent consistunt terrea pace Nulplacinum sine pace deo non manus ad aram Fortuna arbitriis tempus dispendat vbi Ita rapit iuuenes illa serit senes

κλιω Τευτερπη τε θαλεια τε μελπομενη τε γεβλαχορη τερφιω τε πολυμνεια τουρανιη τε καλλιοπη θεδη προσφερεται ἐξιναπα σαωυ ιεσυς Χριστυδ μαρια τελος.

Indicis characteꝛ diuersaꝛ mane rierū impzessioni paratarū: Finis.

Erhardi Ratdolt Augustensis viri solertissimū: pzeclaro ingenio ⁊ miri fica arte: qua olim Venetijs excelluit celebratissimus. In imperiali nunc vrbe Auguste vindelicoꝛ laudatissi me impzessioni dedit. Annogꝛ salu tis. M.LLLL.LXXXVI. Lalē. Aprilis Sidere felici compleuit.

only ten specimens were pulled, all on parchment; the *Theuer-dank*, a fantastic *roman à clef*, describing Maximilian's wooing of Mary of Burgundy in the style of medieval romances, was accomplished at Nürnberg in 1517. For Augsburg did not maintain its original impetus as a centre of printing. Both Erhard Ratdolt's and Johann Schönsperger's sons, who carried on the paternal businesses, were of no importance.

However, pleasing ornaments and a wealth of illustrations remained characteristic of Augsburg publishers, such as the German Petrarch which Heinrich Steiner printed in 1532 with 261 woodcuts. Steiner had begun as a printer of religious tracts in the interest of the Reformers; but from about 1530 he specialized in making foreign literature, chiefly Italian, accessible to the German public. His greatest hit was the publication of Andrea Alciati's *Emblemata*. The first edition came out in 1531, containing 104 Latin 'emblems' with 98 woodcuts. It was frequently reprinted and augmented, and soon translated, with further additions, into French, Italian, and Spanish. In the emblem books, word and picture were mutually interdependent in that a motto in prose or verse with a moral lesson interpreted a symbolic picture and was in turn interpreted by it. During the next 150 years such an 'Emblem Book' was to enter the library of every man of fashion and thought all over western Europe.

ULM. Although politically and economically Augsburg's near-equal among the imperial towns of Swabia, Ulm as a printing place only reflects dimly the splendour of Augsburg achievements. The combination of letterpress and illustrations is characteristic of Ulm book production as well. The Ulm proto-typographer (from 1472), Johann Zainer, seems to have been a brother of Günther Zainer in Augsburg. His editions of Boccaccio (1473) and Aesop (1476), translated by the humanist and town-physician Heinrich Steinhöwel, were adorned with tasteful woodcuts and borders. More important is Ptolemy's *Cosmographia* which Leonhard Holle published in 1482; its 32 woodcut maps and the pleasing roman type (resuscitated by St John Hornby under the name of 'Ptolemy')

aber das rych Licuri gegen dem mynen. Esopus
schmollet vnd sprach. Es ist nit dar vnder. sonder
in vil dingen fast dar über. Wañ ze glycher wyß/
wie die sunn den mon betunckelt. Also betunckelt
das rych licuri dyn rych mit synem schyn.

¶ Nectanabꝰ verwondert ab ꝯ behenden antwürt
vnd fertiger vßsprechung esopi. Vnd sprach. hast
du mir die her gefürt/ die den turn buwen söllenn
Esopꝰ sprach/ warumb nit. zöge mir nūn die statt
da hin du in buwen wilt. Der küng gieng bald
vß der statt vf das feld vñ zöget im wa hin er in
buwen wölte. Esopus stellet vff die fier ortt der
hoffstat. die fier adler mit den blatern an die füß
gebunden mit den knaben die das flaisch in den
henden hetten. vnd hieß wo die knaben das flaisch
höch enbor heben. vñ als die adler dē flaisch nach
in die höhy flugen. wo schrien die knaben. bietend
vns den züg. wolher mit dē kalg/ wolher mit den
stainē/ wolher mit dem holcz vñ mit anderm zůg.
zů dē buw notturftigñ. Do das nectanabꝰ ersach.
sprach er zů esopo. wie ist dē kündent die lüt fliegē

Aesop's Fables, translated into German by Heinrich Steinhöwel,
printed by Johann Zainer in Ulm, 1476–7

have a permanent appeal to the book-lover. However, both Zainer and Holle went bankrupt, and that was the end of notable printing in Ulm.

NÜRNBERG. The leading role in the first century of German printing fell to the imperial city of Nürnberg. Here the connexion between printing and commerce is particularly striking. Not a producer of raw materials, but the home of many finishing industries, Nürnberg reached its position as the commercial hub of central Europe through the liberal policy of its ruling families who favoured the free exchange of goods. Thus Nürnberg attracted merchants and bankers from every part of Europe who found it advantageous to transact business in and from this town. This was the very place to give scope to the capitalistic enterprise of the biggest European printer of the fifteenth and sixteenth centuries, Anton Koberger (1445–1513). He set up shop in 1470 and for a time combined printing, publishing, and bookselling. All these things he did on a grand scale, on the lines of the international cartels and trusts of the era of 'early capitalism'. At the height of his activities, Koberger ran 24 presses served by over 100 compositors, proof-readers, press-men, illuminators, and binders. The catalogue of his firm over the years 1473–1513 enumerates more than 200 titles, most of them large folio volumes. Hartmann Schedel's *Liber chronicarum* (1493) was perhaps the most sumptuous of Koberger's publications; it contained some 1,800 woodcuts – and a limited edition had them coloured by hand – which make the book a mine of iconographic, geographic, and cartographic information. Koberger went into partnership with printer-publishers in Basel, Strasbourg, and Lyon, partly because his own presses could not cope with the output, partly because he wished to facilitate the sale of his books abroad. In Paris he maintained an agency of his own; elsewhere he shared his agents with other importers, not necessarily booksellers. The final account in 1509 of the *Liber chronicarum* showed unsold stock in Paris, Lyon, Strasbourg, Milan, Como, Florence, Venice, Augsburg, Leipzig, Prague, Graz, and Budapest. The narrow-

CYTHIA intra Imaũ montem terminatur ab occaſu Sarmaria Aſiati ca ſcđm lineã expoſitã A ſeptentrione terra in cognita. Ab oriẽte Ima

o monte ad arctos vergente ſcđm meridia nã ferme lineã q̃ a p̃dicto oppido vſcɞ ad terrã incognitam extenditur. A meridie ac etiam oriente Satis quidẽ & Sugdianis & Margiana iuxta ipſorũ expoſitas lineas vſ cɞ oſtia oxe amnis in byrcanũ mare exeũtiſ ac etiã parte q̃ hinc eſt vſcɞ ad Rha amnis oſtia q̃ gradus habet 87 $\frac{1}{2}$ 48 $\frac{1}{2}$ $\frac{2}{3}$. Ad oc caſum aũt vergitur in gradibɔ 8 $\frac{1}{4}$ 44 $\frac{1}{4}$

Rhymmi ff oſtia	91	48 $\frac{1}{4}$
Daicis ff oſtia	94	48 $\frac{1}{4}$
Iaxarti ff oſtia	97	48
Iſtai ff oſtia	100	47 $\frac{2}{3}$
Polytimeti ff oſtia	103	44 $\frac{1}{2}$
Aſpabotis ciuitas	102	44

Ptolemy's *Cosmographia*, printed by Leonhard Holle in Ulm, 1482

mindedness and jealousy of the guilds eventually forced Koberger to concentrate on one trade only: abandoning printing, binding, and retail-selling, he chose to remain a publisher. Koberger, though by no means unlettered, was above all a business man – but of the type which has remained prevalent among publishers: a business man with ideals and a sense of responsibility towards his authors and his public.

Koberger was also the first publisher for whom publishing meant a rise in social status: he married into the city aristocracy of Nürnberg and was admitted to the town council – the equivalent of the rare baronies bestowed upon German publishers such as Cotta and Tauchnitz, or the knighthoods bestowed upon English publishers such as Frederick Macmillan, Newman Flower, Stanley Unwin, Allen Lane, and Geoffrey Faber.

As happens so often, the genius of the founder of the firm did not pass on to his heirs; having rested on their laurels, the Kobergers had to close down in 1526.

The extent to which the international trade of places such as Nürnberg and Augsburg facilitated the acquisition of books can be gathered from the library of the Nürnberg physician Hieronymus Münzer (d. 1508) who ordered books from Venice, Lyon, Bologna, Florence, Milan, and at the same time bought in Nürnberg books published in Venice, Reutlingen, Padua, Treviso, Louvain, Strasbourg. On 9 August 1516 Ulrich von Hutten wrote from Bologna to the Englishman Richard Croke, at the time Greek lecturer at Leipzig university, and asked him for a copy of the *Epistolae obscurorum virorum*: on the 22nd he acknowledged the receipt of the book – a feat made possible through the excellent courier service of the trading companies.

MAINZ. In glaring contrast with those bustling centres of every kind of business activity, Mainz, the birthplace of printing, was kept from utter oblivion in the annals of printing by one man only, Johann Schöffer, Peter's son. He took over the business on his father's death in 1503 and until his death in 1531 was a kind of unofficial printer to the university. Most of

Royanum bellū decēnale pmo Esebon siue Abesson iudicis anno (teste eusebio) surrexit. quo tps sequētes claruerūt. Troya em quā Ilion tros regis troyanoz filius amplissimā instaurauit mille z quingentis passibus a mari remota erat: vbi oīm rerum vbertas erat: Ipsa quippe que decēnalem grecoz obsidionem passa fuit; et ab eis tandē deleta.

Hercules Menela⁹ Helena

Hercules ille cū Ja-
sone troyā vastauit
que statim a pamo fuit re
edificata. Idez hercules
agone olimpiacus cōsti-
tuit et bella multa cōfecit
que dicūt duodecim insi-
gnes et inhumanos pse-
cisse labores.

ESte hector fuit pmo
genitus pami et he-
cuba vxore incōpabilis for-
titudinis et strēnuitatis. Jo
ob maximū ei⁹ militie fulgo
rem apud troyanos maxio i
precio habitus est. hic ob in
credibile ei⁹ pudentia atz for
titudine nō solū parentes: sed
et patriā nobilitate gliā
splēdidā fecit. hic ex Andro-
macha piuge plres genuit fi
lios. E qb⁹ frāc⁹ vn⁹ fuit A q
(vt atuincen⁹ hystoriaf bur
gund⁹) frāci origine babuere.

Hector

Helena fuit vxor me
nelai regis: a pari
de filio priami rapitur. z
ad troya pducitur. ppter
qd troyanū bellū exortus
Ipsam tm post troye ex
cidium Greci menelao red
diderūt. q gaudes nauim
cū illa cōscendit patriam
petitur⁹: sed repestatib⁹
acti in egyptū ad polibuz
reges deuenere. Indeqz di
scedentes octo ānis errātes
(vt testis est eusebi⁹) tandes
in patriam rediscerūt.

PAris qui et Alexāda
dicta⁹ est eiusdē hecto
ris frater: ex pamo z hecu
ba nat⁹: sb specie legationis
cū. xx. nauib⁹ in grecia smit
titur Et a menelao hospici
suscipit. Cui⁹ cū asperisset
vxores illaz. absente marito
tande ai oibus regis tho

zauris abstulit et Troyam pduxit. Ex qua rapina bellum decēnale grecoz aduer
sus troyanos susceptū est. hic cū troyanis vrbem obsidentib⁹ multa strēnue ges
sisset: A pmbo achillis filio occisus fuit.

Agamenon

AGamenon fuit frater regis Menelai dux toti⁹ exercitus grecoz. cōtra troyā
bellauit. q tandem traditorie et turpissime capit. fuitz Atrei regis fil⁹ . ab
omni exercitu imperator resignatus. ad bellū pergens Clitemestrā cōiuges ex
qua multos susceperat filios reliquit. Et apud troyam multos passus labores. z
simultates principum pro quibus ab imperio depositus. z illi palamedes suffect⁹
est. Quē cum vlixes occidisset ipse maiori gloria imperium reassumpsit. Tandez
Troya capta et diruta cum ingenti preda et cassandra priami filia in patriam redi
turus naues conscendit Verum z ipse tempestate actus. p annū ferme errauit.

Isti duo de Troya fugientes duo regna constituūt: longe tame post.
Franco quide ex hectore fil⁹ pami nepos a quo
francoz nome tractū est. a troya fugat⁹ postea to
ta Asia puagata in danubij ripis tandē puenit. Ibi cū
aliqdiu cōsedisset. deinde locum queres a cōmuni bo
minū societate seiuncta: ad thanai fluentia z paludes
meotidas secessit. vbi Sicambriā cōdidit vrbem.

Franco

Turcus

Turcus fili⁹ Troili filij regis Priami. A q pplim ab eo descendente. quidem
Turcos tenoiari dicūt. Alij eoz origine ex Scythia referunt.

Hartmann Schedel's *Liber chronicarum*, illustrated with 1,800 woodcuts and
printed by Anton Koberger in Nürnberg, 1493

his productions are in the realm of classical scholarship. In his first year he commissioned the first German translation of Livy; it came out in 1505 with 214 woodcuts, and was reprinted seven times before the firm closed down in 1559. The 1505 edition deserves mention also because of its preface. This clearly sets out the origins of the invention which later scholars have done their worst to obscure: 'In Mainz', it says, 'the ingenious Johann Gutenberg invented the wonderful art of printing in the year of Our Lord 1450, after which it was improved and finished by the industry, expenses, and labour of Johann Faust and Peter Schöffer in Mainz.'

In addition to the German Livy, Johann Schöffer brought out a complete Latin edition (1518–19), which was textually and typographically a great advance upon the two previous editions published in Rome (1469) and Venice (1498). His friend, Ulrich von Hutten, some of whose anti-papal pamphlets he printed, may have inspired or strengthened Schöffer's interest in the national aspects of medieval history. Their common friend, Sebastian von Rotenhan, planned a collection of German chronicles, of which, however, only one volume was completed as Rotenhan was called away on diplomatic missions. Archaeology seems to have been Schöffer's great love. He printed an enlarged edition of the *Inscriptiones vetustae Romanae* which Konrad Peutinger had collected in and near Augsburg (1520); the *Collectanea antiquitatum Maguntinensium* (1520), a description of Roman monuments in and near Mainz; and the *Liber imperatorum Romanorum* (1526) which was illustrated, not by the fancy pictures of renaissance knights which spread themselves in other books of the time, but by reproductions adapted from genuine Roman coins and other ancient monuments.

COLOGNE. Cologne, the most populous town of medieval Germany, became for some decades the centre of north-west German printing. Between 1464, when Ulrich Zell established the first press, and the end of the century more than 1,300 titles went forth from Cologne; but two-thirds of them were pamphlets of twelve leaves or less. Nearly all books published

in Cologne were in Latin; more than half were theological writings and of them more than half were treatises in the Albertist and Thomist tradition. This one-sidedness of Cologne book production finds its explanation in the strictly orthodox Thomistic attitude of the university teachers, whose hostility to humanist learning was soon to draw upon them the satire of the *Epistolae obscurorum virorum*.

Ulrich Zell, who died in 1507, produced more than 200 titles; Heinrich Quentell, a native of Strasbourg who, after some years in Antwerp, printed in Cologne from 1486 to his death in 1501, surpassed him with about 400 items; he supplied the greater part of the philosophical texts read at the universities of Cologne and Trier. Johann Koelhoff, a pupil of Wendelin of Speier in Venice, started his career in Cologne (1472–93) with the edition of a dozen tracts by Thomas Aquinas; Peter Quentell, Heinrich's grandson, finally became the leading anti-Lutheran printer after 1520, although this did not prevent him from printing for William Tindale the Protestant English translation of the New Testament in 1524–5.

The two outstanding productions of early Cologne printing, however, are two German books, Heinrich Quentell's Low German Bible (1479) and Johann Koelhoff the younger's *Chronicle of Cologne* (1499). Quentell's Bible came out in two editions, one in the Rhenish-Westphalian dialect and the other in that of Lower Saxony. Its numerous illustrations exerted considerable influence upon later Bibles as the woodblocks were bought by Koberger and used for his popular Nürnberg Bible of 1483. Koelhoff's *Chronicle*, invaluable for us because of its notes on the origin of printing, however, ruined the printer: the book was confiscated and banned, and Koelhoff was exiled (d. 1502).

For England, Cologne has a special significance in that William Caxton learned printing here in 1471–2 and Theodore Rood and John Siberch, the first Oxford and Cambridge printers, were natives, Rood of Cologne city, Siberch of the neighbouring town of Siegburg.

LÜBECK. Lübeck, the head of the Hanseatic League, was of signal importance for the spread of printing to north-east and eastern Europe. Its greatest printer was Stephen Arndes, a native of Hamburg. He had learned type-founding, composing, and printing at Mainz and spent the years 1470–81 in Italy, where he first collaborated with Johann Neumeister in Foligno. He was then called to Schleswig, probably through a high Danish official whose son he had met in Italy, and in 1486 settled in Lübeck. Besides a number of liturgical books commissioned by various Danish chapters and monastic orders, Arndes's main production is the Low German Bible of 1494, a masterpiece of press-work as well as illustration. However, like so many of the early printers, Arndes does not seem to have made a financial success out of his work: although he continued printing until his death in 1519, he was obliged to supplement his earnings by a clerkship to the Lübeck courts.

Through the old-established Hanseatic trade channels even south German publishers sold their books to northern customers. In 1467 a Riga bookseller had in stock two Bibles, fifteen Psalters, and twenty Missals printed by Schöffer in Mainz.

From Lübeck set sail the printers who introduced the new craft to the Baltic towns among which Rostock and Danzig were the most important. Johann Snell, who printed in Lübeck from 1480 to about 1520, set up the first presses in Denmark and Sweden, although for some time the bulk of Danish and Swedish books were still printed in Lübeck. Lübeck was also the starting point of the first abortive attempt to introduce printing in Russia. Embassies of the Tsar Ivan III, which in 1488–93 went to Germany in order to obtain the services of German technicians, invited the Lübeck printer, Bartholomaeus Gothan, to set up a press in Moscow. Gothan, who had recently (1486–7) worked in Stockholm and printed the first book for use in Finland (*Missale Aboense*, 1488), went in 1493 to Novgorod (and perhaps Moscow). He was dead before September 1496, probably murdered by the Russians, before

he had produced any books in Russian. However, a curious survival of Gothan's stay in Russia has recently come to light. Russian manuscript translations of a Dialogue between Death and Life, the History of Troy, the Tyrant Dracolewyda, the Lucidarius, and other German texts circulated in Novgorod in the early sixteenth century: all of them can be traced to books printed in Lübeck between 1478 and 1485; and there is little doubt that they formed part of Gothan's luggage.

It was the great Tsar Ivan IV the Awesome (usually mistranslated 'the Terrible') who eventually established Russian printing. At his request, Christian III of Denmark in 1552 dispatched a Copenhagen printer, Hans Missenheim, to Moscow where he initiated Ivan Feodorov, the Russian prototypographer, into the art of printing.

ITALY

Italy was the first foreign country to which German printers took the new invention in 1465. It was also the first country where the German printers lost their monopoly. On 3 August 1470 the first book, a Quintilian, was completed at a press owned by an Italian, Johannes Philippus de Lignamine, a native of Messina resident in Rome: in May 1471 the first book appeared, actually printed by an Italian, the priest Clement of Padua working in Venice; and by 1475 the native genius had asserted itself and henceforth dispensed with transalpine tutelage. The motherland of the new learning, the centre of Christian civilization, the country of origin of modern banking and accounting offered opportunities to adventurous publishers and printers for which there was little room in the still predominantly medieval structure of German society. Thus it was Italy where there originated the two kinds of type which have ever since been the basic elements of western printing, viz. 'roman' and 'italic'; which produced the first Greek and Hebrew founts; where the title-page and pagination, music print and pocket edition were launched upon the world of letters.

ROME. It was inevitable that the first printers in Italy, Sweynheym and Pannartz, should within a short space of time transfer their activities from the tranquil monastery of Subiaco to Rome. The seat of the Curia was naturally also a hub of big business, ecclesiastical as well as worldly. Much work hitherto done by the efficient scribes of the papal administration gave permanent occupation to the printing press. Indulgences and papal bulls had been among the earliest productions at Mainz, and official forms, decrees, circular notes, and the like have kept Roman printers busy ever since. In addition, Rome had, from the times of Cicero and Horace, been the central book market of the Mediterranean world and beyond; and people who used to buy manuscripts in Rome now purchased printed books there. About 1470 the Nürnberg humanist Hartmann Schedel – the compiler of Koberger's *Chronicle* of 1493 – jotted down some prices asked in Rome for printed books: a Lucan cost 1 papal ducat (about 10s. gold sterling), a Virgil 2 ducats, St Augustine's *City of God* 5 ducats, Livy 7 ducats, Pliny's *Natural History* 8 ducats, a Latin Bible 10 ducats.

The number of titles available in Rome at this time was, indeed, quite remarkable. In an application to Pope Sixtus IV in 1472, Sweynheym and Pannartz stated that they had printed 28 works in 46 volumes, some of them in several editions, usually 275 copies each. The list includes the two editions (1468, 1470) of the two-volume collection of St Jerome's letters, which is chiefly remarkable, at least to English readers, for containing a treatise erroneously ascribed to the doctor of the church but actually written by a very unsaintly Englishman. It is the 'Dissuasio Valerii ad Rufinum ne uxorem ducat', an amusing diatribe against the dangers of matrimony – the very book which, eighty years earlier, the fifth husband of the Wife of Bath used to read 'gladly night and day for his desport' and at which 'he lough alwey ful faste'. The sometime clerk of Oxford's copy was bound up with other tracts on 'wykked wyves', including one by St Jerome, and it owed its immense popularity not least to the

mistaken identification of its author. In reality, it is culled from the 'Entertainments of Civil Servants' (*De nugis curialium*) by the twelfth-century wit Walter Map, who has thus become the first Englishman to appear in print.

At the same time Ulrich Han, another Roman printer of German birth, issued some 80 books, mostly editions of Latin authors, but including also a *Missale Romanum* (1476), in which for the first time the lines and notes of the music were printed with the letterpress.

On the whole, however, the productions of the Roman presses are less remarkable for their typography which is uniformly mediocre than for their contents which reflect the international position of the city. The *Mirabilia urbis Romae*, the medieval Baedeker for the guidance of pilgrims and sightseers, which from *c.* 1140 had been copied innumerable times, was now printed and reprinted with frequent amendments which often supplanted medieval folklore by flights of renaissance pseudo-scholarship. Ptolemy's *Cosmographia*, planned by Conrad Sweynheym and published after his death by Arnold Buckinck in 1478 and reprinted in 1490, showed on twenty-seven engraved maps the picture of the world as it had been known to the West for a thousand years. It was the Roman printer Stephan Planck from whose press the first print of Columbus's letter went out, from which Europe learned of the revolution of its geographical conception; this pamphlet, too, kept Roman printers busy for many years.

Only two Roman printers deserve special mention: Ludovico degli Arrighi and Antonio Blado. Arrighi, a writing-master, professional copyist, and minor official in the Cancelleria Apostolica, published in 1522 the first printed specimen book which taught laymen the use of the *littera cancelleresca* of papal briefs. These cursive letters were cut by the goldsmith, Lautizio Perugino, with whom Arrighi in 1524 started a printing and publishing partnership. The most distinguished among their many distinguished patrons was the humanist poet, Giangiorgio Trissino, remembered for his introduction of blank verse into drama and as a keen spelling reformer, one

Ther nach stet geschribē die gnade vnd ablas:
Auch das heiltū by den·vii·haubt kirchē: vnd
allen kirchen zu Rom vnd vil wunder zeichen
vnd geschicht zu Rome ist·Auch alle station es
in kirchen vber iar

Er heylige pa-
bst filuester der
schribt in siner
Cronica daß zu
Rō sint gewest
dußēt·cccc· vnd
v· kirchen: der
vil zu brochen
sint· Uß den
kirchē die noch
zu Rom sint ha-
bē die heiligen
pabst erwelt vnd gesatzt·vii·haubt kirchen die
mit grosser gnad begabt dā by anderē kirchē·
Je erst haubt kirch zu Rō ist zu sant Jo-
han laterā: vnd ist die oberst haubt kir-
che in der gantzē welt: vnd was ein pal-
last des keisers Constantini· Da er in dē tauff
von aussatz gereiniget wart da gab er den pal-

of whose innovations – the differentiation of *u* and *v* and *i* and *j* – was adopted by Arrighi and has thus survived. Trissino recommended Arrighi to Pope Clement VII as a man 'who, as in calligraphy he has surpassed all other men of our age, so, having recently invented this most beautiful method of doing in print almost all that he formerly did with the pen, has in beautiful types gone beyond every other printer'. Arrighi

Stampata
in
Roma
per Lodouico
Vicentino et Lautitio
Perugino, Con Priuilegio et
Gratia che da altri non si possa istam=
pare' questa Opera, ne' altra
istampata in questa
nuoua Littera
insino
al
decennio.

Colophon of Ludovico Arrighi's specimen book
of his *littera cancelleresca*, cut by
Lautizio Perugino and printed
by Arrighi in Rome, 1524

probably perished in the Sack of Rome in May–June 1527. Antonio Blado worked from about 1515 to 1567 and was in 1549 awarded the title of Tipografo Camerale or printer to the Holy See; in this capacity he printed the first *Index librorum prohibitorum* in 1559. Blado is famous in the history of literature as the publisher of two first editions of a very different character: Machiavelli's *Il Principe* (1532) and Loyola's *Exercitia spiritualia* (1548), the epitomes of worldly statecraft and religious devotion. The type in which these books were printed was an improvement upon Arrighi's design; the

la sua mossa impetuosa quello che mai altro Pontifice con tutta lhuma-
na prudentia hauria condutto, perche s'è gli aspettaua di partirsi da
Roma con le conclusioni ferme, & tutte le cose ordinate, come qualun
che altro Pontifice harebbe fatto, mai non li riusciua, Perche il Re di
Francia hauria trouate mille scuse, & gli altri gli harebbero messo mil
le paure. Io uoglio lasciar' stare le altre sue attioni che tutte sono sta
te simili, et tutte le sono successe bene, & la breuità de la uita non li ha
lasciato sentire il contrario, perche sè fussero soprauenuti tempi che
fusse bisognato procedere con respetti, nè seguiua la sua rouina, per
che mai non harebbe deuiato da quelli modi a quali la natura lo inchina
ua. Conchiudo adunche che uartando la Fortuna, et gli huomini stan-
do ne i loro modi ostinati, sono felici, mentre concordano insieme, &
come discordano, sono in felici, io iudico ben' questo, che sia meglio
esser' impetuoso, che respetiuo perche la Fortuna è donna, & è neces-
sario (uolendola tenere sotto)batterla, & urtarla, & si uede che la
si lascia più uincer' da questi, che da quelli, che fredamente procede
no. Et però sempre come donna è, amica de giouani perche son'men
respettiui, più feroci, & con più audacia la comandano.

ESHORTATIONE A LIBERARE LA
 Italia da i Barbari. Cap. XXVI.

O N S I D E R A T O adunche tutte le cose di so-
c pra discorse, & pensando meco medesimo sè al presente in
 Italia correuano tempi da honorare un'Principe nuouo; &
sè c'era materia che dessi occasione à uno prudente, & uirtuoso à intro
durui forma, che facesse honore à lui, et bene alla uniuersità de gli huo
mini di quella, mi pare concorrino tante cose in beneficio d'uno Princi
pe nuouo, che non sò qual' mai tempo fussi più atto à questo. Et se co
me io disse era necessario, uolendo uedere la uirtù di Moisè, ch'el
Popolo d'Israel fussi schiauo in Egitto, & à conoscere la grandezza
& lo animo di Ciro, che i Persi fussero oppressi da Medi, & ad illu-
strarte la eccellentia di Theseo che gli Atheniesi fussero dispersi. Co
si al presente uolendo conoscere la uirtù d'uno spirito Italiano, era nes
cessario, che la Italia si coducessi ne termini presenti, et che la fusse più
schiaua, che gli Hebrei, più serua che i Persi, più dispsa che gli Athenie
si, senza capo, senza ordine, battuta, spogliata, lacera, corsa, & hauessi

Machiavelli, *Il Principe*, first edition printed by
Antonio Blado in Rome, 1532

EXAMEN CONSCIENTIAE

generale ad purgationem animæ, et ad
peccatorum Confessionem
vtilissimum.

Ro comperto ponitur triplex in-
cidere homini cogitationum genus.
Vnum ex proprio surgens motu
ipsius hominis: Reliqua vero duo extrinsecus
aduenientia, ex boni scilicet vel mali Spiritus
suggestione.

De Cogitatione.

Vobus modis elicitur meritum ex ma-
la Cogitatione in materia peccati mortalis de
qua hic sermo est. Primo. quando suggeritur
de patrando mortali crimine cogitatio, sed ea
confestim repugnando vincitur.

<div align="right">C iiii Secundo</div>

Loyola, *Exercitia spiritualia*, first edition printed by
Antonio Blado in Rome, 1548

Blado type re-created by Stanley Morison in 1923 is a happy blend of the best features of Arrighi's and Blado's scripts.

VENICE. However, as has already been observed in Germany, intellectual and spiritual forces were insufficient to attract the business men of the printing trade. They followed the high roads of commerce, and in Italy these led to Venice, the queen of the Adriatic and in the fifteenth century the mistress of trade all over the then known world. Two brothers from Speier in the Rhenish Palatinate, John and Wendelin, opened the first press in Venice in 1467. In the following year John brought out the first book printed in the mistress of the Adria, as the colophon proudly proclaimed:

> *Primus in adriaca formis impressit aeneis*
> *Urbe libros Spira genitus de stirpe Johannes.*
> *In reliquis sit quanta vides spes lector habenda,*
> *Qom labor hic primus calami superaverit artem.*

> In Adria's town, one John, a son of Speier,
> First printed books by means of forms of brass.
> And for the future shall not hope rise higher
> When the first fruits the penman's art surpass?

it was Cicero's *Epistolae ad familiares*; the first edition of 300 copies was sold out at once, and a second 300 was struck off within four months. In its colophon John again dwelt on his achievement:

> From Italy once each German brought a book.
> A German now will give more than they took.
> For John, a man whom few in skill surpass,
> Has shown that books may best be writ with brass.
> Speier befriends Venice.

After John's death (1470) Wendelin successfully carried on. He turned out ten books in 1470 and fifteen each in the two following years. The publications of the brothers were well produced and show discrimination in their choice of authors. Apart from Latin classics, the stock-in-trade of every printer in Italy, they issued the first books in the Italian language,

including Petrarch's *Canzoniere* (1470) and a Bible transla-
tion (1471).

The monopoly granted to John of Speier lapsed with his
death, and the printing trade was thrown open to competi-
tion, for the Signoria of Venice firmly believed in free enter-
prise, the pillar of Venetian commerce. The first rival of
Wendelin was another foreigner, a Frenchman, Nicolas
Jenson. Within ten years he produced about 150 books, which
is the same average as that of the Speier presses, and may
therefore be taken as a testimony to the capability of editors,
compositors, and printers during the 1470s. Jenson cultivated
a variety of subjects, with the fathers of the church and Latin
classics in evidence: Justin, Eusebius (both 1470), and Augus-
tine (1475) among the former, and Caesar, Suetonius, Quinti-
lian, Nepos (all 1471), and Pliny's *Natural History* (1472)
among the latter. Several writings of Cicero were inevitably
included in his programme; but a Vulgate (printed in gothic
letters in 1476) was still something rare on the Italian market.
Jenson's expanding business made him take into partnership
financiers whom he found chiefly among the German mer-
chants of the Fondaco dei Tedeschi; but he never became
dependent on them. He was patronized by Pope Sixtus IV,
who in 1475 made him a papal count; but it was as the pope's
honoured guest and not his indigent retainer that he died at
Rome in 1480.

The importance of Venice as a centre of the book market
appears in the enormous number of about 150 presses which
were at work there around the turn of the century. Their
quality, however, was inverse to their numbers. Erhard
Ratdolt, after Jenson's death the best printer in Venice, re-
turned to his native Augsburg in 1486; the general standard
remained low, and a firm like that of the Florentine, Lucan-
tonio Giunta, is only remarkable for its shoddy mass-produc-
tion.

All the more brightly shines the star of the greatest printer
of sixteenth-century Venice, Aldus Manutius. Like all Vene-
tian printers of any consequence, Aldus was a foreigner. He

was born about 1450 in Bassiano on the northern fringe of the Pontine Marshes, and early came into personal contact with Pico della Mirandola, the brilliant champion of Florentine Platonism. From him Aldus imbibed his love for the Greek language and literature which was to impress itself upon his activities as a publisher. Two princes of Carpi, nephews of Pico and his former pupils, supplied the capital for the press which Aldus set up in Venice about 1490; to one of them Aldus dedicated the first edition of his Latin grammar (9 March 1493). However, the editing of Greek authors was Aldus's principal aim and interest.

The signal success of these Greek editions (about which more will be said later on) encouraged Aldus to apply his scholarship and business acumen to a new venture in the production of Latin texts. Here he struck out a line for himself. By this time new generations of book-readers had grown up to whom the stately tomes of liturgical books or collected editions of ancient writers and fathers of the church had little appeal. The *conoscenti* and *dilettanti*, the gentlemen of leisure who had imbibed the taste and a little of the scholarship of the humanists, and the schoolmasters, parsons, lawyers, and doctors who had passed through their university courses of *litterae humaniores* wanted books which they could carry about on their walks and travels, read at leisure in front of their fireplaces, and which would incidentally be within the financial reach of the poorer of these potential book-buyers. Aldus had one of those brainwaves which distinguish the truly great publisher. He decided upon the production of a series of books which would at the same time be scholarly, compact, handy, and cheap. In order to be commercially successful, it was not only necessary to raise the number of copies of each edition – Aldus printed 1,000 instead of the 100, 250, or at most 500 hitherto considered the rule – but he had to cram as much text as possible on to the octavo format which he allowed for his 'pocket editions'. Here his liking for cursive letters stood him in good stead; and Francesco Griffo's cursive fount fulfilled this condition.

Onticuere omnes , intentique ora
 tenebant,
Inde toro pater Aeneas sic orsus
 ab alto,
Infandum Regina iubes renouare
 dolorem,

T roianas ut opes,et lamentabile regnum
E ruerint Danai,quáque ipse miserrima uidi,
E t quorum pars magna fui·quis talia fando
Myrmidonum,Dolopum ue,aut duri miles Vlyssi
T emperet à lachrymis?et iam nox humida cœlo
P rœcipitat,suadentq; cœdentia sydera somnos·
S ed si tantus amor casus cognoscere nostros,
E t breuiter Troiœ supremum audire laborem,
Q uanq̃ animus meminisse horret,luctuq̃;refugit,
I ncipiam·Fracti bello,fatis'q; repulsi
D uctores Danaum,tot iam labentibus annis,
I nstar montis equum diuina Palladis arte
A edificant,sectaq̃;intexunt abiete costas.
V otum pro reditu simulant,ea fama uagatur·
H uc delecta uirum sortiti corpora furtim
I ncludunt cœco lateri,penitus'q; cauernas
I ngenteis,uterum'q; armato milite complent.
E st in conspectu Tenedos notissima fama
I nsula,diues opum,Priam dum regna manebant,
N unc tantum sinus,et statio male fida carinis·
H uc se prouecti deserto in littore condunt.

Pocket edition of Virgil's *Aeneid*, printed with one of
Francesco Griffo's founts by Aldus Manutius
in Venice, 1510

From April 1501, when Virgil's *Opera* came out in Griffo's cursive, Aldus issued every two months over the next five years one of the 'Aldine' editions over the imprint of the dolphin and anchor, which, in addition to the excellence of the texts supplied by eminent scholars, was accepted all over Europe as a sure guarantee of an impeccable, handsome, and reasonably priced edition of ancient authors.

An interesting sidelight on Aldus's international reputation is seen in the fact that reprints of his editions, purporting to come from Aldus's press, were at once rushed out by unscrupulous rivals. The printers of Lyon published no fewer than 59 'Aldines' between 1501 and 1526; they were aided and abetted in this sordid trade by Francesco Griffo who cut several sets of punches for Lyonese firms. Even the first edition of the *Epistolae obscurorum virorum* appeared in 1515 with the colophon *In Venetia in impressoria Aldi Minutii*; it was, in fact, printed by Heinrich Gran of Hagenau in Alsace. In view of the prevalent laxity towards what we now call plagiarism, it is therefore a rare example of scholarly honesty that Johannes Sturm, the founder of the Strasbourg *Gymnasium* (1538), handsomely acknowledged his debt to Aldus. From 1540 Sturm brought out reprints of Aldine editions for the use of his students, and he mentioned his source in these words: 'We have followed Aldus throughout, partly because of his personal authority and partly because of the annotations of the Italian scholars' (*Aldum per omne secuti sumus tum propter authoritatem viri tum propter Italorum observationes*).

Aldus very nearly became also the pioneer in the field of polyglot Bible editions – an honour which was to fall to Cardinal Ximenes, the originator of the Complutensian Bible. In 1497 or 1498 Aldus projected a Hebrew-Greek-Latin Bible; but for unknown reasons the plan was abandoned and a single specimen page (the only known copy now in the Bibliothèque Nationale, Paris) is the sole witness to this bold scheme.

For over a century the firm of Manutius maintained its honoured place. After Aldus's death (1515), his father-in-law, Andrea Asolano, himself the owner of the late Nicolas Jenson's

HERODOTI HISTORICI INCIPIT:
Laurentii Vallen, conuersio de Græco in Latinum:

ERODOTI Halicarnasei historiæ explicatio hæc est: ut neqȝ ea quæ gesta sunt: ex rebus humanis obliterentur ex æuo: neqȝ ingentia & admiranda opera: uel a Græcis edita: uel a Barbaris gloria fraudetur: cum alia: tum uero: qua de re isti inter se belligerauerūt. Persarū eximii memorāt dissensionū auctores extitisse Phœnices qui a mari quod Rubrum uocatur: in hoc nostrum proficiscentes: & hanc incolentes regionem: quam nunc quoqȝ incolunt: longinquis continuo nauigationibus incubuerunt: faciendisqȝ Aegyptiarum & Assyriarum merciū uecturis in alias plagas: præcipueqȝ Argos traiecerunt: Argos &enim ea tempestate omni-

Lorenzo Valla's Latin translation of Herodotus, printed by
Gregorius de Gregoriis in Venice, 1494; a particularly fine specimen
of arabesque decoration

77

press, acted as faithful steward for his nephew Paulus (b. 1511) until the latter came to maturity. More a scholar than a man of business, Paulus increased the fame of the firm through his excellent editions, especially that of Cicero, but failed to expand or even maintain its commercial success. His son Aldus the younger, who inherited the firm after Paulus's death in 1574, was as good a philologist and as bad a business man as his father. In 1585 he handed the press over to a manager, and closed it in 1590 when he was appointed head of the Vatican press.

Its geographical position and historic associations made Venice also the natural avenue through which the southern Slavs came into contact with the art of printing. Of all the incunabula preserved in Yugoslav libraries about 75 per cent came from Venetian presses. Croats – not always easily recognizable as such – occur as printers in Venice from 1476. Boninus de Boninis (Dobrić Dobričević), who printed in Verona, Brescia, and Lyon, is perhaps the most important. In Venice also originated the first books printed in the Croatian language and with Glagolitic letters: a Missal (1483), a Breviary (1493), and an Evangelistary (1495).

The first books printed east of the Adria are a Serb-Cyrillic 'Oktoih' (1493) and Psalter (1495) and a Croat-Glagolitic Missal (1494), all published in Cetinje by Hieromonachos Makarios, who later (1507–12) also became the first printer in Walachia. But the first great secular Dalmatian book, Peter Zoranić's novel *Planine*, again appeared from a Venetian press (1569).

Alone among the Italian cities, Venice preserved its printing tradition throughout the sixteenth century. While the house of Manutius continued to specialize in ancient authors, two other great Venetian publishers applied themselves whole-heartedly to the cultivation of Italian letters. Francesco Marcolini, a native of Forlì, came to Venice in 1534. He was the publisher of Pietro Aretino, perhaps the most gifted satirist, pornographer, and literary blackmailer of any age, but made up for it – if the thought ever occurred to him that he had to make

up for it – by his graceful edition of Dante. His elegant press-work did much to popularize the Roman cursive as developed by Arrighi, Blado, and Tagliente.

Even more important for the propagation of the national literature was Gabriele Giolito de Ferrari, a Piedmontese who settled in Venice together with his father in 1538 but made himself independent three years later. He became not only the publisher of Ariosto, of whose works he brought out almost thirty editions, but also reprinted older Italian masters, especially Petrarch and Boccaccio. When the church began to frown upon the semi-paganism of these writers, Giolito adapted himself to the change of climate and from 1568 published a series of edifying books called *Ghirlanda spirituale* (spiritual garland). By the time he died (1578), he had published some 850 books, but under his sons the firm rapidly declined and in 1606 was dissolved.

See Supplementary note, page 384

FRANCE

The history of the printed book in France is from the very beginning marked by two features which one is inclined to ascribe to the French national character: centralization of the trade and elegance of the production. Lyon is the only place besides Paris that held its own as an independent centre of printing and publishing, until the Inquisition stifled and killed this seat of Protestantism. Geneva, it is true, achieved for Calvinist literature the importance Wittenberg had in the Lutheran world, but Genevan printing was more influential outside than inside France. Places such as Rouen and Orleans only lived on the crumbs that fell from the table of the Paris printers. Up to the middle of the sixteenth century Paris was the leading, and after the decline of Lyon the only, city on which French typography, printing, and publishing have centred ever since.

This trend was strengthened by the fact that printing was introduced in France as the official concern of the Sorbonne, the intellectual centre of the country, and soon enjoyed the

special attention of royalty. Charles VII's patronage of Nicolas Jenson may be spurious – in any case, Jenson did not return to Paris but went to Venice; but Louis XII and particularly François I displayed a genuine interest in the art of printing, though not untinged by the desire to make it serve the political aims of the monarchy.

The first printing venture in France derives its main interest from the fact that it was the first enterprise in which the publisher held the whip-hand over the printer. It is not surprising that the printer's exclusive dominion was first challenged by the university dons. They have, understandably, definite ideas about the kind of book they consider worth promulgating for the sake of learning as well as teaching. The Sorbonne, the oldest university north of the Alps, led the way. As early as 1470 its rector and librarian invited three German printers to set up a press on the premises of the university; the rector and librarian selected the books and supervised the printing, even to laying down the type; their insistence on a roman fount was decisive in preparing the speedy overthrow of gothic lettering in the western world. The books were mostly textbooks for students chosen with an eye on their suitability as models of elegant Latin style; among them Leonardo Bruni's translation of Plato's letters (1472) is worth mentioning as the only print of this work ever done, as well as the only Platonic text printed in France in the fifteenth century. When in 1473 the two academic dignitaries who had sponsored the press left Paris – Johann Heynlin for Basel where he became the adviser of Johann Amerbach, and Guillaume Fichet for Rome – the three German printers carried on for five more years as a private company, and from 1478 to his death in 1510 only one of them, Ulrich Gering of Constance, remained in business.

By this time, although a number of other Germans were at work in Paris, French-born printers had established themselves. Among them, Pasquier Bonhomme brought out the first printed book in the French language, the *Croniques de France* in three volumes in 1476. But the men who set the pace

for the development of the specifically French book were Jean Dupré and Antoine Vérard. Both of them specialized in illustrated and ornamented *éditions de luxe*. Dupré, who opened shop at the sign of the Two Swans in 1481, is perhaps more remarkable for his business capacity. The counterpart of Koberger and Manutius, for a time he controlled the French book market through his association with wealthy financiers and the foundation of branches and agencies throughout the provinces, including a flourishing establishment in Lyon. Vérard, on the other hand, who began printing in 1485 and died in 1512, originated the Book of Hours – of which he himself produced nearly 200 different editions – which in their harmonious blend of neat lettering, elegant borders, and delicate illustrations set up a target for fine bookwork by which French printing has profited ever since. Philippe Pigouchet (*fl.* 1488–1515), Thielmann Kerver (*fl.* 1497–1522), and others vied with Vérard in the charm and care bestowed upon their productions, which, beside the Books of Hours, included chronicles, courtly romances, and the famous *Dance of Death* which Guy Marchant published in 1485.

About the turn of the century the taste for these fundamentally medieval categories of reading matter abated, and the spirit of the renaissance began to permeate French thought. Vérard was a pioneer in introducing renaissance forms in his book-ornaments; but it was of greater importance for the growth of the specifically French brand of classicism that he was followed by a galaxy of scholar-printer-publishers who, throughout the sixteenth century, gave France the lead in European book production.

The line opens with the Fleming Josse Bade (1462–1535), who latinized his name to Jodocus Badius Ascensius, from Aasche near Brussels although his birthplace was Ghent. He studied in Italy and then learned the printing trade in Lyon at the press of Johann Trechsel, whose daughter Thalia he married. Lyon is an exception to the general rule in that the first printer was a Frenchman, or rather a Walloon, called Guillaume le Roy (printed 1473–88), who had been trained in

Arnabe seuite fut du lignaige
de cypre/τ fut lun des septãte
τ deup disciples de nrẽseigneur
Et est loue en moult de manieres surhaul
ce en lystoire du fait des apostres:car il fut
tresbien informe τ ordõne quãt a soy:quãt
a dieu τ quãt a son prochain. Quãt a soy
il fut ordõne selõ trois choses:cestassauoir
raisõnable:couuoiteuse:τ preuse.Il eut for
ce raisonnable en lumiere de congnoissãce
Dõt il est dit au fait des apostres au piiii
chapitre. Ilz estoient en leglise qui estoit
en antioche prophetes τ docteurs entre les
quelz barnabe τ symon estoient.Seconde

Jacobus de Voragine's *Legenda aurea*, printed with gothic
type by Jean Dupré in Paris, 1489;
from 1490, in Lyon, he used roman type

¶Cy cōmance le rōmant de la rose
Ou tout lart damours est enclose
Maintes gens dient que en songes
Ne sont que fables et mensonges
Mais on peult telz songes songier
Qui ne sont mie mensongier
Ains sont apres bien apparant
Si en puis bien trouuer garant
Vng acteur denomme macrobes
Qui ne tient pas songes a lobes
Aincois escript la vision.
Qui aduint au roy cipion
Quieunques cuide ne qui die
Que ce soit vne musardie
De croire que songe aduienne
Et qui vouldra pour fol men tienne
Car endroit moy ay ie fiance
Que songe soit signifiance

Des biens aux gens et des ennuyz
Que les plusieurs songet par nuytz
Moult de choses couuertement
Que on voit puis appertement
Au quizieſme an de mō eage
Ou poĩt q amours prēt peage
Des ieunes gens couchie mestoye
Vne nuyt comme ie souloye
Et me dormoye moult forment
Si vey vng songe en mon dormāt
Qui moult fut bel a aduiser
Comme vous orres deuiser
Car en aduisant moult me pleust
Mais en songe onques riēs neust
Qui aduenu du tout ne soyt
Comme listoire le recoit
Or vueil ce songe rimoyer
Pour voz cuers plus fort esgayer
Amours le me prie et commande
Et se nulz ou nulle demande
Comment ie vueil que ce rōmans

a 2

The popular verse romance *Roman de la Rose*,
printed by Guillaume le Roy,
the first printer in Lyon, about 1486

the press of the Speier brothers in Venice, and that he was followed by German nationals, among whom Trechsel, a graduate of Erfurt university, takes pride of place. Compared with the sixty-odd printers traceable in Paris during the last decades of the fifteenth century, Lyon numbered some forty presses during the same time – sufficient evidence to show the economic importance of the city whose world-famous fairs attracted merchants from Germany, Italy, Spain, and which enjoyed the special patronage of Louis XI (1461–83). Moreover, the Lyon printers had the advantage of being far removed from the censorship exercised by the theologians of the Sorbonne and were therefore, in contrast to their brethren in Paris, free to follow the humanist trend, of which Trechsel's illustrated Terence (1493) is a good specimen.

Bade left Lyon for Paris in 1499 and here continued his father-in-law's work with a series of ancient and modern Latin authors; among the latter were most of the early writings of Erasmus. In addition, he was the first publisher of Guillaume Budé, one of the greatest Greek scholars of all times. The Praelum Ascensianum, as Bade called his firm, used as its device a printing press, which is incidentally the earliest representation of the instrument. After Bade's death his firm merged with a press which gained even greater fame as a fountain diffusing classical literature, namely that founded in or shortly before 1502 by Henri Estienne (Henricus Stephanus). His outstanding adviser and author was Jacques Lefèvre d'Étaples (Faber Stapulensis), the leading French Graecist, whose Psalterium quintuplex (1509) and commentaries on the Psalms (1507) and the Pauline Epistles (1512) first subjected biblical studies to philological methods. For his Latin editions Stephanus enjoyed the editorial assistance of Geofroy Tory (1480–1533) who afterwards set up a printing press of his own.

Henri Estienne's widow married a partner of her late husband, Simon de Colines, who worthily continued the tradition of the firm, until Robert Estienne (1503–59) entered the business in 1525. Robert was married to Perette Badius and after his father-in-law's death (1535) amalgamated the presses

A Book of Hours, in the elegant French style of these devotional
books, printed by Geofroy Tory in Paris, 1525

of Badius and Stephanus. At the same time there flourished another son-in-law of Badius, Michel Vascosan; and it is to Colines, Tory, Robert Estienne, and Vascosan that the reign of François I (1515–47) owes its appellation as the Golden Age of French typography. These printers introduced to France the principles of the Aldine press – the exclusive use of roman and italic founts, a handy size, and a cheap price. Influenced by Tory's principles, Colines and Estienne acquired entirely new sets of types. Colines himself is credited with the design of italic and Greek founts and especially the roman 'St Augustin Sylvius' of 1531, the ancestor of all 'Garamond' types. The firm was fortunate in obtaining the services of Claude Garamond as their punch-cutter and 'typographical adviser', as we should now describe his functions.

Simon de Colines, although not a scholar himself, fully maintained and even extended the range of learned and scientific works, including the natural sciences (Jean Ruel's *De natura stirpium*), cosmology and astrology (Jean Fernel and Sacrobosco), in addition to pleasant Aldine-type editions of Horace and Martial.

Robert Estienne and, after him, his son Henri II (1528–98) are the two most eminent scholar-printers of their century. Robert was both a sound classical student and a devout Christian, and these inclinations combined happily in his critical editions of the Vulgate (1527–8) and the Old Testament in Hebrew (1539–41, revised 1544–6). In his Greek New Testament of 1551 he divided the chapters into numbered verse, an innovation which quickly became generally accepted. Robert's greatest achievement in the field of pure scholarship was his *Thesaurus linguae latinae* (1531 and frequent revised editions); it is still not entirely superseded. His *Dictionarium latino-gallicum* (1538), *Dictionaire francoislatin* (1539–40), and concise school-editions of both – all frequently reissued – made Robert also the father of French lexicography.

Robert Estienne enjoyed the patronage, amounting to personal friendship, of King François I, the only sovereign of all ages who bestowed upon printing that loving care that a

& clos à clauſu, pro orto. Sāctus Maûrus, ſainct Mor

Pauper pou-rè, P.2. vel paû-u-rè. Maûrus, maûra, um, gentile, Morè.

Paulus pol.

Cæterū vti aû in quibuſdam quoque interdum ſeruatur, vt audire aûir, pauper paûu-rè: Sic rurſus o factū ex aû, ſæpe in oû vertimus, O.5, vel in eû, O.6, vt

Caudacōè, ſyn. d. ſæpius tamen coûè & cēûè.

Caudatus, a, um, cōè, ſæpius coûè. Inde

cōûard cōûardè, pro timidus, a, um, quaſi qui trahit caudā & ſibi poſt principia cauet, vltimus in bello, vt primus ſit in fuga, Xerxis Perſarum regis imitatione.

Clauus claû. ſæpius cloû, Gal. cleû, Pic. à quo

Cloûer & enclôûer illi. hi cleûer & encleûer dicunt.

Audire aûir, oi r, & oûir.

Aucha vel ocha, aûè, oûè, oîè. O.7. eûè, Pic.

E Latinis quandoque tranſit in a, vt E in a

Sero ſatum ſatu. Reor ratum. Priſc. 1

Sic e in a Galli ſæpe commutant, vt

Per præpoſitio, par.

Perfectus parfaict. Sic ferè exper compoſita.

Marcant, id eſt mercator, & ambulans à mercans.

Marcer, id eſt ambulare, à mercari, fortè quia Impiger extremos currit mercator ad Indos.

Marcander autē, id eſt emptionem curare & emere.

Marcandicè, id eſt merx, & mercatus.

Mercarius autem mercer.

Mercatus marcē, id eſt forum, vel pretium. quod & marcer à mercari dici poteſt. canone 3º.

Videns voîant.

Sapiens ſau-ant. P.3.

Dormiēs dormāt. & reliqua ferè participia in ns, à verbis ſecūdæ, tertiæ & quartæ coniugationis in ant, quomodo à verbis primæ terminamus.

Sed prudens prudent, nomē participium ſonans, vt

d.i.

Sylvius, *Isagωge*, a Latin-French dictionary, printed by Robert Estienne in Paris, 1531, with the 'St Augustin Sylvius' type designed by Simon de Colines

Charles I displayed for his picture gallery and most monarchs reserved for grandiose buildings and the jewellery of their mistresses. Like Maximilian I, François shrewdly recognized the immense power which might result from an appeal to what afterwards became known as public opinion, through the medium of the printed word. In 1527 his government publicly explained and justified their policy in a pamphlet *Lettres de François Ier au Pape*, which, in its studious *suppressio veri* and

Printer's device used by the
Estienne family in various forms from 1526: the
philosopher under the Tree of Knowledge;
motto 'Noli altum sapere sed time'
(Rom. 11 : 20)

suggestio falsi set the standard for many a subsequent White Book. Later, Estienne lent his pen and press to several such documentary publications which 'properly informed everyman' why the alliances of the Most Christian King with the German Protestants and the Turkish Sultan served the cause of European peace and religious concord.

A more honourable posterity issued from two other measures taken by François. In 1538 he ordered Estienne to give one copy of every Greek book printed by him to the royal library, which, from this modest beginning, became the first

PAVLI IOVII NOVOCOMEN-
sis in Vitas duodecim Vicecomitum Mediolani
Principum Præfatio.

ETVSTATEM nobi-
lissimæ Vicecomitum fami-
liæ qui ambitiosius à præalta
Romanorū Cæsarum origi-
ne, Longobardísq; regibus
deducto stemmate, repete-
re contédunt, fabulosis pe-
nè initiis inuoluere viden-
tur. Nos autem recentiora
illustrioráque, vti ab omnibus recepta, sequemur: cō-
tentíque erimus insigni memoria Heriprandi & Gal-
uanii nepotis, qui eximia cum laude rei militaris, ci-
uilísque prudentiæ, Mediolani principem locum te-
nuerunt. Incidit Galuanius in id tempus quo Medio-
lanum à Federico AEnobarbo deletū est, vir summa
rerum gestarum gloria, & quod in fatis fuit, insigni
calamitate memorabilis. Captus enim, & ad trium-
phum in Germaniam ductus fuisse traditur: sed non
multo pòst carceris catenas fregit, ingentíque animi
virtute non semel cæsis Barbaris, vltus iniurias, patriā
restituit. Fuit hic (vt Annales ferunt) Othonis nepos,
eius qui ab insigni pietate magnitudinéque animi, ca-
nente illo pernobili classico excitus, ad sacrū bellum
in Syriam contendit, communicatis scilicet consiliis
atque opibus cū Guliermo Montisferrati regulo, qui
à proceritate corporis, Longa spatha vocabatur. Vo-
luntariorum enim equitum ac peditum delectæ no-
A.iii.

Paolo Giovio, *Biographies of the Visconti Dukes of Milan*,
printed by Robert Estienne in Paris, 1549

copyright library. In the following year the king promulgated a code of rules for printers, the most important of which is the clause banning the use of any printer's mark which might be confused with that of another press – an order which safe-guarded equally the interests of the producers and buyers of books.

François I's death (1547) deprived the Calvinist Robert Estienne of the protection he needed against the hostile theo-logians of the Sorbonne. He therefore left Paris for Geneva in 1550, and the firm thereafter continued both in Paris and Geneva. In Paris, Robert's brother Charles (1504–64) brought out a complete edition of Cicero (1555) as well as a *Guide des chemins de France* which is enlivened by comments on 'bad roads', 'infested by brigands', 'good wine', 'plentiful oysters'. But Charles died in the debtors' prison and left a sorely encumbered business to his nephew Robert II (1530–71) who had remained faithful to the church of Rome. Mean-while Henri II (1528–98) and François (1537–82) main-tained the splendour of the paternal press in Geneva. Henri has to his credit a long series of pagan and early Christian classics including the *editiones principes* of Anacreon, Plu-tarch, and Diodorus Siculus; but his outstanding achievement is the *Thesaurus linguae graecae* (1572), the worthy counter-part and companion of his father's work. Henri II's son, Paul (1567–1627), cooperated with the great Genevan philologist, Isaac Casaubon, his brother-in-law, in maintaining the scholarly standard of the Geneva branch. But he fell foul of the authorities and fled to Paris. Here his son, Antoine, re-turned to the old faith and was rewarded with the title of *imprimeur du roi* and *gardien des matrices grecques*. His death in 1674 ended the uninterrupted tradition through nearly two centuries of the most brilliant family of scholar-printers that ever existed.

The Estiennes thus bridged the period between the incuna-bula and the Imprimerie Royale of Louis XIII, showing the unique stability as well as the almost uniform excellence of French printing through the centuries. But the ultimate return

of the family to Paris also indicates the unrivalled role of the metropolis in the world of French letters. Only Lyon, the greatest – virtually the only – competitor of Paris, brilliantly maintained its position for almost a century. In Lyon, printing proper remained in the hands of German immigrants longer than anywhere else, and the influence of neighbouring Basel is very much in evidence. The branch which Anton Koberger opened in Lyon not only sold the products of the Nürnberg firm on the French market but also made independent arrangements with many Lyonese printers in order to cope with the demands for Koberger books.

The press of Johann Trechsel was carried on by Johann Klein, who married the founder's widow, and printed from 1498 to 1528, and afterwards by Trechsel's sons, Melchior and Caspar. The brothers' most famous productions are the two series of woodcuts which they commissioned from Hans Holbein in Basel and published as *Historiarum veteris instrumenti icones* and *Les Simulachres et historiees faces de la mort*, both in 1538, supplemented by Old Testament passages and Dance of Death verses respectively. The Trechsels were also the first publishers of the Spanish doctor Michael Servet who edited for them among other books Ptolemy's *Geography* (1535). But the book which caused Servet's death at the stake in Geneva (1553), his *Restitutio Christianismi* (1552-3), was published in Vienne by Balthasar Arnoullet – both printer and place probably chosen for their obscurity. In this book Servet described the pulmonary circulation; but this discovery remained unknown as all copies of the book were burned, only three secretly surviving. William Harvey was unaware of it when he laid before his contemporaries the *Exercitatio anatomica de motu cordis et sanguinis in animalibus* (Frankfurt, 1628).

Besides the Trechsels, Sebastian Greyff, latinized Gryphius (1491-1556), a native of the Swabian imperial city of Reutlingen, is one of the eminent printers of Lyon, where he worked from 1520. His editions of ancient authors rivalled those of the Aldus and Stephanus presses. For his critical

editions of the classical physicians, Hippocrates and Galen, Gryphius obtained no less an editor than François Rabelais. A Lyon printer, who unfortunately does not give his name, also produced Rabelais's *Gargantua* (2nd ed., the oldest extant, 1532) of which, so the author proclaimed, more copies were sold in two months than Bibles in nine years – perhaps a somewhat Gargantuan statement. Only two copies survive, though.

Gryphius was also the first publisher of the free-thinking humanist Étienne Dolet who in 1538 opened a press of his own from which he issued Clément Marot's Calvinist satire *L'Enfer* (1542) and his own heretical tracts which eventually led him and his books to the stake in Paris (1546).

But Lyon's fame in the history of printing rests as much with its type-designers as with its printers. The greatest of them was Robert Granjon. He moved to Lyon in about 1556, having been in close contact with that town for some ten years. In 1546 he had supplied a set of italics to the Lyonese printer Jean de Tournes I, who printed with it a book on the astrolabe. This was illustrated by the wood-engraver Bernard Salomon, whose daughter, Antoinette, Granjon subsequently married. In Lyon, Granjon continued to furnish de Tournes with punches and matrices; but at the same time he published books under his own imprint. Granjon's types, Salomon's illustrations, and the presswork of Jean de Tournes, father (1504–64) and son (1539–1605), shed a final lustre on the Lyon book production of the second half of the sixteenth century. Jean I was connected with the literary *salons* of Lyon of which Louise Labé, *la belle cordière*, was the uncrowned queen. Her only book, immortal through the sonnets it includes, was published by de Tournes in 1555. Jean II, because of his Protestant faith, had to emigrate to Switzerland in 1585 and died there.

Lyon was outdone by the overpowering competition of Paris when it was still at its height, instead of petering out in penury and incompetence as did most of the German and Italian cradles of early printing.

EVVRES
DE
LOVÏZE LABE'
LIONNOIZE.
*

Reuues & corrigees par ladite
Dame.

A LION
PAR IAN DE TOVRNES.
M. D. LVI.
Auec Priuilege du Roy

Louise Labé, *Euvres*, revised edition, printed with fully developed
arabesques, by Jean de Tournes I in Lyon, 1556

Spanish civilization, in all its aspects, has throughout the centuries been marked by distinctive peculiarities which, though difficult to pin down in detail, keep Spanish art, Spanish literature, Spanish music, Spanish religiosity separate from the general development of the rest of Europe. The same specific flavour can also be found in the history of the printed book in Spain.

All the early printers were Germans – but they became at once acclimatized to a far greater degree than any German or French printer in Italy ever became italianized. They began printing in the most up-to-date roman types – but at once reverted to gothic founts which were lineal descendants of Spanish manuscript lettering. More than anywhere else they depended on ecclesiastical patronage – but, right from the start, books in the vernacular outnumbered those in Latin. Liberal leading, white initials on a black background, woodcut title-pages frequently decorated with armorial designs, are some of the typographical characteristics which put early Spanish books in a class by themselves.

The Great Trading Company of Ravensburg in southern Swabia, the biggest export-import firm of fifteenth-century Europe, was the agency which provided Spain with her first printers. Their main factory in the Iberian peninsula was Valencia in Aragon, and here in 1473 the German manager set up a press serviced by three of his compatriots, Lambert Palmart of Cologne, John of Salzburg, and Paul Hurus of Constance. Of these, Palmart remained in Valencia, John of Salzburg and Hurus went to Barcelona in 1475, Hurus later to Zaragoza. Castile, at the time lagging far behind Aragon in economic and cultural importance, received its first presses from Aragon. Burgos, the original capital and still a political and ecclesiastical centre of the kingdom, Salamanca and Alcalá, the two university towns, and Seville, the great emporium for the trade with the New World, became the seats

Title-page of the *Aureum opus*, the autobiography of King Jaime I of
Catalonia and Aragon (1208–76), printed by Diego de Gumiel in
Valencia, 1515; typical of Spanish book-design

95

of flourishing presses before the end of the century. Madrid, raised to the status of royal residence in 1561, first appears in printing history in 1566, but thereafter outstripped the older places.

In 1495 a Spanish princess, Queen Eleanor of Portugal, called the printers, Valentin of Moravia and Nicholas of Saxony, to Lisbon, where in 1489 the first book had been produced by a Hebrew printer. The first vernacular book published in Lisbon in 1495 was a Portuguese translation of Ludolf of Saxony's *Life of Christ* in four volumes.

In addition to the usual Latin indulgences, missals, grammars, and dictionaries, Spanish literature made an early entry in print. Diego de San Pedro's novel *Cárcel de amor* was published by Johann Rosenbach in Barcelona in 1493 and by Frederick Biel of Basel in Burgos in 1496, Juan de Lucena's *Repetición de amores* by Hutz and Sanz in Salamanca in 1496, Vagad's *Crónica de Aragón* by Hurus in Zaragoza in 1499. Religious and secular poetry, edifying and entertaining prose, collections of laws and statutes, in Spanish and Hebrew (which up to 1492 was almost the second literary language of Spain), comprise about two-thirds of the whole Iberian book production.

In 1490 Queen Isabel put printing in Seville on a permanent footing by commissioning four *Compañeros alemanes* to print a Spanish dictionary, the first of a dignified line of officially sponsored national dictionaries of which those of the Académie Française, the Spanish Academy, and the University of Oxford were to become the most famous.

The most noteworthy press in Seville was that founded by Jacob Cromberger in 1502. He was the main publisher of the great humanist Elio Antonio de Nebrija (or Lebrixa) whose editions of Persius and Prudentius were famous for their scholarship and are still attractive for their presswork. The text was set in roman and was surrounded by the commentary in gothic. King Manuel I of Portugal commissioned Cromberger to print the *Ordonanções do reino* in 1507 and summoned him to Lisbon for the second edition in 1520; the third

Suma de geographia ā
trata de todas las partidas τ prouinci
as del mundo: en especial delas indias.
τ trata largamente del arte del marear
juntamente con la espera en romance:
conel regimiēto del sol y del norte: ago
ra nueuamente emendada de algunos
defectos ā tenia enla impressiō passada.

Encino's geographical handbook, printed by Juan Cromberger
in Seville, 1530

was done in 1539, again in Seville, by Jacob's son Juan, who had taken over the press in 1527. As Seville was the port in which the whole commerce with the Americas was concentrated, Juan Cromberger's attention was drawn to the prospects which the New World might offer to the printing trade. He obtained an exclusive privilege for printing in Mexico and sent over one Juan Pablos (= Johannes Pauli?) who in 1539 published the first American book, *Doctrina christiana en la lengua mexicana e castellana*, a fitting epitome of the Spanish combination of missionary zeal and imperialist expansion.

The printers at Salamanca specialized in the publication of classical authors for which they used roman types; and after the turn of the century these were gradually introduced also in Spanish texts. Salamanca's fame as a seat of learning was rivalled, and as a seat of printing outdistanced, by the new foundation of Alcalá (1508). Cardinal Francesco Ximenes, its founder and generous patron, appointed as university printer Arnão Guillén de Brocar of Pamplona, the first native Spanish printer of significance. He began his career at Pamplona in 1492 with theological books of which he had issued not more than sixteen by 1500, all printed with great care in noble round gothic letters. They were followed by seventy-six more before he died in or shortly after 1523; and his reputation is well attested by the fact that King Charles I (better known as the Emperor Charles V) appointed him typographer royal, a dignity which Charles later conferred also upon his son, Juan. However, Arnão's reputation as the greatest printer of sixteenth-century Spain derives from his magnificent production of the Complutensian Polyglot (Complutum being the Latin name of Alcalá de Henares), a multilingual Bible in Hebrew, Chaldee, Greek, and Latin. Cardinal Ximenes, who died in 1517, did not see the completion of this monument of scholarship and craftsmanship which, in his words, was 'to revive the hitherto dormant study of the Scriptures' and in fact marks the beginning of the Catholic Reformation. Ximenes spent the princely sum of 50,000 gold ducats (about £25,000 gold) on it. The editorial work began in 1502, the

Τελος / Της ᾽αποκαλύψεως.

Explicit liber Apocalypsis.

Deo gratias.

Ad perpetuam laudem et gloriam
dei z domini nostri iesu christi hoc sacrosanctum opus noui testa
menti z libri vite grecis latinisqz characteribus nouiter impres
sum atqz studiosissime emendatum: felici fine absolutū est in
hac preclarissima Cōplutensi vniuersitate: de mādato z
sumptibus Reuerendissimi in christo patris z illustris
simi dñi domini fratris Frācisci Ximenez de Cisne
ros tituli sancte Balbine sancte Romane eccle
presbyteri Cardinalis hispanie Archiepi to
letani z Hispaniaꝝ primatis ac regnoꝝ
castelle archicācellarij:industria z soler
tia honorabilis viri Arnaldi guillel
mi de Brocario artis impressorie
magistri. Anno domini Mil
lesimo quingentesimo de
cimo quarto. Complu
tensis
Ianuarij die decimo.

Last page (Rev. 22 : 17–21), colophon and printer's device of the Greek-Latin Volume Five (published first) of the Complutensian Polyglot Bible, printed by Arnão Guillén de Brocar in Alcalá, 1514

printing of the six volumes stretched from 1514 to 1517, but the book was issued only in 1522. Brocar's trial-run, as it were, of the beautiful Greek type, was an edition of Musaeus's *Hero and Leander*. It is a fitting tribute to the great cardinal that one of the last books of typographical merit printed in Alcalá – or, for that matter, in Spain – should have been his biography written by Alvar Gómez de Castro and published by Andres de Angulo in 1569.

A number of the punches and matrices used by Spanish printers in the sixteenth century have come down to our time as part of the stock of the Spanish branch of the Bauer Foundry of Frankfurt. This foundry was originally owned by the monastery of San José in Barcelona and appears as a business concern from 1745. As Barcelona was one of the earliest printing places in the peninsula, it is quite possible that here some genuine 'incunabula' matrices may have survived.

ENGLAND

England owed the introduction of printing to a native – a merchant rather than a scholar – who was supported by, but not dependent on, the nobility and gentry of the realm – William Caxton. 'His services to literature in general, and particularly to English literature, as a translator and publisher, would have made him a commanding figure if he had never printed a single page. In the history of English printing he would be a commanding figure if he had never translated or published a single book. He was a great Englishman, and among his many activities, was a printer. But he was not, from a technical point of view, a great printer' (Updike).

Born in the Weald of Kent in 1420/4, he became a London mercer and spent much of his time for thirty years in Bruges, where he eventually rose to the position of a modern Consul-General in charge of the interests of the English mercantile community. After relinquishing his office (perhaps not of his

own free will), he found leisure for an English translation of Raoul Lefèvre's chivalrous romance *Recueil des histoires de Troye* which he dedicated to Margaret, sister of King Edward

Printer's device of William Caxton,
used from 1487 or 1489: trade-mark flanked
by the letters w and c

IV and duchess of Charles the Bold of Burgundy, in whose territories Bruges was situated.

In order to publish the book according to his own taste, Caxton, like William Morris four centuries after him, set himself to learn the craft of printing. This he did in 1471–2 in Cologne with one of the many printers active in that teeming city. After his return to Bruges, demands for copies from

'dyuerce gentilmen and frendes' caused him to set up a press of his own in 1473, and as its first fruit the *Recuyell of the Histories of Troye* came out in 1474. This was quickly followed by the popular *Game and Playe of the Chesse*, translated by Caxton from the Latin of Jacobus de Cessolis, a second edition of the *Recueil*, *Les Faits de Jason*, *Méditations sur les sept psaumes*, and *Les quatre dernières choses*. All these books used to be ascribed to the Bruges calligrapher and printer Colard Mansion; but it has now been established that they came from Caxton's press where Mansion, in fact, learned printing before setting up independently in 1474.

Caxton returned to England in 1476 and established his press in the abbey precincts at Westminster, first near the Chapter House and later in the Almonry, at the sign of the Red Pale. At the same time, Caxton imported books from abroad on a fairly large scale and perhaps also exported some to France; the latter, 'printed in French', may have been copies of Caxton's Bruges publications or simply unsold remainders of the imported stock. Thus, Caxton was not only the first English printer-publisher but also the first English retailer of printed books, all his London contemporaries in this trade being Dutch, German, and French.

Up to his death in 1491 Caxton enjoyed the patronage, custom, and friendship – it is difficult to make clear-cut distinctions – of the Yorkist kings Edward IV and Richard III, as well as their Tudor successor, Henry VII. The second Earl Rivers, Edward IV's brother-in-law, was his first author: his *Dictes or Sayengis of the Philosophres*, the first book to be published on English soil, left Caxton's press on 18 November 1477. In the same year he brought out an *Ordinale Sarum* which is worth mentioning because it was accompanied by the first advertisement in the history of English publishing – a handbill addressed to 'ony man spirituel or temporel' who might be interested in acquiring 'good chepe' a 'wel and truly correct' edition of the festival calendar according to the use of Salisbury. But Caxton's real importance lies in the fact that among the 90-odd books printed by him, 74 were books

no drede ne fere no thynge / For I shalle not accuse the / For I
shalle shelve to hym another way / And as the hunter came /
he demaunded of the sheepherd yf he had sene the wulf pas=
se / And the sheepherd both with the heed and of the eyen she=
wed to the hunter the place where the wulf was / & with the
hand and the tongue shewed alle the contrarye / And in=
contynent the hunter vnderstood hym wel / But the wulf
whiche perceyued wel alle the fayned maners of the sheepherd
fledd alwey / ⸿ And within a lytyll whyle after the sheepherd
encountred and mette with the wulf / to whome he sayd / paye
me of that I haue kepte the secrete / ⸿ And thenne the wulf
answerd to hym in this manere / I thanke thyn handes and
thy tongue / and not thyn hede ne thyn eyen / For by them I
shold haue ben bytrayed / yf I had not fledde alwey / ⸿ And
therfore men must not truste in hym that hath two faces and
two tongues / for suche folke is lyke and semblable to the scor=
pion / the whiche enoynteth with his tongue / and prycketh sor=
e with his taylle

Aesop's Fables, translated into English and printed by
William Caxton in Westminster, 1483

in English. Some 20 of them were in the publisher's own translations which, together with the prologues and epilogues which he contributed to his other publications, secure Caxton a lasting place in the history of English prose writing. Caxton's selection of titles shows him the good business man he was. They comprise chivalrous romances such as the heroic deeds of the 'good crysten man' Eracles and the conquest of the Holy Land by Godfrey of Boloyne (1481), handbooks of moral and social education such as *The Doctrinal of Sapience* (1489) and *Aesop's Fables*, classical authors such as Cicero and Virgil's *Eneydos* (from a French paraphrase), a popular encyclopedia, *The Myrrour of the Worlde* (1481, reprinted 1490), English and universal histories, *Brut* (1480) and Higden's *Polychronicon* (1482) – in short, books that strongly appealed to the English upper classes at the end of the fifteenth century. However, while all these contemporary favourites have been forgotten, it is to the immortal credit of this public and its publisher that Caxton also printed and English society bought the *editiones principes* of the greatest glories of English medieval literature: Chaucer's *Canterbury Tales* (the first edition (1478) was soon followed by a second (1484), and Caxton's immediate successors had to satisfy further demands in 1492, 1495, and 1498), *Parliament of Foules*, *Hous of Fame*, *Boece*, *Troilus and Cryseide*; John Gower's *Confessio Amantis* (1483); several poems of John Lydgate's, and Sir Thomas Malory's *Le Morte Darthur* (1485).

After Caxton's death his business went to his assistant Wynkyn de Worde, a native of Wörth in Alsace. He excelled in quantity rather than quality, for by 1535, the year of his death, he had published about 800 items. His two best books owe everything to Caxton – the English translation of the *Golden Legend*, which came out in 1493, and two reissues of the *Canterbury Tales*. However, about two-fifths of Wynkyn's output was intended for the use of grammar-school boys. These books do not only include the well-worn grammars by and after Donatus and John Garland but also the then most up-to-date reformers of the school curriculum, such as Colet,

se prouynce by the whiche the
worlde is generally departyd
somwhat shal be shortly sette
to this werke by helpe of oure
lorde. but not of al. but oonly
of suche as holy wrytte ma /
kyth remembraunce.

Incipit liber. xv. de prouinci/
is. Capitulū Primum

Prologus

The worlde wide is depar
ted iŋ thre as Psider sa/
yth li? xv? / for one part
hight Asia. a nother Eu
ropa. the thyrde Affrica/
Thise thre partes of the
worlde were assygnyd lyke moche iŋ ol
de tyme by men/ for Asia stretchyth out
of ꝗ south by ꝗ eest vnto the northe/And
Europa oute of the northe vnto ꝗ west/

Bartholomaeus Anglicus, *De proprietatibus rerum*,
a thirteenth-century encyclopedia, printed by
Wynkyn de Worde in Westminster, 1495

Erasmus, and William Lily. Wynkyn de Worde may justly be called the first publisher who actually made the schoolbook department the financial basis of his business.

In 1500 Wynkyn moved to the City of London where other printers were already at work. One of them, Guillaume Faques, who overcame the disadvantage of French origin by changing his name to William Fawkes, was appointed *regius impressor* to King Henry VII in 1503. By royal command he printed 'in celeberrima urbe London, 1504' a beautiful *Psalterium*, a devotional book which, however, could not compete with the immensely popular *Horae ad usum Sarum*. Some 250 issues of the latter are recorded between Caxton's edition of *c.* 1477 and 1558, after which it was superseded by the *Book of Common Prayer*. Fawkes was succeeded as royal printer in 1508 by Richard Pynson, a Norman by birth. He had started printing in London in 1490 and remained in business until his death in 1530. During these years Pynson published some 400 books, technically and typographically the best of the English incunabula. They include the *Canterbury Tales* and much popular reading matter in English as well as his finest efforts – a *Horae* (1495) and three Missals (1501, 1504, 1512) *ad usum Sarum*. But Pynson's main publishing interest lay in the legal sphere. He obtained a virtual monopoly of law codes and legal handbooks for the use of professional lawyers as well as laymen such as justices of the peace and lords of the manor.

Pynson also printed Henry VIII's learned *Assertio septem sacramentorum adversus Martinum Lutherum* (1521) which Leo X honoured with the bestowal of the title of *Fidei Defensor* upon the royal author and his successors *in perpetuum*.

Between them, Wynkyn de Worde and Richard Pynson published about two-thirds of all books for the English market from 1500 to 1530; of the remainder, local rivals and foreign presses had an almost equal share, but from 1520 onwards English printers began to make headway against both the two London giants and foreign competitors.

It was probably due to Henry's theological upbringing that

He shal no gospel glose here ne teche
We leue al in the grete god quod he
He wolde sowe som difficultye
Or sprynten cokyl in oure clene corn
And therfore hoost I warne the biforn
My ioly body shal a tale telle
And I shalle clynke you a ioly belle
That it shal wakyn alle this company
But it shal nat be of philosophy
Ne of physlias ne termes queynte of lawe
There is but lytel latyn in my mawe

Here endith the squyers prologue
And here begynneth his Tale

a T surrye in the londe of Tartary
There duelled a kyng that warred russy
Throught whiche ther dyed many a doughty man

Chaucer, *Canterbury Tales*, third printed edition, published by
Richard Pynson in London, 1492

he was violently opposed to English translations of the Scriptures. Thus it came about that all the earliest English Bibles were printed abroad. Tindale's rendering of the New Testament appeared in Cologne, Worms, and Mainz (incidentally from the presses of the stout Catholics, Quentell and Schöffer), that of the hexateuch in Antwerp. The first complete Bible in English, by Miles Coverdale, came out in Antwerp (1536); its revised edition would have been published in Paris, had not the French Inquisition intervened and forced the printer to flee across the Channel. The Great Bible, as it came to be called, was thus finished in London in 1539 after Thomas Cromwell had succeeded in acquiring the Paris press and matrices. Seven editions were called for within two years. Owing to the King's vacillating policy, its printer, Richard Grafton, was thus actually commissioned by Henry to publish a work for which, only two and a half years earlier, Tindale had been burned at the stake.

In 1543 Richard Grafton and Edward Whitchurch were given the royal privilege to print all service books for use in the King's realm. Two years earlier and again in 1543 Whitchurch had produced the first Anglican breviary, *Portiforium secundum usum Sarum . . . in quo nomen romano pontifici falso ascriptum omittitur*. Henry's privilege is of special interest in that it mentions for the first time the importance of the book-trade for the 'balance of payment' of the country in addition to its potential political use which other sovereigns had already recognized. The first English Act of Parliament to concern itself with printed books had in 1484 expressly exempted the printer, bookseller, illuminator, etc. 'of what nation or country he be' from the restrictions imposed upon foreign labour; this enlightened view was very likely due to the personal interest of King Richard III and the men of his court and council. This Act was repealed in 1534 when foreign 'prynters and bynders of bokes' were excluded from selling books in England. Now, in 1543, the official draftsman of the royal privilege made Henry say: 'In tymes past it has been usually accustomed that theis bookes of divine service . . .

have been printed by strangiers in other and strange countreys, partly to the great loss and hindrance of our subjectes who both have the sufficient arte, feate and treade of printing and by imprinting such bookes myght profitably and to thuse of the commonwealth be set on worke.'

This privilege obliged the printers, whatever their personal opinions may have been, to print all the divergent and mutually exclusive service books which the changing policy of successive governments required them to publish – just as the present-day managers of Her Majesty's Stationery Office issue with impartiality command papers which advocate and those which repeal, say, the nationalization of iron and steel. Likewise the names of Grafton (d. 1572) and Whitchurch (d. 1562) appear indifferently on Henry VIII's catholic *Primer* and Edward VI's protestant *Prymer*, on Edward VI's compromising *Order of Communion* and on the English translation of Calvin's radical *Forme of common praiers*, on the two Edwardian as well as the Elizabethan *Booke of common prayer*. They would probably have printed also for Queen Mary I had not Grafton published the proclamation of accession for Lady Jane Grey in July 1553. Mary showed herself not at all 'bloody' on this occasion: Grafton escaped with a few weeks' imprisonment, a fine, and the deprivation of his title as the Queen's Printer. He even entered Parliament, first for the City of London and later for Coventry.

In the next century one Henry Hills even managed to be successively printer to the army, the Anabaptists, the Lord Protector, the Rump Parliament, King Charles II, and King James II, and tried to suppress the Oxford University Press.

Queen Mary's reign marks a turning point in the history of the English book-trade. In 1557 the printer-publishers, organized since the beginning of the sixteenth century in the Stationers' Company (formed originally as a guild of text letter-writers in 1403), received a royal charter, partly for the better tracking down and punishment of producers and purveyors of heretical writings. The Company was soon to become an all-powerful executive organ which, while it lasted,

effectively stifled the free development of the English book-trade.

In view of the unique role which the two English University Presses have come to play in the academic life of this country and beyond, it is rather amazing to see how slowly both Oxford and Cambridge grasped the potentialities inherent in Gutenberg's invention. It is characteristic that, in contrast with London, the first presses in either town were established by Germans. In Oxford, Deitrich Rode (Theoderich Rood) of Cologne between 1478 and 1486 printed seventeen undistinguished books, mostly writings of the schoolmen, with Cicero's *Pro Milone* (1486) as the first classical author published in England – and this in the place which had enjoyed the humanist patronage of 'good Duke Humphrey'. Considering the meticulous care which the Oxford University Press now bestows upon its productions, the 'imp who supplies the misprints' – the *Druckfehlerteufel* in German printers' parlance – must have enjoyed himself when he dropped an x out of the date of the colophon in Rood's first book. The reading MCCCClxviii instead of the correct MCCCClxxviii has provoked some learned controversy among bibliographers.

Cambridge even lagged forty years behind Oxford. John Lair, or John Siberch as he called himself after his place of birth, Siegburg near Cologne, arrived in Cambridge in 1519, and by the time he left early in 1523 he had produced only ten small books and an indulgence. His modest importance rests on his being the first to have Greek types in this country, although the *primus utriusque linguae in Anglia impressor*, as he styled himself, printed no books in Greek. In 1534 Cambridge secured a charter from Henry VIII which authorized the Chancellor or his deputies to appoint three 'stationers and printers' who might produce and sell books approved by the university. But for a long time these printers remained mere licensees before they became university printers in the proper sense.

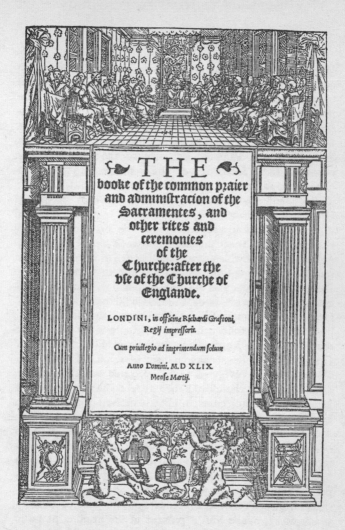

THE
booke of the common praier
and administracion of the
Sacramentes, and
other rites and
ceremonies
of the
Churche: after the
vse of the Churche of
Englande.

LONDINI, in officina Richardi Graftoni,
Regij impressoris.

Cum priuilegio ad imprimendum solum

Anno Domini. M.D.XLIX.
Mense Martij.

First edition of Edward VI's *Booke of the Common praier*, printed by
Richard Grafton in London, 1549

III

GREEK AND HEBREW PRINTING

When about 1490 Aldus Manutius decided upon making the editing of Greek authors the mainstay of his business, his first problem was the creation of a fount of Greek letters. The frequent occurrence of Greek words in Cicero's correspondence had right from the beginning caused printers to add Greek letters to their founts, as did Peter Schöffer and Sweynheym and Pannartz as early as 1465. They usually employed Latin letters for all those which are identical in appearance in both languages, such as A, B, E, H, O, P, C, T, X, Y, and only had special punches made for specifically Greek letters such as Δ, Θ, Φ. Jenson, in 1471, used a Greek type as noble as his roman fount. The first book printed entirely in Greek was Constantine Lascaris's EPΩTHMATA, a Greek grammar which came out in Milan in 1476, and Milan remained for some time the main centre of Greek printing. Demetrius Chalcondylas of Crete, who had written the (Latin) preface to Lascaris's book, himself edited the first printed Greek text of Homer; dedicated to Lorenzo de' Medici, it was published in two folio volumes in Florence in 1488-9. Before that date Erhard Ratdolt had already included a full set of Greek letters in his specimen sheet of 1486. All these early designers tried to evolve a Greek type that would match the Latin founts and therefore aimed at reproducing calligraphic forms which, in both cases, ultimately derived from epigraphic lettering. The beautiful, stately, and clear Alcalá type in which Arnão Guillén de Brocar in 1514 printed the Greek portions of Cardinal Ximenes's Polyglot Bible, is the greatest achievement of this school of type-design. It was modelled upon a manuscript which Pope Leo X had put at the cardinal's disposal expressly for this purpose.

Unfortunately, Aldus's predilection for cursive letters – which was to make him a pioneer in the printing of Latin texts – led him to commission Greek founts which made fine printing of Greek texts a virtual impossibility. Instead of

adopting or adapting the serviceable Greek fount cut by the Venetian printer, Giovanni Rosso, in 1492, Aldus chose as the model for his Greek type the informal, everyday hand of his contemporary Greek scholar-friends, a careless and ugly script, made even less legible through its numberless contractions and ligatures (the only feature of the Aldine Greek which was later abandoned). It was, it is true, convenient for the penman but for that very reason lacked the clearness, discipline, and impersonality which are the hall-marks of any type that aspires to be generally applicable.

From Aldus's press there were issued the *editiones principes* of Musaeus, Theocritus, Hesiod (1495), Aristotle (1495–8), Aristophanes (1498), Thucydides, Herodotus, Sophocles (1502), Plato (1513), and some twenty more which have kept alive Aldus's fame among scholars, if not typographers.

The unfortunate precedent set by Aldus was made a permanent feature of Greek printing when Claude Garamond accepted Aldus's principles for the founts which he cut at the behest of King François I of France. For the Complutensian Greek face found no favour elsewhere, probably because its width was too large for economic commercial productions. Thus the field was left to Garamond's *grecs du roi* until quite recently Robert Proctor, Victor Scholderer, Jan van Krimpen, W. A. Dwiggins, and Hermann Zapf produced Greek sets which are equal to the best Latin founts.

The three sets of *grecs du roi* remained the property of the crown and after some vicissitudes eventually found their place in the Imprimerie Nationale; but matrices were put at the disposal of printers on condition that the books thus printed bore the note '*typis regis*'. Typographically – that is, 'for evenness of colour, for precision of casting, and for the exactness of alignment and justification' – the *grecs du roi* constitute a huge advance over Aldus's types, but Robert Proctor's praise as 'by far the best type of its kind that has ever been cut' seems extravagant. For Garamond, too, used as his model a contemporary Greek hand which, if anything, contained even more contractions and ligatures than the one that served the

Venetian cutter. The calligrapher who drew the designs, Angelos Vergetios of Crete, received the title of professor from the king. Robert Estienne was the first printer to be permitted the use of the *grecs du roi*. Four books by Eusebius (1544–6) and three editions of the New Testament (1546–50) propagated the three founts, all of which were used together in Estienne's edition of Appian (1551). Curiously, Estienne was appointed *imprimeur & libraire ès lettres hebraiques & latines* (1539), whereas the title of royal printer for Greek was bestowed, together with his naturalization, upon one Conrad Neobar of Cologne. After Neobar's death in 1540, Robert Estienne called himself *typographus regius* without further qualification.

Italy was also the birthplace of Hebrew typography. It is most likely that Jewish scholars, craftsmen, and financiers were at once alive to the intellectual and commercial possibilities inherent in the new invention. As German printers turned up for shorter or longer periods in dozens of Italian towns and townlets, Jews, who were to be found all over the peninsula, must have had ample opportunities of closely watching them at work. The first books in Hebrew characters appeared from 1475 onward in a number of places. Abraham ben Garton of Reggio di Calabria and Meshullam of Pieve di Sacco were the Hebrew proto-typographers; in 1475 the former printed a commentary on the Pentateuch, and the latter a Jewish law code. Mantua, Ferrara, Bologna, and Soncino were the next places from which Hebrew books emanated. Among them the village of Soncino near Cremona has gained special fame thanks to the printers' dynasty which took their family name from it. The Soncino family originally came from Germany (Speier in the Palatinate or Fürth near Nürnberg). Israel (d. 1489) took to printing after his banking business had failed. His son Joshua set up a press in Naples but died as early as 1492. His younger son, Gerson, was to become 'the greatest Jewish printer the world has ever known'. As restless as the majority of the early printers, he moved to Brescia, Barco, Fano, Pesaro, Ortona, Rimini, spent some time in France, and finally left for Turkey in 1527. There he

ΑΠΠΙΑΝΟΥ ΑΛΕΞΑΝΔΡΕΩΣ ΡΩΜΑΙ-
ΚΩΝ ΚΕΛΤΙΚΗ.

ΚΕΛΤΟΙ Ρωμαίοις ἐπεχείρησε, ϗ τὴν Ρώ-
μην εἷλον ὅλην τῆς Καπιτωλίῳ, ϗ ἐμπεπρήκασι. Κά-
μιλλος δ᾽ αὐτοὺς ἐνίκησε, ϗ ἐξήλασε, ϗ μετ᾽ χρόνοις ἐ-
πελθόντας αὖθις ἐνίκησε, ϗ ἐθριάμβευσεν ἀπ᾽ αὐ-
τῶν, ὀγδοήκοντα γεγονὼς ἔτη. ϗ τρίτῃ δὲ Κελτῶν
στρατιᾷ ἐμβεβληκεν εἰς τὴν Ἰταλίαν ἰὼ καὶ αὐτὴν
οἱ Ρωμαῖοι διεφθάρκασι, ὑφ᾽ ἡγεμόνι Τίτῳ Κοΐντῳ.
μετ᾽ δὲ ταῦτα Βοΐοι, Κελτικὸν ἔθνος θηελαοδέσατον ἐ-
πῆλθε Ρωμαίοις, ϗ αὐτοῖς Γάϊος Συλπίκιος δικτά-
τωρ μετ᾽ στρατιᾶς ἀπήντα, ὅς ϗ στρατηγήματι τοιούτῳ χρήσασθαι λέγεται· ἐ-
κέλευσε γὰρ τοὺς ἐπὶ τῷ μετώπου τεταγμένους ἐξακοντίσαντας ὁμοῦ συλκαβήσαι
τοὺς λόγχας, μέχρι βάλωσιν οἱ δεύτεροι, ϗ τρίτοι ϗ τέταρτοι· τοὺς δ᾽ ἀφιέντας ἀεὶ σχω-
ζειν, ἵνα μὴ κατ᾽ αὐτῶν ἐνεχθείη τὰ δόρατα· βαλόντων δὲ τὴν ὑπάτων, ἀναπηδᾶν
τοὺς ὁμοῦ, ϗ σὺν βοῇ πάντας εἰς χεῖρας ἰέναι· καταπλήξειν γὰρ ὧδε τοὺς πολε-
μίους τοῦ τῶν δοράτων ἄφεσιν, ϗ ἐπ᾽ αὐτῇ τὴν γιλίαν ἐπιχείρησιν. τὰ δὲ δόρατα τὰ
οὐκ ἐοίκοτα ἀκοντία, ἃ Ρωμαῖοι καλοῦσιν ὑσσοὺς, ξύλου τεταγμένου τὸ ἥμισυ, ϗ τὸ
ἄλλο σιδήρου τετραγώνου, ϗ τόδε ϗ μαλακοῦ, χωρὶς γε τῆς αἰχμῆς. ϗ οἱ Βοΐοι
οὖν ὑπὸ Ρωμαίων ὅτε ἐφθάρησαν πορυστρατιᾷ. αὖθις δὲ πάλιν Κελτικῆς ἐνίκησε
Ποπίλιος, ϗ μετ᾽ ἐκεῖνον τοὺς αὐτοὺς Κάμιλλος ὁ τοῦ Καμίλλου υἱός. ἔφησε δ᾽ ϗ τ
Κελτῶν ϗ Παῦλος Αἰμίλιος ἔξητατα. μετὰ δὲ τ τοῦ Μασίου ὑπατείαν, πλεῖστόν
τε ϗ μαχιμώτατον, τῇ τε ἡλικίᾳ μάλιστα φοβερώτατον χρῆμα Κελτῶν εἰς τὴν
Ἰταλίαν ϗ τὴν Γαλατίαν εἰσέβαλε, ϗ τινὰς ὑπάτους Ρωμαίων ἐνίκησε, ϗ στρα-
τόπεδα κατέκοψεν, ἐφ᾽ οἷς ὁ Μασιος ἀποσταλεὶς, ἀπάντας διέφθηρε. τελευταία δὲ
ϗ μέγιστα ἰὼ ἐς Γαλάτας Ρωμαίοις πεπραγμένων ὅτι τὰ ὑπὸ Γάϊῳ Καίσαρι
στρατηγοῦντι γενόμενα. μυριάσι τε γὰρ δισδώδεκα ἀγέλων, ἐν τοῖς δέκα ἔτεσιν ἐν οἷς
ἐστρατήγησεν, ἐς χεῖρας ἦλθον· εἴτις ὑφ᾽ ἓν τὰ μέρη συναγάγοι, τετρακοσίων πλείο-
σι· ϗ τούτων ἑκατὸν μὲν ἐζώγρησεν, ἑκατὸν δὲ ἐν τῷ πόνῳ κατέκανον, ἔθνη δὲ τε-
τράκόσια, ϗ πόλεις ὑπὲρ ὀκτακοσίας ἰὼ μὴ ἀφιστάμενα σφῶν, τὰ δὲ τεσεπι-
λαμβάνοντες ἐκρατῶσαν. μετὰ δὲ τ Μαρίου ϗ Φαβίου Μαξίμου ὁ Αἰμιλια-
νὸς ὀλίγην κομιδῇ στρατιὰν ἔχων ἐπολέμησε ταῖς Κελταῖς, ϗ δώδεκα μυριάδας
αὐτῶν ἐν μιᾷ μάχῃ κατέκτεινε, πεντεκαίδεκα μόνοις τῶν ἰδίων ἀποβαλών. ϗ ταῦτα
μὲν εἴργασα τε ἔπραξε πιεζόμενος ὑπὸ τραυμάτων, ὑπουργίᾳ, ϗ τὰ σώματα ὁπλῶν, ϗ
ἐπαθαρρύνων, ϗ διδάσκων ὅπως τοῖς βαρβάροις πολεμητέον, τῷ μὴ ἐπ᾽ ἀπη-

Appian's *Roman History* (chapter on the Kelts), printed with
Garamond's *grecs du roi* by Charles Estienne in Paris, 1551

printed at Constantinople and eventually Salonika where he died in 1534. Gerson's descendants continued to print in the Ottoman empire and are last heard of in Cairo in 1562–6.

The Soncinos issued some 130 books in Hebrew founts. In addition Gerson also printed in the vernacular; for his edition of Petrarch's poems (1503) he used types cut by Francesco Griffo of Venice. Gerson was driven out of business in Italy by the competition of a Venetian printer. This man, Daniel Bomberg, a Christian business man of German descent, obtained from the Senate a privilege for printing Hebrew books (1515–49), and to the end of the sixteenth century Hebrew printing in Venice remained in Christian hands.

'The most prolific cutter of Hebrew types' was also a gentile. Guillaume Le Bé (1525–98), a Frenchman from Troyes, learned the trade in Robert Estienne's type-foundry. In 1545 he went to Venice and there he cut no fewer than eight Hebrew founts for two Christian printers during the next four years, in addition to Greek and Roman punches. Back in France, he supplied more Hebrew founts to Garamond and Plantin.

Thereafter, Hebrew typography went from bad to worse, with the exception of the founts designed by Christopher van Dyck and those used by the Jewish printer, Joseph Athias of Amsterdam (d. 1691), who bought the amalgamated foundry of van Dyck and Daniel Elzevir after the latter's death (1680). Only quite recently the Monotype Corporation has brought out some types which go back to the Reggio and Soncino models. An interesting suggestion was put forth in 1932 by Hugh Schonfield: a romanized Hebrew, adapting Caslon and Bodoni and including caps, small caps, lower case, and italic founts which so far have been absent from Hebrew printing. But this idea has been turned down by the typographical advisers of the presses now flourishing in Israel. However, the Jerusalem Type Foundry is working successfully for a renaissance of Hebrew typography; a face cut for it by Eric Gill in 1937 for the first time adds serifs to Hebrew letters.

5. PRINTING IN THE VERNACULAR

THE effect of the spread of printing upon the intellectual conditions of the European nations resulted in the simultaneous strengthening of two diametrically opposed trends of thought. On the one hand, the ties which linked up the individual members of the European commonwealth of nations were strengthened. The thoughts of philosophers, the discoveries of scientists, the writings of poets, and many other products of the human mind now swiftly became common property and were soon to be the precious heritage of all nations regardless of their national and personal origin. The medieval conception of the *Respublica Christiana* was dying when Gutenberg made his invention; the printer's craft resuscitated it in the form of the *Respublica Litterarum* in which every nation exerts its proportionate influence.

On the other hand, the spread of printing tended to deepen, and even created, national frontiers in the sphere of intellectual activities. For the more the circle of readers widened, the less authors and publishers could rely upon their mastering Latin, the common vehicle of communication in the Middle Ages. The public who were now given an easy access to literature wished it to be made easier still and preferred books printed in their mother tongue to those in the idiom of scholars.

'Scholars' here includes schoolboys. It was not only Cicero, Livy, Virgil, Horace, and the rest of present-day school authors who were read in sixteenth-century grammar schools. Italian masters, it is true, believed in the superior virtue of a strictly 'classical' curriculum. But in Spain, France, the Low Countries, and Germany there were educationists who preferred medieval Christian authors whose style could pass muster, to the ancient pagans whose morals could not. The versification in hexameters of the Gospel according to St Matthew by the fourth-century Spaniard Juvencus was printed ten times before 1519. Of the poems of his greater

contemporary and compatriot Prudentius some twenty editions appeared between 1497 and 1540. Their places of publication were the main seats of a decidedly Christian humanism: Deventer, Zwolle, Leipzig, Salamanca, Paris, Antwerp, Vienna; but centres of a more secular outlook, such as Nürnberg, Lyon, and Rouen, are also represented. Erasmus's insistence on Cicero's latinity as the sole standard of purity eventually eliminated these and similar authors from the school curricula. This, however, did not damp the enthusiasm of the Holoferneses for the imitations of Virgil's *Eclogues* by the Carmelite general Battista Mantovano (1448–1516): 'Ah, good old Mantuan! Who understandeth thee not, loves thee not.' Knowledge – perhaps not invariably matched by love – of Mantovano's poems is sufficiently attested by more than 300 editions published between their first appearance in 1488 and Shakespeare's schooldays.

The numbers of titles printed in Latin and the vernaculars is in itself no absolute yardstick as, at least from the beginning of the sixteenth century onward, editions of Latin texts tended to become proportionally smaller. Even so, the change of the ratio of books tells its own story. Before 1500, about three-quarters of all printed matter was in Latin, about one-twelfth each in Italian and German. Only in England and Spain vernacular books outnumbered Latin ones from the beginning. The proportion of Latin and German titles sold at the Frankfurt and Leipzig book fairs was 71:29 in 1650, 38:62 in 1700, 28:72 in 1740 and 4:96 in 1800. Publishers in university towns held out longer: in 1700 Jena still produced 58 per cent books in Latin and Tübingen even 80 per cent; whereas, at the same date, the mercantile town of Hamburg listed only 37 per cent of books in Latin.

The first books printed in the vernacular are therefore of special interest, as they permit an estimate of the taste of the class which had no Latin but was capable of reading and affluent enough to buy reading matter. The list of vernacular books in German is headed by Ulrich Boner's *Edelstein* and Johann von Tepl's *Ackermann aus Böhmen*, both published

by Albrecht Pfister in Bamberg in 1461. Both are moralizing fables of considerable literary merit, the former written in 1349, the latter in 1405; they have continued to appeal, the one to rationalist, the other to pious readers of later ages. These were followed in 1466 by the first Bible in German translation, published by Johann Mentelin in Strasbourg. A Bible translation heads the list of books in Italian – or rather two, both of which appeared in Venice in 1471. This incidentally shows how quickly competition was growing. Two years later a printer in Parma apologized for the careless printing of a book: because other printers were bringing out the same text, he says, he had to rush his book through the press 'more quickly than asparagus could be cooked'. The *editio princeps* of Dante's *Divine Comedy*, published by Johann Neumeister in Foligno in 1472, has already been mentioned. An Italian-German dictionary, printed by Adam of Rottweil at Venice in 1477, is remarkable as the first dictionary of two living languages. The Latin-German editions of Aesop by Johann Zainer in Ulm (1476–7) and of Cato by Johann Bämler in Augsburg (1492) are among the earliest bilingual texts.

The French and Danish languages appeared first in print in national chronicles, the *Croniques de France* (Paris, 1477) and the *Danske Rym-Kronicke* (Copenhagen, 1495) and the first book in modern Greek was appropriately the immortal Greek epic, a translation of Homer's *Iliad* (Venice, 1526).

Geneva, otherwise of little importance in the early history of printing, is remarkable, though, for the high percentage – about one-third – of vernacular books among its incunabula. The first four books, printed in the same year, 1478, by the Genevan proto-typographer Adam Steinschaber, a graduate of Erfurt university, are all in French: two theological books translated from the Catalan and Latin, and two French romances. Romances remained popular with Genevan printers and, no doubt, their customers; they probably included the first appearance in print of the *Roman de la Rose* (about 1480).

In the development of vernacular printing England again

occupied a unique position in European letters as had been its happy lot in Anglo-Saxon times. Just as from the seventh to the twelfth centuries England was the only country in western Christendom which kept its language alive in poetry and prose while the Continent was submerged by Latin, England entered upon the era of printing with a wealth of books in the English tongue. The mantle of King Alfred fell on William Caxton's shoulders. More than four-fifths of Caxton's books were in the English tongue, either original works or translations. The next generation of English printers continued in this vein, with the result that the victory of English over Latin as the most popular medium of printed literature was assured from the very beginning.

In England, as everywhere else, the printing press has preserved and codified, sometimes even created, the vernacular; with numerically small and economically weak peoples its absence has demonstrably led to its disappearance or, at least, its exclusion from the realm of literature. The survival of Welsh is largely due to the fact that from 1546 books were printed in Cymric. The first Welsh book, a collection of prayers known by its incipit as *Yny Lhyvyr hwnn* ('in this book'), was printed in London by Edward Whitchurch, probably commissioned by the Welsh antiquary, Sir John Price. The first Welsh text printed in the Principality was a Roman Catholic tract, *Y Drych Cristianogawl* (The Christian Mirror), printed clandestinely in Rhiwledyn near Llandudno in 1586–7. But the fact that Welsh has to this day remained the only Celtic language with a living literature equal to that of any other nation is largely due to the magnificent Bible translation of Bishop William Morgan (1588). Combining the rich and flexible vocabulary of bardic poetry with the majestic rhythms of Jerome's Vulgate and the Geneva Bible, Morgan set up a standard which has determined the course of Welsh prose as Luther's Bible and the Authorized Version did for German and English literatures.

At the same period and also in connexion with the Elizabethan settlement of the national church, the Irish language

was drawn into the orbit of the printing press. In or before 1567 Queen Elizabeth I ordered the cutting of a special fount of Irish types for editions of the New Testament and the Anglican Catechism; but it was used first for the printing of an 'irishe balade' on the Day of Doom by a contemporary Irish bard of the Roman faith (1571). As has not infrequently happened with the English Government's activities in the affairs of Ireland, the result was very different from the intention. Far from converting the Irish to the English Church, the Gaelic characters became a powerful weapon against the English Church and State. Irish literature (and Irish tourism) would probably be better off without the encumbrance of a script which, though most decorative on postage stamps, raises an additional bar to its understanding; but there can be little doubt that here again type-founders and printers have done a permanent job in sustaining a national civilization. The opposite fate overcame Cornish, the next-of-kin of Welsh and Irish; it has become extinct for the lack of a printed literature.

The same applies to the Basque language; that curious relic of Old Iberian has been fixed in print since 1545 and thus got a fair chance of surviving despite the superiority of Spanish as a means of communication. The survival of the Catalan language too owes much to the fact that the first printing presses in the Iberian peninsula were set up in Catalonia. A collection of poems in honour of the Blessed Virgin (1474) and a Bible translation (1478) were the first books in the Catalan language. The Valencia Bible has suffered a tragic fate; it was burnt by the Inquisition for nationalistic rather than dogmatic reasons, and the one copy saved from the holocaust perished in 1697 when the royal library in Stockholm was damaged by fire. The Inquisition also suppressed the most beautiful Book of Hours from the press of Thielmann Kerver in Paris (1517) because the prayers to the Holy Virgin were printed in Spanish; only one copy is known to have survived.

Even in the Baltic and Balkan countries, where the economic and cultural foothold of Germany was strongest, the

main effect of printing was a national revival, first of the languages and later of the literatures of those peoples. The Lithuanian, Latvian, Estonian, and Finnish languages might in the course of the sixteenth century have been absorbed by German, Polish, and Swedish, as were the languages of the Prussians, Pomeranians, Courlanders, and other tribes before them, had they not been preserved in print. Estonian, Latvian, and Livonian translations of Lutheran writings, printed in Wittenberg, were shipped to Riga and Reval as early as 1525; a Lithuanian translation of Luther's Catechism was printed in Königsberg in 1547; Bishop Agricola's Finnish Primer, in Stockholm in 1542 – these were the first printed books in the respective languages. Although they were printed abroad – and printing in Finland, for instance, did not begin until 1642 – their very existence sufficed to form the basis of vernacular literatures in the Baltic languages, reaching international recognition in the award of the Nobel prize to the Finnish writer, Sillanpää (1939).

The fate of the languages spoken by the Germans in what used to be the fringes of the Holy Roman empire was also conditioned to a great extent by the printing press. The Netherlands, which formally seceded from the empire only in 1648, had established their Low Frankish dialect as a distinct 'Dutch' language when, after the early publication of an Old Testament in Dutch (Delft, 1477), in 1523 Luther's New Testament was translated and printed in Antwerp. Switzerland – until 1648, too, a nominal member state of the German empire – took a different road. The Zürich edition of the New Testament which came out in 1524 kept closely to Luther's text, only sparingly introducing a few Alemannic words and phrases. The great bulk of Swiss literature has followed this method ever since, so that attempts, made from time to time, to elevate 'Swiss German' to the rank of a literary language have met with no lasting success. The farthest outposts of German settlements in Europe – in Transylvania and the Baltic countries – which might have developed their own languages as easily as the Netherlands, remained entirely within

the orbit of the German language as they accepted Luther's Bible together with the Lutheran creed.

The foregoing examples have already shown the strong impact upon the spread of vernacular printing exercised by the Reformation. Bible translations, mostly following the Lutheran version, therefore play a conspicuous part in six-teenth-century vernacular book production. In Germany, up to 1517 – the year when Luther published his 95 theses – the yearly output of books in the German language averaged 40; in 1519, it was 111; in 1521, it reached 211; in 1522, 347; in 1525, 498. Of the last, 183 were publications by Luther him-self, 215 by other reformers, and 20 by opponents of the new faith, leaving about 80 vernacular books on secular subjects.

By 1500, 30 Bible translations had already been printed in vernacular versions (mostly in German), compared with 94 Latin editions of the Vulgate. After 1522 every European nation received the Scriptures in its mother tongue: the Netherlands in 1523 (N.T.) and 1525 (O.T.), England in 1524 (Tindale's N.T.) and 1535 (Coverdale's Bible), Denmark in 1524 (N.T.) and 1550, Sweden in 1526 (N.T.) and 1540-1, Iceland in 1540 (N.T.) and 1584, Hungary in 1541, Spain and Croatia in 1543, Finland in 1548-52, Poland in 1552-3, the Slovenes in 1557-82, the Rumanians in 1561-3, the Lithu-anians in 1579-90, the Czechs in 1579-93.

Having fortified the 'language walls' between one nation and another, the printers proceeded to break down the minor differences of speech – most noticeably of vocabulary, gram-matical forms, and syntax – within any given language group. If today the 'Queen's English' has become the standard idiom of millions of writers and readers, beside which the dialects of Kent, Lancashire, Northumberland and all the rest have vanished into local insignificance, William Caxton and his brothers-in-art may justly claim the credit for it. It was Caxton who overcame the perplexing confusion of Middle-English dialects, and, by adopting that of the Home Counties and London, fixed a standard never to be abandoned.

Caxton was very conscious of his service to a unified English

language. He reinforced his argument by the charming anecdote of the Kentish woman off North Foreland whom a London merchant asked for some 'eggys'. 'And the good wyfe answerde that she coude speke no frenshe.' It was only when another man asked for 'eyren' (cp. German 'Eier') that she 'sayd she vnderstod hym wel'. Wynkyn de Worde continued this process. For his edition of Bartholomaeus Anglicus (1495) he used a manuscript written about fifty years earlier but he changed all words which did not conform to the standard speech Caxton had adopted. A comparison between the manuscript and the print shows that every one of Wynkyn's alterations has come to stay: *call* and *name* for *clepe*, *go* for *wend*, *two* for *twey*, *third* for *pridde*, etc. Wynkyn thus can put forward a modest claim to having inaugurated what we now call the house-style of a printing or publishing firm, which overrides the inconsistencies of individual authors.

The standardization of the English language through the effect of printing has led to a tremendous expansion of the vocabulary, a virtual ban on the development of accidence and syntax, and an ever-widening gulf between the spoken and the written word. Local and regional differences tend to be ironed out or suppressed; though a very large number of provincial words and phrases have conversely been raised to the national level. Sir Walter Scott, for instance, deemed it necessary to explain to his English readers such Scots terms as 'daft, dour, usquebaugh', which, largely through his own writings, have since become completely naturalized south of the Border. Within the past twenty or thirty years the growth of American literature and literary criticism – supported by the mass of not-so-literary magazines and, of course, film, wireless, and television – has introduced into standard English hundreds of 'Americanisms', a considerable part of them, in fact, good old English words which left these shores on the *Mayflower* and now return on the Monotype.

It is a matter for speculation whether the growing preponderance of American letters within the English-reading world may not thaw English accidence and syntax, which have vir-

tually become frozen since the early sixteenth century. For as soon as a printed grammar of sorts became available to every schoolboy – and Latin grammars and English primers were among the first books to pour forth from the presses – the idea got hold of the populace that there are fixed standards of 'right' and 'wrong'. The rules laid down by the author of a grammar or dictionary became binding and stopped the free development of the language – at least so far as its appearance in print is concerned.

The most remarkable, or at least the most visible, expression of the standardization of the English language through the egalitarianism of the press is to be seen in our modern spelling. Up to the invention of printing, spelling was largely phonetic; that is to say, every scribe rendered the words on parchment or paper more or less as he heard them (although monastic scriptoria and princely and municipal chancelleries strove after a certain uniformity within their orbits): the modern compositor sets them up as Horace Hart and Collins decree. Milton was one of the last authors who dared to force upon his printers the idiosyncrasies of his spelling, such as the distinction between emphatic *hee* and lightly spoken *he*.

However, this disadvantage is more than balanced by greater gains. The Queen's English, as fixed by William Caxton and his brothers-in-art, has become the common medium of expression and thought of millions of people all over the world. Every book or newspaper printed in the English language is immediately intelligible to the Cockney, the Canadian, and the Californian, and to every inhabitant of every Wellington, whether in British Columbia, Ontario, Cape Province, Shropshire, Somerset, New South Wales, New Zealand, South Australia, Western Australia, Kansas, Ohio, Texas – regardless of the variations of speech, local, regional, and national.

The same influence of the printed word can be observed in the development of the German and Italian languages. Whereas throughout the Middle Ages Low German and High German were two independent literary languages, the printers of Luther's Bible translation secured for 'Lutheran German' – a

skilful blend of High, Central, and Low German – the undisputed ascendancy of 'standard German' soon reducing all other forms to the status of dialects. The translation of Johannes Stumpf's Swiss History from its original 'Swiss German' into 'the language of the imperial and Saxon chancelleries', which Christoph Froschauer caused to be made for its publication in 1548, was a decisive step as the book enjoyed wide popularity throughout Switzerland.

The same thing happened in Italy. The Tuscan tongue as used in Annibale Caro's *Lettere familiari* (1572–5) and the *Vocabolario* of the Accademia della Crusca (1612) was adopted by all Italian printers and thus superseded the rival claims of the Roman, Neapolitian, Lombard, and other Italian dialects.

This general tendency towards standardization, however, has never satisfied the ardour of well-meaning spelling reformers. Their hankering after the unattainable goal of phonetic spelling and phonetic printing started early in the sixteenth century. Trissino, in 1524, recommended the addition of some Greek letters to the Latin alphabet in order to show the difference between open and closed vowels, such as o and ω. He was more successful in persuading the printers to adopt his very sensible suggestion that *i* and *u* should be used for vowels and *j* and *v* for consonants, as has since become the general custom.

In France, Robert Estienne established the use of the acute and grave accents and the apostrophe in the 1530s (e.g. *i'auray aimé* instead of the earlier *iauray aime*). French grammarians regret that he was not bolder in his innovations. But Estienne had the conservatism natural to a printer and distrusted modernizers such as Louis Meigret (1542), Jacques Peletier (1550), and Honorat Rambaud (1578), who proffered rival reforms of phonetic spellings. In England, Charles Butler's *History of the Bees* (Oxford, 1634) was the first book to repudiate Caxton.

The 'fundamental fallacy' of all spelling reformers, as Sir Alan Herbert once pointed out in Parliament, is 'that the function of the printed or written word was to represent the spoken

word. The true function surely of the printed or written word is to convey meaning, and to convey the same meaning to as many people as possible.'

All attempts at a thorough-going spelling reform are doomed to fail as their initiators neglect the most potent factor of conservatism, the printer. It may safely be prophesied that Horace Hart's *Rules for Compositors* will outlast the schemes and pamphlets of the Simplified Spelling Society. *The Times*, although it is spelt in the language as spoken by King Henry VIII, may be read and understood by millions of people whose pronunciation varies from Pidgin English, American, and Cockney to Broad Scots and the Queen's English.

───

6. PRINTER AND PUBLISHER

THE central figure of the early book-trade was the printer. He procured the services of an engraver to cut punches specially for him and had them cast at a local foundry; he chose the manuscripts he wished to print and edited them; he determined the number of copies to be printed; he sold them to his customers; and all the accounts went through his ledgers – if he kept any. And if he did not perform all these functions himself, it was he who had to raise the capital, who commissioned an editor, who organized the distribution through his own agents.

It is only the paper-makers and bookbinders who from the beginning to the present have kept their independence: their crafts went back to the times of the handwritten book, and their technical skill and experience were at the printers' disposal, saving these newcomers the need for capital outlay and costly experiments.

The situation has gradually changed towards making the publisher the life-force of the book-trade. He selects the author and the book – frequently originating and commissioning a particular subject; he chooses the printer and mostly even the

type and paper; he fixes the price of the books; and he organizes the channels of distribution. The printer, in fact, has, in the public eye, become a mere appendage of the publisher; not one in ten thousand readers of Penguin Books has probably ever looked at the imprint.

The difficulty of combining the functions of printer, editor, publisher, and bookseller was in itself formidable enough to cause a gradual separation – all the more as, even at the beginning, the personal inclinations of the individual must have made him concentrate on one or the other aspect of the business. Already Peter Schöffer, whose main interest was typographical, employed proof-readers, and one of them gratefully mentions their liberal remuneration. The three German printers who were invited by the Sorbonne in 1470 brought with them three German correctors, and a few years later the first British proof-reader, David Laux of Edinburgh, appears among these specialists in Paris. Johannes Froben neatly expressed the good publisher's concern for his public in the words: '*Qui librum mendis undique scatentem habet, certe non habet librum sed molestiam*' – the buyer of a book full of misprints does not really acquire a book but a nuisance. And his star author Erasmus's solicitude for faultless texts made him issue, in 1529, the first *Errata et Addenda* appendix. Aldus Manutius preceded him with the insertion of a slip in his Aristotle edition where a whole line had dropped out; but Erasmus filled 26 pages with about 180 corrections 'so that owners of his writings might rectify their books and printers of future editions could avail themselves of his emendations'.

Very early the idea must have recommended itself to form publishing companies in which authors or editors, business men and printers would pool their knowledge, money, and practical experience. The first two ventures of this kind are even more remarkable in that the partners envisaged a definite programme of publications. In Milan, in 1472, a priest, a schoolmaster, a professor, a lawyer, a doctor, and a printer formed such a publishing company. The participants were not just financing the printer but they constituted a policy-making

board which decided the selection of the books to be issued and fixed their prices.

An ambitious undertaking on similar lines was started in Perugia, in 1475. Jacob Langenbeck, son of the burgomaster of the Hanse town of Buxtehude and a professor of theology at the Sapienza Vecchia, conceived the idea of publishing the *editio princeps* of the *Corpus juris civilis*. For this purpose Langenbeck combined with a representative of the Baglioni, the ruling family of Perugia – and the reign of terror they exercised must have made such a reinsurance most desirable – a punch-cutter from Ulm, the printer Stephen Arndes from Hamburg, and the university bedel, a native of the Rhineland, who was to sell the firm's books to the professors and students. Langenbeck's brother Hermann, professor of civil law and vice-chancellor of Greifswald university, was to join the firm as editor. But when he arrived in Perugia Jacob had died and the ambitious enterprise petered out in bankruptcy and lawsuits, the *Digestum vetus* and the first part of the *Pandects* being the only tangible result. Two of the partners, however, were to get on very far: Dr Hermann Langenbeck became burgomaster of Hamburg (1482–1517) and, through his Maritime Law Code (1497) and commentary on the Hamburg Town Law, the creator of Hanseatic jurisprudence; and Stephen Arndes became the leading printer of the Low German and Danish world centred on Lübeck.

As the majority of the early printers were of humble station and small account, there is a scarcity of biographical information which hardly permits generalizations concerning their individual fortunes: but it would seem that only a few succeeded in making the book-trade a paying proposition. These few, however, who rose to an assured place in the commercial world, owed their prosperity, if not always their reputation with posterity, to their publishing activities rather than their typographical achievements.

The first man to make publishing (and bookselling) his exclusive occupation seems to have been Johann Rynmann who died at Augsburg in 1522. Of the nearly two hundred

books which appeared over his imprint, not one was produced by Rynmann himself; he had them printed in Augsburg, Basel, Hagenau, Nürnberg, Venice, and elsewhere, and 'the most famous and leading archibibliopola of the German nation' – according to his own valuation – confined himself to their stocking and selling.

Most of the early printers, including Gutenberg himself, seem to have been better printers than business men. Their lack of commercial success can be attributed to the fact that they did not realize the dominant dilemma of the publishing trade, namely the outlay of considerable capital in advance of each publication coupled with the slowness of the turnover, if any. And if they realized it, most of them, again including Gutenberg himself, were unable to supply the necessary capital. The few printer-publishers who were in a position to invest large sums, and to tide themselves over the waiting period, made good as is borne out by the firms of Schöffer, Amerbach-Froben, Manutius, and Koberger. But as a rule the printers had to secure their capital from outsiders, and this cooperation of artisan and financier easily led to the subsequent separation of printer and publisher. This development is reflected in the way in which the one and the other have been introducing themselves to the purchaser of their products.

The colophon was the first means by which the printer-publisher proclaimed his part in the technical process, secured his moral and legal rights – such as his rivals were prepared to acknowledge – in the commercial exploitation of the finished article, and vouchsafed any further information that might stimulate its sales. As the name implies, the colophon is the end-part or tail-piece of the book. It should therefore be applied only to statements which appear after the text, and its loose use for the publisher's name or device on the title-page is to be deprecated. Owing to the parting of the ways of printer and publisher, the present-day colophon in the true sense of the word has been reduced to the bare statement: 'Printed by A. Brown & Co. Ltd, Newton, Loamshire.' Even these lines are frequently shifted to the bottom of the back of

the title-page proper. The colophon might have disappeared altogether from English books if it were not enforced by law.

The early colophon fulfilled to some extent the function of a modern title-page, about which something will be said presently. It also contained material which would nowadays be restricted to the blurb or left to the discretion of the reviewers. A laudatory reference to the quality of the printer's work is very common, and the novelty and marvel of the art of printing is often stressed. Thus Gutenberg says of the *Catholicon* of 1460 that '*non calami stili aut penne suffragio, sed mira patronarum formarumque concordia proporcione et modulo, impressus atque confectus est*'.

In 1471, in the preface of one of the first books printed in France, the Paris professor, Guillaume Fichet, refers to '*Joannem cui cognomem Bonemontano, qui primus omnium impressoriam artem excogitaverit qua non calamo (ut prisci quidem illi) neque penna (ut nos fingimus) sed aereis litteris libri finguntur, et quidem expedite polite et pulchre.*'

The colophon which Arnold Pannartz added to his edition of Lorenzo Valla's *De elegantia linguae latinae* (1475) comprehends an advertisement in terms so modest that *The Times Educational Supplement* would not refuse it: 'Anyone who wants to master spoken Latin should buy this book for he will rapidly become efficient if he applies himself carefully and zealously to the task.' Other publishers tried to stimulate the sale of their publications by running down those of rival firms. Ulrich Han, in the colophon to his *Decretals* (1474), told the prospective buyer to 'acquire this book with a light heart' as he would find it so excellent that, by comparison, other editions 'are not worth a straw' (*floccipendes*).

Some, perhaps most, printers had the colophons composed by professional writers. Wendelin of Speier, for instance, employed the poet Rafael Zovenzoni of Trieste during the years 1471–3 who, with pride entirely unjustified, appended his name to these 'carmina'.

The spurious *Letters of Phalaris*, which in the last years of the seventeenth century created the famous controversy out

of which Richard Bentley emerged as the greatest classical scholar of the age, had long before gained notoriety in the history of English books. Its first edition, brought out by Theodore Rood of Cologne in Oxford in 1485, contains a colophon in verse for which the Oxford don who composed it may well claim the invention of the 'Buy British' slogan. With a fine disregard for truth, he boasts:

> *Quam Ienson Venetos docuit vir Gallicus artem*
> *Ingenio didicit terra britanna suo.*
> *Celatos Veneti nobis transmittere libros*
> *Cedite: nos aliis vendimus, O Veneti.*

(The art which the Venetians had to be taught by the Frenchman Jenson, Britain has learned by its native genius. Cease, ye Venetians, sending us any more books for now we sell them to others.)

Caxton's colophons are in a class by themselves. They often combine a genuine colophon with a dedication and all that a modern editor would put into a preface or postscript. They are in fact brilliant little essays on the text they follow, and as much part of English literature as of English printing.

Usually printed after the colophon, devices or printers' marks have also been used from the very beginning of printing. The identity of printer and publisher soon turned them also into publishers' devices. The purpose was the same: to serve as a hall-mark of quality, and to safeguard what later became known as copyright.

Heraldic propriety, artistic design, or striking inventiveness make many of the early printers' devices precious specimens of graphic art. Their importance is heightened when they appear together with, or in place of, a famous firm. Fust and Schöffer's well-known double-shield is in the tradition

of the trade-marks of medieval craftsmen, such as goldsmiths and masons. The heraldic devices of Spanish printers are among the most impressive. The serpent coiled round the cross (Melchior Lotter of Wittenberg) or a flowering branch (Robert Granjon of Lyon) were popular. Aldus Manutius's dolphin and anchor is perhaps most famous of all. The devices of the later sixteenth and the seventeenth century suffer from the baroque exuberance of the designers. That of the Stephanus press, for instance, which represents the tree of knowledge as interpreted by humanist philosophy, is an illustrated motto (and has actually been used as such in Emblem Books); it fails in the main purpose of a trade-mark, namely to be recognized at first glance.

Within two decades of the invention of printing, the printers had evolved the main forms of publicity which publishers have used ever since to advertise their production: the leaflet containing details about a book or a number of books published; the prospectus announcing intended publications; the poster to attract casual passers-by; and the list showing the stock of a publisher or bookseller. Again and again the historian is struck by the fact that all these various offshoots of Gutenberg's art sprang into existence full-grown and fully armed like Athena from Zeus's forehead.

When referring to the 'first' prospectus, catalogue, etc., we must keep in mind the parlous state of preservation of these ephemeral by-products of the printing press. The fact that most of these early specimens have survived in one copy only is eloquent in itself. Mentioning the first item only means the first extant piece, so that the date of its actual 'invention' may be even earlier.

Heinrich Eggestein of Strasbourg, otherwise known as the printer of the second German Bible translation, issued the earliest known advertisement in 1466. He was speedily followed by Peter Schöffer, Bertold Ruppel, Sweynheym and Pannartz, and by Mentelin about 1470, Caxton in 1477, Koberger, Ratdolt and others from about 1480 onwards. Schöffer's first advertisement already included 21 titles.

IL LIBRO DEL CORTEGIANO
DEL CONTE BALDESSAR
CASTIGLIONE,

Nuouamente riſtampato.

AL DVS

IN VENETIA, M. D. XLV.

Castiglione, *Cortegiano*, reprint of 1545, originally printed by
Aldus Manutius in Venice, 1528. Aldus's device, the anchor and dolphin,
first used in 1502 without the surrounding ornament, was adapted
from a sesterce of the emperor Vespasian, which
Cardinal Bembo presented to Aldus

Volētes sibi oparare infrascriptos libros magᵈ
cū diligētia correctos. ac in hmōi lra moguntīe
impssos. bñ ꝗnuatos. vemāt ad locū habitatio-
nis infrascriptū.

Primo pulcram bibliam in pergameno.
Item scdam scōe beati thome de aquino.
Item quartū scripti eusdē.
Itē tractatū eiusdē de ecclē sacris ꞇ articlis fidei.
Itē Augustīmū de doctrina xpiana. cum tabula
notabili pdicantibₒ multū pficua.
Itē tractatū de rōne et ꝯsciētia.
Itē mgrm iohānē gerson de custodia līngue.
Itē ꝯsolatoꝛiū timoeate ꝯscie venerabilis fratris
iohānis nider sacre theologie pfessoris eximij.
Itē tractatū eiusdē de ꝯtractibₒ mercatoꝛꝝ.
Itē bullā ꝑ ipᵐ sedi contra thurcos.
Itē historiā de psentacōe beate marie vᵍginis.
Itē canonē misse cū pfacōibₒ ꞇ ꝑparatoꝛis suis.

antiphomis in magna ac grossa littera.
Itē iohānē ianuensem in catholicon.
Itē sextumdecretaliū. Et clemētinā cum apparatu
iohantis andree.
Itē in iure ciuli. Institucōnes.
Itē arbores de ꝯsangͤnitate ꞇ affinitate.
Itē libros tullij de officijs. Cū eiusdē paradoxis.
Itē historiā griseldis. de maxia ꝯstātia mͬlieruͭ
Item historiam Leonardi aretini ex vocatio de a-
more Tancredi filie sigismūde in Guiscardum.

hec est littera psalterij

Peter Schöffer's first book list, 1470. The twenty-one titles include the
42-line Bible of 1462 (1), the *Catholicon* of 1460 (14), the *Canon Missae* of
1458 (12), three tracts by St Thomas Aquinas (2, 3, 4), two books by
St Augustine (5, 11), Justinian's *Institutiones* (17), Cicero's *De officiis* (19),
Petrarch's *Griseldis* (20), and Leonardo Aretino's *Tancred* (21)

Sweynheym and Pannartz, who showed 19 titles in 1470 and 28 in 1472, introduced the useful features of adding the prices of each book and the number of copies of each edition. The prices ranged from 16 groschen for Cicero's *De oratore* to 10 ducats for Thomas Aquinas's *Catena aurea* and 20 ducats for their 2-volume Bible; the editions comprised normally 275 and occasionally 300 copies.

The first publisher's catalogues to include the price of each item were those issued by Aldus Manutius in 1498 (of the first 15 of his Greek texts), 1503, and 1513.

Anton Sorg's catalogue of 36 books (1483–4) is the first to contain only vernacular, in this case German, titles. The publisher therefore took pains to explain to his prospective customers of non-academic standing what the advertised books were about and what profit or entertainment the readers would derive from them. Thus he recommends an Aesop as 'to be read for amusement, with pretty illustrations'; and a manual on letter-writing is called particularly useful as it also contains a section on how to address titled persons, a list of synonyms, and various stylistic 'colours', i.e. 'airs and graces'.

Schöffer seems to have been the first to emphasize that the advertised book was 'emprynted after the forme of this present lettre', as Caxton put it in the leaflet announcing his *Sarum ordinale*. Koberger combined on one leaflet the detailed propaganda for one book, Archbishop Antoninus of Florence's *Summa theologiae*, with a classified list of 22 other publications. Here the section Theology is headed by the latest publication, viz. Antoninus's *Summa*, 'ut supra claret'; it includes 'Biblias amenissime impressas'. In the section Sermones, which includes, somewhat oddly, 'Boecium de consolatione philosophiae', one item is praised as 'denuo correctum fideliterque impressum', or 'wel and truly correct' as Caxton says the same in English.

Koberger's advertisement contains virtually everything the publicity manager of a modern firm could think of. He starts with some general observations on the usefulness and pleasures afforded by the various branches of literature – learned mono-

graphs, books of general interest, fiction – lavishly supported by great names from Homer and Plato downwards, just as a pamphlet of the National Book League might open with a tribute to Chaucer and Shakespeare. Koberger then leads on to the supreme importance of theology among these assorted manifestations of the human mind, and the hardened modern reader will not be surprised to learn that among theological books the prize must go to the one which has fortunately just come out. This, so Koberger says, is not only the most comprehensive work of its kind, as can easily be perceived by the inserted summary of its contents – in fact so voluminous that no other publisher dared to handle it – but it is at the same time incredibly cheap, especially if you take into account the care bestowed on the scholarly impeccability of the text and the excellence of the presswork of which the leaflet is a fair specimen. And, as outside university towns there were hardly any bookshops, customers' convenience is also attended to. The travelling salesmen and agents of the publisher will display their stock at such and such a hostelry where customers are invited to inspect what they can ill afford not to buy.

Such, at greater or lesser length, is the tenor of these advertisements. They were printed either as handbills or as broadsheets. The latter were often in the form of posters and nailed to the doors of inns, churches, schools, colleges, and other places where they attracted attention. Caxton's bill therefore ends with the reasonable request, 'Please don't tear it off.'

These leaflets now usually go by the name of prospectus irrespective of their describing books already published or 'looking forward' to books to come. The latter or true prospectus made its first appearance in 1474 when the astronomer and mathematician Regiomontanus sent forth a list of Greek mathematical texts and other scientific books from his own press in Nürnberg. Regiomontanus told his customers exactly which books of his list were available (*explicita*), which in the press (*iam prope absoluta*), and which were in some state or other of preparation. This programme, however, did not advance very far, as Regiomontanus closed his press in the

Jf it plese ony man spirituel or temprel to bye ony pyes of two and thre comemoraciõs of salisburi vse enpryntid after the forme of this presét lettre whiche ben wel and truly correct, late hym come to westmonester in to the almonesrye at the reed pale and he shal haue them good chepe ⋰

Supplico stet cedula

William Caxton's poster advertising an *Ordinale Sarum*, c. 1477
(Unique copy in the Bodleian Library, Oxford)

following year when he was appointed bishop of Regensburg.

Some of these book lists incidentally show that, at an early date, the retail business was considered lucrative enough to become independent from a specific publishing and printing firm. Zainer, Koberger, and other publishers occasionally inserted in their lists some books which originated in presses other than their own; and there exists a list, printed at Memmingen about 1500, with some 200 titles of *libri venales Veneciis Nurenbergae et Basileae impressi*, that is to say, the magazine of a 'book-carrier' (as they were called) who was neither the printer nor the publisher of the wares he offered for sale. Twelve book-carriers appear as tax-payers in Augsburg between 1483 and 1500, and thirty book-carriers acquired citizenship in Leipzig between 1489 and 1530.

All these efforts to sell the book became regularized at the beginning of the second century of the printed book. In 1552 Robert Estienne in Paris and Johannes Oporinus in Basel, and in 1563 the Aldine Press in Venice issued catalogues of all their available books. It was – or so the Venetian publicity manager said – a response to inquiries from scholars and booksellers who wanted to make sure of obtaining genuine Aldines instead of inferior imitations.

7. EARLY BEST-SELLERS

THE criterion of popularity of medieval books is the number of manuscripts that have survived or are known to have existed. Wolfram von Eschenbach's *Parzival*, with more than eighty manuscripts, and Chaucer's *Canterbury Tales*, with more than sixty manuscripts, rank among the favourites of entertaining narrative literature.

From Gutenberg onward the number of editions and the size of each edition have to be combined in assessing the success of a book. Care must be taken, however, to distinguish between the visible, and usually instantaneous, success of some books, which can be expressed in figures, with the imponderable, and usually slow, effect of others, which defies arithmetical analysis. There have always been books which, despite their modest circulation, have exerted a tremendous influence upon the general climate of opinion. Neither Jacob Burckhardt's *Renaissance in Italy* nor Karl Marx's *Das Kapital* was a publisher's success, but the study of history, art-history, sociology, economic theory, political science, and the state of the world would be very different from what they are today but for these two books.

On the other hand, the 'best-seller' provides the historian with a fairly reliable yardstick of the prevalent mode of thought and taste of a period. There are, of course, certain categories of printed matter which give no clue to the real interests of the public. When, for instance, Johann Luschner printed at Barcelona 18,000 letters of indulgence for the abbey of Montserrat in May 1498, this can only be compared with the printing of income-tax forms by Her Majesty's Stationery Office, which hardly respond to a genuine demand on the part of a public thirsting for information or entertainment.

For similar reasons school-books must be excluded from the consideration of best-sellers, although their publication has, from the incunabula period onwards, always been the most profitable branch of the publishing trade. Gutenberg's

press issued no fewer than 24 editions of Donatus's grammar. Some 20 Latin grammars and dictionaries were published by one Cologne printer within only four years. Between 1518 and 1533, Robert Wittington published 13 Latin grammars, all of which had to be reprinted several times. Ten thousand copies of the popular *ABC and Little Catechism* were sold within eight months in 1585. Lily's Latin grammar, first published by Wynkyn de Worde in 1527, remained in use at Eton until 1860. And so the tale goes down to Noah Webster's *The American Spelling Book* (1783) of which about 65 million copies were sold within a hundred years, and to Hall and Stevens's *School Geometry* (1903) which is probably the best-selling school-book in Great Britain. But the whining school-boy with his satchel might conceivably have been less insistent upon this prodigious output if printers and publishers had only consulted him instead of his master.

The greatest difficulty in assessing best-sellers is our ignorance of the numbers of copies printed or sold of any given book. On the whole, publishers have been rather secretive on the subject unless they want to use such figures for advertising purposes. A statement such as 'third edition' or 'fifth reprint' may mean much or little, according to the size of each impression. It may, of course, be prudent not to reveal the fact that only 1,000 copies have been printed of a book which the blurb asserts 'no intelligent reader can afford to miss'; but it may be suggested that publishers would do themselves and the public a service if they would openly state '2nd edition (11th–20th thousand)' or whatever the case may be. At best, it would be splendid publicity, free of cost; at worst, it would show the solicitude of a publisher for a book which he considers worth keeping alive even if of limited appeal.

The average edition of a book printed in the fifteenth century was probably not more than about 200 – which, however, it must be kept in mind, was a 200-fold increase upon the scribe's work. Exceptions can usually be explained by special circumstances. Thus, the 800 copies on paper and 16 on vellum of the *Revelations of St Bridget*, which Gothan printed

in Lübeck in 1492, were commissioned by the convent of Vadstena in Sweden. Aldus Manutius of Venice seems to have been the first publisher who habitually printed editions of 1,000 copies. He was also the first publisher to make the imprint of his firm a determining factor in the sale of his books. Book-buyers in 1500, just as book-collectors in 1950, asked for an 'Aldine' Horace because of the general reputation of the house rather than the particular quality of the edition.

The first printed book that deserves the appellation of best-seller (and quickly also became a steady seller) was Thomas à Kempis's *De imitatione Christi*. Two years after the author's death (1471), Günther Zainer of Augsburg printed the *editio princeps*, and before the close of the century 99 editions had left the presses, including translations of which a French one, printed by Heinrich Mayer in Toulouse in 1488, and an Italian one, printed by Miscomini in Florence in 1491, were the earliest. The collected edition of Thomas's writings which Hochfeder published in Nürnberg in 1494 was less successful, but the *Imitation* has remained the most widely read book in the world, next to the Bible. More than 3,000 editions have been listed, and it was considered worthy to be the first publication of the Imprimerie Royale (Paris, 1640) as well as to be included in the popular Penguin Classics.

The next supplier of best-sellers of European format was another Dutchman, Erasmus of Rotterdam. Between 1500 and 1520, 34 editions of 1,000 copies each were sold of his *Adagia*; 25 editions of his *Colloquia familiaria* were printed between 1518 and 1522 and enlarged and revised editions followed year after year; and the *Encomium Moriae* surpassed both of them.

Erasmus is a pioneer in the history of letters as much by his personality (which can still be enjoyed in his correspondence) as his writings. Both the *Moria* and the *Colloquia* were later put on the *Index librorum prohibitorum*, which contributed no little to keeping them in circulation. He was the first author deliberately to seek out a suitable publisher and to try to mould the publishing policy of a firm, as well as to make

agreements which stipulated author's fees – an innovation which was not taken up again by either publishers or authors for about 200 years. But then Erasmus had an international reputation which permitted him to impose conditions upon publishers who, conversely, could be sure to get their money's worth. In Venice, 1507–8, he worked in Aldus's establishment, in Paris he cooperated with the Ascensian Press of his compatriot, Josse Badius, and in 1513 he came – through the mistake or deception of his literary agent in Cologne – into contact with the Basel firm of Johannes Froben, with which his name has ever since been linked. In his last will he made the directors of the firm his heirs and executors.

Erasmus had the failing of many a zealous partisan in that he saw the country going to the dogs when his faction suffered a set-back. Only thus can it be understood that in 1529 he seriously maintained that 'everywhere where Lutheranism prevails learning is languishing. For what other reason should Luther and Melanchthon recall people so emphatically to the love of studies? The printers assert that, before this gospel spread, they had sold 3,000 copies more easily than 600 now.'

The truth, of course, is that by this time Erasmus's theological and moral treatises, commentaries on the Scriptures, editions of the Fathers, and philological controversies had been ousted – never to be resuscitated – by the writings of the Reformers. Erasmus's epitaph on his lifelong friend Thomas More: 'If only Morus had not meddled in these dangerous matters and left theological questions to the theologians' is sufficient to explain his dethronement by an age which took very seriously theology and other 'dangerous matters'. Both Luther and Loyola rejected Erasmus.

The great publishing successes of the sixteenth century were achieved in the realm of theology. With the publication of the 95 theses in 1517 the unknown young professor of Wittenberg university became at one stroke a figure of national fame, and the small Wittenberg press of Hans Lufft suddenly gained a place among the biggest firms. Thirty editions of Luther's *Sermon on Indulgences* and 21 editions of his *Sermon*

Die erste Epistel Santt
Pauli / An die Corinthern.

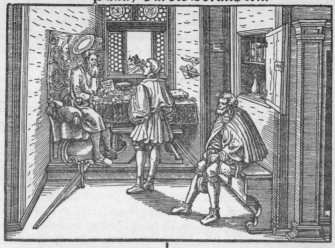

1.

Aulus beruffen zum Apo
stel Jhesu Christi / durch den willen Gottes / vnd Bruder Sosthenes.

Der Gemeine Gottes zu Corinthen / den geheiligeten jnn Christo Jhesu / den beruffenen Heiligen / sampt allen denen / die anruffen den namen vnsers HERRn Jhesu Christi / an allen jren vnd vnsern örtern.

Gnade sey mit euch vnd fride / von Gott vnserm Vater / vnd dem HErrn Jhesu Christo.

Vberschrifft.

Vnterschrifft.

Grus.

Jch dancke meinem Gott alle zeit ewer halben / fur die gnade Gottes / die euch gegeben ist jnn Christo Jhesu / das jr seid durch jn an allen stücken reich gemacht / an aller lere / vnd jnn aller erkentnis / wie denn die predigt von Christo jnn euch krefftig worden ist / also / das jr keinen mangel habt an jrgent einer gaben / vnd wartet nur auff die offenbarung vnsers Herrn Jhesu Christi / welcher auch wird euch fest behalten bis ans ende / das jr vnstrefflich seied auff den tag vnsers Herrn Jhesu Christi. Denn Gott ist trew / durch welchen jr beruffen seid / zur gemeinschafft seines Sons Jhesu Christi vnsers Herrn.

(Gemeinschafft)
Das ist / Jr seid mitterben vnd mitgenossen aller güter Christi.

Jch ermane euch aber / lieben Brüder / durch den namen vnsers Herrn Jhesu Christ / das jr alzumal einerley rede furet / vnd lasset nicht spaltung

First edition of the complete Bible in Luther's German translation, printed by Hans Lufft in Wittenberg, 1534 (1 Cor. 1 : 1–10, with Luther's marginal glosses)

on the Right Preparation of the Heart – authorized and pirati-
cal – poured from the presses within two years (1518–20).
Over 4,000 copies of his address *To the Christian Nobility* were
sold within five days in 1520. But the popular appeal of these
pamphlets was far outstripped by the sales of Luther's trans-
lation of the Bible.

There had appeared in print nearly 20 German Bibles before
Luther, all of which had found a market – above all, the
splendid Low German version of 1494, printed by Stephen
Arndes in Lübeck – but Luther's translation was the first to
become a best-seller in the strict meaning of the term.

The first edition of his New Testament came out in Septem-
ber 1522. Despite the high price of $1\frac{1}{2}$ fl. (about 30s.) 5,000
copies were sold within a few weeks, and in December a second
edition was called for. Fourteen authorized and 66 pirated
editions came out within the next two years. The Old Testa-
ment began to appear in parts from 1523, and the first whole
Bible came out in 1534 – still at the comparatively high price
of about 3 guineas. The number of copies printed is not
known; that of the edition of 1541 was 1,500. All in all, about
400 editions of the whole Bible or parts of it appeared during
Luther's lifetime. Of these, only a quarter were genuine
Wittenberg editions, the others were pirated reprints.

It is quite impossible to give even an approximate estimate
of the number of copies printed, especially as there would have
to be added numerous unauthorized editions with major or
minor variants. Luther's fierce opponent, Hieronymus Emser,
not only used Luther's text almost verbatim for his 'transla-
tion', but also incorporated Lucas Cranach's woodcuts in-
cluding the one depicting papal Rome as the Babylonian
woman of the Revelation – plagiarists cannot be too careful!

Apart from the writings of Erasmus and Luther only one
book of the sixteenth century can be acclaimed as a best-
seller. This is Ludovico Ariosto's *Orlando furioso*, 'the
culminating point in the development of the Italian romantic
epic' (Barbara Reynolds), which came out in its final version
in 1532, shortly before the poet's death. Within the next ten

years it was reprinted thirty-six times and down to the present more editions of it have been published than of any other Italian book. It is, however, worth noticing that *Orlando furioso* is a typical 'national' best-seller. This superb epitome of renaissance civilization has never captured the imagination of non-Italians, even to the extent of the distant respect accorded to Tasso's unreadable *Gerusalemme liberta*. It is significant that no translation of even moderate distinction has ever appeared in any European language.

8. THE TITLE-PAGE

'THE history of printing', Stanley Morison says in his *First Principles of Typography*, 'is in large measure the history of the title-page.' It might even be true to say that the introduction of the title-page constituted one of the most distinct, visible advances from script to print. For neither ancient nor medieval authors, scribes, and librarians seem to have felt a need for what has become that part of the book which is the beginning – and often, with more or less justification, also the end – of reading it.

The Ptolemaic library of Alexandria (probably following the usages of Assyrian and Egyptian libraries) was catalogued according to incipits, i.e. the first word or words of a text. Where the modern librarian will look up the press-mark of Homer's *Iliad*, his Alexandrian colleague would have searched for that of Μηνιν ἀειδε. The fact that we call the books containing the 'good tidings' of Our Lord by the name of evangel (Anglo-Saxon, *gospel*), is a survival of this custom as the oldest report – and therefore *the* report, at least in Rome, its place of origin – was only known under the 'title' of Ἀρχη του εὐαγγελιου, 'the beginning of the gospel'.

Throughout the Middle Ages there remained this indifference to the proper naming of books and, even less understand-

able from the modern viewpoint, to that of their authors –
both the sources of innumerable wrong or doubtful ascriptions
as well as of hopeful and often rewarding searches among
composite codices of miscellaneous tracts by various, unnamed
authors.

'The invention of printing did away with many of the tech-
nical causes of anonymity, while at the same time the move-
ment of the renaissance created new ideas of literary fame and
intellectual property' – with this conclusion E. P. Goldschmidt
aptly sums up his penetrating and incidentally very entertain-
ing study of the age of untitled books.

It was, however, neither the name of the author nor that of
the book which was first given prominence on what was to
evolve into our title-page; nor was this 'title-page' placed
where we are accustomed to find it, namely on the first, or
more usually on the second, leaf of the made-up print. Con-
tinuing and expanding the habit of medieval scribes who liked
to put their names, the date of the completion of their labour,
a prayer, or other brief notes at the end of a codex, the very
first printers instituted what is known as the colophon. Of the
features of a modern title-page, the earliest colophons contain
one or more of these items: the place and date of printing, the
printer's name and device, the title (but not yet the author) of
the book. The earliest known colophon is fuller than some
later ones: the title (*Psalmorum codex*), the names of the
printers (Johannes Fust and Peter Schöffer), and, by implica-
tion, the place of printing (Mainz) and the exact date of the
completion (14 August 1457). The next extant colophon gives
the title (*Catholicon*) – omitting characteristically the author,
viz. Johannes Balbus – the place (Mainz) and year (1460) of
printing; it is most regrettable that the printer left out his own
name, for it certainly came from the press of Gutenberg him-
self. The third colophon again mentions Fust and Schöffer as
printers, Mainz as the place, and 14 August 1462 as the date
of publication; the book – a two-volume Bible – needed no
author's name; but its description in the colophon, '*hoc
opusculum*', is distinctly odd.

The inventor of the 'real' title-page was Peter Schöffer, but, like so many inventors in every field of science, he did not fully realize the importance of his invention, and thus gave it up after only one trial. His failure to grasp the inherent potentiality of this device is even clear from the object to which Schöffer applied it: not to one of his Bible, Psalter, or Rationale books with their unlimited possibilities, as the future was to show, but to a papal bull (of 1463), that is to say, a kind of broadsheet for which a modern printer would rightly regard a line of display letters as quite sufficient.

Equally sporadic was the next attempt at bringing in a title-page. This was made in 1470 by Arnold Therhoernen, a printer of Cologne, in his edition of Werner Rolevinck's *Sermo de praesentatione beatae Mariae*. This booklet is of importance also in another respect in that it is one of the first publications with the foliation inserted. The numbering of the pages seems to us an obvious and indispensable aid to the reader but it did not become fully established until the beginning of the sixteenth century. Pagination was preceded by the insertion of catchwords, i.e. the repetition of the first word (or syllable) of a page at the foot of the preceding page. Such catchwords occur for the first time in the Tacitus printed by John of Speier at Venice in 1469. The catchword was first abandoned by the Foulis Press of Glasgow from 1747 onward. It survives in the rationalized form of the 'signature', i.e. the letter or figure appearing on the first page of a sheet (usually of 16 or 32 pages) which acts as guide in gathering the sheets before binding. However, this practice, too, was not immediately followed up, although, like foliation and pagination, it was not altogether unknown to scribes of manuscripts.

All these early title-pages, and quite a number of later ones, took in fact the place of a modern 'half-title' and probably served the same purpose, namely, to prevent the first printed leaf from becoming dirty while lying about in the printing shop before passing into the hands of the binder. However, the astute business men – who, it must be borne in mind, still combined the functions of printer, publisher, and bookseller –

very soon realized the inherent potentiality of the full title. Erhard Ratdolt, of Augsburg and Venice, was the first to take this step. His edition of Johannes Regiomontanus's astronomical and astrological calendar of 1476 was preceded by a page which supplied all the details we expect to find on a title-page, including a laudatory poem which is rather the equivalent of an introductory preface by the author's friend or of a gratifying review. The whole page is set in a beautiful woodcut frame and is thus clearly distinguished from the text itself.

The expression of justified pride in the quality of the work and the self-advertisement of the printer-publisher long remained a feature of the title-page until in recent times it gradually passed out of the hands of the production manager into those of the director of publicity without, however, declining in pitch or volume.

Regiomontanus's calendar sold so well that Ratdolt was able to reissue it in the original Latin as well as in vernacular translations. It therefore must have played its part in conditioning the public to the appearance of this new feature. From the producer's point of view, the title-page offered more than the technical advantage of a protective cover: it was at the same time an effective and cheap means of advertising the book. This aspect emerges from a scrutiny of the books which were first adorned with a title-page: they were all new publications which needed some introduction to the public. The first 'reprint' bearing a title-page is Giorgio Arrivabene's edition of the Vulgate, printed in Venice in 1487, and preceded by a leaf with the single word 'Biblia' on it.

By 1500 the title-page had established itself; and in any book of the sixteenth century or later it is its absence rather than its presence that requires comment and explanation.

Another device which was come to stay was the insertion of running heads. They appear for the first time in the Brescia edition of 1490 of Albertus Magnus's *Philosophia pauperum*. Their use incidentally suggests that imposition, that is the printing of multiple pages from the same forme, had by this time become the practice.

AVreus hic liber est : non est preciosior ulla
Gema kalendario : quod docet istud opus.
Aureus hic numetus : lune : solisq; labores
Monstrantur facile : cunctaq; signa poli :
Quotq; sub hoc libro terre per longa tegantur
Tempora : quisq; dies : mensis : & annus erit.
Scitur in instanti quecunq; sit hora diei.
Hunc emat astrologus qui uelit esse cito.
Hoc Ioannes opus regio de monte probatum
Composuit : tota notus in italia.
Quod ueneta impressum fuit in tellure per illos
Inferius quotum nomina picta loco.

.1476.

Bernardus pictor de Augusta
Petrus loslein de Langencen
Erhardus ratdolt de Augusta

Title-page, with woodcut border, of Regiomontanus's astronomical
and astrological calendar, printed by Ratdolt in Venice, 1476

More than any other single part of the book, the title-page has ever since been a true reflection of the general taste of the reading public – not only with regard to typography. Baroque, rococo, classicism, *art nouveau*, expressionism, surrealism – each art period has produced title-pages in its own image.

The decorative woodcut border, introduced by Ratdolt, dominated the first half of the sixteenth century, and artists such as Dürer, Holbein, and Cranach added lustre and distinction to it – as did William Morris and his followers at the end of the nineteenth century when they revived the style of the early printers in a spirit, as we now see, as remote as possible from their alleged ancestors.

Very soon, however, printers were groping for a principle which has eventually come to be accepted as basic to true typography – namely, that every page of a book, apart from additional illustrations, should be composed solely out of the compositor's case. That is to say, ornaments should be type-ornaments, consisting either of common letters' arranged in decorative patterns or of decorative patterns cut and moulded as supplements of a type-fount: the latter becoming known as printers' flowers.

Type-ornaments were sporadically used by Wynkyn de Worde; their real popularity dates from Robert Granjon who, from about 1560, cut a wealth of complicated but always pleasing arabesques. The Netherlands, at the time the leading European book market, and England greatly appreciated these patterns down to about 1640. Pierre-Simon Fournier revived and enlarged this fashion which, from about 1760 to 1780, found imitators and copyists all over Europe – the German Johann Michael Fleischmann and the Dutch firm of J. Enschedé (for which Fleischmann worked from 1743 to 1768) excelling through inventiveness.

A rival of the woodcut title-page grew up in the engraved title-page. The first example, already as fully repulsive as this aberration was ever to be, appeared in London in 1545. The artist is likely to have been a Dutchman, for it was the Antwerp printer Christopher Plantin who soon afterwards made the

RVBRICA

ALNOME DEL NOSTRO
SIGNORE
IESV CHRISTO
E DELA
SVA GLORIOSA MADRE
SEMPRE
VERZENE MARIA
COMENCIA VNO BELLO
TRACTATO
ALA CREATVRA MOLTO
VTILE
ET ANCI NECCESSARIO
CIOE
DELA SCIENTIA ET
ARTE
DE BEN MORIRE
ET BEN
FENIRE LA VITA
SVA

An early, highly original example of printer's flowers: *Arte de ben morire*
printed by the brothers Giovanni and Alberto Alvise in Verona, 1478

engraved title-page a European epidemic spreading from the pocket editions of the Elzevirs to the stately folios with which the Imprimerie Royale accompanied the reign of Louis XIV. It was the violation of typographical honesty and good taste, inherent in the combination of an engraved border with the proper title set in ordinary type, which eventually opened the eyes of the printers and led to the abandoning of this device.

With the growth of the 'classical' school of typographers, for which may stand the names of Baskerville, Didot, and Bodoni, the purely typographical title-page carried the day, relegating woodcuts and engravings to freak productions mostly of a sham-archaic character.

All through these centuries the wording of the title itself reflects the prevalent mood and taste of each successive period. Throughout the sixteenth and seventeenth centuries there can be observed the gradual change from the prim matter-of-factness of the renaissance, through the wordy didacticism of the mannerist period, to the verbosity of the baroque, hand in hand with an increasing artificiality of the layout, culminating in the tomfooleries of titles arranged in the shape of triangles, hexagons, hour-glasses, and other fantastic patterns.

The present title-page of the *Book of Common Prayer* faithfully preserves, under the statutory force of an Act of Parliament, the exhaustive and exhausting wordiness of its seventeenth-century origin – twice as long as the Edwardian and Elizabethan title and twenty times as long as a modern author, printer, and publisher would allow: 'The Book of Common Prayer' would no doubt be considered sufficient.

Geofroy Tory, the Paris printer of *c.* 1530, was the first to practise the natural layout, and French printers even in the worst periods have evinced a more sensitive as well as sensible attitude than any other nation towards the need for clarity and simplicity. In one respect the older printers were luckier than their successors from the eighteenth century onward: they were not bound by the school-book regulations concerning the division of syllables nor by grammatical considerations regarding the comparative weight of nouns, articles, prepositions, etc.

The divergent opinions of sixteenth- and twentieth-century printers as to the proper layout of a title-page can best be illustrated by contrasting the edition of Sir Thomas Elyot's famous treatise on education brought out in 1534 by the King's Printer, Thomas Berthelet, with the shape the typographer and printer of the present book would give it. (See illustrations on pp. 154-5.) This example shows the two main points that distinguish a modern title-page. In Oliver Simon's words, 'besides fulfilling its function of announcing the subject or name of the work and its author, [it] gives to the book the general tone of its typographical treatment'. Circumlocutions such as 'the book named . . .' and 'devised by' or the double stress on the author's knighthood are now rightly regarded as unnecessary frills which a title-page is all the better without. The same applies to sub-titles, such as in the second, 1687 edition of Thomas Stanley's *History of Philosophy*, 'containing the lives, opinions, actions and discourses of the philosophers of every sect', which only elaborate the obvious implications of the main title. Making the title short and self-explanatory and making the typography of the title-page conform with the typography – and, to a certain extent, the subject-matter – of the text are, in fact, two aspects of the general tendency of modern typography towards sense and sensibility.

9. BOOK ILLUSTRATION

THE picture book may lay some claim to the paternity of the book printed with movable types. For the first books printed in a 'press' preceded Gutenberg's invention by about thirty years. They are called 'block-books' or xylographica because each page was printed from a solid block of wood which contained the picture and the caption, both cut together on the same piece of wood. Woodcuts were first printed on single sheets; of these the Virgin with four Saints of 1418 in the Royal Library in Brussels and the St Christopher of 1423 in the John Rylands Library in Manchester are the oldest surviving

dated specimens. From about 1430 onward (no block-book
is dated before 1470, though a Dutch *Apocalypse* may have

Title-page of Sir Thomas Elyot, *The Boke named
the Gouernour,* first published in 1531, reprinted by
Thomas Berthelet in London, 1534

been published in 1451–2) they were printed together in book
form. Nearly all of them originated in western Germany,
Switzerland and the Netherlands.

One of these xylographers, Laurens Janszoon Coster of Haarlem (1405–84), has even been credited with the invention

THE GOVERNOR
BY
SIR THOMAS ELYOT

PENGUIN BOOKS

Title-page of Sir Thomas Elyot, *The Governor*,
as it might appear in a modern edition

of printing with movable types in or about 1440. This 'Coster legend', fabricated by a Dutchman in 1568, has been proved to be a fable by modern Dutch scholars; but the monuments

erected in Coster's honour by his townsmen will no doubt keep the myth alive among such people as will believe that Bacon wrote Shakespeare.

By about 1480 the block-books had outlived their usefulness and were no longer produced. An interesting late-comer, however, appeared in 1593 in Manila. The first book printed in the Philippine Islands, a bilingual *Doctrina Christiana* in Spanish and Tagalog, is a block-book. The type was probably designed by one of the Dominican missionaries; but the execution lay in the hands of Chinese craftsmen to whom the block-book had for centuries been the only known medium of printing. Here, then, East and West met bodily, 150 years after their amalgamation in Gutenberg's office.

Measured by the technical production of the block-books, Gutenberg's invention signalled an advance in two directions: the break-up of the compact text into individual letters and the supersession of wood by metal, thereby increasing the durability as well as the precision of these individual letters.

The older technique, however, lived on for some time. Playing cards, illustrated broadsheets, and other ephemeral matter were until the end of the eighteenth century produced and hawked by numerous *Briefmaler* (illuminators of documents – *Briefe* – playing cards, broadsheets, etc.). A Strasbourg by-law as early as 1502 carefully distinguished them from 'honest printers'. In fact, a good deal of the productions of these *Briefmaler* – who flourished especially in Nürnberg, Augsburg, and Regensburg – was as disreputable as any modern horror comic.

The great majority of the block-books were cheap tracts for the half-literate to whom the picture was more important than the caption, which anyway had to be very brief because of the laborious process of cutting the letters. Books of religious edification lent themselves most easily to this kind of mass production, such as the *Biblia pauperum*, treatises on the Last Things, the *Mirabilia urbis Romae*, and legends of popular saints.

In this way readers were quite used to combining the concepts of 'book' and 'illustration'; and printers were quite ready to embellish their novel productions in one or other of

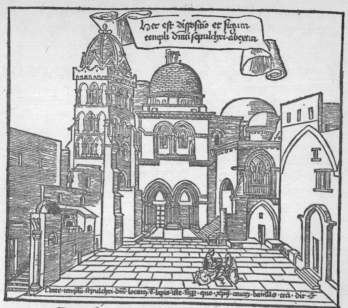

Hec eſt diſpoſitio et figura templi dñi ſepulchri aberta

Ante templũ ſepulchri dñi locatz̃, ⁊ lapis iſte ſup̃ quo Xp̃s cruce̅ baiulãs ⁊c̃a dir⁊

¶ De ingreſſu in te̅mplũm dñic̃a ſepulcri et proceſſione inibi ſacta
ad loca ſacta.

D̃e .xij. Iulij ŝota veſperatũ in ipm venerant a̅ dñic̃a ſepul-
cri templũ a paganis ·id eſt rectorib9 ipiu9 cũitatis ſancte
Ieroſolime ſuim9 admiſſi ·et numerati ·oſtijs p eos ap̃tis.
pro qua re vnuſquiſq; noſtrũ quinq; eſſoluit ducatos· nec
vnq̃ alias ŝoc aperitũ templũ aŝ eis ·niſi vel propter aduenie̅tes pere-
grinos ·vel fratres mutandos qui ibi p cuſtodia deputãtur· Moy q
nobis intromiſſis templũ clauſerũt· Intrauerũt aute̅ nobiſcũ Gardia
nus ip̃e et pl̃ures ſuoꝝ cõfratrũ· Quaprimũ aũt deuotus quiſq; ṗia-
nus vel peregrin9 in templũ ŝoc pedem poſtuerit· plenaria cõſequitur
remiſſione̅·

¶ Eſt aute̅ ŝec diſpoſitio templi eiuſdem ſacratiſſimi· Eccleſia ipa rotũ-
da eſt· et ŝabet p diametrũ inter columnas ſeptuaginta tres pedes· aŝ-
ſideſq; que ŝabent p circuitũ a muro exteriori eccleſie dece̅ pedes ſuper
ſepulcrũ dñi· qb in mediũ eiuſdem eccleſie eſt apertura rotũda ita vt
tota cripta ſancti ſepulcri ſit ſub diuo· Galgatŝana aute̅ eccleſia adŝe-
ret iſti· et eſt oblonga loco· choꝛi eccleſie ſancti ſepulcri adiũcta· ſed parũ
demiſſioꝛ· ſunt tame̅ ambe ſub vno tecto· Speluuca in qua eſt ſepulcrũ
dñi ŝabet in logitudine octo pedes· in latitudine ſimiliter octo vndiq;
tecta marmore exteri9 ſed interi9 eſt rupes vna ſicut fuit tp̃e ſepulture

Bernhard von Breydenbach, *Peregrinationes in Terram Sanctam*,
with woodcuts by Erhard Reuwich, printed by Peter Schöffer in Mainz,
1486. Paragraph signs and the initial D hand-coloured in red

the customary ways. Ornamented initials and woodcuts therefore make their appearances simultaneously with books printed from movable type. It has been computed that about one-third of all books printed before 1500 were illustrated. Albrecht Pfister of Bamberg in the 1460s inserted woodcuts in his popular books, and from about 1470 onward Augsburg specialized in illustrated books. When Bernhard von Breydenbach went on a pilgrimage to the Holy Land, he was accompanied by an artist, Erhard Reuwich, whose sketches, including a valuable map of Palestine, were duly incorporated in the traveller's *Peregrinationes in Terram Sanctam* (Mainz, 1486). Reuwich himself cut his drawings in wood and supervised the printing of the book which, thanks to its combination of pilgrims' guide, travelogue, and geographical textbook, had a tremendous success and was soon translated into German, Dutch, French, and Spanish.

This early collaboration of author and illustrator is all the more remarkable as normally the correspondence between text and picture was very slight indeed. In the most lavishly illustrated book of the fifteenth century, Hartmann Schedel's *Liber chronicarum*, which Koberger published in 1493, the 1809 illustrations were supplied by only 645 wood-blocks. The 596 portraits of emperors, popes, and other celebrities were made up from 72 wood-blocks so that the same effigy was used, with a different caption, for 8 or 9 different personalities, and the same view of a walled city was named Rome, Jerusalem, Paris, or whatever the context required. Most printers used the blocks they had in stock without much discrimination whenever sales considerations demanded a book with illustrations. The so-called Leda-Bible of 1572 is a notorious late example of this indifference. In it the New Testament was illustrated with woodcuts taken from an edition of Ovid's *Metamorphoses*; an initial depicting Jupiter visiting Leda in the guise of a swan introduced the Epistle to the Hebrews.

As regards the quality of the illustrations, Italy, for a while, outclassed every other country. Here Ulrich Han produced in 1467 the first book illustrated by as many as 30 woodcuts,

cum religioso tripudio plaudendo & iubilando, Quale erano le Nym-
phe Amadryade, & agli redolenti fiori le Hymenide, riuirente, saliendo
iocunde dinanti & da qualũq; lato del floreo Vertunno stricto nella fron
te de purpurante & meline rose, cum el gremio pieno de odoriferi & spe-
ctatissimi fiori, amanti la stagione del lanoso Ariete, Sedendo ouante so-
pra una ueterrima Veha, da quatro cornigeri Fauni tirata, Inuinculati de
strophie de nouelle fronde, Cum la sua amata & bellissima moglie Po-
mona coronata de fructi cum ornato defluo degli biódissimi capigli, pa
rea ello sedéte, & a gli pedi dellaquale una coctilia Clepsydria iaceua, nel
le mane tenente una stipata copia de fiori & maturati fructi cum imixta
fogliatura. Præcedéte la Veha agli trahenti Fauni propinq; due formose
Nymphe ansignane, Vna cũ uno hastile Trophæo gerula, de Ligoni. Bi
denti. sarculi. & falcionetti, cũ una ppendéte tabella abaca cũ tale titulo.

INTEGERRIMAM CORPOR. VALITVDINEM, ET
STABILE ROBVR, CASTASQVE MEMS AR. DELI
TIAS, ET BEATAM ANIMI SECVRITA
TEM CVLTORIB. M. OFFERO.

Francesco Colonna, *Hypnerotomachia Poliphili* (written before 1479),
printed with Francesco Griffo's third roman fount by
Aldus Manutius in Venice, 1499

namely Johannes de Turrecremata's *Meditationes*. The second edition published in 1473 contained 3 more illustrations. Johannes of Verona printed in 1472 the first illustrated book on a technical subject, Roberto Valturio's *De re militari*, on military engineering. In Venice Erhard Ratdolt perfected his charming borders and ornaments designed by Bernard Maler, and Aldus produced 'the most famous and the most beautiful woodcut book ever published', as Francesco de Colonna's *Hypnerotomachia Poliphili* (1499) has been called. Nicolaus Laurentii, a German printer working in Florence, brought out the first book illustrated with metal engravings in 1477; but this process did not catch on before the middle of the sixteenth century, when the *Speculum romanae magnificentiae* (Antonio Lafreri, Rome, 1548–68) supplied on more than 130 engraved plates a conspectus of the surviving monuments of ancient Rome and thus constituted the earliest topographical work of permanent value. The first illustrated editions of Dante's *Commedia* (1481), also by Nicolaus Laurentii, and Boccaccio's *Decamerone* (1492) testify further to the good taste as well as the capability of Italian printers.

In France, the illustration of printed books continued the high standard of French illuminated manuscripts. Martin Huss of Lyon, it is true, bought the 259 woodcuts for his *Miroir de la redemption humaine* from the Basel printer Bernhard Richel (1478; 2nd ed. 1479; 3rd ed. by Matthias Huss, 1482). But the next illustrated book, a French version of Breydenbach's *Peregrinationes* (Lyon, 1488), already shows a remarkable degree of independence. The text was thoroughly revised by the editor, Nicolas de Huen, who drew on his own experiences in the Holy Land; and the woodcuts of the original were replaced by free adaptations, some of which were executed in the new technique of copper-engraving. The Books of Hours, produced by Vérard, Kerver, Tory, and others, vie with one another in the excellence of the draughtsmanship and presswork of their graceful ornaments and borders. Most of them were afterwards coloured by hand, and these illuminators, too, were craftsmen of the highest order.

Peter Schöffer tried at a remarkably early date to simplify production by making the printer do the work of the rubrisher as well as the scribe of hand-written books. There the scribe always left blank spaces in which the rubrisher afterwards painted large coloured initials. Schöffer now printed his *Psalter* of 1457 with black, red, and blue letters so that the book could go straight from the press to the binder. But the process of colour-printing proved to be too laborious and expensive. Although bold attempts continued to be made to print initials, headings, and other portions of the text in colour, colouring by hand remained the rule into the eighteenth century.

THE ERA OF
CONSOLIDATION

Chapter Two

THE ERA OF CONSOLIDATION
1550–1800

THE main characteristics of the 250 years following the 'heroic century' of the printed book may be listed as follows:

The personal union of type-founder, printer, editor, publisher, and bookseller is a thing of the past. Occasionally the functions of type-founder and printer, publisher and editor, publisher and bookseller are still combined by one man or one firm, but on the whole the occupational differentiation has come to stay. Virtually no technical progress took place in the composing and printing rooms. New type-faces represent refined imitations of the achievements of Jenson, Griffo, and Garamond rather than fresh conceptions. The organization of the trade, and especially the channels of distribution, become stabilized – literally and figuratively.

At the same time, the 'order of precedence' underwent a decisive change. The publisher, as we understand the term, becomes the central figure of the trade. It is at his orders that the printer prints, the bookseller sells, often the editor edits, and sometimes the author writes. The printer becomes a subsidiary of the publisher and even loses his independence as the producer of his own types. He obtains his founts ready-made from the type-founder, with the result that a few prominent foundries gained an immense influence upon the kind of type

printers had at their disposal not only in their respective native lands but, through a brisk export trade, all over western Europe.

The professional author enters the arena as an independent force between the publisher and the public. The reading public widens considerably and in the process changes its character. Publishers and authors have to cater for new readers with new tastes, different from the fairly homogeneous public of churchmen, academics, and sophisticated gentry whom a Gutenberg, Aldus, Stephanus, or Caxton supplied with reading matter. The spread of literacy gradually induces new sections of the population to adopt the habit of reading. Women and children, in particular, present the publisher with the potentiality of doubling or trebling his output. The periodical and newspaper press are becoming the chief vehicles of spreading knowledge among this new public.

1. TYPE-DESIGN

ROMAN TYPE

DURING the period from the middle of the sixteenth to the end of the eighteenth century, a number of brilliant French, Dutch, and English type-designers and punch-cutters perfected the achievements of Griffo and Garamond. Each of the typefaces which Granjon created in the sixteenth century, van Dyck and Grandjean in the seventeenth, Caslon, Baskerville, the Fourniers, and Bodoni in the eighteenth is in its kind beautiful and serviceable and has left a permanent mark on the art of typography. But, held against the pioneer efforts of the first century of printing, the chief merit of these new founts lay precisely in the fact that their designers did not attempt to replace the accepted Aldus pattern by any startling innovation. They introduced, it is true, a good many refinements of detail and succeeded in giving each of their various founts a greater consistency in itself; but this was mainly due to improvements in

the mathematical precision of design and in the technical manufacture of punches and matrices. On the whole, however, the unity underlying all 'antiqua' faces outweighs their differences and stresses the fact that the literary civilization of the West was now firmly based on the one Latin alphabet.

At the same time, the profession of punch-cutter and founder was no longer commonly bound up with that of printer and publisher. In fact, it seems that type-founding became a specialized profession at a very early date. One Nicolas Wolf, a native of Brunswick, for instance, appears as a *fondeur de lettres* in Lyon in 1493, and supplied the local printers with types before he eventually set up as a printer in 1498; and there were 18 type-founders active in Lyon between 1500 and 1550. Garamond, however, was the first to concentrate on the large-scale production of punches and matrices for general sale. Granjon followed his example. He was the first to trade on an international scale. He delivered matrices to Italy, France, Germany, Switzerland, and especially the Netherlands. From the middle of the sixteenth to the end of the seventeenth century leadership of type-design and type-founding went to the Low Countries. But the types which, through the agency of the dominant publishers, Plantin and Elzevir, became known to every printer and every reader in Europe, were those cut by Garamond and Granjon, and thus lastly modelled on the founts cut by Griffo for Aldus. French designers, such as Jacob Sabon (who completed a set of punches begun by Garamond), father and son Le Bé, and Granjon himself, were mainly responsible for the work done for the house of Plantin. The Dutchman Christopher van Dyck (1601–1669/70), a goldsmith by profession, was the chief supplier of punches for the Elzevirs, as far as these did not buy their material from the Luther foundry in Frankfurt.

The quick entry of 'Dutch' founts into every moderately well-equipped printing shop throughout Europe is largely due to the business ascendancy exercised by some big type-foundries of European reputation. For only a few printing houses could afford to order and produce types for their exclusive use.

The majority of printers now bought types 'ready-made', as it were. The foundry established by Christian Egenolf in Frankfurt in 1531 and from 1629 known by the name of Luther was perhaps the most influential firm in the seventeenth century; even in the eighteenth century they sold their produce as far afield as Philadelphia where the first American foundry was established as late as 1772 by Christopher Sauer, a customer of the Luther firm. By that time the first place had been taken by the Leipzig firm of Ehrhardt which had their best founts cut by Nicholas Kis in Amsterdam, 1683–9. The Frankfurt and Leipzig foundries described their types generally as 'Dutch' (*holländische Schriften*). This may be taken as an acknowledgement of the superior achievements of Dutch letter-design, dating back to Henric of Delft (who called himself Henric de Lettersnider) in the fifteenth century and now represented by Christoffel van Dyck, Bartholomaeus and Dirk Voskens, and others who worked for the great printer-publishers of Antwerp, Amsterdam, Leiden, Haarlem; not to forget the 'Sieur Zonen' (Mister Son) whom Fournier made inherit Dirk Voskens's business. The term 'Dutch types' was therefore a useful trade-mark. Imitating – and often vulgarizing – French types stemming from Garamond and Granjon, exchanging material with the Plantins and Elzevirs, the Luther and Ehrhardt foundries could therefore compete successfully in the Dutch market, which throughout and beyond the seventeenth century dominated the European publishing trade. The famous collections of types which Dr Fell bought in the Netherlands for the Oxford University Press (1675) included some French sets of Granjon provenance and some supplied by van Dyck.

The supersession of the Netherlands by the France of Louis XIV as the principal economic and political power of the Continent aptly found its typographical expression in the execution of a completely new set of type. Commissioned by the king himself in 1692 for the exclusive use of the Imprimerie Royale, the *romain du roi* exhibited the cold brilliance distinctive equally of the absolute monarchy and the logical mind of France. A committee of the Academy of Sciences, of which

the Abbé Nicolas Jaugeon was the most active member, was charged with the theoretical preparation of the design, and they deliberately turned away from the principles of calligraphy and epigraphy which had so far guided every type-design. The academicians drew up the design of each letter on a strictly analytical and mathematical basis, using as their norm a rectangle subdivided into 2304 (i.e. 64 times 36) squares. The artist, in William Morris's words, was ousted by the engineer. The resultant aridity of the design was fortunately mellowed by the eminent type-cutter Philippe Grandjean (1666–1714) who from 1694 to 1702 gave his whole time to the work, supported by some able assistants. Although the 21 sizes cut between 1697 and 1745 by Grandjean, Alexandre, and Luce remained the exclusive property of the Imprimerie Royale, the *romain du roi* epitomized the aesthetic ideals of the age of reason to such an extent that every French typographer imitated it as far as the royal privilege would permit him to do. The *Modèles de caractères* (1742), in which Pierre-Simon Fournier (1712–68) presented the whole range of his type-faces, show to perfection that the *romain du roi* could, in the hands of a sensitive cutter, be adapted to suit the taste of a new age. This tradition was continued by the Didot family, François (1689–1758), François-Ambrose (1730–1804), and Firmin (1764–1836), the last French *imprimeur du roi* (1829). They further 'assimilated the royal novelties', and (Stanley Morison states) 'French type-founding has never turned back to the Aldine-Garamond-Granjon roman.'

The hegemony of English commerce and industry in the eighteenth century could not fail to stimulate the English printing trade to make itself independent of foreign supply. England was the last western nation to admit roman type as the standard for vernacular printing. The turning point came as late as 1611 when Robert Barker, then King's Printer, issued the Authorized Version in both roman and black-letter editions. For by this time the English and Scottish public had become conditioned to reading their Bible in roman characters. The 'Geneva Bible' of 1560 was the first Bible in English

MANUEL
TYPOGRAPHIQUE,
UTILE
AUX GENS DE LETTRES,

*& à ceux qui exercent les différentes
parties de l'Art de l'Imprimerie.*

Par FOURNIER, le jeune.

TOME I.

A PARIS,

Imprimé par l'Auteur, rue des Postes,
& se vend
Chez BARBOU, rue S. Jacques.

M. DCC. LXIV.

Pierre-Simon Fournier, *Manuel typographique*
(Paris, 1764), in which his point system
was given its final form

QUINTI
HORATII FLACCI
CARMINUM
LIBER PRIMUS.

ODE I.

AD MAECENATEM.

Maecenas, atavis edite regibus,
O et præsidium et dulce decus meum!
Sunt quos curriculo pulverem Olympicum
Conlegisse iuvat; metaque fervidis
Evitata rotis, palmaque nobilis,
Terrarum dominos evehit ad Deos:
Hunc, si mobilium turba Quiritium
Certat tergeminis tollere honoribus;

Edition of Horace, printed by Pierre Didot (1761–1853) in Paris, 1799

thus printed. It was translated by Protestant exiles of whom John Knox was one, and financed by John Bodley, father of the future founder of the library at Oxford. The New Testament portion was printed by Conrad Badius, Josse's son and Robert Estienne's brother-in-law, and Calvin contributed an introductory epistle. Although the English government championed the black-letter 'Bishops' Bible' of 1568, Cecil winked at the importation of copies of the Geneva Bible and Walsingham encouraged its reprint in London. The General Assembly of the Kirk authorized it for Scotland in 1579. By 1611, about 150 editions had made every literate English and Scottish home accustomed to read the family Bible in roman type.

But for another century English printers remained dependent on the importation of continental matrices, chiefly from Holland. The majority of type-founders in this country were French Huguenots and Protestant refugees from the Spanish Netherlands; the first Englishman who carried on type-founding as his sole occupation and not as a side-line of printing was Benjamin Sympson (1579). It was William Caslon (1692–1766), a Worcestershire man, who freed England from this servitude. He set up in London as a type-cutter and type-founder in 1716. His first specimen sheet (1734) established his fame once and for all and brought England to the van of European typography. His types became especially popular in America where they were championed by Benjamin Franklin who caused the authenticated copies of the Declaration of Independence to be printed in Caslon types by Mary Katharine Goddard in Baltimore.

Caslon's types represent (in Updike's words) a 'thoroughly English' variety, 'legible and common-sense', of the tradition which, through the Dutch designers of the seventeenth century, goes back to Garamond and Granjon in the sixteenth and eventually Griffo in the fifteenth century. William Caslon II joined his father as a partner in 1742, and the firm of 'William Caslon & Son' remained in the family until the death of the last male Caslon in 1873.

For some unknown reason Caslon chose for the display of

his types the beginning of Cicero's first Catiline oration, and *Quousque tandem* for long remained the stock-in-trade of typographical specimens. This was unfortunate, as a capital Q is of the rarest occurrence in English and, because of its tail, requires a special treatment quite uncharacteristic of other capital letters. The letter which, in upper and lower case, affords the widest facilities of judging any given set of letters, is M and m; it has therefore by general agreement been made the yardstick with which students of incunabula unravel the intricacies of early types and identify them.

Caslon was followed by John Baskerville (1707-75), the greatest type-designer of the post-incunabula age. He, too, hailed from Worcestershire, but spent nearly his whole life in Birmingham, which thus for once enters into the history of civilization. A nineteenth-century doggerel unflatteringly contrasts the town and the man:

> When Birmingham, for riots and for crimes,
> Shall meet the keen reproach of future times,
> Then shall she find, amongst our honoured race,
> One name to save her from entire disgrace.

Like many of the earliest printers, Baskerville came to typography through calligraphy, which he taught from 1733 to 1737; and like the early printers he applied his versatile genius to type-design as well as to type-founding, to composing as well as to printing, to paper as well as to ink – and his attention to the right kind of paper and his improvement of printers' ink were hardly less important than his creation of a new kind of type.

His first book, a quarto *Virgil* (1757), began the series of some fifty Baskerville productions which, as Philip Gaskell has said, 'has few rivals in the whole history of printing'. His masterpiece, the folio Bible of 1763, which he printed under the licence of Cambridge University, 'achieved a particularly happy liaison between type, layout, paper, and ink. It is [Mr Gaskell continues] one of the finest books of the whole eighteenth century.' One of Baskerville's outstanding contributions

to modern printing is his insistence on typography pure and simple as the means of achieving a fine book. This idea, which has now become commonplace, was revolutionary in an age when a book was judged by the contribution of the illustrator and engraver rather than the groundwork of the compositor and printer.

Baskerville was a true prophet not without honour save in his own country. Impoverished and derided, he repeatedly tried to sell his whole equipment to some continental printing press and only failed because of the 'excessive' price of £8,000 he demanded. His widow eventually, in 1779, sold his punches, matrices, and presses to Beaumarchais for his Kehl edition of Voltaire (see p. 192). Thereafter Baskerville types were sold and resold to various French foundries, and their origin had been completely forgotten when, in 1917, Bruce Rogers, the then typographical adviser to the Cambridge University Press, rediscovered them. Finally, in 1953, Monsieur Charles Peignot, of Deberny & Peignot, made a princely gift of all the surviving original punches to the Cambridge University Press – except the (very undistinguished) Greek type which Baskerville made in 1758 for the Oxford University Press, where it is still preserved.

Between them Caslon and Baskerville not only reformed the English printing of their day but have exercised a lasting influence upon the typography of every nation that uses the Latin alphabet. Their types owed their success to the aesthetic satisfaction of the graceful shape of each letter as well as to their adaptability to printing matter of every description, from the stately tomes of a lectern Bible to the charming presentation of lyrical poetry. They possess the great virtue of unobtrusiveness combined with eminent readability. They never seem to come between reader and author and can be read for long periods with less eye-strain than most faces.

Fournier and Baskerville were the chief inspiration of the only great Italian typographer of the eighteenth century, Giambattista Bodoni (1740–1813). After his apprenticeship at the Vatican Press he spent his whole life in the service of the dukes

ORLANDO

FURIOSO

DI

LODOVICO

ARIOSTO.

TOMO *TERZO.*

BIRMINGHAM,

Da' Torchj di G. BASKERVILLE:
Per P. MOLINI Librajo dell' Accademia
Reale, e G. MOLINI.

M. DCC. LXXIII.

Ariosto, *Orlando furioso*, printed by John Baskerville
in Birmingham, 1773, for the Royal Academy in Naples
(hence G[iovanni] for J[ohn])

of Parma as the head of their Stampa Reale; it was housed in the old ducal palace, nicknamed La Pilotta, which now accommodates the Museo Bodoniano. Here Bodoni was in a position to work according to his maxim: '*Je ne veux que du magnifique et je ne travaille pas pour le vulgaire.*' His *Manuale tipografico* (1788; second and final edition, seen through the press by his widow, 1818) shows the reasons for his immense popularity during his lifetime and the comparative neglect after his death. The solemnity, even pomposity, of his designs made them unfit to serve the objectives to which the typographers and printers of the nineteenth century applied themselves – mass-instruction and mass-entertainment.

GOTHIC TYPE

After the defection of England in the first half of the seventeenth century, black-letter type had become an anomaly. No new design of Fraktur faces could therefore have any repercussions in European typography. There were, anyway, very few new designs, and of these only the ones cut by the Leipzig typefounder, Bernard Christoph Breitkopf (1695–1777), are of some merit. The Berlin founder Johann Friedrich Unger (1750–1804) was deeply impressed by the work of Didot and Bodoni, but his attempt to adapt Fraktur to the canons of classicist taste was a complete failure. His 'Neue Deutsche Lettern' of 1791 (some of which were engraved by Firmin Didot) abandoned the only meritorious features of Fraktur, namely, robustness and colour. Thus, as Updike succinctly sums up the development of black-letter, 'by the year 1800 the boldest and noblest typography in Europe had degenerated to the weakest and poorest'.

Judicious men had by this time come to see that the stubborn adherence to gothic types was a main obstacle to Germany's full share in the life of the civilized world. In 1765 the grammarian, encyclopedist, and translator Adelung stated that the use of gothic letters 'is undoubtedly the reason that prevents other nations from learning our language and thus deprives

52

Norcia, piccola Città d'
Italia nell'Umbria, nel
Ducato di Spoleto. Ab-
benchè soggetta alla san-
ta Sede, forma nondime-
no una specie di Repub-
blica, ed elegge quattro
Maestrati. San Benedet-
to nacque in questa Cit-
tà, e vi ebber pure i lo-
ro natali Giambat. Lalli,
e Monsignor Querenghi.

Giambattista Bodoni, *Manuale tipografico*, first edition (Parma, 1788)

them of the use of many good books produced in Germany'. Some years earlier the first non-academic German book had appeared in roman print, Ewald von Kleist's nature poem, *Der Frühling* (1749). But this bold venture of an officer of Frederick the Great found hardly any followers for 200 years. Among them, however, was the best-produced German book of the eighteenth century, Wieland's collected works, which Göschen printed in a fashionable roman type, specially commissioned from Justus Erich Walbaum (1768–1837) 'after Didot' (42 vols, 1794–1802).

For there were those (and their number was to increase during the next century) who treated as a matter of national prestige what at first had been not more than a matter of taste and accident. Common sense as well as aversion to the nationalistic associations of the 'German' script combined to bring about the eventual defection of the Scandinavian countries. The first Danish book printed in roman appeared in 1723; and in 1739 the Swedish Academy, under the chairmanship of Linnaeus, recommended the use of roman in Swedish books and decreed that its own proceedings were forthwith to be printed thus. Although some Scandinavian books continued to be printed in gothic type for another hundred and fifty years, it was obvious by the end of the eighteenth century that black-letter had become a German provincialism.

IRISH AND ANGLO-SAXON TYPES

Religious propaganda, which was responsible for the cutting of oriental types destined originally for polyglot Bibles and later on of considerable assistance in the study of oriental languages, was also the mainspring of two curious bypaths of western typography. The creation of both Irish and Anglo-Saxon founts was a by-product of the Elizabethan church policy. The Irish characters, however, were speedily used for spreading Irish nationalism rather than Anglican theology; they have therefore been referred to in the chapter dealing with the bearing of printing upon the growth of vernacular literature.

Anglo-Saxon founts, on the other hand, were introduced into the composing room with no view to reviving Anglo-Saxon speech, but in order to enable Archbishop Parker to publish from 1566 a series of Anglo-Saxon texts. Although Parker and his assistants were considerable scholars, their purpose in collecting and printing pre-Conquest books in Anglo-Saxon (and Latin) was mainly conditioned by their wishful belief that those writers would furnish material with which to underpin the tenets of the Elizabethan church settlement.

However, these artificial founts – German, Irish, Anglo-Saxon – are outside the main stream of western letters. It is rather one of the most wholesome consequences of the world-wide expansion of the printing press that the one Latin alphabet should have become the one medium in which every human thought can find adequate expression.

2. BOOK PRODUCTION

THE NETHERLANDS

THE Dutch publishing trade of the seventeenth century owed its pre-eminence to the speculative spirit of a venturesome mercantile community, ever on the look-out for fresh markets and not greatly hampered by respect for traditional authority (other than their own, be it said).

The two leading firms were Plantin, dominating the southern, Roman Catholic part of the country, and Elzevir, reigning supreme in the Protestant north. The pivotal position of the Low Countries in European affairs in the second half of the sixteenth and throughout the seventeenth centuries extended the market of both these firms far beyond the confines of their countries. Plantin's agents went as far as North Africa where they sold his Hebrew Bibles to the numerous Jewish congregations.

Christophe Plantin was a Frenchman by birth. He settled in Antwerp in 1549 and soon became the foremost publisher of

the leading emporium of northern European trade. Considerably more than half of all books printed in the Low Countries before the middle of the sixteenth century had come from Antwerp presses. In 1576 Plantin employed twenty-two presses, thus equalling Koberger's establishment three generations earlier; no other firm, including Aldus and Stephanus, ran more than from two to six. Plantin took great care with the

Printer's device used by Christopher Plantin
in various forms from 1557: compass on book;
motto 'Constantia et labore' (more often:
'Labore et constantia')

production of his publications, employing the best French type-cutters and setting much store by good and copious illustrations. He favoured – and improved – copper-plate engravings; these actually do not match well with letterpress but held the field of book-illustration until Thomas Bewick (1753–1828) renewed the art of wood-engraving.

Plantin's main interest, however, lay in publishing rather than printing, and the diversity of his publications is as imposing as their number. Liturgical and edifying religious books, Greek and Latin authors, scientific and medical works as well

as modern French writers are represented in his list. The greatest work that came out under Plantin's imprint was the Polyglot Bible in eight volumes (1568–73). It was to be subsidized by King Philip II of Spain, who in 1570 appointed Plantin his court printer and made him the supervisor of all Dutch printing: but Philip never paid up. In Philip's honour, the Bible was called *Biblia regia*. It was meant to take the place of the Complutensian Bible which by this time had gone out of stock; 1,212 copies were printed, twelve of them on parchment for the king, the others on paper of varying quality with corresponding differences of price.

For ten years, however, the fate of the *Biblia regia* was in suspense as the theologians of Salamanca tried to have it placed on the *Index librorum prohibitorum*. In fact, while the Bible was irreproachable from the strictest Roman point of view, its printer-publisher was secretly an adherent of a Protestant sect which set no store by denominational differences and institutional worship. After the sack of Antwerp by the Spanish soldiery (1576) Plantin left the town and from 1583 to 1585 worked in Leiden as printer to the university. The Antwerp press he left in charge of his two sons-in-law, Francis van Ravelingen (Raphelengius) and Jan Moerentorff (Moretus, 1543–1610). After Plantin's return to Antwerp (1585) Raphelengius, another Protestant, took over the press in Leiden where he later became a professor at the university, while Moretus remained Plantin's chief assistant and after his father-in-law's death (1589) became the sole proprietor of the Antwerp branch. Jan's son, Balthasar (d. 1641), was a friend of Peter Paul Rubens who made a large number of designs, especially title-pages. These were engraved on copper-plates and further enhanced the splendour of Plantin's books. Through eight generations Moretus's descendants kept the firm in business in the same premises until 1875 when Hyacinth Moretus sold it to the city which established the Musée Plantin-Moretus, the premier museum of the history of printing.

The liberation of the northern Netherlands from their Spanish overlords was speedily followed by a flowering of literature,

science and learning, the stage and the arts, which, against the background of an unbroken economic prosperity, justifies the appellation of the Golden Age which the Dutch have given to their seventeenth century. It was also the Golden Age of the Dutch book-trade, and this coincided with the fortunes of the house of Elzevir. The founder of the firm was Louis I, a native of Louvain, who entered the trade in Plantin's shop in Antwerp. As a Calvinist he fled from Alba's persecution and in 1580 settled in Leiden as a bookseller. His connexion with the university (of which he was a beadle) may have encouraged him to venture into publishing. His first book was an edition of Eutropius (1593), and editions of classical authors remained the chief concern of the firm. Its activities coincided with the great age of Dutch classical scholarship, thus securing a deserved reputation for accuracy which only the subtler methods and fresh discoveries of the later nineteenth century have superseded. Of the 38,000 students whom the Leiden professors attracted between 1575 and 1700 nearly 17,000 were foreigners, some of them from as far afield as Norway and Ireland, Spain and Poland, Turkey and Persia. Every one of them can be assumed to have gone down with some textbooks bought in Leiden and thus become a propagandist of Elzevir editions.

For his trade-mark Louis chose an eagle holding seven arrows and the motto of the seven United Provinces ' *Concordia parvae res crescunt*'. For the spirit of enterprise that animated the Republic also pervaded the house of Elzevir. Louis and his descendants deliberately concentrated on the business aspects of the trade. They were content to leave the editing to their editors and the printing to their pressmen. Contrary to the belief held by some dealers and collectors, the typography of Elzevir books is almost uniformly mediocre. The need for obtaining capital made Louis I buy up and subsequently auction whole libraries. He thus struck out a new line of business which has since proved to be the most lucrative branch of the book-trade, that of the second-hand book-dealer. Wholesale, retail, and second-hand bookselling remained to all subsequent generations of the family as important as printing and

RESPVBLICA

five

STATUS

IMPERII

ROMANO-GERMANICI.

Tomus II.

LVGD. BATAVOR.

Ex Officinâ Elseviriorum.

ᛐIɔ Iɔ ϛ XXXIIII.

Title-page of one of the 'Little Republics', on the
Holy Roman Empire, printed by the Elzevirs in
Leiden, 1634. The printer's device recalls that of
the Estiennes: the philosopher under the tree of
knowledge; motto 'Non solus' (St John 16: 32)

publishing. Their close contact with the book-buying public conversely benefited their publications for, better than any preceding printer-publisher, they knew their market, that is, the intellectual requirements as well as the length of the purses of their actual and potential customers.

By the time of his death (1617) Louis I had established the firm on a broad international basis. Two of his seven sons had settled as booksellers in The Hague and Utrecht, while Matthias, the eldest, and Bonaventura, the youngest, together carried on the paternal house in Leiden. Matthias retired from business as early as 1622; so it came that the peak period of the firm was accomplished by Bonaventura (1583–1652) and Matthias's sons, Abraham I (1592–1652) and Izaak (1596–1651). They inaugurated in 1629 the duodecimo series of classical authors, which carried the name of Elzevir all over France, Germany, Italy, England, and Scandinavia. Aldus Manutius had been the pioneer of such editions, well-produced and cheap; but the Elzevirs did better in scholarship and price – though perhaps not in the make-up. The uniform price of one guilder for the 500-page volume was an additional asset as it took count of the psychology of book-buyers who like to associate a series with its outward appearance as well as its price. They also sponsored the series of 'Little Republics', thirty-five monographs in sextodecimo which dealt each with the geographical, political, economic, etc., structure of a European or overseas country. A director of the Dutch East India Company acted as advisory editor of these useful little handbooks.

Izaak, however, had as early as 1616 established a press on his own account and in 1620 become printer to the university of Leiden. He specialized in oriental books, but a few years later sold out to Bonaventura and Abraham, who in turn were appointed university printers – an honour which henceforth remained vested in the family. The first contemporary author published by the Elzevirs was Hugo Grotius, whose *Mare liberum* appeared in 1609. This side gained special importance in the Amsterdam branch of the firm, opened by Louis III, the

son of the Utrecht bookseller, in 1638. Bonaventura's son Daniel (1626–80) went with him into partnership, and, while the Leiden branch was slowly declining, gave a new lease of life and prosperity to the old name. Descartes, Bacon, Comenius, Pascal, Molière, Milton, Hobbes are among the eminent authors published by the Amsterdam Elzevirs. With Daniel's death (1680) the Amsterdam firm became extinct; but the survival of its fame is attested by the duodecimo edition of 1794 of John Locke's *Conduct of Understanding* which, though published in London, purported to be 'printed for Daniel Elsevier junior'. The Leiden branch survived somewhat longer, but under Abraham I's son, Jan (1622–61), and grandson, Abraham II (1653–1712), the business declined steadily and disappeared unhonoured and unsung on the latter's demise.

A branch of printing in which the Dutch – then the leading seafaring nation – excelled was the design and publication of maps and atlases. The very term 'atlas' was first used by Rumold Mercator, who in 1595 published the maps of his greater father, Gerhard (1512–94), under this title. In 1604 the Mercator plates were sold to Joost de Hondt, an Amsterdam engraver and map-dealer; he had worked for some years in London and there married the sister of Pieter van de Keere, another Dutch map-engraver who was to become more famous as the printer of the first English newsbook. From 1606 to the end of the eighteenth century, atlases published by the firm of Hondt were to be found all over Europe. Their most eminent rivals were the atlases published by another Amsterdam firm, that founded by Willem Blaeu (1571–1638) and continued by his sons Jan and Cornelis. Their *Atlas novus* (6 vols, 1634–62) and *Atlas major* (11 vols, 1650–62), which also appeared in German, French, and Spanish editions, were masterpieces alike of geographical science, typographical skill, and the engraver's art – a combination never surpassed by the more utilitarian products of modern cartographical institutes.

Another article of primary importance for the Dutch export trade in books was the 'emblem book' which, from about 1580, reached the height of its international vogue. It was the

superiority of Dutch engravers and printers in the production of illustrated books which made them paramount in this field. The *Sinnepoppen*, literally 'Dolls for the Spirit', which Roemer Visscher published in Amsterdam in 1614, is an attractive example; the 180 pictures by Claes Janszoon Visscher show objects from the everyday life of contemporary Dutch burghers and farmers. The first English emblem book, Geoffrey Whitney's *A Choice of Emblems and other Devices*, was therefore appropriately printed in the Low Countries; Plantin published it in Leiden in 1586. Even a generation later it was a Fleming by descent (though already a Londoner by birth), Martin Droeshout, who engraved the portrait of Shakespeare which formed the frontispiece of the First Folio of 1623.

It was again the Plantin press with its excellent craftsmanship which inaugurated the second wave of fashion of the emblem books. When their appeal to courtiers and nobles began to pall, their mottoes and pictures were adapted to devotional and educational purposes. Both the Jesuits and the Puritans quickly realized the good use they could make of the still prevailing mode of allegorical interpretation of spiritual and moral truths. Moretus's volume commemorating the first centenary of the Society of Jesus, *Imago primi saeculi Societatis Jesu* (1640), is the most sumptuous of these publications.

One Dutch firm whose origins go back to the 'golden age' has not only survived to this day but, in the fields of type-designing and printing, regained for the Netherlands of the twentieth century the position of international eminence the country occupied in the seventeenth century: Johann Enschedé & Zonen of Haarlem. Its founder, Izaak Enschedé (1682–1762), started a printing shop in 1703. From 1713 to the present, his firm has been printing the Book of Psalms for the Dutch Reformed Churches, and from 1737 to the present also the *Haarlemsche Courant*, the town's newspaper (founded in 1656) where Izaak had learned the trade; until 1869, members of the Enschedé family even edited the paper. Izaak's son, Johannes I (d. 1780), entered the business in 1719 and soon added to it a retail bookshop and the marketing of paper.

GESCHREVEN SCHRIFT.

Fr. Garmond à deux Points.

De Liefhebbers van Konsten en Weetenschappen zien hier het tweede, voor de Haerlemsche Lettergietery gesneeden, Geschreeven Schrift, door wylen den Heer JOAN MICHAEL FLEISCHMAN, den grootsten en konstigsten Letter-Stempelsnyder, die 'er ooit in de Waereld geweest is, en mogelyk komen zal, in 1768 voleindigt; zynde zyn laatste Konst-Werkstuk voor deze Lettergietery, en de laatste door hem ge= justeerde Matryzen. Zyn Naam en Konst zal, door zyne uitmuntende Letteren, die ten getale van ruim zeventig onderscheidene Schriften zig in de Haarlemsche Letter= gietery bevinden, na verloop van veele Eeuwen, nog door de Geleerde Waereld met roem vermeld worden.

Specimen of the 'second script-type', cut by J. M. Fleischmann for the type-foundry of Enschedé in Haarlem, 1768

However, father and son branched out in what was to become the backbone of the firm when, in 1743, they bought up the type-foundry of Hendrik Floris Wetstein of Amsterdam. This contained among other types several sets of roman and italic cut by J. M. Fleischmann, then the most popular and saleable letters in the international market. To them were later added hundreds of founts, nearly all produced by the best eighteenth-century punch-cutters such as Dirk Voskens, J. F. Unger, and Firmin Didot. In the nineteenth century, Johann Enschedé & Zonen (as the firm had been renamed in 1771) bought up the founts of Ploos van Amstel, which included the valuable Hebrew types once belonging to Joseph Athias, and the superb collection of matrices brought together by Pierre Didot. Their quality as printers was recognized when the Bank of the Netherlands entrusted them with the production of its bank notes in 1814 and the Dutch government with the printing of its postage stamps in 1866. New life and energy was infused in the business with the employment from 1923 to his untimely death in 1958 of Jan van Krimpen as type-designer and typographical adviser: as type-founders and printers Enschedé & Zonen is once again the peer of any firm in the world.

Printer's device of the firm of
Johann Enschedé & Zonen
in Haarlem

In contrast with the businesslike and comparatively liberal attitude of the Dutch authorities France maintained her lead thanks to the continuance of the conservative, centralized, and classicistic tradition going back to the patronage of François I, the scholarship of the Stephanus family, and the typographical canons established by Garamond and Granjon.

Louis XIII (1608–43) was as great a patron of the art of printing as François I had been a century earlier, but he lacked the easy-going ways and the intellectual curiosity of his ancestor, and generous support of printers and binders was to him exclusively a means of enhancing and glorifying royal absolutism. In 1620 Louis established a private press in the Louvre. In 1640 Richelieu made it a state-controlled office under the name of Imprimerie Royale and appointed as its first director the Paris printer-publisher Sebastien Cramoisy. Through all the vicissitudes of French history, changing its appellative to 'de la République' and 'Impériale', again to 'Royale', 'Nationale', 'Impériale', and finally back to 'Nationale', this foundation has remained to the present day the centre of French printing. *Éditions de luxe* of Thomas à Kempis's *Imitatio Christi* (1640) and of the complete works of Bernard of Clairvaux (1642) were the first-fruits of the new enterprise. They were later followed by collections of the Church Councils (37 vols), Byzantine authors (29 vols) and ancient writers expurgated 'in usum delphini' (64 vols), the *Médailles sur les principaux événements du règne de Louis le Grand* (1702), and other books exalting French history, as well as mathematical and scientific works – all characterized by the strict classicism of their contents and the austere beauty of their appearance.

Louis's patronage also extended to the folio edition of the Greek Fathers which the Société de la Grand' Navire, a syndicate of Paris booksellers, printed with the *grecs du roi* in 1624 and to the Polyglot Bible which was to outrival Plantin's *Biblia regia*. The political connexion which France had maintained

with the Turkish empire since François I's time facilitated the importation of oriental types as well as oriental scholars. Antoine Vitré was appointed *Imprimeur du roi pour les langues orientales* (1622), and the ten volumes of the French Polyglot displayed Armenian, Chaldee, Coptic, Samaritan, Syrian, and other early translations of the Scriptures, most of which had hitherto been unavailable in the West. A member of the Paris Parlement, Guy-Michel Le Jay, paid for the whole editorial and typographic work out of his own pocket. After Vitré's and Le Jay's death (both died in 1674) the precious oriental matrices went to the Imprimerie Royale in 1692.

The tendency of the absolute monarchy towards directing every aspect of the life of the subject did not overlook the book-trade. Louis XIII's ordinance of 6 July 1618 attempted a comprehensive regulation of the whole trade. The Chambre des Syndicats which it set up was to exercise functions very similar to those entrusted to the Stationers' Company sixty years earlier. But there was a telling difference: the French book-sellers were obliged to meet and deliberate in the presence of two crown officials, and for all practical purposes became an organ of the royal administration rather than a self-governing body. In order to facilitate the control, the number of licensed printers was finally restricted to 36 in Paris, 18 in Lyon and Rouen, 12 in Bordeaux. Censorship remained in the hands of the Sorbonne until the combination of absolutist and Gallican tendencies eventually led to its transfer to royal officials.

The stifling restrictions to which French publishing was subjected under the *ancien régime* resulted not unnaturally in the publishers' choosing the easy way of preferring fiction, poetry, and plays of recognized authors to the hazards of books which might bring upon their heads the wrath of the temporal or spiritual powers. But these French books played an important part in conditioning the rest of Europe to French taste and civilization, especially when, from the middle of the seventeenth century, French book-illustrators broke the hegemony of the Dutch engravers. Henri Estienne's treatise on *L'Art de faire les devises* (Paris, 1645), which epitomized and regularized the

DE
IMITATIONE
CHRISTI
LIBER PRIMVS.

Admonitiones ad spiritualem vitam vtiles.

CAPVT I.

De imitatione Christi, & contemptu
omnium vanitatum mundi.

QVI sequitur me, non ambulat in tenebris : dicit Dominus. Hæc sunt verba Christi, quibus admonemur, quatenus vitam

A

Thomas à Kempis, *De imitatione Christi*, the first publication
of the Imprimerie Royale in Paris, 1640

tradition of emblem books, at once gained European fame; an English translation, Thomas Blunt's *The Art of Making Devises*, appeared within a twelvemonth.

Soon French publishers were lucky to obtain the cooperation of the best artists of the time: Claude Gillot designed the ornaments for Houdar de la Motte's *Fables* (1719), François Boucher illustrated an edition of Molière (1734), Gravelot an Italian and a French *Decamerone* (1757), Joseph Eisen and Pierre-Philippe Choffard contributed the vignettes and miniatures to La Fontaine's *Contes* (1762) and Ovid's *Metamorphoses* (1767–71), Jean Baptiste Oudry, the animal painter, drew nearly 300 illustrations for La Fontaine's *Fables* (1755–9), Cochin *fils* illustrated Ariosto's *Roland furieux* (1775–83) – to mention only some outstanding achievements of fine-book production in France which are still the delight of every connoisseur. Baskerville and Bell turned to Paris artists for the illustration of their books.

The first collected edition of Voltaire's works, which came out in 1785–9 in seventy volumes octavo or ninety-two volumes duodecimo, is one of the epics of printing and publishing. It was planned and carried out by Pierre-Augustin Caron de Beaumarchais (1732–99), the author of *The Barber of Seville* and *The Marriage of Figaro*. For 160,000 francs he bought the copyright of all Voltaire's manuscripts from the Paris publisher Pancoucke to whom Voltaire had bequeathed the task of producing his collected works. For 150,000 francs he bought the entire equipment of Baskerville's press from the latter's widow, thus securing the best type of the eighteenth century for the century's greatest writer. From the Margrave of Baden he secured premises in the little fortress town of Kehl opposite Strasbourg, with privileges which made him all but the ruler of an independent principality. Beaumarchais then founded a *Société littéraire et typographique* of which he was the sole member. This society acted as the publicity agency of the Kehl publishing house, and a lottery with a first prize of 24,000 francs was one of its baits for attracting subscribers. The Empress Catherine II of Russia was to be the

FABLES

CHOISIES,

MISES EN VERS

PAR J. DE LA FONTAINE.

TOME PREMIER.

A PARIS,

Chez ⎰ DESAINT & SAILLANT, rue Saint Jean de Beauvais.
⎱ DURAND, rue du Foin, en entrant par la rue S. Jacques.

M. DCC. LV.

De l'Imprimerie de CHARLES-ANTOINE JOMBERT.

La Fontaine, *Fables*, illustrated by J.-B. Oudry, printed by
Ch.-A. Jombert in Paris, 1755

patron of the undertaking, and a set of Voltaire's works printed on parchment at the cost of 40,000 francs was dedicated to her. But Catherine objected to the inclusion of her correspondence with Voltaire, and her political dislike of Beaumarchais, the stormy petrel of the revolution, turned her also against his 'Voltaire figaroisé'. This taunt was without foundation, for considering the absence of modern bibliographical criteria, Beaumarchais's edition was a masterpiece of editorial skill as well as typographical achievement.

GERMANY

The Lutheran Reformation had spent its impetus by the middle of the sixteenth century; but Protestantism, and consequently the Protestant book trade, maintained its ascendancy over the intellectual life of Germany well into the beginning of the nineteenth century. This incidentally meant the shift of the centre of gravity from the south to central and north Germany. The barriers erected by the Habsburg and Wittelsbach rulers against the danger of heretical writings, it is true, gave the publishers of Vienna and Munich a monopoly within these dominions; but their influence on German life and letters was nil. It was not until Bartholomä Herder (1774–1839) sailed with the animating breeze of the 'catholic *Aufklärung*' that a catholic publisher took his place in the front rank of German publishing: the 14 editions of Carl von Rotteck's *Allgemeine Geschichte* (9 vols), which he published between 1812 and 1840, contributed more than any other single book to the political awakening of German liberalism and democracy.

But this belongs to a later period. From 1550 to 1800 typefounding, printing, publishing, and book-selling were almost Protestant preserves. This applies also to Frankfurt. Even when its book fair was ruined by the Jesuit censorship, Frankfurt retained a leading role in the production and marketing of types and in the design and printing of illustrated books. The reputation gained by the woodcuts published by Egenolff and Feyerabend was increased by the copper-engravings in which

werdē/ als Hertzog Eberhard/ Keyser Conrads/ Hertzogen
zu Francken / vnd Heinrici vorfahr / Bruder / vnd vnder
andern Hertzog Arnold auß Bayern / die jhm zuvor nach
Leib vnd Leben stunden / hernach seine beste vertrauwete
Freunde worden/ vnd jn für jren Herrn vnd Röm. Keyser
erkannt vnd gehalten. Als nun dieser Heinricus in ver-
waltung seines Reichs gemeynem Teutsch vnd Vatter-
land vorzustehen allen fleyß fürwandte / alle abtrünnige
vnd widerspenstigen straffte / die auffruhren vñ embörun-
gen/ so sich hin vñ wider erhuben/ stillete/ die vngläubigen
zum gehorsam vñ Christlichen Glauben vervrsachete/ vnd
darzu alle deß Reichs Fürstē jm hierin behülfflich zu seyn
beschriebe/ welche jren Pflichten nach erschienen / vnd das
Barbarisch Volck also bestritten/ hat er vnder andern dem
Hochgelobten Adel Teutscher Nation/ von wegen jres ge-
horsams vnd Mannlicher thaten/ zur ewigen gedechtnuß
das Ritterspiel der Thurnier/ so der zeyt bey den Teutschē
vnbekañt / aber doch in Britannia vnd anderßwo breuch-
lich/ in Teutschenlanden angefange/ auffbracht/ auch selbs
thurnieret / vnd ferrner die vier fürnembsten Teutschen
Resier oder Kreyß/ Nemlich deß Rheinstroms/ Francken/
Bayrn vnd Schwaben / sampt andern so darinn vnd da-
runder zum Heyligen Röm. Reich Teutscher Nation ge-
hörig/ begriffen/ mit sondern Freyheiten vnd Gnaden be-
gabet/ Bey welchē hernach alle folgende Römische Keyser
vnd Könige dieselben gelassen vnd gehandhabt/ ist auch in
krafft dero ob fünff hundert vnd achtzig Jarn/ biß auff den
letzten zu Wormbs gehaltnen Thurnier/ gethurniert vnd
erhalten worden. Das aber gemeldte Thurnier zu pflan-
tzung aller ehrbarn tugenden/ Ritterlicher vbung/ Mann-
licher thaten / zu außreutung aller schand vnd laster/ gute
Ordnung vnd Policey vnder den Christlichen Häuptern
vnd

Georg Rüxner, *Turnierbuch* (Book of Tournaments),
printed with a popular Fraktur type by Sigmund Feyerabend
in Frankfurt, 1566

Theodor de Bry (1528–98) and his sons Johann Theodor and Johann Israel excelled. Frankfurt craftsmanship was fed from the Low Countries and Switzerland. Theodor was a native of Liège; Johann Theodor's son-in-law, who was to outrival the de Bry firm, was Matthäus Merian from Basel (1593–1650). Far into the eighteenth century his descendants, especially his grandson, Johann Matthäus (1659–1716), carried on the tradition established by Matthäus in the fields of sumptuously illustrated folios. Two series gained special and well-deserved fame; both covered, or aimed to cover, the whole of Europe. The *Theatrum europaeum* (1633–1738) gave a chronicle of contemporary events, comparable with Edmund Burke's *Annual Register* (1759 to date); while the 29 volumes of the first edition (1642–72) of the *Topographia* is a priceless pictorial record of seventeenth-century towns, famous for the realistic as well as the artistic perfection of its 92 maps and 2,142 prospects.

As in the days of Anton Koberger, Nürnberg became once more the seat of a gigantic firm of printer-publishers. Georg Endter (1562–1630) founded it; his son Wolfgang (1593–1659) led it to its apex: it came to an end in 1717. The greatest production of the Endters was the 'Electors' Bible' of 1641, commissioned by Duke Ernest the Pious of Gotha and illustrated by Joachim von Sandrart, whose *Teutsche Akademie* (1675–9) has made him the father of German art-history.

Two more books of general importance which appeared over Endter's imprint are the Nürnberg poet Georg Philipp Harsdörffer's *Frauenzimmer-Gesprächspiele* (8 parts, 1644–9) which provided suitable material for polite conversation, and the same author's *Poetischer Trichter* (3 parts, 1647–53) which epitomized, as it were, the rule of reason in the sphere of poetry.

Duke Ernest originally intended to have the 'Electors' Bible' printed and published by the firm of Stern in Lüneburg, which was the greatest rival of the Endters in the German book trade of the seventeenth century. The house of Stern has the unique distinction of still, after nearly 400 years, being owned and run by the direct descendants of the founder, Hans Stern, who set up shop in 1580 and died in 1614. Bibles, theological tracts,

XCVIII.

Muséum. Das Kunstzimmer.

Muséum 1
est locus,
ubi *Studiosus*, 2
secretus ab hominibus,
solus sedet,
Studiis deditus,
dum lectitat *Libros*, 3
quos penes se
super *Pluteum* 4
exponit, & ex illis
in *Manuale* 5 suum
optima quæq; excerpit,
aut in illis

Das Musenzimmer 1
ist ein Ort/ ([Student] 2
wo der Kunstliebende
abgesondert von den Leuten/
alleine sitzet/
dem Kunstfleiß ergeben/
indem er liset Bücher/ 3
welche er neben sich
auf dem Pult 4
aufschläget / und daraus
in sein Handbuch 5
das bäste auszeichnet/
oder darinnen

Liturâ,

Amos Comenius, *Orbis pictus,* a schoolbook of
'Latin without tears', printed by Wolfgang Endter
in Nürnberg, 1654

197

hymn books, calendars, and almanacs were the backbone of the business; the Scheits Bible, named after the Hamburg engraver Matthias Scheits who contributed the 150 illustrations, was their most ambitious undertaking (1672). Their business extended as far as Amsterdam, Copenhagen, Stockholm, Danzig, Königsberg, Reval, Vilna – and even Nürnberg.

None of these places, however, could bear comparison with Leipzig, which from the middle of the seventeenth century became the centre of German book production and distribution.

Leipzig was favoured by its geographical position in the heart of central Europe, the privileges with which the Saxon government had endowed its trade fairs and the liberality with which the town council interpreted them, the importance of its university where the professors Gottsched and Gellert from 1730 to 1770 exercised a virtual dictatorship over the literary life of Germany, and last but not least the business acumen of its printers, publishers, and booksellers. The firm which Johann Friedrich Gleditsch (1653–1716) founded in 1694 continued until 1830, when Brockhaus bought it up. The firm founded by Moritz Georg Weidmann in 1682 owed its survival to the present day to Gleditsch's younger brother, Johann Ludwig (1663–1741), who married Weidmann's widow; he was also very active in persuading the leading Dutch booksellers to transfer their business with central and eastern Europe from Frankfurt to Leipzig. It was a partner of the house of Weidmann who gave the *coup de grâce* to the Frankfurt book fair when he dissolved his Frankfurt warehouse in 1764 and made other Leipzig firms follow suit. This man, Philipp Erasmus Reich (1717–87), known in his days as 'the prince of the German booktrade', has left his name in the annals of the trade as the inventor, one might say, of the 'net price' principle, as the indefatigable fighter against the pirate printers, and as the originator of the idea of a booksellers' association (1765) which eventually materialized in the Börsenverein of 1825. With Wieland's *Musarion* (1768) and *Agathon* (1773) and Lavater's *Physiognomische Fragmente* (1775–8), Weidmann crossed the threshold of the 'classical' era of German literature. But the

'age of Goethe' is represented in print chiefly by the three publishers, Göschen, Cotta, and Unger.

Georg Joachim Göschen (1725–1828) of Bremen opened his publishing house in Leipzig in 1785; Schiller's *Don Carlos* (1787), Goethe's *Iphigenie* (1787), *Egmont* (1788), *Tasso* (1790), the *Faust* fragment (1790), and the first collected edition of his writings (1786) appeared over his imprint. When Goethe and Schiller went over to Cotta, Göschen enticed Wieland from Weidmann, and between 1794 and 1802 brought out two editions (in quarto and octavo) of his works.

Johann Friedrich Cotta (1764–1832) was a descendant of Johann Georg Cotta (1631–92), a native of Saxony, who after his apprenticeship with Wolfgang Endter in Nürnberg set up in the Swabian university town of Tübingen in 1659, from where the firm moved to Stuttgart in 1810. Cotta met Schiller in 1793 and thereafter published most of his works, from *Die Horen* (1795) to *Wilhelm Tell* (1804). Goethe, introduced to Cotta by Schiller, made Cotta the principal publisher of his later works, from *Faust I* (1808) to *Faust II* (1832), and several collected editions (1806–8 etc.), culminating in the complete edition (60 vols) of 1827–42. On Schiller's recommendation Cotta also published Hölderlin's *Hyperion* (1797–9) and, later, the first edition of his *Gedichte* (1826), edited by Uhland and Schwab. He also launched the *Musenalmanach für 1802*, in which A. W. Schlegel and Tieck presented the poets of the Romantic school. But this venture proved a dismal failure as did Kleist's *Penthesilea* (1808), and Cotta henceforth fought shy of romantics and Romantics.

Johann Friedrich Unger (1753–1804) was too much engaged in his printing (1780), type-founding (1790), and newspaper (*Vossische Zeitung*, 1802) businesses to give much time to the publishing side. However, he has to his credit Goethe's *Neue Schriften* (7 vols, 1792–1800) – including *Reineke Fuchs* and *Wilhelm Meisters Lehrjahre* – Schiller's *Jungfrau von Orleans* (1802) – printed in roman at the express wish of the poet who objected to '*Ungers altdeutscher Eiche*' – and, above all, A. W. Schlegel's translation of Shakespeare (9 vols, 1797–1802,

Faust.

Ein Fragment.

Von

Goethe.

Ächte Ausgabe.

Leipzig,
bey Georg Joachim Göschen,
1790.

Title-page of the authorized edition of Goethe's *Faust-Fragment*,
printed in Fraktur type at Goethe's wish, published by
G. J. Göschen in Leipzig, 1790

Musen-Almanach

für

das Jahr 1798.

herausgegeben

von

SCHILLER.

———————————

Tübingen,

in der J. G. Cottaischen Buchhandlung.

Schiller's *Musenalmanach für 1798,*
printed in roman type at Schiller's wish, published by
J. G. Cotta in Tübingen, 1797

1810). Unger's untimely death caused the bankruptcy of his far-flung enterprises. It also deprived him of the honour of becoming one of the foundation members of the Börsenverein der deutschen Buchhändler (1825), in which all the other publishers and booksellers mentioned here took an active part.

THE ENGLISH-SPEAKING COUNTRIES

ENGLAND. From the time of Caxton to the middle of the sixteenth century and again from about 1560 to the beginning of the Civil War the book-buying public twice enjoyed eighty years of remarkable stability as regards the price of printed matter charged by the retail trade. The dividing line is the debasement of the coinage in the early 1540s, or rather its aftermath, for book prices have always lagged behind the rise of prices of other commodities. Chaucer's *Canterbury Tales*, for instance, was sold at 3s. unbound and 5s. bound from 1492 to 1545. The average level was 1d. for 3 sheets until 1550, and for 2 or 1½ sheets from 1560–1635, after which date book prices rose by about 40 per cent. Illustrated books were twice as expensive (per sheet) as unillustrated ones, and poetry was dearer than prose. Some famous Elizabethan books were retailed as follows: Ascham's *The Scholemaster* (1573; 6d.); Camden's *Britannia* (1594; 5s.); Castiglione's *The Courtyer* (1577; 2s. 4d.); Hakluyt's *Voyages* (1589; 11s. 11d.); Holinshed's *Chronicles* (1577; 26s.); Hooker's *Ecclesiasticall Politie* (1597; 6s. 6d. unbound); Lyly's *Euphues* (1581; 2s. unbound); North's translation of *Plutarch's Lives* (1579; 14s.); Spenser's *Shepherdes Calender* (1591; 1s. unbound); Shakespeare's *Venus and Adonis* (1573; 1s.).

In the history of the English book-trade the turn of the seventeenth to the eighteenth century was epoch-making. The lapse of the Licensing Act in 1695 and the passing of the Copyright Act in 1709 (with effect from 1 April 1710) were the two decisive events.

English literature, it is true, had not had to wait for the relaxation of the fetters imposed upon it by the Star Chamber or

the Stationers' Company, or for the legal protection secured to authors and publishers by act of Parliament. The Authorized Version of 'King James's Bible', all the Quartos and the four Folios of Shakespeare, Bacon's *Essays*, Milton's *Paradise Lost*, Bunyan's *Pilgrim's Progress*, Herrick's *Hesperides*, Sir Thomas Browne's *Religio Medici*, and Izaak Walton's *Compleat Angler* are only a few of the highlights of English seventeenth-century writing. But their interest is literary and historical; as achievements of the printer's art these books deserve as little respect as the greatest work of Spanish seventeenth-century literature, Cervantes's *Don Quixote*.

All these works of national literature were also satisfactory from the publishers' bread-and-butter point of view. Shakespeare was a success from the beginning, taking into account the limiting effect on sales of the then high price of £1 for the First Folio; Bunyan at once started as a best-seller. In between these two, however, the 'Catalogue of the most vendible books in England' (1657) acclaimed two writers who are now known only to the specialist of seventeenth-century literature, Francis Quarles and George Wither. Their most popular books appeared both in the same year, 1635, and each of them was a shining representative of a particular category of emblem books. Wither, the Puritan Parliamentarian, compiled *A Collection of Emblemes Ancient and Modern* which modified the moral tenets of chivalrous Elizabethans to suit the outlook of middle-class Roundheads. Quarles, the Anglican Royalist, brought up to Caroline standards the sentiments of Spenser and Sidney in his *Emblemes* and, 1638, *Hieroglyphikes of the Life of Man*. These were combined in a single volume in 1639, which was reprinted in 1643 and, after the interval of the Commonwealth when Wither proved more acceptable to the ruling taste, again in 1658, 1660, 1663, 1669, 1676, 1683, 1684, 1696, 1701, 1710, 1716, 1723, and as late as 1736, 1745, and 1777 – an illuminating commentary on the persistence of a literary fashion long after it has lost its intellectual and social impetus.

It is characteristic of the low quality of English book-work in this period that even the text of the Scriptures was affected

by the prevailing carelessness. Notorious examples are the Judas Bible of 1611, in which Matt. 26: 36 has Judas instead of Jesus, the Wicked Bible of 1632 ('Thou shalt commit adultery'), the Printers' Bible of 1702 ('Printers have persecuted me', Psalm 119: 161), and the Vinegar Bible of 1717 ('Parable of the Vinegar', Luke 20). The Reims Bible of 1582, a good specimen of Elizabethan prose, was treated with almost incredible levity by successive revisors, publishers, and printers. There is hardly an edition down to the present century in which single words, groups of words, or whole lines have not been omitted through sheer carelessness.

Dr John Fell (1625–86), dean of Christ Church, vice-chancellor of the university of Oxford, and bishop of Oxford, started the reformation of English printing. His acquisition of Dutch and French matrices has already been referred to; he also tempted a Dutch type-cutter to settle in Oxford where Fell, in 1676, attached a type-foundry to the University Press. With the publication of the first Oxford university *Almanack* and Anthony Wood's *Historia et Antiquitates Universitatis Oxoniensis* (both 1674), the Oxford University Press was set on its career as a prime promoter of fine and scholarly printing.

Even under the absolutism of the Stewarts the two university presses enjoyed a certain degree of latitude. Restrictions fell hardest upon the London printers who worked immediately under the eyes of the royal censor, the Star Chamber, and the Stationers' Company. Their number was fixed at 25 in 1586 and at 23 (with 4 foundries) in 1637 and reduced to 20 in 1662; it remained at this figure until 1695. In 1662 York was admitted as the fourth town of the kingdom where printers were allowed to exercise their craft. This restriction was relaxed during the Civil War when the need for producing royalist propaganda made Charles I take the King's Printers, Robert Barker and John Bill, and their presses with him to York and Shrewsbury. Between March 1642 and August 1643, they printed nearly 170 items in these two places.

The lapse of the Licensing Act in 1695 at last removed the anomalous restriction to the four cities and thus made possible

THE
Pilgrim's Progreſs
FROM
THIS WORLD,
TO
That which is to come:

Delivered under the Similitude of a

DREAM

Wherein is Diſcovered,
The manner of his ſetting out,
His Dangerous Journey; And ſafe
Arrival at the Deſired Countrey.

I have uſed Similitudes, Hoſ. 12. 10.

By *John Bunyan.*

Licenſed and Entred according to Order.

LONDON,
Printed for *Nath. Ponder* at the *Peacock*
in the *Poultrey* near *Cornhil*, 1678.

Title-page of the first edition of John Bunyan's
Pilgrim's Progress, published by Nathaniel Ponder
in London, 1678

the extension of the printing trade to the provinces. The foundries of John Baskerville in Birmingham, Fry and Moore in Bristol are among the leading firms in the middle of the eighteenth century. But Baskerville's equipment went to France after his death, and the firms of Fry and Moore soon moved to London. The contribution to English letters of provincial publishers was even more modest. Oliver Goldsmith's *Vicar of Wakefield*, it is true, came out in Salisbury in 1766. But Joseph Cottle of Bristol (1770–1853) is the only English publisher outside London whose name looms in the annals of English letters. The accoucheur of the Romantic movement, he ventured his slender means in the publication of Coleridge's *Poems* (1796), Southey's *Joan of Arc* (1796), and Wordsworth and Coleridge's *Lyrical Ballads* (1798). All three, however, placed their subsequent writings with London publishers. The tradition and the lure of the metropolis proved irresistible.

SCOTLAND. In the eighteenth century Scotland, too, obtained at last an honourable place in the annals of printing. Scotland had been almost the last of the civilized countries to see a printing press established within its frontiers; but, as it happened with Caxton in England, her first printers were natives. In 1508 Walter Chepman and Andrew Myllar set up a press in Edinburgh, and James IV at once granted them a protectionist tariff against English competitors. However, for two centuries Scottish printers were never serious rivals of either English or foreign craftsmen. Thomas Bassendyne (d. 1577), who published an edition of David Lyndsay and the first New Testament printed in Scotland, is an honourable exception; he used French and Dutch types.

Robert Waldegrave became the King's Printer in 1591 after he had been forced to leave England for publishing anti-episcopalian writings, including the Marprelate tracts. He printed King James VI's *Poeticall Exercises* (1591) and *Basilicon Doron*, the first edition of which was limited to seven copies for private distribution (1599). The first public issue, heavily revised, was published early in 1603, and after James VI had become James I of Great Britain, a London syndicate reprinted

A
SPECIMEN
OF THE
SEVERAL SORTS
OF
LETTER
GIVEN TO THE
UNIVERSITY
BY
Dr. JOHN FELL
LATE
LORD BISHOP of OXFORD.

To which is Added
The LETTER Given by Mr. *F. Junius.*

OXFORD,
Printed at the THEATER *A.D.* 1693.

Specimen book of the Dutch and French types procured by
Dr John Fell for the Oxford University Press;
with an appendix by the antiquary François du Jon

the book four times in the same year. Although the holograph is written in Scots – James never acquired a full command of English – Waldegrave printed it in English. Thus it came about that the *Basilicon Doron* was the first original English book to be translated into modern languages. The first French edition (1603, twice reprinted in 1604) was authorized by Robert Cecil and the English ambassador in Paris; though it seems that James never paid the fee he had promised to the translator. Three pirated editions appeared in the same years. There were also Dutch (two, 1603), German (1604), Swedish (1606), and, of course, Latin (London and Hanau (two), 1604) translations. A Welsh version (London, 1604) was interrupted by the outbreak of the plague; the Welsh publisher, Thomas Salisbury, fled from London and abandoned the work. For reasons difficult to explain, interest in the *Basilicon Doron* revived about 1680: the English edition was reprinted in 1682 (London) and the Latin version in 1679 and 1682 (both in Frankfurt-on-the-Oder).

Scotland came into her own only after the Union with England. In 1713 there was published in Edinburgh a *History of the Art of Printing*, the first history of typography in the English language, though actually for the greater part a translation from the Frenchman Jean de la Caille's *Histoire de l'imprimerie* (Paris, 1689). The author was James Watson (d. 1722), the publisher of the *Edinburgh Gazette* and the *Edinburgh Courant* and of a collection of *Comic and Serious Scottish Poems* (1706-11). Watson advocated the importation of Dutch pressmen to improve Scottish printing, and he completely ignored English printing past and present, as he opined that the southern kingdom's 'own writers are very capable to do themselves justice'.

It was, however, Glasgow and not Edinburgh which, from 1740 to 1775, assumed the rank of the printing metropolis of Scotland. Here the brothers Robert (1707-76) and Andrew (1712-75) Foulis (originally spelt Faulls and always pronounced 'fowls') occupied a position as booksellers, printers, publishers, and editors not dissimilar to that of the Aldus, Amerbach,

A DECREE

OF
Starre-Chamber,
CONCERNING
PRINTING,

*Made the eleuenth day of July
last past.* 1637.

❡ Imprinted at London by *Robert Barker,*
Printer to the Kings moſt Excellent
Maieſtie: And by the Aſſignes
of *Iohn Bill.* 1637.

Star Chamber decree on printing, printed by Robert Barker,
King's Printer, in London, 1637

Froben, and Estienne of an earlier age. Apart from theological tracts, the brothers specialized in philosophy – to this day a strong suit with Scots publishers and customers – and classical, mostly Greek, authors in their original languages and in translations. Their scholarly ambition is evident in the care devoted to proof-reading; every sheet was scrutinized six times, thrice in the office and thrice by the two university professors whom the brothers employed as editors. While their presswork in general equalled the standards of the better English, French, and Dutch presses of the time, the Foulises' special claim to fame rests upon their influence upon the development of title-page layout which, so their historian says, 'can scarcely be overestimated'. The Foulis title-page, with 'no lower case, nor italics, nor two sizes of capitals in the same line', constituted a veritable 'revolution'. By 1795, when Andrew the younger, Robert's son, closed the business, the firm had published some 700 books and pamphlets. Of these, the *Homer* of 1756–8 and *Paradise Lost* of 1770 'are two of the best examples of the dignified simplicity of eighteenth-century printing'.

Part of the excellence of the Foulis press is due to its founts, which were cut and cast by Alexander Wilson of St Andrews (1714–86). Giovanni Mardersteig's 'Fontana' type, designed for Messrs Wm Collins, is based on one of Wilson's founts. His roman and italic types closely followed Caslon, while his Greek founts imitated Garamond's *grecs du roi*. The happy co-operation between the university printers and the university type-founder set a standard from which Scottish printing has never receded.

AMERICA. One of Caslon's and Baskerville's early admirers was Benjamin Franklin, the first American printer of note. Printing had been introduced to the New England colonies as late as 1638. In that year Joseph Glover, formerly rector of Sutton in Surrey, imported a press and three printers from Cambridge, England, to Cambridge, Massachusetts. Glover himself died on the voyage, but Stephen Daye and his sons Stephen and Matthew set up their press under the auspices

of the president of Harvard College, who had married Glover's widow. The first print produced in an English colony was fittingly the form of an 'Oath of Allegiance to the King' (1639); the first book came out a year later as *The Whole Booke of Psalmes*, commonly known as the Bay Psalm Book. Twenty years later a second press was imported from England, again to Harvard College which had secured for Cambridge, Massachusetts, the sole privilege of printing. In 1663, John Eliot, a graduate from Jesus College, Cambridge (1604–90), had his translation of the Bible into the Indian language printed by Marmaduke Johnson, the first professional master-printer in the Americas. Johnson also broke the privilege of Cambridge and in 1674 moved his press to Boston. His example was followed by the London Quaker, William Bradford, who in 1685 set up the first press in Philadelphia and in 1693 in New York. But it took another seventy years before Georgia, as the last of the Thirteen Colonies, acquired a press in 1763.

By this time printing had also spread to Canada. The first press was established at Halifax, Nova Scotia, by Bartholomew Green Jr of Boston; but owing to his premature death it fell to his partner, John Bushell, to start the first Canadian newspaper, the *Halifax Gazette*, on 23 March 1752; it was suppressed in 1766 for its opposition to the Stamp Act. Most early newspapers in the Maritime Provinces and Upper Canada were short-lived, but the two oldest journals of Lower Canada have survived to this day. The *Quebec Gazette*, founded in 1764 by William Brown and Thomas Gilmore and now incorporated in the *Quebec Chronicle-Telegraph*, can boast of being the oldest newspaper in the Americas; the runner-up is the *Montreal Gazette*, first published in 1778 as *La Gazette du Commerce et Littéraire*. Its founder, Fleury Mesplet (1734–94), had learned the printing trade in his native Lyon, whence he went to Paris where his republican and anti-clerical sentiments brought him into conflict with the authorities, set up shop in London in 1773, and in the following year let himself be persuaded by Benjamin Franklin to emigrate to

THE

VVHOLE
BOOKE OF PSALMES
Faithfully
TRANSLATED *into* ENGLISH
Metre.

Whereunto is prefixed a difcourfe de-
claring not only the lawfullnes, but alfo
the neceffity of the heavenly Ordinance
of finging Scripture Pfalmes in
the Churches of
God.

Coll. III.

*Let the word of God dwell plenteoufly in
you, in all wifdome, teaching and exhort-
ing one another in Pfalmes, Himnes, and
fpirituall Songs, finging to the Lord with
grace in your hearts.*

Iames v.

*If any be afflicted, let him pray, and if
any be merry let him fing pfalmes.*

Imprinted
1640

Title-page of the 'Bay Psalm Book', the first book published in
English America, printed by Stephen Daye
in Cambridge, Mass., 1640

M. T. CICERO's

CATO MAJOR,

OR HIS

DISCOURSE

OF

OLD-AGE:

With Explanatory NOTES.

PHILADELPHIA:

Printed and Sold by B. FRANKLIN,

MDCCXLIV.

Title-page of Benjamin Franklin's typographical masterpiece, printed
with Caslon type specially imported (Philadelphia, 1744)

Philadelphia. In 1776 he moved to Montreal, which the rebels expected to join the United States, but his revolutionary zeal landed him in jail. His enterprising vigour, however, was unbroken. Beside the *Montreal Gazette* he printed some seventy books in Latin, French, English, and the Iroquois language.

AUSTRALIA. The first printing press was taken to Sydney by Governor Phillip in 1788, but unfortunately the necessity for including a printer amongst those sent out with the avowed intention of founding a colony was overlooked, and it was not until the arrival of Governor Hunter in 1795 that in one George Hughes a suitable person was found to start a printing office. The first extant example of his work is a play-bill, *The Recruiting Officer*, dated 8 March 1800, in which the name of G. Hughes appears as a performer. Printing proper started with the arrival of a creole from the West Indies, George Howe. Howe worked from a room at Government House, his plant being used solely for printing government edicts until 5 March 1803, when he obtained permission from Governor King to publish the first Australian newspaper, the *Sydney Gazette and New South Wales Advertiser*; the paper continued until 1842 when a period of industrial depression killed it.

SOUTH AFRICA. For more than a century the sparse population of the Cape were content with reading matter, chiefly of a religious character, imported from the Netherlands. In 1784 a German bookbinder in the service of the Dutch East India Company, by the name of Christian Ritter, set up a small press in Cape Town. He issued an almanac (1796) and other trifles. The British who wrested the colony from the Batavian Republic began the publication of an official weekly gazette in 1800. It was produced by the merchant firm of Walker & Robertson. A year later the government bought up the press and has since continued to publish the gazette. The first book printed in South Africa was a Dutch translation of a tract by the London Missionary Society (1799). The first literary production was a short poem, *De Maan*, by a Dutch pastor, Borcherds, of Stellenbosch (1802).

3. PUBLISHERS AND PATRONS

THE gradual divergence of printer, publisher, and bookseller can be traced through the various forms which the imprint has taken. All three agents still appear until the end of the seventeenth century in a combination such as: 'Printed by Tho. Cotes, for Andrew Crook, and are to be sold at the black Bare in Pauls Church-yard' (Thomas Hobbes's *Briefe of the Art of Rhetorique*, 1637). It can usually be assumed that the bookshop to which buyers were thus directed was controlled by the publisher. This is confirmed by the imprint of another book by Hobbes, which runs: 'Printed for Andrew Crooke, and are to be sold at his shop, at the Sign of the Green-Dragon in St Paul's Church-yard, 1662.' It is a sign of the growing importance of the publisher over the printer that the latter's name most easily disappeared from the imprint. Thus the first edition of Cervantes's *Don Quixote* (1605) only refers to the publisher and the bookseller: '*En Madrid, por Iuan de la Cuesta. Véndese en casa de Francisco de Robles, librero del Rey.*' On the other hand, the first Shakespeare folio mentions the printers only: 'Printed by Isaac Iaggard, and Ed. Blount, 1623.' Rarest is the omission of the publisher's name in favour of those of the printer and bookseller, as in 'Printed and Sold by B. Franklin', when it is to be inferred that the actual risk of the production – the publisher's main function – was also borne by the same man. On the other hand, W. S. Landor paid himself for the production of his *Poems from the Arabic and Persian*, which came out in 1800 as 'Printed by H. Sharpe, High Street, Warwick, and sold by Messrs Rivingtons, St Paul's Church Yard'. But the phrase 'Printed for William Crook at the Green Dragon without Temple-Bar' is the version which remained most commonly in use until book-publisher and bookseller, too, parted company. The improved organization of the retail trade made it unnecessary for the publisher to rely on the goodwill of any special retailer. A Leipzig publisher, in 1717,

seems to have taken the lead in boldly advertising that his publications are 'available in every bookshop'. Since that time, the fact or fiction that every bookseller of repute has, or at least ought to have, his books in stock has become part and parcel of the modern publisher's publicity.

The occasions when printer and publisher are identical have become increasingly rare. In these cases, whether it is a historic relic or a conscious pride in the art of typography, the imprint

Printer's device used by the
Oxford University Press
from 1630;
coat of arms of the
'Academia Oxoniensis';
motto 'Dominus illumina-
tio mea' (Ps. 27: 1)

Printer's device of the
Cambridge University Press,
first used by John Legate
in 1600:
'Alma Mater Cantabrigia';
motto 'Hinc lucem et
pocula sacra'

almost invariably stresses the fact that the book is published by its printer rather than that the printing has been done by its publisher. '*Typis Johannis Baskerville*', '*Impresso co' caratteri bodoniani*', '*De l'Imprimerie royale*', '*Druck und Verlag von B. G. Teubner*' are typical examples.

Similarly, the publishing firms maintained by the universities are generally known by the name of the printing establishments. For 'Cambridge (or Oxford) University Press' actually refers only to the printing-house run by the respective university, whereas the Syndics in Cambridge and the Delegates in Oxford have the general responsibility for printing, publishing, bookselling, and paper-making. Oxford maintains an addi-

EL INGENIOSO
HIDALGO DON QVI-
XOTE DE LA MANCHA,

Compuesto por Miguel de Ceruantes Saauedra.

DIRIGIDO AL DVQVE DE BEIAR,
Marques de Gibraleon, Conde de Benalcaçar, y Baña-
res, Vizconde de la Puebla de Alcozer, Señor de
las villas de Capilla, Curiel, y
Burguilios.

Año,

1605.

CON PRIVILEGIO,
EN MADRID, Por Iuan de la Cuesta.

Véndese en casa de Francisco de Robles, librero del Rey nro señor.

Title-page of the first edition of Cervantes's *Don Quixote*,
printed by Juan de la Cuesta in Madrid, 1605

tional 'Publisher to the University' who is free to publish books other than those approved by the Delegates; Oxford also uses, in the Clarendon Press, another, separate publishing imprint.

Originally the university authorities had been content to let the printer's name stand for the academic publishers. 'Printed by Tho: and John Buck, printers to the University of Cambridge', or 'Cambridge, printed by John Baskerville, Printer to the University', was the usual wording. Thomas Thomas, who in 1583 was appointed the first official printer to the university, emphasized his position by showing the arms of the university on his title-pages. His successor, John Legate, replaced it by a baroque device, embodying the motto of *Alma Mater Cantabrigia* (herself appearing as a not very alluring precursor of a Girton athlete). Thomas's and Legate's designs have since remained the devices of the Cambridge University Press.

From the relationship between printer and publisher we now turn to that between publisher and author. Both these professions may be said to have become established in the modern connotation of the terms, so far as Great Britain is concerned, as a result of the Copyright Act of 1709, 'An Act for the encouragement of learning by vesting of the copies of printed books in the authors or purchasers of such copies during the times therein mentioned'. The main beneficiaries of the Act were the authors. For the first time their work was recognized as a valuable commodity for which they could claim the protection of the law and as a property of which they could dispose in the open market to their best advantage. However, the petition for the Copyright Act came from the publishers. They, in fact, profited hardly less than the authors by the security which the law now accorded to the buyer as well as to the seller of intellectual produce. The ensuing disappearance of pirating printers permitted the publisher to fix the prices of his wares at a level which at the same time ensured him of a reasonable profit and permitted him to let his author share in it.

These legal changes had far-reaching social results. The old patronage on which authors and printers had to a large extent

THE BIBLE:
THAT IS,
THE HOLY
SCRIPTVRES CON-
teined in the Old and New
TESTAMENT.

TRANSLATED AC-
cording to the Hebrúe and Greeke,
and conferred with the best transla-
tions in diuers languages.

PRINTED BY IOHN
Legate, Printer to the Vni-
uersitie of Cambridge.

Anno Do. 1591.
Maij 29.

Title-page of the 'Bishops' Bible', printed by John Legate,
printer to the University, in Cambridge, 1591

relied gradually disappeared. The place of the individual patron was taken by the public at large. In order to reach the public, novel ways of publicity had to be developed and older ones to be intensified. Advertisements, prospectuses, stock-lists, general and particularized bibliographies, critical – if possible, favourable – reviews in newspapers and periodicals: all these and other kinds of publicity had henceforth to be adapted to the needs, or supposed needs, of an ever-increasing clientele of ever more varying and unpredictable tastes. The expiration of the original copyright statute in 1731 was prob-ably responsible for the sudden upsurge of serial publications in 1732. Moxon's *Mechanick Exercises*, a teach-yourself series, and Henry Care's *Weekly Pacquet of Advice*, Protestant propa-ganda pamphlets, both starting in 1678, seem to have been the earliest forerunners of books which could be bought in instal-ments; and this system has remained attractive to publishers and booksellers as well as to the thrifty consumer.

The rewards to the successful publisher and the successful author increased correspondingly. The publisher who, through shrewdness or good luck, correctly gauged what the public wanted, or succeeded in making the public want what he had to offer, could now order his printer to strike off copies by thou-sands instead of hundreds. The author who wrote the right kind of book for the right kind of publisher and got himself established with the public was now able to live on his royal-ties. No longer had he to pursue his literary work in the time he could spare from his duties as an official, a teacher, a clergyman; nor had he to abase himself before king, prelate, nobleman, or city father. That at least is the view accepted since Dr Johnson's day; he defined the individual patron as 'a wretch who supports with insolence and is paid with flattering'.

Until the middle of the eighteenth century it was considered bad manners to write for cash remuneration instead of for reputation. Up to that time only a few writers had ever received a fee from their publishers; and if they received it they were anxious to hide the fact. Erasmus, for instance, was deeply

hurt when some Italian colleagues hinted that Aldus Manutius had paid him for a book; and he violently defended himself against similar insinuations on the part of Hutten and others. In fact, Erasmus was quite shameless in wringing money out of wealthy patrons. His three visits to England were each time prompted, as he coolly stated, by expectations of 'mountains of gold'. He certainly received single gifts and annual pensions amounting to several thousands of present-day pounds sterling from the king, archbishop, bishops, lords, and dons. These benefits were only surpassed by Erasmus's self-conceit and ingratitude. Luther never received so much as a farthing for his hundreds of books and pamphlets. Thomas Murner, the Roman Catholic pamphleteer, seems to have been the first to receive a fee for his *Geuchmatt* in 1514.

The usual way by which an author either solicited favours to come or returned thanks for favours received was the dedication of a work to an individual or a corporation. In fact, these dedications and subsequent rewards were a regular item in the budget of dedicators as well as dedicatees. Thus, in 1502, the humanist poet, Conrad Celtis, received 20 guilders from the city council of Nürnberg for 'the pains' he took over his pamphlet in praise of the imperial city. The Council of Zürich had thirty-eight books dedicated to it between 1670 and 1685; and the expenses of the councillors on this account, like those of others in authority, are not to be distinguished from the sums which are provided for the encouragement of art and literature in the budget of the modern state.

The dedication of the 'unpolished lines' of *Venus and Adonis* to 'so noble a godfather' as the Right Honourable Henry Wriothesley, Earl of Southampton and Baron of Tichfield; of the 'untutored lines' of *The Rape of Lucrece* to the same; and of the Sonnets to their 'onlie begetter', the mysterious 'Mr W.H.', gives a faint idea of the self-abasing adulation which an aspiring author felt obliged to express. Shakespeare's attitude can still be justified by the natural bashfulness of any poet who presents to the world 'the first heir of his invention' as well as on account of the social conventions of the first Elizabethan

age. For the patronage extended to men of letters in the six-teenth century was far less a matter of literary connoisseurship than of political propaganda. The Earl of Leicester, who headed the anti-Cecil faction at Elizabeth's court, had up to a hundred books dedicated to him; nearly all of them were practical manuals, historical dissertations, religious tracts – in short, useful books, designed to further the causes in which the patron was engaged. The writers, compilers, or translators of these treatises were mostly men who wanted to display their aptitude for certain posts in state or church: and preferment rather than money was in fact their usual reward.

However, the fulsomeness of a dedication usually stands in inverse ratio to the literary merits of the production as well as the literary discrimination of the person to whom it is dedi-cated. In very few cases can there be assumed a genuine con-nexion between the dedicatory page and the following text. On the whole, the dedications are only indicative of the kind of people from whom the author expected some tangible reward. They were, in fact, not infrequently altered from edi-tion to edition, and there are even issues of the same edition with different dedications imprinted.

By the eighteenth century the lack of personal sentiment had led to the fixing of a kind of piece-rate tariff. It ranged normally from five to twenty guineas, with single poems at the bottom and theatrical plays at the top of the scale. More was expected when royalty accepted a dedication. Laurence Echard received £300 from George I for the dedication of his *History of England* (1707) and Benjamin Hoadly £100 from George II for that of his comedy, *The Suspicious Husband* (1747). On the whole, Thomas Gordon (d. 1750) neatly summed up the hollowness of these cash-and-carry dedications when he wrote: 'I have known an author praise an Earl for twenty pages together, though he knew nothing of him but that he had money to spare. He made him wise, just and religious for no reason in the world but in hopes to find him charitable; and gave him a most bountiful heart because he himself had an empty stomach.'

About the middle of the century the dedication for monetary

reward died out and was replaced by the genuinely respectful or genuinely affectionate inscription which it has remained. When Henry Fielding dedicated his *Historical Register* (1737) to the public at large, he epitomized the development from 'the great' to 'the multitude' (as Dr Johnson called it) as the author's abiding paymaster and patron.

One of the reasons for the disappearance of individual patronage was its inherent tendency towards confusing literary merit and political expediency. Even the eponymous patron of all patrons, Maecenas, gently made his Virgil, Horace, Propertius support and glorify the political programme of the Emperor Augustus. In Augustan England patronage was as much a weapon of party politics as a means of furthering literature. Authors as well as their patrons can be distinguished fairly clearly on the party lines of Whig and Tory. Lord Somers, who drafted the Declaration of Rights in 1689 and the treaty of Union with Scotland in 1707, and Charles Montagu, Earl of Halifax, who ruled Exchequer and Treasury under William III and George I, befriended Addison, Steele, Congreve, Prior, Vertue, Locke, and Newton in the Whig interest. Robert Harley, Earl of Oxford, and Henry Saint-John, Viscount Bolingbroke, the Tory leaders under Queen Anne, bestowed their favours upon Dryden, Pope, and Swift. Whereas these men at least combined their services to a political group with genuine conviction, smaller men did not scruple to sell their pens and their consciences to the highest bidder.

It was a symptom of the decline of genuine interest in literature for literature's sake that the patrons of both parties indulged in their benefactions chiefly at the taxpayer's expense. Addison was rewarded with a secretaryship of state; Steele and Congreve with various commissionerships, the latter also with the secretaryship of Jamaica; Matthew Prior was employed in the foreign service and rose to the rank of ambassador; Swift obtained the deanery of St Patrick's, Dublin, and missed a bishopric by his misplaced hopes for a return of the Tories. Alexander Pope occupied a singular position. His patrimony was large enough to make him entirely independent of the need

for soliciting monetary rewards; and his membership of the Roman church, anyway, barred any political preferment. Thus he was able to describe himself

> above a patron, though I condescend
> Sometimes to call a minister my friend.

Rather, he nobly employed his position as a man of letters who was at the same time on terms of equality with the rich and mighty to serve his fellow-authors, to encourage the self-esteem of publishers, and to advance the alliance between author, publisher, and public.

A peculiar English way of rewarding an author's political services and incidentally gratifying his vanity was the post of poet laureate. Dryden obtained it in 1668 for his adherence to the Stewart restoration and lost it in 1688 to his Whig rival, Thomas Shadwell; Laurence Eusden received it in 1718 in recognition of his wedding ode for the Duke of Newcastle, the past-master of political corruption; Colley Cibber achieved the laureateship in 1730 for his lifelong devotion to the 'Venetian aristocracy' and especially for his anti-Jacobite play *The Non-Juror*. Even Wordsworth (1843) and Tennyson (1850) owed their appointment to their loyalism rather than their poetic genius. It needed the ludicrous interval of Alfred Austin with his twenty-odd volumes of unreadable verse to take the laureateship finally out of the political arena and clothe it with a dignity of which even a great poet, such as John Masefield, may be proud.

The very closeness of the connexion between literary patronage and political jobbery brought about its end. For from Robert Walpole until the Reform Bill of 1832, the governments of every shade of opinion found it more efficacious to bribe journalists and members of the House of Commons directly instead of through the circuitous route of plays, pamphlets, and poetry. Walpole himself, moreover, was devoid of literary interest: Edward Young and John Clay were the only two poets upon whom he bestowed favours out of the public purse. During the 1760s George III and the Marquess of Bute made

a transitory attempt to revive official patronage: Gibbon was made a Lord Commissioner of Trades and Plantations (worth £700 per annum), Robertson received the sinecure of Historiographer Royal for Scotland (£200), and Hume was appointed an Under-Secretary for Scotland. Bute paid the printing costs of Macpherson's *Fingal* and *Temora* and appointed their author secretary to the Governor of West Florida in the year 1764.

But by this time the court and the aristocracy had lost interest in the society of authors. Writers ceased to mix with the mighty. Even an intellectual nobleman like Horace Walpole sneered at 'indolent Smollett, trifling Johnson, piddling Goldsmith' and smugly stated, 'how little have they contributed to the glory of a period in which all arts, all sciences are encouraged and rewarded'. No wonder that the writers repaid snobbery with savage satire, as in Churchill's lines:

> They patronize for fashion sake – no more,
> And keep a bard just as they keep a whore.

Johnson roundly declared: 'We have done with patronage.'

The first tract on *The Case of Authorship by Profession or Trade, stated with regard to Booksellers, the Stage, and the Public* (1758) by the American-born Whig pamphleteer and historian, James Ralph, took, it is true, a dim view of 'the last profession that a liberal mind would choose'. But this opinion was getting obsolete at the very time when it was so forcefully stated by a journalist disappointed in his political and financial expectations. For some of the greatest free-lances of all ages, Dr Johnson in England, Voltaire in France, and Lessing in Germany, were now making authorship a full-time, respectable, and self-supporting profession.

As a matter of fact, writers could now afford to do without either the occasional or even the regular support of titled patrons. For the professional, i.e. the publisher, now outbade the amateur in terms of ready cash. The fees and royalties of authors were rising all the time, since publishers were now able to reap the fruits of the Copyright Act. When considering the

sums paid to eighteenth-century writers, the reader should keep in mind that, according to Dr Johnson's estimate – and he knew what he was talking about – the cost of living averaged only some £30 a year. Although the great Doctor cynically stated that he never wrote but for 'want of money which is the only motive of writing I know of', he also admitted that 'the booksellers are generous, liberal minded men'. In fact, he had no reason for complaint about his rewards. He received 10 guineas for *London* (1738), 20 guineas for *The Vanity*, £125 for *Rasselas* (1759), an additional 100 guineas above the stipulated fees for the *Lives of the Poets*, and £1,575 for the *Dictionary* (1755).

In the field of fiction, Henry Fielding probably did better than any other writer. His *Joseph Andrews* (1742) brought him £183 10s. 10d., *Tom Jones* (1749) £700, and *Amelia* (1752) £1,000. The two French and one Dutch translation of *Tom Jones* which appeared in the same year, 1750, yielded nothing to the author in the then state of lawlessness of international copyright; but they may have reassured his publisher as to Fielding's hold on the public. When Oliver Goldsmith never got out of debt the fault lay with his extravagance rather than any meanness on the part of his publishers. It is true he received not more than 60 guineas for *The Vicar of Wakefield*; but then it must be remembered that this was a complete loss to the publisher, who, after three editions, was still out of pocket by £2 16s. 6d. Goldsmith obtained £150 for *The Good-natured Man*, £250 each for his histories of Rome and Greece, £500 for his English history, and 800 guineas for the *History of Animated Nature*. This order may seem deplorable on grounds of literary merit, but it reflects the prevailing interest of the reading public which the publisher's cashier cannot leave out of sight. History, natural history, travels, biographies were in greatest demand. The quack doctor and vitriolic pamphleteer 'Sir' John Hill is said to have made an annual income of £1,500 by his compilations on medicine, botany, horticulture, pharmacy, naval history, and other subjects for which there was a market during the years of his prolix activities, 1750–75.

William Robertson commanded £600 for his *History of Scotland* (1759) and £4,500 for his *Charles V* (1769). Out of the *History*, which ran into fourteen editions before Robertson's death in 1793, his publisher, Andrew Millar, made a net profit of £6,000; the first American reprint in 1811 is said to have sold 75,000 copies. Millar also rewarded Hume with £3,400 and Smollett with £2,000 for their respective histories of England. William Strahan, Millar's compatriot and sometime partner, ventured £500 each on Sir James Steuart Denham's *Inquiry into the Principles of Political Economy* (1767), the exposition of mercantilism, and Adam Smith's *Wealth of Nations* (1776), the bible of free trade.

Strahan was also the publisher of Gibbon's *Decline and Fall*. The first edition was originally fixed at 750 copies, but had been reduced to 500 when printing began in June 1775. It then happened that Strahan began to read the manuscript – and immediately raised the printing order to 1,000. The first volume came out on 17 February 1776 at the price of a guinea and sold within a fortnight. Out of the six volumes, the last three of which were published on 8 May 1788, Gibbon netted about £9,000.

The migration to London of Scottish publishers was partly the result of the attitude of the London trade, which sometimes approached a boycott of Scottish books. Hume's *History*, for instance, hung heavily on the hands of its first Edinburgh publisher, who could sell fewer than fifty copies in London within a twelvemonth. Its signal success began when the expatriate Scotsman, Millar, took over the book.

The flowering of English eighteenth-century literature is closely related to the growing personal interest publishers began to take in 'their' authors. The first publisher to give his firm a profile of its own, Jacob Tonson (1656–1736), was originally a bookseller in Chancery Lane. He acquired the copyright of Milton's *Paradise Lost* and his edition of 1688 put the greatest epic in the English language in circulation: the original publisher, Peter Parker, had sold the 1,300 copies of the first edition between August 1667 and April 1669 but waited until 1674

before bringing out a new edition. Tonson became the publisher of Dryden, Otway, Addison, Steele, Pope, Rowe, and through their works and his own famous *Miscellany* did as much for the Augustan age as did Cotta for German classicism a century later. Barnaby Bernard Lintot (1675–1736) took up the same line, and, sometimes in partnership with Tonson, brought out Pope, Gay, Farquhar, Rowe, Parnell, and Fenton among others. Robert Dodsley (1703–64), alone and with his brother James, became the publisher of Pope, Akenside, Anstey, Churchill, Young, Goldsmith, Shenstone, Sterne, Bishop Percy, and Johnson. He suggested to the Doctor the idea of an English Dictionary, and secured Edmund Burke as the editor of the *Annual Register*. Robert Dodsley had started in life as a footman and made his name as versifier and playwright. Alexander Pope helped him to set up as a publisher, and it is probably due to his own earlier experiences that Dodsley showed himself a generous friend of his authors. He paid Edward Young £220 for *Night Thoughts* (1742), Charles Churchill £450 for *The Duellist* (1763), Bishop Percy £300 for the *Reliques* (1765), and returned to Christopher Anstey the copyright of the extremely successful satire, *New Bath Guide* (1766), in addition to a fee of £200. Like almost every publisher, Dodsley once slipped up. He refused to accept *Tristram Shandy* for the modest fee of £50; but he atoned for this blunder by taking the book for £650 after Sterne, with the help of a loan, had got the first two books into print at a jobbing press in York (1760). Dodsley's anthologies of plays and poems by 'old authors' did much to revive interest in Elizabethan literature besides Shakespeare.

A peculiarity of seventeenth- and eighteenth-century publishing was the cooperative association. Partnerships had been a characteristic of the trade from the very beginning. Originally, as with Gutenberg and Fust, this was no doubt due to lack of capital on the part of the printer-publisher, but later it was probably caused chiefly by the wish to spread the risk of any publishing venture of uncertain prospects. Here, France led the way in the early seventeenth century when syndicates were

as easily founded for a particular enterprise as they were quickly dissolved after its achievement. The first folio edition of Shakespeare's plays in 1623 was such a joint enterprise of the four London publishers William Jaggard, Edward Blount, John Smithweeke, and William Apsley. It seems that the driving force behind the great venture was William Jaggard's son, Isaac (born 1595), who had just published the first English translation of Boccaccio's *Decameron* (1620, reprint 1625). The publishers may have entered upon the enterprise with some misgivings for the only previous folio edition of plays was by no means a success: Ben Jonson's *Workes*, thus published in 1616, had to wait until 1640 before a second edition was deemed salable. But the Jaggards and their partners proved justified.

Characteristic of the English partnerships or 'congers' of the eighteenth century is their business-like organization, including the restriction of membership to genuine publishers who freely bought and sold shares. Johnson's *Lives of the Poets* was thus sponsored by thirty-six booksellers, his *Dictionary* by a conger of seven; but in 1805 a one-hundred-and-sixtieth share of the latter book was sold. This is an extreme case, but shares of one twenty-fourth were quite common. Thomas Longman, the founder of the firm of Longmans, Green & Co., was an adept at manipulating these congers; John Rivington and John Murray are others who started the subsequent fortunes of their firms this way.

The congers eventually disappeared because the increasing wealth of individual publishers made them face the inevitable risks of their trade with less apprehension, and chiefly because by the end of the century the spirit of cooperation had given way to the fierce tenets of unrestricted competition.

The eighteenth century, however, did not close before it had produced what, but for the genius of the man, would have been an incomprehensible anachronism. John Bell (1745–1831) deserves a niche of his own in the history of letter-founding, inking, printing, publishing, and binding no less than in the history of journalism (newspapers as well as

periodicals), bookselling, and popular education. Not only did the man try his hand in every one of these professions – which by this time had become each an almost self-contained craft of its own – but he gained for himself a lasting reputation in more than one of them.

It is to John Bell, the zealous educationist, enterprising publisher, and adept editor, that we owe *The British Theatre* (21 vols, published in weekly issues from 1776), the *Poets of Great Britain from Chaucer to Churchill* (109 vols, 1777–92), and the *Constitutional Classics* (1813; including a complete Blackstone) – three series which even after more than 150 years have not been entirely superseded.

To John Bell the letter-founder we owe the 'Bell type' which Richard Austin designed for him in 1788 and which, after having fallen out of favour with the English public, gained an immense popularity in America, whence it eventually made a return to England.

But the 'Bell type' was only a side-issue of Bell's indefatigable activities in the world of books and newspapers. He revolutionized the whole typography and display of the English newspaper. He was the co-founder or sole founder of half a dozen morning, evening, and Sunday papers. He quarrelled with every associate, but not before he had made them accept his reforms. One of his foundations was *The Morning Post* (1772), which survived until 1937 as one of three London papers of distinction. His *English Chronicle* in 1786 and his *The World* in 1787 banned from the newspaper world the long 'ſ' which Bell had first dispensed with in his *Shakespere* edition of 1785. Bell was the first printer to realize that a newspaper is read at a speed and for purposes different from the reading of a book; and he drew the typographical conclusions. His newspapers broke up the solid setting of the book-page and gave prominence to the paragraph as the unit on which the newspaper-reader's interest is centred. No higher tribute can be paid to Bell, the printer-journalist, than that *The Daily Universal Register* immediately in 1787 copied every feature of typography and layout of *The World* and remained

THE
Universal
DAILY
Register,

Printed Logographically
By His Majesty's Patent

NUMB. 1.] SATURDAY, JANUARY 1, 1785. [Price Two-pence Halfpenny.

SHIPPING ADVERTISEMENTS

To the Public.

TO bring out a New Paper at the present Day, when so many others are already established and condemned in the public opinion, is certainly an arduous undertaking; and no one can be more fully aware of its difficulties than I am...

(body text largely illegible)

Front-page of the first number of the *Daily Universal Register* 1 January 1785; renamed *The Times or Daily Universal Register* on 1 January 1788, and *The Times* on 18 March 1788. The address 'to the public' was written by John Walter I, who printed the paper at his Logographical Press

dependent upon it even more (if that was possible) when on 1 January 1788 it changed its name to *The Times*. The only item *The Times* did not take over until fifteen years later was Bell's most sensible exclusion of the long 'ſ'. Thus John Bell may well be described as the godfather, however unwilling, of what was to become the greatest newspaper in the world.

4. OFFICIAL AND PRIVATE PRESSES

THE profit-motive, which has openly or surreptitiously animated printers and publishers from Gutenberg's time to the present, can more accurately be described as a hopeful expectation of balancing the dubious prospects of uncertain gain and far more certain loss through investing capital in presses, paper, and publications. Long before unprofitable political theorists declared the profit-motive the eighth deadly sin, attempts had been made to run the book-trade on a non-profit-making basis.

In some cases the promoters of such enterprises actually intended to break into the regular trade, to overthrow its monopoly, to force down prices, and in general to benefit a public which they regarded as insufficiently cared for by the ordinary publishing firm. Such was the case, for instance, with the Society for the Encouragement of Learning which was founded in 1736 but succumbed to the united opposition of the trade after twelve years. Dr John Trusler, an indefatigable projector in the fields of theology, medicine, journalism, and typography (in which he can be credited with the design of a 'script type'), also tried his hand at revolutionizing the book-trade. In 1765 he established the Literary Society which 'was to print works of reputation at their own risk and give the authors all profits arising from the same'. The fanciful notion that either the public or the author or both would be better off without the publisher never loses its attraction to perfectionist reformers. The Society for the Diffusion of Useful Knowledge pur-

sued similar aims, but the tremendous success of its *Penny Magazine* (1832–45) and *Penny Cyclopaedia* (1833–44) was chiefly due to the enthusiasm and business acumen of its publisher, Charles Knight. The modern book clubs are to some extent the heirs of these associations.

Publication by subscription was another method of excluding the publisher as a middleman and of making the profits flow direct into the author's pockets. This seems to have come into use early in the seventeenth century. The London grammarian and lexicographer, John Minsheu, produced his *Guide to* [eleven] *Tongues* (1617) by subscription. His contemporary, John Taylor, the 'water poet', did the same with his poems. The custom reached its widest application in the eighteenth century. Expensive works, the success of which was difficult to forecast, were usually undertaken by subscription. The two translations of Homer which for more than a century determined the conception of heroic poetry in England and Germany were thus offered to the public. Both proved a signal success to their author-publishers. Pope made £5,320 out of his English *Iliad* (1720); Voss had 1,240 subscribers for the first edition of his German *Odyssey* (1781).

However, the commonest form of publishing outside the trade is by means of official and private presses. Official presses are usually run by governments or public corporations such as universities; private presses mostly by individual enthusiasts or groups of like-minded people. In every case the owners of these presses produce what their political or scholarly requirements and their literary or typographical predilections make them wish to produce. Considerations of profit always play a minor role, although the managers of official presses and the patrons of private presses are known not to be averse to a favourable balance-sheet.

Official presses became firmly established in the second half of the sixteenth century. The first presses of this kind, those installed at the Sorbonne by Heynlin and Fichet in 1470, and in Alcalá university by Cardinal Ximenes in 1508, did not survive the tenure of office of their first patrons and therefore

failed to found a tradition. This was brought about by the Roman Curia.

Pius IV called Paul Manutius, Aldus's son, to Rome in 1561 to act as technical adviser to the press which the pope intended to make the fountain-head of catholic propaganda. Cardinal Reginald Pole's posthumous *De Concilio* was Paul's first publication in Rome (1562). But Paul lacked the business acumen of his father, and the beginnings of the Stamperia Vaticana were by no means promising. It was left to the organizing genius of Sixtus V to put the papal press on sure and enduring foundations. The bull *Immensa aeterni Dei* of 22 January 1587 created the congregations of cardinals which have since carried out the government of the Church of Rome; and one of these departments was expressly charged with the control of the Vatican Press. Aldus Manutius the younger, Paul's son, was put in its charge. The revised *Vulgate* was the first-fruit of the press. Sixtus himself had read the proofs; but he had also rashly tampered with the text, on which a commission of scholars had spent many years. The edition which Sixtus pronounced the only valid and authentic one was therefore scrapped soon after the pope had died. His emendations were perhaps not quite as bad as his enemies asserted. But the experts whom the amateur had offended happened also to be members of the Society of Jesus which Sixtus, a Franciscan monk, had cordially disliked. Academic vanity and sectional antagonism therefore avenged themselves simultaneously. In 1592 a fresh commission brought out the 'Clementine Vulgate', which is still the official Roman Catholic Bible.

The Congregatio de Propaganda Fide, founded in 1622, set up its own printing press in 1626. This 'Tipografia della Congregazione de Propaganda Fide' printed exclusively books for the mission field and therefore needed types in virtually every language. Its first director, Stefano Paolino, was a type-cutter by profession. He threw himself heart and soul into the new venture, and his first specimen book of 1628 already contained the founts of some twenty Asian and African languages, the very names of which were probably unknown to Paolino's

fellow-printers elsewhere. By the end of the eighteenth century this number had increased to forty-four. This office gave Giambattista Bodoni his first training as a typographer. The depredations of the French revolutionaries destroyed this unique printing establishment. '*Pour enrichir la France*', punches, matrices, types, and other equipment were sequestrated in 1799 and 1812, and handed over to the French Imprimerie Nationale, where they still remain.

The Imprimerie Nationale is in fact the oldest surviving secular government press. It evolved from the king's private press which Louis XIII in 1640 transformed into the Imprimerie Royale. This origin has always been reflected in the Imprimerie's primary concern with fine printing. Its publishing side has been confined to the production of *éditions de luxe* and monumental series which did not interfere with the activities of private firms.

The two English university presses go back to the reign of Elizabeth I, in Cambridge (1583) and Oxford (1585), although these precise dates do not really correspond with the complicated history of these institutions. Cambridge was first led into a publishing experiment by Richard Bentley about 1700, but this proved a costly failure, and it was not until 1872 that the Syndics became publishers in the full sense. Both as printers and publishers the Cambridge and Oxford University Presses have become the pattern on which other university presses (including those in the United States) have modelled themselves. However, the pre-eminence which both presses enjoy in respect to their typographical achievements, as well as their list of publications, is of recent growth, dating from the appointments of Bruce Rogers, Walter Lewis, and Stanley Morison in Cambridge, and of Horace Hart and John Johnson in Oxford. The fame of Dr Fell, Richard Bentley, and John Baskerville obscures the fact that their efforts to raise the standard of the university presses did not set up a lasting precedent. While those men were in charge both Oxford and Cambridge were in the van of good printing in England. But during the greater part of the sixteenth to nineteenth centuries

neither Oxford nor Cambridge was conspicuous for its design.

The university presses are rivals of the 'profit-making' publishers chiefly in school and university textbooks. The greater part of their publications is of a strictly academic nature and has little 'commercial' attraction. The only books for which the two presses have always commanded a wide market are the Bible and the *Book of Common Prayer* of the Church of England, for which the university presses (and the Queen's Printers) have the exclusive copyright in England (the legal position regarding the printing of Bibles in Scotland is quite different and fairly incomprehensible to the Sassenachs). This side was so important in Oxford that a special department, the Bible Press, was in 1688 separated from the general or Learned Press; Horace Hart reunited them in 1906.

A unique feature in the history of Oxford University Press deserves mention. The first Earl of Clarendon (1609–74) left the manuscript of *The True Historical Narrative of the Rebellion and Civil Wars in England* to the university, of which he had been chancellor in 1660–7. His son, the first Earl of Rochester, saw it through the press in 1702–4 and, after the passage of the Copyright Act, obtained a special Act of Parliament by which this one book was excepted from the liberalization of the copyright and vested perpetually in the Oxford University Press. This pious but ill-advised step has ever since excluded from the open market a masterpiece of English historical writing – a warning example of the bad effects of monopolism in the realm of the mind.

The existence of private presses can be traced to three causes: interest in artistic typography, production of works which, for one reason or other, are unsuitable for the ordinary trade channels, and riding a hobby-horse for the fun of it. Dr Desmond Flower (who has thus defined private printing) would also bring under this heading books which have been ordered and paid for by some enthusiast, such as the Emperor Maximilian's *Theuerdank*, printed by Schönsperger in 1517, and Archbishop Parker's *De antiquitate ecclesiae*, printed by

John Day in 1572, as well as books sold by subscription. But it seems more appropriate to limit the term to those presses which work exclusively under the orders – and often with the active participation – of one principal who is usually the owner of the establishment. If this definition is accepted, von Löhneysen, the director of the Brunswick mines in the Harz mountains, may have been the first private printer. In 1596 he set up a press of his own in Zellerfeld on which he printed a number of stately tomes on mining and horsemanship. The private press of Louis XIII of France has already been mentioned. In the eighteenth century private presses became a fashion with the aristocracy, and Madame de Pompadour's press at Versailles is as inconsequential in the history of printing as was Marie-Antoinette's Arcadian model farm in the development of agriculture.

There were only two noteworthy private presses in the eighteenth century – both in England. The one was that which Horace Walpole ran from 1757 to 1789 at his country seat of Strawberry Hill near Twickenham. It started auspiciously with some odes by Thomas Gray and included not only much ephemeral and second-rate writings of Walpole himself, but also his more enduring bio-bibliographies of *Royal and Noble Authors* and *Engravers*, the valuable *Anecdotes of Painting in England*, and, above all, *The Castle of Otranto* (1764), which started the 'gothic' novel of horror and mystery.

On the other hand, the books which William Blake (1757–1827) produced with his own hand are as unique in their technical execution as in their literary content. He drew and engraved each page as a whole, text as well as illustrations, very much in the manner of the early fifteenth-century block-books, and he also reverted to colouring by hand. He thus tried to combine the individualism of the medieval scribe with the technical advantages of mechanical reproduction. His typographic achievement is of the highest order, but it is the achievement of a solitary genius and is as inimitable as his poetry.

5. THE READING PUBLIC

THE emergence of the 'good and generous master' of the authors, as Oliver Goldsmith about 1760 called 'the public collectively considered', is a combined result of the Enlightenment and the Industrial Revolution. Rationalism infected the rising middle class, at least in the second generation, with a desire for intellectual improvement. The secular and empiric background of both rationalism and industrialism determined the literary trend of the age. '*Goût*', '*gusto*', '*Geschmack*', 'taste' became the catchword and criterion by which Europe now judged personal manners as well as literary productions. The elegant discourse replaced the ponderous argument; the novel became the chief vehicle of literary entertainment.

Down to the end of the seventeenth century, both literacy and leisure were virtually confined to scholars and 'gentlemen'; during the eighteenth century, the commercial middle class and especially womankind acquired a taste for reading; and the introduction in the nineteenth century of compulsory school attendance ever widened the circle of potential readers whom the Welfare State of the twentieth century has eventually given the social conditions in which to enjoy reading.

The seventeenth century made some decisive moves towards a broadening of general education. The name of the Czech educationist, Amos Comenius (1592–1671), here stands first. He outlined the principles of primary education which have been followed by teachers ever since; and his *Orbis pictus* (1654) was the first picture-book especially designed for children. The petty dukedom of Weimar was the first country to demand compulsory school attendance, at least on principle, in 1619. It was not until a hundred years later that Prussia introduced this principle as the first great power (1717). England did not follow suit until 1870, but this deficiency was compensated for by the endeavour of private individuals and voluntary societies. From the charity schools instituted by the

Society for the Promotion of Christian Knowledge (1699), the Sunday schools inaugurated by the printer Robert Raikes at Gloucester (1780), the academies set up by Quakers, Methodists, and other dissenting bodies, there came forth an ever-increasing number of potential readers.

In 1791 the London publisher James Lackington made an entry in his diary which neatly expounds the bookseller's point of view: 'The sale of books in general has increased prodigiously within the last twenty years. The poorer sort of farmers, and even the poor country people in general who before that period spent their winter evenings in relating stories of witches, ghosts, hobgoblins etc., now shorten the winter nights by hearing their sons and daughters read tales, romances etc., and on entering their houses you may see *Tom Jones*, *Roderick Random*, and other entertaining books, stuck up in their bacon-racks etc. If John goes to town with a load of hay, he is charged to be sure not to forget to bring home *Peregrine Pickle's Adventures*, and when Dolly is sent to market to sell her eggs, she is commissioned to purchase *The History of Joseph Andrews*. In short, all ranks and degrees now read.'

As will be shown in subsequent chapters, the lending library took a prominent place in satisfying this growing demand for reading matter; and a glance at the best-sellers of the time indicates that the novel gave greatest satisfaction to the greatest number of readers.

But the new literacy did not draw its nourishment only from novels. From the middle of the seventeenth century onward, a calendar, with some miscellaneous information and a few pious thoughts, began to make its way annually into the houses of people whose literary needs were easily satisfied. The oldest calendar of this type still being published is the 'Miners' Calendar' printed in Goslar from 1650. The educationists of the Enlightenment transformed these almanacs into vehicles of popular instruction for the lower classes. Practical advice for home and garden and field spread the advances of human and veterinary medicine and of scientific agriculture and husbandry; philosophical ideas were embodied in homely essays,

stories with a moral purpose, and didactic poetry. Some of the miscellanies achieved a huge success. Benjamin Franklin's *Poor Richard's Almanack* (Philadelphia, 1732–64) sold more than 100,000 copies. Of a similar publication (though on a decidedly lower intellectual plane) in Germany, Zachariah Becker's *Noth- und Hilfsbüchlein für Bauersleute* (1788), 150,000 copies were sold by 1798 and a million by 1811.

Lackington's proverbial John and Dolly would certainly be charged to buy next year's calendar when they went to the Christmas Fair. But during the rest of the year they were as likely as not to be told to bring home from the market town also the latest number of *The Star*, *The Oracle*, *The World*, or *The Times*. For by the end of the eighteenth century the periodical press had come to be regarded as a regular accompaniment of everyday life.

6. THE PERIODICAL PRESS

THE desire for quick information and for regular entertainment brought into existence the periodical press. The former was catered for by the newspaper, the latter by the magazine or 'periodical' in the narrower sense. Both owed their origins to the business instinct of the printers. They realized that 'the swift currents of the age', of which statesmen and scholars were complaining from the beginning of the sixteenth century, required new channels of expression. They also realized that there was in being a public which was not at all frightened by the rapids but eager to shoot them. And the printers were determined to canalize these swift-running waters so as to turn their own mill-wheels.

Hand-written 'news-letters', containing miscellaneous political and economic information, circulated freely between the headquarters and branch offices of the big trading companies of the first half of the sixteenth century. The news-letters of the Augsburg firm of Fugger were even made available to favoured

Hereafter enſue the trewe encountre or
Bataple lately don betwene. Englade and
Scotlande. In whiche bataple the. Scottiſ-
ſhe. Kynge was ſlayne.

¶ The maner of thaduaūceſynge of mylozd of
Surrey tzeſourier and. Marſhall of. Englande
and leuetenūte generall of the nozth pties of th
e ſame with. xxvi. M. men to wardes the kyn-
ge of. Scottꝭ and his. Armye vewed and nom
bzed to an hundred thouſande men at the leeſt.

Illustrated news-pamphlet on the battle of Flodden Field,
printed by Richard Faques in London, 1513
(Unique copy in the University Library, Cambridge)

241

outsiders whom it was thought desirable to make see events and trends as the Fuggers saw them. From the middle of the century onward, speculative printers took the decisive step of transforming these private news-letters into public news-books, which soon developed into news-sheets and eventually newspapers.

The earliest English news-book – or more properly, newspamphlet – is *The trewe encountre* of the battle of Flodden Field, printed by Richard Faques in London soon after the event (9 September 1513). The Anglo-Scottish wars of the 1540s produced more pamphlets of this kind, including one of the earliest eye-witness accounts which Richard Grafton published on 30 June 1548. However, all these were *ad hoc* publications concerned only with one topical event of general interest, and without intent of being followed up. Such newspamphlets became more frequent towards the end of the century when a French correspondent remarked in one of them that 'you in England expect newes with everie happie winde'. Between 1590 and 1610 some 450 English news-books are known to have been issued; over 250 of them still survive in at least one copy.

Very soon, however, the two main characteristics of the newspaper, as we understand the term, established themselves, namely, miscellaneous contents and periodicity of appearance. As early as 1566 there appeared news-sheets in Strasbourg and Basel which were numbered and thus declared themselves as parts of a series.

The editor, publisher, and agent (but not printer) of a series of unnumbered news-sheets, which appeared between 1594 and 1615 in Augsburg, deserves mention for an interesting experiment in the field of periodic publications. Samuel Dilbaum, born in Augsburg in 1530, started in January 1597 a monthly under the title of 'Historical Relation or Narrative of the most important and noteworthy actions and events which took place here and there almost in the whole of Europe in the month of —, 1597'. The text was arranged under headings such as Netherlands News, French History, Events in England, Span-

ish Affairs; and each number comprised from six to twelve leaves. Periodicity was intended as is shown by 'trailers' advertising the contents of the next issue; it was maintained throughout the year at the end of which a special title-page for all twelve numbers was supplied. However, this remarkable attempt to produce a kind of 'Annual Register' in monthly instalments lapsed after its first year, and only one complete set has survived. The unfortunate choice of the little Swiss town of Rorschach on Lake Constance as the place of printing may have contributed to the failure, and the printer, Leonard Straub (1550–1606), seems to have been more enterprising than prudent – he had learned the trade in the houses of Froschauer in Zürich and Froben in Basel, and became the first printer in St Gall, but never got out of the financial troubles which he brought upon himself by the installation of a large paper-mill in 1582.

Newspapers proper made their first appearance with the *Avisa-Relation oder Zeitung*, printed in Wolfenbüttel, and the *Relation* of the Strasbourg printer Johann Carolus, both of which started publication in January 1609. The Wolfenbüttel *Aviso* was founded, directed, and (at least partly) written by Duke Heinrich Julius in furtherance of his policy of reconciling the Protestant and Catholic factions; edited in Prague, where the duke spent his last years (d. 1613) as the emperor's councillor, it contains much first-hand political intelligence. The third-oldest newspaper now known is the *Gedenckwürdige Zeitung* which came out from May 1610 in or near Cologne.

A decade later, 'corantos' (as they were usually called) began to spread. Dutch printers were the first in the field; and *Krant* is still the common Dutch term for newspaper. They turned to good account the well-organized network of foreign correspondents who supplied the Dutch East India Company and the States General of the United Provinces with commercial and political intelligence. From 1618 the *Courante uyt Italien, Duytslandt, etc.* and a year later its rival, the *Tijdinghen uyt verscheyde Quartieren*, came out once or twice weekly. In 1620 Amsterdam printers also brought out corantos in French

and English. It was only in 1631 that the first French news-book, *Nouvelles ordinaires de diuers endroits*, was printed in Paris by the booksellers Louys Vendosme and Jean Martin. Their sheet was however speedily killed by Théophraste Renaudot's *Gazette* which was supported by Cardinal Richelieu.

English printers did not wait for official encouragement. Some months after the Dutch map-engraver and printer Pieter de Kèere had started the first English-language news-book (of which sixteen issues have survived), the London stationer Thomas Archer printed English corantos in London. The first number seems to have come out in the summer of 1621, but Archer's corantos are known to us only from references in contemporary letters.

Nathaniel Butter, who in 1604 became a freeman of the Stationers' Company, must therefore be regarded as the father of English journalism. His father and his widowed mother had occasionally brought out some 'reports' on topical events, and nearly half of the 200 items Butter published from 1602 under his own imprint – they include the first edition of *King Lear* (1608) and Chapman's *Homer* (1616) – are news-tracts relating to happenings in India, Russia, Persia, Sweden, at sea and at home. His first 'Corante, or, newes from Italy, Germany, Hungarie, Spaine and France' came out on 24 September 1621. He continued for twenty years to publish Corantos, Avisos, Passages, Newes, Relations, etc., 'at the sign of the Pied Bull at St Austin's Gate'. They included the first English series of news-books to be numbered and dated: 50 issues running from 15 October 1622 to 2 October 1623, printed mostly by Bartholomew Downes for a syndicate of which, beside Butter, Nicholas Bourne and Thomas Archer were the most permanent members, as is the case with the greater part of Butter's periodical publications.

As can be seen from the changing titles, the publishers did not yet rely on a permanent 'trade-mark' but rather expected to attract customers by fresh stimulants – the function now apportioned to the headlines. Nor must the term 'weekly news' be pressed too closely. At the end of 1631 and the begin-

Avisa
Relation oder Zeitung.

Was sich begeben vnd
zugetragen hat / in Deutsch: vnd Welschland / Spannien / Niederlandt / Engellandt / Franckreich / Vngern / Osterreich / Schweden / Polen / vnnd in allen Provintzen / in Ost: vnnd West Indien etc.

So alhie den 15. Januarij angelangt.

Gedruckt im Jahr / 1609.

The first newspaper, edited in Prague by Duke Heinrich Julius of Brunswick-Wolfenbüttel and printed by Julius Adolph von Söhne in Wolfenbüttel, 1609–12

ning of 1632 for instance, Butter and Bourne issued 'the continuation of our weekely intelligence' on 9, 10, 19, 22, 29 November, 8 and 17 December, 2, 12, 19, 24, 30 January, 8, 13, 24, 27 February. 'The wind and seas', an editor frankly admitted, was the main reason for this irregularity as the arrival of news depended entirely on the arrival of boats. In this respect, English journalists were behind their continental brethren who were better situated to keep to definite days of publication. Butter's pledge to his reader 'to keepe a constant day every weeke' had soon to be modified by 'or at least every fortnight if the poste keepeth his course'.

In every other respect, however, English news-writers and news-printers (in the words of the Swedish scholar Folke Dahl) 'were miles ahead of almost all of their continental colleagues'. There are especially two features which have remained a distinguishing mark of English news-sheets. There are the easy and friendly terms prevailing between editors and readers, which started in the 1620s by editors taking the readers into their confidence and led to the readers putting their confidence into 'letters to the editor'; and there is the skilful layout of the news-sheets, which 'gave evidence of a truly journalistic inventive genius' in compelling the prospective reader's attention. For instance, number 44 of 21 August 1623 of the Butter and Bourne series displays the following items of 'Our last weekly Newes':

What hath last hapned in the Empire betweene the Emperor and the Princes. The state of Tillies and Brunswicks Armies since the last encounter. The King of Denmarks Preparations. Count Mansfields fastnesse. Together with other businesse of the Low Countries and the Grisons. The Election of the new Pope. The Turkish Pyracies. And certaine prodigies seene in the Empire.

This sweeping survey of the various European theatres of war (with a creditable emphasis on the two most sensitive danger spots, the Low Countries and the Alpine passes), the recognition of the news value of a papal election and of marvels transcending the course of nature, as well as the reference to

The certaine Newes

of this present Weeke.

BROVGHT BY SVNDRY

Posts from seuerall places, but chiefly
the progresse and arriuall of Count *Mansfield*
with the Duke of *Brunswicke* into *Champeney* in
FRANCE; and the ioyning of sundry of the
Princes with them, &c.

With the preparation of the French

King to resist him: And what great feare Count
MANSFIELDS vnexpected arriuall hath
put all FRANCE in, &c.

Out of the best Informations of Letters and
other, this second of August 1 6 2 2.

LONDON,
Printed by *I. H.* for *Nathaniel Butter*, and are to
be sold at his shop at the signe of the *Pide Bull*
at *S. Austins* Gate. 1622.

One of the series of news-books, published by Nathaniel Butter
between 1621 and 1632; this number printed by I[ohn] H[aviland]
an unscrupulous tycoon and execrable printer

the danger to trade and shipping in the Mediterranean – the selection of these headlines would not be unworthy of our leading national newspaper.

At the same time Messrs Butter and Bourne also knew of the special appeal of national sentiment. Reporting the victorious campaign of Gustavus Adolphus of Sweden in 1631-2, their 'forraine avisoes' seldom fail to mention 'perticular exploits by some gentlemen of our nation', such as the raids of 'the Lord General the Marquis Hamilton' into Silesia or the wounding of the Lord Craven and the death of Lieutenant-Colonel Talbot at the storming of Kreuznach. The prominence accorded to these English and Scots officers is proof enough of the journalistic abilities of the editors; for the Dutch and French dispatches, on which the English news-writers were dependent, are not likely to have fussed about the handful of foreign volunteers in the Swedish army.

The undisguised enthusiasm of the editors for the success of the anti-Habsburg powers was their undoing. The Spanish and Austrian agents in London 'vext at the soule', launched official complaints, and Charles I, himself mortified by the indirect criticism of his policy of appeasement at any price, had all news-books suppressed by Star Chamber decree (17 October 1632). The ban was only lifted on 20 December 1638, and on the same day Butter and Bourne brought out a 96-page issue.

Beginning with the battle-scene which adorned Faques's *Trewe Encountre*, illustrations are frequently to be found in news-books and news-sheets. A Belgian printer, Abraham Verhoeven of Antwerp, was the first to introduce illustrations as a regular feature of news-sheets. His *Nieuwe Tijdinghen*, which began to appear in 1620, had the page of contents adorned with simple woodcuts meant to whet the onlooker's appetite by display as well as innuendo. The first illustrations inserted in English newspapers were of a decidedly political design: the Commons assembled in Parliament, portraits of the King and Queen and Prince Rupert were among the inducements that might tempt Englishmen in 1643 to buy a copy

of *A Perfect Diurnall of the Passages in Parliament*, of which the picture was a kind of nascent 'masthead'. The *Mercurius Civicus* went further: it changed its blocks frequently and brought them into real relationship with its news items. However, for another 150 years illustrations in newspapers were few and far between. It was only from the beginning of the nineteenth century that illustrations became a regular feature of the periodical press.

After the middle of the seventeenth century the news-book was superseded by the news-sheet. The *Leipziger Zeitung*, which began publication in 1660 and continued until 1921, and the *London Gazette*, which has come out since 1665, were among the first thus to take into account the taste of a new class of readers. For the change of format and make-up was not a matter of typographical convenience; on the contrary, the production of sheets of an uncommon size must have posed some awkward technical problems. It was rather an outward sign of change which the reading public was undergoing at this period. The scholar ceased to be the main representative of the literate and literary public: the man of the world, the *homme de bon ton*, became the client to whose taste the discerning publisher adapted himself. The politician, business man, or man about town, who frequented the fashionable coffee-houses in London, Paris, Leipzig, and Hamburg, had neither the leisure nor the inclination to obtain the latest intelligence from books; he preferred the sheet which, being really only a sheet, showed him more or less at a glance what news the *Pegasus* or the *Post Boy* had to relate.

The same urge towards easier and quicker access to informative reading matter which changed the compact news-book to the volatile news-sheet was instrumental in creating the periodical magazine. For the magazine is in effect a 'book in instalments' and therefore, according to the reader's inclination and mental equipment, may serve equally well as a less exacting substitute for, or a gentle introduction to, the more solid fare. As a child of the age of rationalism, the periodical has preserved the tenets so dear to its philosopher-parents, namely the

spreading, as far as possible and in the most acceptable manner, of 'enlightened views on God, Mankind, and the Universe'. This aim may be difficult to detect in some of our contemporary periodicals, but the failure to recognize the useful instruction offered by 'comic papers' and the like may lie in the eye of the beholder.

Philosophy and learning were the main subjects that filled the pages of the first periodicals. They sprang up almost simultaneously throughout Europe. In Germany the Hamburg theologian and poet Johann Rist started his *Monatsgespräche* in 1663, in France Denis de Sallo, a member of the Paris Parlement, launched the *Journal des sçavans* in 1665, in England the *Philosophical Transactions* came out in the same year under the auspices of the Royal Society, and in Italy Francesco Nazzari issued the Roman *Giornale de' letterati* in 1668.

Soon, however, the *Mercure galant* (1672; renamed *Mercure de France* in 1714) led the way into wider fields, including among its features court and society news, literary criticism, and original poetry. The *Athenian Mercury* (1691) and the *Gentleman's Journal* (1692) were its first English counterparts. Christian Thomasius, the leading German rationalist, in 1688 edited in Leipzig a periodical, the long-winded title of which indicates its outlook and purpose as well as those of many of its successors: 'Entertaining and serious, rational and unsophisticated ideas on all kinds of agreeable and useful books and subjects.' Thomasius expressly welcomed women among its readers, and it did not take long to bring into existence periodicals which addressed themselves exclusively to the fair sex, such as the *Ladies' Mercury* (1693), the *Female Tatler*, a companion piece of Steele and Addison's journal, or Gottsched's *Die Vernünftigen Tadlerinnen* ('The Rational Woman-Critics', 1725).

By the early years of the eighteenth century the periodical press, newspapers as well as magazines, had become an established institution, and from decade to decade gained new strength. The provinces, too, were beginning to have their own local papers, mostly bi-weekly at first. The *Norwich Post* (1701–

The Daily Courant.

Wednesday, March 11. 1702.

From the Harlem Courant, Dated March 18. N. S.

Naples, Feb. 22.

ON Wednesday last, our New Viceroy, the Duke of Escalona, arriv'd here with a Squadron of the Galleys of Sicily. He made his Entrance drest in a French habit; and to give us the greater Hopes of the King's coming hither, went to Lodge in one of the little Palaces, leaving the Royal one for his Majesty. The Marquis of Grignî is also arriv'd here with a Regiment of French.

Rome, Feb.25. In a Military Congregation of State that was held here, it was Resolv'd to draw a Line from Ascoli to the Borders of the Ecclesiastical State, thereby to hinder the Incursions of the Transalpine Troops. Orders are sent to Civita Vecchia to fit out the Galleys, and to strengthen the Garrison of that Place. Signior Casali is made Governor of Perugia. The Marquis del Vasto, and the Prince de Caserta continue still in the Imperial Embassador's Palace; where his Excellency has a Guard of 50 Men every Night in Arms. The King of Portugal has desir'd the Arch-Bishoprick of Lisbon, vacant by the Death of Cardinal Sousa, for the Infante his second Son, who is about 11 Years old.

Vienna, Mar. 4. Orders are sent to the 4 Regiments of Foot, the 2 of Cuirassiers, and to that of Dragoons, which are broke up from Hungary, and are on their way to Italy, and which consist of about 14 or 15000 Men, to hasten their March thither with all Expedition. The 6 new Regiments of Hussars that are now raising, are in so great a forwardness, that they will be compleat, and in a Condition to march by the middle of May. Prince Lewis of Baden has written to Court, to excuse himself from coming thither, his Presence being so very necessary, and so much desir'd on the Upper-Rhine.

Francofort, Mar. 12. The Marquis d' Uxelles is come to Strasburg, and is to draw together a Body of some Regiments of Horse and Foot from the Garisons of Alsace; but will not lessen those of Strasburg and Landau, which are already very weak. On the other hand, the Troops of His Imperial Majesty, and his Allies, are going to form a Body near Germershein in the Palatinate, of which Place, as well as of the Lines at Spires, Prince Lewis of Baden is expected to take a View, in three or four days. The English and Dutch Ministers, the Count of Frise, and the Baron Vander Meer, and likewise the Imperial Envoy Count Lowenstein, are gone to Nordlingen, and it is hop'd that in a short time we shall hear from thence of some favourable Resolutions for the Security of the Empire.

Liege, Mar. 14. The French have taken the Cannon de Longie, who was Secretary to the Dean de Mean, out of our Castle, where he has been for some time a Prisoner; and have deliver'd him to the Provost of Maubeuge, who has carry'd him from hence, but we do not know whither.

Paris, Mar. 13. Our Letters from Italy say, That most of our Reinforcements were Landed there; that the Imperial and Ecclesiastical Troops seem to live very peaceably with one another in the Country of Parma, and that the Duke of Vendome, as he was visiting several Posts, was within 100 Paces of falling into the Hands of the Germans. The Duke of Chartres, the Prince of Conti, and several other Princes of the Blood, are to make the Campaign in Flanders under the Duke of Burgundy; and the Duke of Maine is to Command upon the Rhine.

From the Amsterdam Courant, Dated Mar. 18.

Rome, Feb. 25. We are taking here all possible Precautions for the Security of the Ecclesiastical State in this present Conjuncture, and have desir'd to raise 3000 Men in the Cantons of Switzerland. The Pope has appointed the Duke of Berwick to be his Lieutenant-General, and he is to Command 6000 Men on the Frontiers of Naples: He has also settled upon him a Pension of 6000 Crowns a year during Life.

From the Paris Gazette, Dated Mar. 18. 1702.

Naples, Febr. 17. 600 French Soldiers are arrived here, and are expected to be follow'd by 3400 more. A Courier that came hither on the 14th. has brought Letters by which we are assur'd that the King of Spain designs to be here towards the end of March; and accordingly Orders are given to make the necessary Preparations against his Arrival. The two Troops of Horse that were Commanded to the Abruzzo are posted at Pescara with a Body of Spanish Foot, and others in the Fort of Montorio.

Paris, March. 18. We have Advice from Toulon of the 5th instant, that the Wind having long stood favourable, 22000 Men were already sail'd for Italy, that 2500 more were Embarking, and that by the 15th it was hoped they might all get thither. The Count d' Estrees arriv'd there on the Third instant, and set all hands at work to fit out the Squadron of 9 Men of War and some Fregats, that are appointed to carry the King of Spain to Naples. His Catholick Majesty will go on Board the *Thunderer*, of 110 Guns.

We have Advice by an Express from Rome of the 18th of February, That notwithstanding the pressing Instances of the Imperial Embassadour, the Pope had Condemn'd the Marquis del Vasto to lose his Head and his Estate to be confiscated, for not appearing to Answer the Charge against him of Publickly Scandalizing Cardinal Janson.

ADVERTISEMENT.

IT will be found from the Foreign Prints, which from time to time, as Occasion offers, will be mention'd in this Paper, that the Author has taken Care to be duly furnish'd with all that comes from Abroad in any Language. And for an Assurance that he will not, under Pretence of having Private Intelligence, impose any Additions of feign'd Circumstances to an Action, but give his Extracts fairly and Impartially; at the beginning of each Article he will quote the Foreign Paper from whence 'tis taken, that the Publick, seeing from what Country a piece of News comes with the Allowance of that Government, may be better able to Judge of the Credibility and Fairness of the Relation: Nor will he take upon him to give any Comments or Conjectures of his own, but will relate only Matter of Fact; supposing other People to have Sense enough to make Reflections for themselves.

This Courant (as the Title shews) will be Publish'd Daily: being design'd to give all the Material News as soon as every Post arrives: and is confin'd to half the Compass, to save the Publick at least half the Impertinences, of ordinary News-Papers.

LONDON. Sold by E. Mallet, next Door to the *King's-Arms* Tavern at *Fleet-Bridge.*

Front-page of the first issue, 11 March 1702, of the first English daily newspaper, the *Daily Courant*, which ran until 1735

1712), the *Bristol Post-Boy* (1702–12), *Sam Farley's Exeter Post-Man* (1704–25), and the *Worcester Post-Man* (1709; still continuing as the *Worcester Journal*) were the earliest.

After the setting up of a daily postal service between Dover and London in 1691, which secured the regular transmission of foreign news to the capital, the daily newspaper became practicable and eventually ousted the twice-weekly or thrice-weekly organs. The *Daily Courant* (1702), the *Daily Post* (1719), the *Daily Journal* (1720), and the *Daily Advertiser* (1730) were the first London papers to emphasize in their very titles their regularity and frequency. The *Daily Advertiser* soon became, and remained until its demise in 1807, what one might call *The Times* of the eighteenth century: an extensive news-service, valuable commercial intelligence, and a wealth of advertisements (among which those of the London publishers were conspicuous) made it indispensable to the upper and middle classes of the country.

Because of the rigidity of French censorship it was only in 1777 that France received its first daily newspaper, the *Journal de Paris*. When the Revolution proclaimed the freedom of the press, the number of Paris papers immediately soared up to 350; it shrunk, however, to thirteen in the bleak climate of the Consulate and to four in the even more rigorous conditions of the Empire.

The English morning paper quickly acquired as its companion the evening paper. The first in the field were Dawks's *Newsletter* (1696), the *Evening Post* (1706), the *Evening Courant*, and the *Night Post* (both 1711). All of them were thrice-weekly papers, but it was they and not the daily papers which first carried punctuality as far as the hour of publication. In order to catch the mail to the provinces which left London on Tuesday, Thursday, and Saturday nights, the *Evening Post* was made available to the couriers 'every post night at six a clock'. This device was taken up by the first (and short-lived) midday paper, the *Noon Gazette* (1781), which was 'published at twelve o'clock', and by the even shorter-lived evening paper the *Cabinet* (1792), which came out 'precisely as the Horse

Guards strikes five'. This stabilization of regularity and relia-
bility of issue reached its apogee in the clock device which *The
Times* has been showing ever since 2 January 1804: set between
the open book of 'times past' and the closed book of the
'future', the timepiece pinned down the then hoped-for average
time of completing publication, at 6.6 a.m.

No such minute accuracy was, or is, required from the
printer of a periodical. But in this field, too, the eighteenth
century brought about a progressive standardization. While
the newspaper world came to accept daily appearance as the
norm, a weekly issue established itself as the most acceptable in-
terval for the publication of the lighter kind of periodicals, with
monthly and quarterly reviews providing the heavier pabulum.

Richard Steele (1672–1729) and Joseph Addison (1672–
1719) have determined more than any other editor the style
of the general periodical which, soon imitated in every civilized
country, was to become the guide and friend, entertainer and
instructor of millions of readers throughout the eighteenth
century. The *Tatler* (1709–11) and the *Spectator* (1711–14) are
the most famous papers which they edited and to which they
contributed 'observations on life and manner'. They provided
their readers with moral instruction, comments on literary and
artistic subjects, straight news, and pleasant entertainment:
the *obiter dicta* of Sir Roger de Coverley, Addison's most en-
during creation, give a good idea of the wide range and polished
treatment of these topics. The *Spectator* probably had an aver-
age of 3,000 subscribers; the first edition of its collected essays
in book form (1712) ran to 9,000 and was reissued ten times
within twenty years. The influence these two papers exerted
upon Europe and America was prodigious. The number of
journals which cultivated 'wit' and 'taste' on the model of the
Tatler and the *Spectator* approached 800 during the eighteenth
century. Most of them, it is true, did not outlast the initial
enthusiasm of their founders or readers; but skilful editorial
and financial management succeeded in keeping others alive
for considerable spans of time. The one that, deservedly, lived
longest was the *Gentleman's Magazine* (1731–1907); it reached

an annual circulation of 10,000 in 1739 and of 15,000 in 1745; and the liberal show of illustrations in woodcut and copper-engraving contributed to its quick success. It was due to the wide appeal of the *Gentleman's Magazine* that the term 'magazine' soon became a generic term for this kind of journal. The *London Magazine* (1732–84) and the *Scots Magazine* (1739–1817, continued as the *Edinburgh Magazine* until 1826) were among its earliest adopters.

A novel feature of these journals was the reviewing of new books. Some periodicals even made literary criticism their main concern. Robert Dodsley's short-lived fortnightly *Museum* (1746–7), the *Monthly Review*, started in 1749 by Ralph Griffiths and continued by his son George Edward until 1825, and the *Critical Review* (1756–1817), of which Tobias Smollett was the first editor, exercised a considerable influence in acquainting the gentry and middle class with current literature, foreign as well as English. These book reviews were usually of considerable length; they told the reader at least what the book was about and interspersed their comments with copious extracts illustrating particular points of style and presentation. Actual criticism was hardly voiced, and the general tone was rather that of a modern blurb or publisher's prospectus. The 'Scotch Reviewers' of the *Edinburgh Review* (1802), who made a sport of censuring 'English Bards', changed all that. They not only introduced partisanship and personalities (which have since disappeared from respectable journals) but bestowed upon the reviewer a nimbus of superiority, which has persisted and all too often tempts the contemporary reviewer to use a book which he is incompetent to judge as a mere pretext for exhibiting his cleverness.

7. LIBRARIES

WHEN Antonio Panizzi once called the British Museum 'an institution for the diffusion of culture', he incidentally paid the

highest tribute to the library as a factor of the promotion of civilization. There were large and well-organized libraries of manuscripts long before the invention of printing. Julius Caesar was the first statesman to include the endowment of a public library among the amenities which a well-run administration should provide for its citizens. This plan was taken up after his death by C. Asinius Pollio, a patron of Virgil and Horace. He built, in 39 B.C., the first public library in Rome. His example was followed by many of the emperors from Augustus and Tiberius onward, and eventually imperial Rome had twenty-eight public libraries. With its destruction the idea of libraries open to the general public was buried for a thousand years.

The libraries of the Middle Ages were monastic, episcopal, or academic. The library as a storehouse of intellectual treasures of the whole civilized world, as a spiritual pleasure-ground for the humblest workman, and as the last refuge of the citizens of the Republic of Letters has been made possible only by the printer's craft. In the renaissance, princes and nobles, merchants and scholars began to build up collections of books. Federigo, Duke of Urbino, it is true, strictly excluded any printed book from his precious library but his attitude was exceptional and only based on his 'natural egoism'. Hardly any printed books detracted from the splendour of the library which King Matthias Corvinus assembled in Budapest – perhaps the most precious collection of renaissance manuscripts and bindings, scattered to the four winds after the King's death (1490). Others thought otherwise: the library of the Nürnberg humanist Hartmann Schedel consisted of about 200 printed and 400 written books; his younger contemporary, Willibald Pirckheimer, owned only 170 manuscripts among some 2,100 books (which the second earl of Arundel acquired in 1636). In 1500 the library of the Deanery of Hermannstadt (Sibiu) in far-away Transylvania, numbered 167 printed books of a total of 320.

Some of these private libraries were the nucleus of national libraries. The Bibliothèque Nationale has evolved from the

library of Charles V, the Mediceo-Laurenziana combined those of Cosimo and Lorenzo de' Medici, the Prussian State Library grew out of the library of Frederick William, the Great Elector; the British Museum had as its chief component the library of Sir Robert Cotton. The University of Oxford owes its library to the diplomatist and scholar Sir Thomas Bodley. It was opened in 1602, and Bodley secured for it a special bounty: he persuaded the Stationers' Company to assign to his foundation a free copy of every book printed in the realm of England. This conception of a 'copyright library' was legally embodied in the Licensing Act of 1663 which stipulated the presentation of three free copies of every publication; the number was gradually increased to eleven but eventually limited to six (British Museum, National Libraries of Scotland and Wales, the Bodleian, Cambridge University Library, and Trinity College, Dublin). Other nations have taken over this principle. It greatly benefits every class and individual professionally interested in books – publishers and booksellers as well as librarians and scholars – as the copyright libraries are the centres where bibliographical inquiries can be answered accurately and bibliographical studies pursued comprehensively.

The first big libraries which were made accessible to the public were the Ambrosiana in Milan, opened by Cardinal Federigo Borromeo in 1609, and the library brought together for Cardinal Mazarin by Gabriel Naudé (1645). Naudé also wrote the first modern treatise on collecting, storing, and cataloguing books, *Advis pour dresser une bibliothèque* (1627); John Evelyn made it available to English bookmen in 1661. Its most remarkable medieval predecessor was the *Philobiblon* of Richard de Bury, bishop of Durham (d. 1345); it was printed as early as 1473 (in Cologne) and is still worth reading as a charming tribute to the '*amor ecstaticus*' Richard felt for books.

Most of the great national libraries were founded in the seventeenth and eighteenth centuries; they were in fact a symbol, in the intellectual sphere, of the centralizing tendencies of

the absolutist monarchy. The Prussian State Library in Berlin (1659), the Kongelige Bibliotek in Copenhagen (1661), the National Library of Scotland (1682), the Biblioteca Nacional in Madrid (1712), the Biblioteca Nazionale Centrale in Florence (1747), the British Museum (1759), and the Library of Congress (1800) are some of these foundations that have justified the ambitions of their founders to serve the highest national interests of their countries.

Descriptive bibliography which has become an intrinsic part of the functions of the national libraries all over the world has its origin in the catalogues which were issued to serve the interests of the bookseller. The first comprehensive and regular compilations were the half-annual lists of new publications which the Augsburg wholesale bookseller, Georg Willer (1515–1594) published from 1564 to 1627. These catalogues comprised the books displayed at the Frankfurt book fairs which, by this time, had become the principal meeting-place of publishers and booksellers, printers and type-founders from all over Europe. In 1565 Willer lists 318 titles published by German and 226 by non-German publishers. Henri Estienne wrote an enthusiastic pamphlet in praise of the *Francofordiense emporium sive Francofordienses nundinae*. From 1598 the town council of Frankfurt produced an official catalogue which eventually superseded the private ventures of the firm of Willer and others. From 1617 to 1628 the London stationer, John Bill, published an English edition of the Frankfurt catalogue, with a supplement (1622–6) of 'Books printed in English'. With the decline of the Frankfurt fairs the catalogues of its rival, Leipzig, became of greater importance. They began in 1594 and have survived in various forms to the present day, whereas the Frankfurt catalogues together with the Frankfurt fair lapsed in 1750. In 1948 the Frankfurt book fair was revived, however, and has established itself as the principal international meeting-place of the whole book-trade.

These fair-catalogues are the precursors of the national bibliographies of current literature, which are now usually in the care of the national libraries of their respective countries.

Of these indispensable hand-lists, the oldest is the *Bibliographie de la France* (1811 ff.), while the U.S. *Cumulative Book Index* (1898 ff.) is the most comprehensive. In Germany, the *Deutsche Nationalbibliographie* took over the original Leipzig book fair catalogues in 1931. The latest-comer in this field is the *British National Bibliography* (1950 ff.). Although the principles of arrangement and presentation vary, all these national bibliographies have in common a very high degree of accuracy and completeness.

As far as comprehensive bibliographies of older books are concerned, the prize would easily go to the *Gesamtkatalog der Wiegendrucke* if there were the slightest prospect that this colossal monument of German scholarship and German procrastination would ever be finished. But as half a loaf is better than no bread, the *British Museum Catalogue of Books printed in the XVth Century* answers every question a student of the incunabula period may reasonably ask. For the following two centuries, Great Britain is superbly served by the *Short-title Catalogues* compiled by A. W. Pollard and G. R. Redgrave up to 1640 and by D. G. Wing for the period 1641–1700. They may be said to stand on the shoulders of the first *Catalogue of English Printed Books* with which Andrew Maunsell in 1595 laid the foundations of descriptive bibliography in this country. Another compilation by an English scholar, Theodore Besterman's *World Bibliography of Bibliographies* (2nd ed. 1950), deserves mention as the most useful summary of the whole field.

But far into the nineteenth century even the 'public' libraries were anything but easily accessible to the public. The way in which librarians everywhere looked at customers is superbly indicated in the regulations issued by the librarian of Gotha in 1774. 'In order to check the previous excessive concourse in the best manner possible', it was decreed that 'anybody who wants to inspect a book has to apply to the librarian who then will show and, if need be, even allow him to read it.'

In fact, the big state, municipal, and college libraries were ill-adapted to serve the needs of the non-academic and non-

professional classes which were increasingly forming the vast majority of the book-reading public. This new intelligentsia set about to help themselves and created two new types of libraries, the 'public library' in the modern connotation of the term and the lending library. Both are children of the eighteenth century, and both originated in the English-speaking world.

The creation of the public library is perhaps the major contribution to the system of general education made by the United States. George Ticknor, the great Harvard scholar, has aptly summed up the basic idea of this institution. 'The public library', he said, 'should come in at the end of our system of free instruction, and be fitted to continue and increase the effect of that system by the self-culture that results from reading.' The Commonwealth of Massachusetts was a pioneer of the movement; Boston was the first town in the New World to provide a public library as early as 1653, and in 1798 Massachusetts took a lead in consolidating its public libraries by an act of the State Legislature. The honour of first allocating a specific annual tax to a free public library must perhaps go to the enlightened citizens of the little town of Peterborough in New Hampshire, who took this step in 1833.

The lending library, that remarkable mixture of commercial enterprise and care for mental improvement, was aptly launched by a Scotsman. Allan Ramsay, poet, wig-maker, and bookseller and father of the great portrait-painter of the same name, attached the first lending library to his bookshop in Edinburgh in 1726. A few years later, in 1731, Benjamin Franklin, at the threshold of his amazing career as a printer, publisher, and diplomatist, opened a 'Subscription Library' at Philadelphia. The Rev. Samuel Fancourt, a dissenting minister, founded the first lending library in London in the 1730s, but neither this nor his second venture in 1746, 'The Gentlemen and Ladies' Growing and Circulating Library', was a lasting success. This fell to the 'British Library', established by George Bathoe in the Strand, when it was taken over by the consummate maker and promoter of books, John Bell.

By the end of the eighteenth century lending libraries had become a common feature of every town of western Europe. In small places where they could not possibly be run with profit, reading clubs and literary societies took over the function to provide their members with the latest productions of the book market. They may as well be classified among the precursors of local and municipal libraries. Their sudden growth astonished contemporary observers. One critic remarked in 1795 that 'people are used to reading nowadays in places where twenty years since a book was hardly available'. A few years later we hear that 'a passion for reading becomes commoner from day to day and spreads among all classes'. In 1804 the three biggest lending libraries of Dresden had a combined stock of 60,000 volumes, that is to say, one volume per head of the population.

The effect of the lending libraries upon the book market was aptly summed up by the London bookseller James Lackington (1746–1815): 'When circulating libraries were first opened', he says in his memoirs, 'the booksellers were much alarmed, and their rapid increase, added to their fears, had led them to think that the sale of books would be much diminished by such libraries. But experience has proved that the sale of books, so far from being diminished by them, has been greatly promoted, as from those repositories many thousand families have been cheaply supplied with books, by which the taste of reading has become much more general, and thousands of books are purchased every year by such as have first borrowed them at those libraries, and after reading, approving of them, become purchasers.'

8. CENSORSHIP

A CENTURY after Gutenberg's invention, censorship of the printed word had become the universal practice of the lay and church authorities throughout Europe. By the end of the eighteenth century it had been abolished in England, France,

Sweden, Denmark, and the United States, and was being challenged everywhere else.

Mainz, the cradle of the art of printing, is also the birthplace of censorship of printed books. Archbishop Berthold von Henneberg (1484–1504) asked the town council of Frankfurt to examine carefully the printed books to be exhibited at the Lenten Fair in 1485 and to collaborate with the ecclesiastical authorities in suppressing dangerous publications. In response to this, the electorate of Mainz and the imperial city of Frankfurt in 1486 jointly set up the first secular censorship office.

The novel feature of Archbishop Berthold's procedure was that censorship was claimed as a state prerogative – a far-reaching consequence which the archbishop neither foresaw nor wished. For Berthold himself was a thoroughly medieval personality: he opposed the new spirit of humanism and secular education, and wanted to keep the new medium of learning under the strict supervision of the church.

The ecclesiastical authorities, in the later Middle Ages particularly the universities, had always exercised a censorship of the written word. As recently as 1479 the university of Cologne a stronghold of the schoolmen, obtained a papal privilege which expressly extended their censorship to printed books.

However, church censorship had been, and was for a long time to be, interested almost exclusively in combating and suppressing heretical writings, and showed a broad tolerance towards sexual immorality and obscenity. Thus, the first edict concerning printed books, issues by the Frankfurt censor, aimed at the suppression of Bible translations into the vernacular; and the first steps taken by the Roman Curia were chiefly directed against heretical and schismatical publications.

Pope Innocent VIII, in 1488, and Pope Alexander VI, in 1501, tried to make censorship uniform throughout Christendom, imposed censorship as a duty upon all in authority, introduced preventive censorship, and subjected non-theological books to ecclesiastical supervision. It is to the credit of the Cologne printers that they at once protested against the papal attempts to extend clerical authority beyond the control of

heretical works. Their courageous action, however, was of no avail. The Roman church, shaken to its foundations by the Protestant Reformation, and alarmed at the increasing power which the secular state arrogated to itself, pursued the policy laid down in two bulls issued by Pope Leo X in 1515 and 1520. Cardinal Caraffa, the restorer of the Inquisition, decreed in 1543 that henceforth no book, old or new, regardless of its contents should be printed or sold without the permission of the Inquisition. Giovanni della Casa, one of Caraffa's assistants, had the first list of banned books printed in Venice; it comprised seventy titles.

Larger lists were issued in Florence (1552) and Milan (1554); and in 1559 Caraffa, now Pope Paul IV, promulgated the first general *Index librorum prohibitorum*. It banned among other books the writings of several cardinals, the poems of della Casa, and an anonymous book *On the Benefit of Christ*, of which one copy only has miraculously survived. It defended the Lutheran doctrine of 'justification by faith' and was sponsored by the cardinals Pole and Contarini; it was translated into French (1552) and twice into English (1548, 1573).

The *Index*, currently brought up to date, remained until 1966 the authoritative guide by which practising Roman Catholics had to regulate their reading. But at the time of its first publication the secular power had already taken hold of censorship as a weapon of statecraft to safeguard political interests rather than to save souls.

Individual books were suppressed for political reasons by various German princes and German and Italian city fathers. Henry VIII of England was the first monarch to issue a list of banned books (1529). In 1538 he forbade the importation of books printed abroad in the English language. Taken in conjunction with the tenor of his privilege granted in 1543 to Grafton and Whitchurch (see p. 108), these royal ordinances display that curious mixture of religious, political, and economic motives which characterizes the theory and practice of all European statesmen of the sixteenth century.

The history of the Frankfurt book fairs exemplifies the deadening effect of state interference on the intellectual as well as

M

Auctores quorum libri & scripta omnia prohibentur.

Marcellus Palingenius Stellatus.
Marcus Antonius Caluinus.
Marcus Antonius Corуinus.
Marcus Cordelius Torgensis.

Marcus Ephesinus.

Marcus Tilemanus Heshusius.

Marsilius de Padua.

Martiniko,

Martinus Borrhaus Stugardian.

Martinus Bucerus.

Martinus Frectus.

Martinus Lutherus.

Martinus Meglin.

Martinus Osterminсherus.

Matthæus Alberus.

Matthæus, qui et Aſſartius Scoffer

Matthæus Philargirus.

Matthæus Zellius Keiserspergen.

Matthæus Zifer.

Mathias Flaccus Illyricus.

Maturinus Corderius.

Maximilianus Maurus.

A page from the first papal *Index librorum prohibitorum*, issued by Pope Paul V and printed by Antonio Blado in Rome, 1559. 'Authors all of whose books and writings are forbidden' under M include: Marsilius of Padua, Martin Bucer, Martin Luther, Mathias Flacius, and Mathurin Cordier

the commercial plane. From the end of the fifteenth century Frankfurt was the centre of the German book-trade and even attracted a large number of foreign publishers and booksellers; agents of Aldus Manutius are known to have trafficked there. In 1579 the Frankfurt book market was placed under the supervision of the imperial censorship commission, since Frankfurt was a Free Imperial City; and the narrow-mindedness and chicanery of the commissioners, ruled by the Jesuits, first stifled and eventually ruined its flourishing book-trade. By the middle of the eighteenth century the Frankfurt book market was dead. The last fair-catalogue which appeared in 1750 contained but 42 German, 23 Latin, and 7 French books – and that at a time when the yearly output of books in Germany amounted to about 1,350 items.

At the same time the Dutch Republic demonstrated the favourable results flowing from the application of a nominal censorship in a liberal spirit. The measures taken against Spinoza, which seem to point to the contrary, were due to the activities of 'pressure-groups' – the Jewish rabbis, the Calvinist radicals, the Orange monarchists. The merchant aristocracy of the Dutch towns, broad-minded and far-sighted, offered a haven of refuge to the persecuted Jews of Spain and Portugal, the Huguenots of France, the Calvinists of Germany, and the Socinians of Poland. The conflux of skilled craftsmen and versatile business men secured the economic predominance of the Netherlands, while the liberality of her universities and the freedom accorded to the printing press made her the centre of learning and journalism in seventeenth-century Europe. Dutch publishers, above all the printing dynasty of the Elzevirs, issued books in Latin, French, English, German, and Dutch, and thus reflected the fact that Holland was in truth the focus of European literacy.

Evading the censor developed into a fine art. The commonest subterfuge was the faked imprint. This might be wholly fictitious, consist in the 'accommodation address' of a foreign publisher, or dispense altogether with naming the printer or place of publication.

Dutch printers of Protestant tracts in the 1520s sometimes

concealed the place of publication under the name of 'Utopia'. thus incidentally showing the popularity of Thomas More's book which had been printed in Louvain in 1516. Others put on the title-page either towns such as Wittenberg, Marburg, or Strassburg from which these Lutheran writings might well have emanated, or conversely the most unlikely 'Rome, at St Peter's court'. They sometimes combined the name of a real printer with a wrong place, e.g. Hans Lufft (of Wittenberg) in Marburg (in fact, Johann Hoochstraten of Antwerp, the printer of Tyndale's *Pentateuch*, 1530). Whereas a number of Dutch printers went to the stake for publishing Protestant books, none who used feigned imprints was found out.

The London publisher J. Charlesworth had the courage to bring out the revolutionary tracts of the exiled Italian philosopher Giórdano Bruno. But he took the precaution to make *De la causa, principio e uno* (1584) appear from 'Venice' and *De gli eroici furori* (1588) from the press of 'A. Baio, Paris'.

The Elzevirs seem to have resorted to this deception in order to mislead foreign censors rather than from fear of trouble at home. For, in view of the known tolerance of Dutch censorship, controversial books printed in the Netherlands were, by that very fact, suspect abroad. Thus, Pietro Aretino's *Capriciosi e piacevoli ragionamenti* (1660), published at 'Cosmopoli' without a printer's name, and Pascal's *Provinciales*, with the imprint 'Cologne chez Pierre de Vallée' (1657), were certainly, Hobbes's *Leviathan*, 'London for Andrew Crooke' (1651), may have been, issued by the Elzevirs in Amsterdam.

Nearly all the great works by which French eighteenth-century creative literature is remembered had to be printed either outside France or under a feigned imprint. Montesquieu's *Lettres persanes* (1721) were published in Holland with the imprint 'Cologne chez Pierre Marteau'. This 'accommodation address', perhaps invented by the Elzevirs who used it first in 1660, covered a variety of books and publishers anxious to avoid censorship and appeared on the title-pages of religious as well as pornographic writings. The same name, in its German form 'bei Peter Hammer in Köln', was at the beginning of the nineteenth century adopted by F. A. Brockhaus for such

military and political publications as were likely to draw the wrath of the powerful Prussian censorship upon the publisher.

Montesquieu's *Considérations sur la cause de la grandeur des Romains et de leur décadence* (1724) appeared in Amsterdam, his *Esprit des lois* (1748) in Geneva. Rousseau's revolutionary books were published in Holland: *La Nouvelle Héloïse* (1761) and *Du Contrat social* (1762) in Amsterdam, *Émile* (1762) at The Hague. Voltaire's *Henriade* was first printed surreptitiously under the title of *La Ligue* at Rouen in 1723, with the fictitious imprint of 'Genève chez Jean Mokpap'. The second edition, now called *La Henriade*, came out in London (1728) with a dedication in English to Queen Caroline, *Le Siècle de Louis XIV* in Berlin (1751).

Perhaps the most effective antidote against censorial intentions is the fact that the public banning or burning of a book is the surest way of directing public attention to it. A Jesuit once jokingly remarked: '*Notabitur Romae, legetur ergo*' – just because a book is put on the Index, the demand for it will increase. When the Spanish Cortes of 1518 directed their puritan zeal against the danger which public morals might sustain from the reading of the *Amadís* romance (first printed in 1508), this officious interference may well have contributed to the immense increase in popularity of the original story as well as its countless continuations, imitations, and adaptations. It was not the wrath of authority but the deadly satire of Cervantes's *Don Quixote* that gave the *coup de grâce* to this European epidemic. When Hobbes's *Leviathan* was prohibited, Samuel Pepys at once bought it, but he had to pay 30s. for a second-hand copy whereas the original price had been only 8s., as the book was now, in 1668, 'mightily in demand'. An Amsterdam publisher was a shrewd judge of human nature when he endeavoured to have the *Bibliotheca Patrum Polonorum* (1656) banned by the censor because the initial sale was not up to his expectation. He was, however, disappointed in his hope to make up by curiosity for what the book lacked in genuine appeal.

The first effective blow dealt to restrictive practices in the

AREOPAGITICA;

A

SPEECH

OF

Mr. JOHN MILTON

For the Liberty of Vnlicenc'd
PRINTING,

To the Parlament of ENGLAND.

Τἄλλ᾽ θεσρι δ᾽ ἐκεῖνο, οἳ τι θέλω πόλι
Χρηςὸν τι βέλθμ᾽ εἰς μέσον φέρειν, ἔχων.
Καὶ ταῦθ᾽ ὁ χρῆζων, λαμπρός ἐσθ᾽, ὁ μὴ θέλων,
Σιγᾷ, τί τέτων ἐςιν ἰσαίτερον πόλι;

 Euripid, Hicetid.

This is true Liberty when free born men
Having to advise the public may speak free,
Which he who can, and will, deserv's high praise,
Who neither can nor will, may hold his peace;
What can be juster in a State then this?

 Euripid. Hicetid.

24°. LONDON,
Printed in the Yeare, 1644.

John Milton, *Areopagitica*, published, uncensored and unlicensed,
on 24 (or 23) November 1644

world of books came from England. An ordinance imposed by Parliament upon printers and booksellers in 1643 roused John Milton to write his *Areopagitica*, clad in the form of an address to Parliament and published in 1644. It is the most eloquent advocacy of the 'liberty of unlicensed printing'. Free comment, Milton maintains, is a privilege of citizenship as well as a benefit to the state. 'As good almost kill a man as kill a good book. Who kills a man kills a reasonable creature; but he who destroys a book kills reason itself, the image of God.' He goes on to demolish the argument, ever recurring with the champions of censorship, that a distinction should be made between good and bad books; for it is but 'a fugitive and cloistered virtue that never sallies out and sees her adversary'; and again, 'Truth needs no licensings to make her victorious. Who ever knew truth put to the worse in a free and open encounter?'

By an irony of fate, the abolition of the Licensing Act was eventually set afoot by an unscrupulous plagiary of Milton's pamphlet and in an unworthy cause. A disreputable Whig scribbler, Charles Blount, attacked in 1693 the Tory licenser in two anonymous tracts, entitled *A Just Vindication of Learning and of the Liberty of the Press* and *Reasons for the Liberty of Unlicensed Printing*. The text of both was almost entirely stolen from Milton's *Areopagitica*; but the insolent plagiarism was not detected, and even in this disguise Milton's impassioned plea proved its force. Booksellers, bookbinders, and printers presented petitions to Parliament. The Licensing Law was renewed for only two years and after the expiration of this period the Commons decided, without a division, to discontinue the 'Act for preventing abuses in printing seditious, treasonable and unlicensed pamphlets, and for regulating of printing and printing presses.' The Lords disagreed, but eventually yielded (18 April 1695).

Thus, Macaulay says in a famous passage, 'English literature was emancipated, and emancipated for ever, from the control of the government'; and, he sums up, this came to pass by 'a vote, which at the time attracted little attention, which produced no excitement, which has been left unnoticed by

voluminous annalists, and of which the history can be but imperfectly traced in the archives of Parliament, but which has done more for liberty and for civilization than the Great Charter or the Bill of Rights'.

A further decisive blow for the freedom of the press was struck by John Wilkes, one of the great champions of English liberty and democracy whose achievements have for long been obscured by the prudish Victorian aversion to his private morals. Wilkes's courageous stand against king, government, parliament, and magistrates brought about the abolition of 'general warrants' for the arrest of unspecified 'authors, printers and publishers'. Henceforth, prosecution could be instituted only against individuals specifically named and specifically charged.

It is worth noting that the long and detailed list of complaints against the British government which the American colonists embodied in their Declaration of Independence contains no hint of any interference with the liberty of authors, printers, and publishers. The great author-printer-publisher, Benjamin Franklin, one of the signers of the Declaration, would no doubt have seen to the insertion of a relevant passage if there had been any reason or pretext for it. Thus it has come about that the Constitution of the United States dispenses with any special safeguards and, as throughout the English-speaking world, leaves the control of the printed word to the normal process of law in the ordinary courts.

It was, however, unfortunate that Congress passed in 1790 a statute which retained one of the worst features of the erstwhile English Licensing Act, namely the restriction of copyright to a privileged class of printers. This statute, it is true, was not limited to a closely circumscribed number of printers and places, but embraced all 'citizens of the United States, or resident therein'. However, it was the decisive step to deny non-American publishers for 160 years the protection which they were subsequently accorded everywhere else in the civilized world. The Congressional Act of 1949 eventually alleviated the strictness, and the signing by the United States of the

International Copyright Convention in 1957 removed for good the ill-effects of that survival of Stewart autocracy.

The situation was different in Europe. With the growth of absolutism in the eighteenth century, censorship became more severe as far as political writings were concerned. *Non licet de illis scribere, qui possunt proscribere* was the order of the day. The American and French Revolutions naturally increased the uneasiness of the ruling powers, and books and pamphlets dealing with those revolutionary movements were usually forbidden without discriminations as to the political attitude of the writer. Burke's denunciation of the French Revolution was condemned together with the writings of Helvétius, Montesquieu, Rousseau, and Voltaire, who had paved the way for it – though profoundly differing among themselves as to the causes of the evil, the remedies, and the ultimate goal. The Bavarian censorship, wishing to be quite safe in eradicating what they must have considered the roots of the ideas of 1789, added to the writers just mentioned the following authors: Frederick the Great of Prussia, Spinoza, Kant, Erasmus of Rotterdam, Swift, Schiller, Wieland, Ovid, Virgil, Thomas More, Plato, and Homer's *Iliad*; why they spared the *Odyssey* can unfortunately not be ascertained.

On the other hand, Hanover, since 1714 its Elector also King of England, was famous for the liberal administration of its censorship: the political journals which the Göttingen Professor Schlözer edited enjoyed a circulation and prestige throughout Europe. Sweden was the first continental country which abolished censorship in 1766; Denmark followed in 1770. What a liberal application of censorship meant to the printing trade may be gathered from the development of the exportation of books from Austria: in 1773 its total amounted to 135,000 fl.; twenty years later, in consequence of the thorough-going reforms of the Emperor Joseph II, it had risen to 3,260,000 fl.

The turning-point came with the French Revolution, which embodied Milton's ideas in constitutional acts. On the eve of the French Revolution, Mirabeau issued his pamphlet *Sur la*

liberté de la presse: imité de l'anglais, Londres (1778), which was in fact a paraphrase of the *Areopagitica*. This publication was instrumental in making the National Assembly declare, on 26 August 1789, in the eleventh clause of the Rights of Man: *La libre communication des pensées et des opinions est un des droits les plus précieux de l'homme; tout citoyen peut donc parler, écrire, imprimer librement.*

A clause on these lines has since become obligatory, as it were, in every written constitution; often augmented by a sentence like that appearing first in the Charte of 1830: *La censure ne pourra jamais être rétablie.* Although this principle has been challenged and denounced by reactionaries and dictators again and again, its significance for the printing trade will always remain of particular momentousness.

Three factors tend to militate against the effectiveness of any censorship, even under an autocratic régime: the time-lag between publication and ban, the human qualities of the censors themselves, and the resistance of the public.

Hobbes's *De cive*, published in 1642, was put on the Roman Index in 1654, by which date four editions had been issued; and it was ordered to be burned by Oxford university as late as 1683, when six editions had reached the public.

This time-lag cannot be explained wholly by the slower means of communication of those days, but must be attributed partly to the good as well as the bad aspects of the human beings wielding the sword of censorship. It may be said that the nicer the censor's conscience the more reluctant he will be to take action. Sometimes painstaking censors have even been of active assistance to authors. The much maligned Lord Chamberlain's office for the licensing of plays offers conspicuous examples of friendly and helpful censorship, as has been testified by such a fearless and independent critic as Sir Alan Herbert.

On the whole, however, the history of censorship offers more examples of mistakes committed through obtuseness than through sensitivity. Censorship for political and moral reasons has probably made itself more obnoxious and ridiculous than

for ideological reasons. After all, a trained theologian can without much difficulty decide whether or not certain propositions fall within the teaching of his church. In the field of politics and morals, however, posterity usually finds it very difficult to account for the complete lack of discrimination between good, indifferent, and bad writers, even between defenders and opponents of a cause.

Censorship is only one aspect of that hankering after control and uniformity, which is never (well – hardly ever) absent from government departments. It found an unexpected supporter in G. W. von Leibniz, one of the most enlightened philosophers and political scientists of his age. He conceived a 'reform' of the German book-trade which in effect would have transformed authors, publishers, and booksellers into state employees (1668–9). Rules and regulations instead of trial and error, instruction instead of inspiration were to be the guiding principles of literature. 'Nothing must be printed', one of the sections ran, 'without a prefatory statement as to what fresh knowledge the author has contributed to the benefit of the community.'

A similar plan was worked out by the Austrian chancellor Metternich, the protector and promoter of every reactionary movement throughout Europe in the first half of the nineteenth century. He envisaged a centralized organization of the whole German book-trade, under strict government control, in order 'to break the unlimited power of the booksellers who direct German public opinion'.

Metternich's scheme was broached in the same year, 1819, when the censorship edicts of Karlsbad tried to stifle the liberal movement in Germany by imposing a preventive censorship upon all political pamphlets of less than 320 pages. Printers and publishers rather successfully counteracted this measure by using the smallest possible size, the largest possible types, and every other device which a century-old fight against censorship had taught them.

THE NINETEENTH CENTURY
AND AFTER

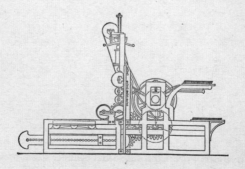

Overleaf: Friedrich König's first cylinder steam-press, 1811

Chapter Three

THE NINETEENTH CENTURY
AND AFTER

DURING the nineteenth century there was a gradual change in the technique of printing. At first, improvements were not widely adopted, as old-established methods were capable of dealing with the increasing demand for printed matter. It was only in very specialized fields, such as the production of the major newspapers, that the new techniques made headway. Within the whole of printing, development was uneven. Some processsses, such as the actual machining of the sheets of paper, moved ahead more rapidly than others.

The reasons for this are complex, but three factors may be considered – the often deliberate policy on the part of craftsmen (employers and employed alike) to limit mechanization; the fact that it was easier to mechanize a printing press than to mechanize the business of setting type; and the presence of an army of compositors who were able for a considerable time to cope with the demand for more type-setting. Not until the 1860s did the concept of mechanization begin to make an impact on letter-founding, type-composition, and bookbinding, and not until the late 1880s did the combined casting and composing machine become a commercial reality.

Nevertheless, as a consequence of a series of political acts, printers and publishers, booksellers and readers adopted, or

were forced into, new ways of production and consumption. The repeal of the 'taxes on knowledge' – the advertisement tax (1853), the newspaper stamp (1855), and the paper tax (1860) – led to an increase in the number of newspapers, and the consequent replacement of the hand-press by the cylinder machine in many establishments. The three Education Acts of 1870, 1876, and 1880 gave rise to a whole new class of readers with an appetite for popular newspapers and magazines, which such men as Lord Northcliffe were able to satisfy, building up giant printing works, based on the rotary press and mechanical type-setting in the process.

Technical progress, rationalized organization, and compulsory education, therefore, interacted upon one another. New inventions lowered the cost of production; mass literacy created further demands, and improved organization eased the flow of books from the publishers to the retailers' shelves. The combined effects of gradual mechanization, cautious adoption of new techniques, and the great expansion of demand meant that there was no wide-scale unemployment in the printing industry, and the reading public reaped the benefit of cheap newspapers, periodicals, and books.

The intellectual climate of the age favoured fundamental changes and the printing trade exerted itself to respond to the need. The educational achievements of rationalist thinkers had multiplied the number of literate persons; periodicals, almanacs, and newspapers penetrated into classes hitherto altogether lacking contact with literature. The Industrial Revolution had created a new public of great wealth who, in the second generation, were eager to fill the gaps in their intellectual and literary education. The American and French Revolutions mightily stirred interest in controversial matters of politics, economics, and society. Locke and Hume, the French Encyclopedists, and Kant had taught the public to reason, to question, and to discuss the problems and institutions which had hitherto been taken for granted. The rising tide of liberalism and democracy compelled the powers that be, or made it advisable for them, to justify their policies and actions; criticism needed rebutting. In

short, public opinion was challenged and as writers on both sides took up the challenge, the printer had to satisfy a demand for publicity unheard-of until that time.

━━━━━

1. TECHNICAL PROGRESS

AFTER 1800 printing, in common with other trades, began its slow transformation into an industry. Improved engineering techniques assisted this process and the break-up of the guild system, the general ferment in society following the end of the Napoleonic wars, and increasing literacy eventually created a climate in which machinery was accepted. This did not happen overnight. A Jena printer in 1721 had voiced the general attitude of the trade, which persisted until recent times, when he foamed at 'the damned hellish fiend' who tried to disturb 'the well-established state of repose of the printers' by suggesting all kinds of innovations.

The attitude of the guilds was made clear when those of Basel in 1772 banned the use of an improved hand-press because the inventor was a typefounder and not a printer. The König printing machine had to be installed and operated in secret at *The Times* in 1814 in case it provoked violent actions among the hand-pressmen. Masters could be no different from men as British typefounders in 1827 bought up and destroyed Louis Pouchée's type-casting machine, which would have threatened their handicraft methods. Only a few years later, in 1830, Parisian pressmen, taking advantage of the disorders created by the *coup d'état*, smashed up the hated imported printing machines.

It took a new generation of mechanically minded pressmen to accept the printing machine eventually, but their colleagues in the composing room kept up a rearguard action against mechanical type-setting for many years.

The first revolutionary invention concerned the mechanical manufacture of paper. A machine to supersede the costly and

slow production of hand-made paper was invented in 1798 by Nicolas Louis Robert at the Essonnes mill owned by the Didot family who were engaged in paper-making as well as type-founding, printing, and publishing. Robert took his patent to England, and here the first efficient machines were set up in 1803 at Frogmore, Herts, by the brothers Henry and Sealy Fourdrinier, stationers and paper manufacturers of London, and at St Neots, Huntingdonshire, by John Gamble, a brother-in-law of Pierre and Firmin Didot. The output of paper became ten times as high. Whereas from 60 to 100 lb. could be made daily by hand in one of the old paper-mills, the new paper-machine produced up to 1,000 lb. a day. By 1824 the price of some kinds of paper had fallen by a quarter or even a third; by 1843, by almost the half. In 1740 the percentage for paper in the cost of book-production was as high as 20·5 per cent; by 1910 it amounted to 7·1 per cent only. The annual paper production in the United Kingdom was 11,000 tons, all hand-made, in 1800; it rose to 100,000 tons in 1860 when 96,000 tons were machine-made, and to 652,000 tons in 1900 when, again, only 4,000 tons were hand-made. At the same dates the price of paper fell from 1s. 6d. to 6½d. and to 1d. per lb.

Almost at the same time the third Earl Stanhope (1753–1816) was responsible for the adoption of two inventions which permitted the potential surfeit of machine-made paper to be brought into circulation, as it were. The first was the process known as stereotyping, and the second was an all-iron printing press. Stereotyping had been 'invented' a number of times already, one of the earliest claimants being Johann Muller of the German church in Leyden, in 1700, before William Ged, an Edinburgh goldsmith, who worked on the process in 1725. It was a method of preserving pages of type for future re-prints and thereby avoiding the resetting of text. Ged took a cast of the former in plaster of paris and from this mould produced a fresh metal plate as often as required. He was defeated by the jealousy of compositors who feared for their livelihood.

The process was revived in France by Firmin Didot who

reversed it by making the metal cast from sunk faces, thus halving the work of reproduction. However, Lord Stanhope bought a process invented in 1784 by Andrew Foulis and Alexander Tilloch, Glasgow printers, which was based on the earlier principle. Stanhope claimed to have improved the process, and the first book to be printed from his stereotyped plates appeared in 1804. His agent, Andrew Wilson, offered the 'secret' of stereotyping to both University Presses at Oxford and Cambridge. Cambridge dropped the process in about 1811, declaring it was no secret, and Oxford in 1829 by which time, apparently independently in France, Italy, and England, the plaster of paris technique was replaced by papier mâché, which reduced at the same time labour, weight, and bulk. Nevertheless, Lord Stanhope was responsible, through his own stereotyper, Christopher Matthews, for the spread of the stereotyping process (and hence cheaper books), first in Britain and then in America.

The Stanhope press, made completely of metal, was not based on a radically new principle, as it retained the screw, operated by a bar as in the wooden press. However, a system of levers attached to the bar increased the power considerably and a full-sized sheet could be printed at one pull, and with greater ease than on the old press. The iron presses which followed – the Columbian, Albion, Washington, and derivatives, abandoned the screw as a means of pressure in favour of either lever and fulcrum, or various systems of toggle joint. The capacity of these presses was not a great deal more than that of the wooden press although, being easier to operate and more efficient, they were an advance. The invention of the inking-roller and the abandonment of the ink-ball, or dabber, also had the effect of speeding up production.

However, the big advance came with the adoption of a new principle of obtaining pressure – the cylinder and reciprocating bed carrying the type forme. This was adopted by Friedrich König, who also harnessed steam-power to printing – at first to a press based on the old hand-press and then to his epoch-making printing machine. This combination of the cylinder

and steam-power was, as John Walter said in *The Times* of 29 November 1814, 'the greatest improvement connected with printing since the discovery of the art itself'. König's first machines were used by the general printer, Thomas Bensley, but it was their installation at *The Times* newspaper which led to the greatest change in the history of printing up to that date.

The work done by a hand-press was about 250 sheets an hour; König's machine raised it to 1,100. The four-cylinder press, invented by Augustus Applegath and Edward Cowper

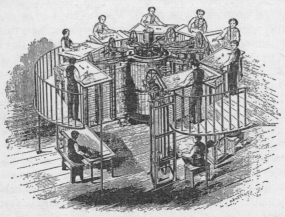

Applegath's vertical type-revolving press at *The Times*, 1848

for *The Times* in 1828, allowed 4,000 sheets an hour to be printed; a type-revolving press invented by the same men printed 8,000 sheets. In 1939, after the rotary press had been in use for half a century, *The Times* could be printed at the rate of 40,000 copies an hour of a 32-page paper. König's invention at once lowered printing costs by 25 per cent and thus made cheaper and larger editions possible. Before that, large editions were looked at rather unfavourably by printers since they made greater profits from composing than printing. There were some printers who cared less for the economic

advancement of the art than for the art itself. Göschen, the famous Leipzig printer and publisher, to whom König first offered his invention, declined it. 'The machine', he said, 'will issue many impressions, but nothing beautiful.' It was, however, another Leipzig publisher, F. A. Brockhaus, of Encyclopedia fame, who in 1826 began to apply König's steam-press to the printing of books.

Inventions for casting type by machine go back as far as 1806, but the first effective caster was that of David Bruce of New York, in 1838, although it was not until the middle of the nineteenth century that type-casting in the bigger offices in Britain was done by machinery. Only hand-moulds were shown at the Great Exhibition of 1851, but the following year saw the installation of the first of the machines by typefounders, after criticism that Britain was behind America in this respect. Between 3,000 and 7,000 pieces of type could be cast by hand in a day. The type-casting machine raised these figures to between 12,000 and 20,000, and the Wicks Rotary typecaster, invented in 1878, incorporating a hundred moulds, was said to be capable of delivering 60,000 pieces of type an hour.

The technical revolution also affected the covering and binding of the printed sheets. Up to the 1820s the printed books reached the public in the same state in which hand-written books had left the medieval scriptoria, namely in sheets loose or loosely stitched together; and it was up to the bookseller or the private book-buyer to have these sheets bound into covers made of boards and coated with leather. It was exceptional that a publisher sent forth his products already bound, and this was done only with cheap editions destined for the poorer customers who could not afford to have their books treated by professional bookbinders. Aldus Manutius was the first to sell his popular classics in standard covers; and the plain Aldine bindings, much admired today, must have struck his more fastidious contemporaries as shoddy fabrics unworthy of a gentleman's library.

About 1820 leather was gradually being replaced by the

cheaper cloth; Pickering's 'Diamond Classics' (1822–32) was the first large-scale venture in publishers' cloth. Towards the end of the century, hand-binding was superseded by machine-binding. In fact, the machine-bound book is not 'bound' at all but should properly be described as 'cased'. For the printed sheets are not really sunk into the covers (as is done with hand-bound books), but the machine merely sticks them on to the case which is prefabricated from cardboard covered with a thin layer of cloth.

With the exception of France, the cased book, provided by the publisher, has conquered the whole world. The result has been a universal decline of the art of bookbinding, again with the exception of France where publishers, binders, and custom-ers continue to prefer the old ways. This is compensated for by a remarkable reduction of the cost of the 'bound' book as well as by an increase of the technical and aesthetic perfection of the cases. Modern mechanical binding is probably strongest in the United States, soundest in England, and most attractive in Germany and Switzerland.

An interesting by-product of the publisher's binding is the dust-cover or book-jacket. The earliest English specimens are those wrapped round a *Keepsake* of 1833, an edition of *The Pilgrim's Progress* of 1860 and Dickens's posthumous novel *Edwin Drood* (1870). The book-jacket became a common fea-ture in the 1890s and has since stimulated the inventiveness of typographers as well as artists. Its usability for advertising purposes was discovered surprisingly late: the first 'blurb' appeared in 1906.

A veritable revolution in the outward appearance and 'feel' as well as in the unlimited availability and cheapness of print-ing material was brought about by the introduction of wood-pulp into the manufacture of paper, by the side, and sometimes in lieu, of the paper made of rags.

The great French physicist Réaumur was the first to recom-mend the manufacture of paper from wood-pulp as early as 1719, but nothing came of this suggestion. Nor did the paper-makers follow up the 'Experiments . . . of making paper with-

out any rags' made by the naturalist Jacob Christian Schaeffer, although his book (Regensburg, 1765) ran into a second edition and was translated into Dutch. Schaeffer used various vegetable substances, such as moss, straw, and wasps' nests; but distrust of the novelty and, with some justification, its technical feasibility prevented the invention from going beyond the laboratory stage. A Saxon weaver, Friedrich Gottlob Keller, accomplished the feat in 1843, and within a decade the production of wood-pulp paper had spread everywhere. It was to become a leading industry in Canada, Sweden, and especially Finland whose national economy has been described as 'built on paper'.

A great improvement of non-rag paper was the introduction of esparto grass, sponsored by *The Times* newspaper in 1854 and brought into general commercial use in 1861.

Commercial printing, such as posters, circulars, sale catalogues, and popular newspapers and magazines – in brief, all ephemeral reading-matter – were henceforth universally printed on wood-pulp paper. But inexpensive books of the sixpenny and shilling types were also made economically possible. The United States has become the chief producer and consumer of non-rag paper; Britain is leading Europe in both production and consumption, with Germany following closely. The chief sufferers, as it were, are the men whose duty or hobby it is to preserve printed material for posterity. Librarians, archivists, curators, and collectors see their exhibits disintegrate before their eyes, and an early book-list of Messrs Macmillan or an early prospectus of the L.N.E.R. is probably of greater rarity than a poster of Anton Koberger or a business report of the Fuggers.

The inventions which made possible and increased the mass-production of printed texts were accompanied by inventions which facilitated and reduced the cost of printed illustrations. The revival and improvement of the technique of wood-engraving (as opposed to wood-cutting) which Thomas Bewick (1753–1828) inaugurated in the last decade of the eighteenth century, it is true, benefited fine printing rather than

popular printing; but it was a step in the right direction in that Bewick restored the sense of typographical harmony which had largely been lost in the era of the uneasy companionship of letterpress and copper-plates. The first illustrated book to be printed on a steam-press was a book on *Cattle* printed by

Wood-engraving by Thomas Bewick

Clowes in 1832. It was, however, popular journalism which hastened the spread of illustrations as a regular adjunct to printed information. The *Penny Magazine*, printed by Clowes from 1832, and the *Illustrated London News* (1842) were the pioneers of educational and entertaining illustration respectively.

Of a more general application was the invention of printing from the surface of an absorbent stone, based on the antipathy of oil and water, and later known as lithography, which Alois Senefelder made in Munich between 1796 and 1799, and for which he obtained an English patent in 1800. The use of photography (from 1840) and the substitution of thin metal plates for the stone expanded the use of this process. Lithography became the principal process for the making of coloured reproductions of works of art, and, in its modern form, continues to be so. The hand-press gave way to the rotary press, with a refinement in which the image was first transferred, or 'offset', on to a resilient rubber-covered cylinder before printing on to paper. When machines are fed by reels of paper, rather than by single sheets, the process is known as web offset lithography, and this method expanded considerably in the decade 1960–70, particularly for the

printing of newspapers. Further expansion is anticipated when several limiting factors have been overcome, particularly the need for the damping of the plate, which inhibits many letterpress printers from going over to lithography.

The transformation of intaglio engraving on copper into an industrial process was also one of the great changes in the later nineteenth century. Soon after its discovery photography was applied to produce printing plates in which the image was etched in depth rather than in relief. The discoveries of W. Fox Talbot, Paul Pretsch, and J. W. Swan, during the period 1850–64, and the eighteenth-century rotary intaglio technique of printing on cloth were brought together by Karl Klíč in Vienna in 1890 to lay the basis of modern photogravure. In this process the image is transferred to a copper cylinder by means of a pigmented, gelatine-coated, sensitized carbon tissue, on which a screen has first been copied. After exposure, the areas not to be etched are protected and the image is etched into small cells to hold the ink – hence the use of the screen. Printing today is usually by the rotary principle, the cylinder rotating in a trough of thin, volatile ink, the surplus of which is scraped away by a thin blade, leaving the ink in the cells for printing.

Klíč's main work was in Britain and his Rembrandt Intaglio Printing Company was a new source of supply of colourful pictorial material. But Eduard Mertens is generally credited with the idea of using photogravure for periodical printing with part of the *Freiburger Zeitung* at Easter 1910. It is in this sphere that photogravure has made its greatest impact on the reading public with the production of colour magazines. The use of the process is likely to be further extended when the primitive hand etching gives way to electronic methods.

Last but not least in this sketch of the inventions which have expanded the social and economic aspects of printing, come the composing machines. The long list of men who wrestled with this problem begins with the scientist and political economist, Johann Joachim Becher in 1682 and includes

Giuseppe Mazzini, who obtained a patent in 1843. More than two hundred composing machines were invented from 1822 onwards. The first machines, beginning with the Young and Delcambre, simply composed typefounders' type into lines. Even the more advanced electrically operated Hooker, and

Young and Delcambre's composing machine, 1840

the tape-controlled Mackie did not attempt to cast type as well. The Hattersley (1866) was used in the English provinces and the Kastenbein (1869) was installed at *The Times* in 1872 and remained in use until 1908.

The main disadvantage of all these machines was the need to justify the lines of type by hand and to distribute it back into the machine after use. As it was often dirty it tended to stick in the tubes and cause delays. Moreover, it was such an expensive business that it could be done economically only by cheap juvenile labour. The opposition of the London Society of Compositors to the employment of unskilled workers explains the restriction of the Hattersley machines to the provinces as well as the near-exclusive use of the Kastenbein to *The Times*, a non-union house.

The problem of justification was gradually solved by the mechanical insertion of spaces between words, and distribution by a number of ingenious distributing devices. However,

POEMS

BY

GOLDSMITH

AND

PARNELL.

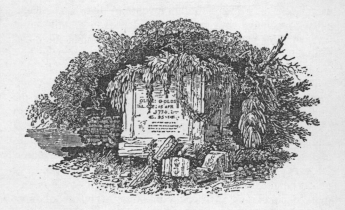

LONDON:

PRINTED BY W. BULMER AND CO.

Shakspeare Printing Office,

CLEVELAND-ROW.

1795.

A publication of the 'Shakespeare Printing Office',
directed 1791–1819 by William Bulmer, who, with his type-founder
William Martin, tried to outdo Baskerville and Bell
with *de luxe* editions

The Times eventually hit on the real solution to the distribution problem, and that was to abolish it by casting new type daily on the Wicks rotary typecaster and after use to melt it down. This solution had, in fact, been suggested by Dr William Church in 1822, when patenting his type-setting machine, which was not known to have been built.

What was wanted was a machine which would both cast and compose new type in the right sequence, and after many trials by many inventors, two basic machines emerged – the Linotype and the Monotype. Their immediate success, however, was largely due to another invention, that of the punch-cutting machine, made by Linn Boyd Benton of Milwaukee in 1885. This mechanical engraver made possible the mass-production of punches which was the indispensable pre-requisite of mechanical composing.

The first Linotype machine was installed at the *New York Tribune* in 1886, although it was not yet recognizable as the origin of the modern machine, the basis of which was laid in 1888. Its inventor, Ottmar Mergenthaler (1854–99), was an immigrant from Württemberg who added his skill as a watch-maker to the restless inventiveness of the Baltimore engineer, James O. Clephane. After ten years work Mergenthaler produced the Linotype machine. His basic innovation was that of circulating matrices, consisting of pieces of brass punched with characters. On the summons of an operator tapping the keys the matrices are brought together in a line, automatically spaced, for molten metal to be pumped into the punched areas and a complete line, or slug, of raised characters to be produced. The matrices are then mechanically returned to the channels, whence they may be brought into use again. Other machines on the same lines as the Linotype were produced and are produced today, the best known perhaps being the Intertype, the first model being installed by the New York *Journal of Commerce* in 1913.

Tolbert Lanston (1844–1913) was the first to adapt the perforated tape to control a machine which would compose and cast type, although others had earlier used this system for

setting founders' type mechanically. Lanston's machine was called the Monotype. The first model was produced in 1889, but it was not until 1897 that it was commercially established, mainly by the addition of a matrix case, which was not Lanston's invention. He did invent the important justification mechanism, by which not simply word spaces but every character in the line received an increment of width according to the pre-determined action of the mechanism. The Monotype system consists of two units – the keyboard and the caster. By operation of the keyboard a paper ribbon is perforated by means of compressed air. This ribbon is fed into the caster which carries the matrix case, and cast type is ejected singly and assembled in a channel until a line is completed. As with the Linotype, other machines on the same lines as the Monotype were developed, but none have survived commercially. The impact of the mechanization of composing on output was great. Whereas a skilled hand compositor has so far been able to compose about 2,000 letters an hour, the average output of the Linotype and Monotype operator is at least 6,000 in the same time.

During the 1960s the composition of letters by photographic means became more common. The idea of dispensing with metal type goes back as far as 1876, and from then onwards various types of machine were invented, until in the 1930s photocomposition could have been commercially possible. The printing industry was not ready for this innovation and not until after the 1939–45 war did the process make headway, when the advantages of light pieces of film over heavy metal formes began to become apparent. The expansion of the offset lithographic process, based on photographic techniques and naturally allied to photocomposition, also gave an impetus to the moves to dispense with type.

In the late sixties very high-speed photocomposing machines, motivated by computer programmes, came on to the market, and these have revolutionized the production of telephone directories, encyclopedias, and similar printed products requiring a great deal of setting. Computerized

composition is also making its way into newspaper production. At first, computer programmes were modest, being concerned with simple typographical niceties such as hyphenation, but they have now blossomed into full-scale typographic control – not merely the choice of type, size, length of line, and amount of space between lines, but even the way in which the type shall be laid out. For classified advertisements a computer can be programmed to place the advertisements not only in alphabetical order but under appropriate headings, and it is possible to include the invoicing to the advertiser.

A further development relates to optical character-recognition devices, by which a manuscript is scanned and converted into impulses for sending into a computerized photocomposition system; composition being performed at the rate of as much as 1,000 characters a second. While these O.C.R. devices herald the end of the five-hundred-year reign of the compositor, his day is not yet over, because conventional type-setting will linger on so long as it is more economic than the advanced systems. The compositor will work in smaller scale printing houses for some time. It is, however, possible to predict that in twenty-five years' time setting from metal type will probably be restricted to antiquarians and amateurs.

The possibilities of the computer are not restricted to the composition side, and will be applied to all aspects of printing, which will henceforth, in its largest branches, tend to be completely mechanical. It is now possible to envisage a book being produced without human intervention (although with human supervision) from the author's manuscript to the delivery of the finished product at the bookseller's, together with the subsequent invoice.

The rapid adoption of web offset lithography did not leave letterpress printers unmoved and by the end of the sixties, by using thin, flexible plates, sometimes made of plastic, and sometimes adopting the 'offset' idea, letterpress endeavoured to stave off the challenge of lithography.

At the same time, photogravure began to shed a limiting factor – the slow, hand method of preparing the copper

cylinders, which had meant, for example, that popular magazines had to be prepared weeks in advance of publication date. By the use of an electronic scanning device images can now be etched automatically on to the surface of the copper cylinders. The device was invented in Germany, where it was adopted by photogravure printers. In Britain its use was delayed by process workers, who continued to echo the feelings of that Jena printer 250 years before.

The way will be open, however, for a great expansion of photogravure if the automatic scanning device is widely adopted. But in the background is the possibility that all three printing processes will eventually be superseded by some version of electrostatic or pressureless printing, which is, as yet, only in the office-copying stage. When that happens, Gutenberg's day will nearly be done – his two main inventions (raised type and the pressure press) becoming things of the past.

―――――

2. THE LATIN ALPHABET IN SCRIPT AND PRINT

ONE of the long-term results of Gutenberg's invention was the irretrievable separation of formal book-hand and informal business-hand. The former was absorbed by the printed type while the latter degenerated into the illegibility of every man's hand worse than his neighbour's. This rot was eventually stopped by means which underline the complete ascendency of the type-cutter over the calligrapher. On the one hand the bulk of so-called handwriting has been transferred to the typewriter, which is essentially a one-man printing press. On the other hand the modern script reformers have drawn their inspiration mainly from the hands of the Florentine and Roman scribes of the renaissance, which served as models for the cutting of 'roman' and 'italic' founts.

This conservative return to the beginnings of modern lettering is equally marked in the type-faces now most commonly used in 'commercial' as well as 'fine' printing, as will be indicated in a later chapter. The nations which thus follow the lead

given by the humanists of Italy and France have recently gained two new adherents, Turkey and Germany.

It was a notable event in the history of civilization when in 1928 Turkey adopted the Latin script and prohibited the publication of books in Arabic characters. The high standard of calligraphy and the resistance of the professional scribes had delayed the introduction of printing in Turkish until 1729 when a Hungarian renegade, who on his conversion to Islam adopted the name of Ibrahim Müteferrika (1674–1745), set up the first Turkish press in Constantinople. After his death the press ceased to exist; it had produced seventeen books (in twenty-three volumes), including an Arabic dictionary and a Turkish–French grammar compiled by the German Jesuit, J. B. Holdermann. The next press was established by Sultan Abdul Hamid I in 1784 as an official press, but it never achieved any distinction.

More gradual was the elimination of Fraktur from the German-speaking world. The first to rebel against the monopoly of gothic were the German scientists, doctors, economists, and technicians. The very nature of their studies forced them into international collaboration, and throughout the nineteenth century they printed their books and periodicals in roman, so as to make them reach a non-German public.

A ridiculous attempt to fuse Fraktur and Antiqua is worth mentioning: in 1853, the Berlin foundry of C. G. Schoppe brought out a 'Centralschrift' and proudly asserted that they had at last resolved the century-old quarrel between roman and gothic. What they had done was the mechanical combination of upper-half roman and lower-half Fraktur characters – the most remarkable specimen of typographical folly ever thought of, as can be seen on the opposite page.

The final conversion of German printing to roman type, however, was not achieved by the natural growth of popular preference or change of taste as had been the case in western Europe in the fifteenth and sixteenth, in England and America in the seventeenth, and in northern Europe in the nineteenth centuries. It was imposed from above upon a reluctant or in-

different people. For some time the Nazis were in two minds. As long as they considered their creed primarily a matter for home consumption, they were inclined to enforce the use of gothic type as the genuine typographic expression of the Nordic soul. When, however, the vistas of the New Order of Europe and of the world domination began to fire their minds, Hitler shrewdly realized the advantages that would accrue to them from presenting the case of Nazi Germany in the typographical guise best calculated to be appreciated by the non-German world. Thus on 3 January 1941 it was decreed that 'the so-called gothic type' was a Jewish invention ('*Schwabacher-Judenlettern*') and that therefore Antiqua was henceforth to be the 'normal script' of the German people – despite its nonsensical argumentation, the one good thing Hitler did for German civilization.

This expansion of the Latin alphabet and roman type has unfortunately stopped at the frontiers of the Soviet Union. In the early 1920s Lenin set up a commission to work out a simplified spelling of the Russian language and to make recommendations for its transcription into the Latin alphabet. But the revival and intensification of Russian nationalism under Stalin has wrecked this scheme. Far from being abandoned, the Russian alphabet has now been imposed upon the colonial peoples in the Asian parts of the Soviet Union. However, this

Nach vielfachen Versuchen ist es mir gelungen, diese neue Schriftgattung zu erfinden, und so zu componiren, daß dieselbe eben so deutlich als Fractur wie Antiqua zu erkennen und zu lesen ist, und eignet sich vorzüglich als Titelschrift

C. G. Schoppe's *Centralschrift* ('unified type') which amalgamated roman upper half and Fraktur lower half (Berlin, 1853)

negative attitude of the Soviet Union may be more than counterbalanced when the Chinese State Council carries into effect its resolution of December 1957. This provides for the supersession of the 30,000 Chinese characters by a 30-letter version of the Latin alphabet suitable for a phonetic rendering of the Chinese and related languages. The addition of a potential 700 million readers of Latin script opens up a staggering vista.

The advance of the Latin alphabet is all the more remarkable as its characters are in theory by no means suited to the requirements of any modern language. The twenty letters of the original Latin alphabet were meant to reproduce the sounds of an Old Italian dialect; they were not even invented by the Latins but adapted from an altogether different language, colonial Greek; and even this Greek alphabet was originally devised to express the sounds of a Semitic language. Thus it is easily understandable that the characters first designed by the Phoenicians three thousand years ago are most imperfect to reproduce the words uttered by a twentieth-century European.

These inherent difficulties can for instance be clearly shown in the greatly varying attempts of the western nations to find a satisfactory sign for sibilants in which the Latin alphabet is notoriously deficient. The same sign s has to express (as visible in this sentence) two entirely different sounds, one of which, moreover, may cede its place to c (as in cent) or sc (as in scent), the other to z (as in size). The shooing sound is rendered sh in English, ch in French, sc(i) in Italian, sch in German, sz in Polish, š in Czech; and in transliterating the simple Russian consonant щ the German compositor has to use seven characters (schtsch), his English colleague four (shch), and even the Czech still two (šč).

Only three later Roman additions – the letters, x, y, z – and three late-medieval inventions – j, v, w – have been preserved in the printed alphabet; and it is to be regretted that William Caxton and his disciples did not save one of the most useful creations of Germanic scribes, namely þ, to denote the central fricative. Its form had, by the fifteenth century, become almost

indistinguishable from that of y; and the early English printers therefore used the latter in printing y^e and y^t for *the* and *that* – simply in order to save space, not because these words were pronounced ye and yat: 'ye olde English tea-shoppe' is a silly pseudo-archaism dear to the semi-literate.

A small number of ligatures and combinations of existing characters have, however, been adopted by printers and thus become definitely naturalized in various national literatures: œ = o + e in French, å = a + o in Scandinavian, ä, ö, ü (sometimes still printed as å, ô, ú) and ſt, ch in German. Further attempts to approximate the printed word to its phonetic sound have been restricted to the addition of diacritical marks: here the French led the way when, about 1770, they regulated the use of accents, cedilla, trema, and the like, which has, for instance, made the one letter e fulfil five functions (e, é, è, ê, ë). The Slav and Baltic languages have perhaps gone farthest in thus varying Gutenberg's characters; but it may be doubted whether the ł, ń, ś, ż, e, ą, ų, etc., of the Polish and Lithuanian alphabets have not impeded rather than eased the approach to these languages and literatures.

Unfortunately, in 1928 the Turks did not accept any of the western alphabets – although the Czech orthography would have been almost ideal for their purposes – but mixed English, French, German, and Rumanian spellings with some inventions of their own. This new Turkish alphabet makes the reading of Turkish texts unnecessarily difficult; e.g. c corresponds to English *j*, ç to English *ch*, *j* to French *j*, ş to English *sh*, and so on; an additional awkwardness is the distinction between dotted *i* (=French *i*) and undotted *ı* (=unaccented French *e*).

A cognate problem, which is of equal concern to the printer, to the philologist, and to the reading public, is that of the transliteration into Latin characters of non-Latin alphabets such as Russian and Arabic. The present confusion, not only between, say, English, French, and German transliterations of the same word but even between different schools of thoughtlessness within the English-speaking orbit has to be encountered to be believed. The half-dozen or more guises of a world-figure such

as Chekhov, Tchekhov, Tschechow, Tchékoff, Čekof, etc., shows the desirability of some standard system acceptable to the largest number of western nations.

3. THE TRADE

By the beginning of the nineteenth century publishing had firmly established itself as a whole-time profession. It would be justified to call it a vocation, as, even in the increasingly commercialized conditions of modern publishing, idealism has still remained an outstanding characteristic of the true publisher.

There have always been numerous booksellers and publishers who placed their business experience and authority at the disposal of the community, especially in the sphere of public and private welfare. A few of them have also played a distinguished part in state affairs. Benjamin Franklin, the versatile author, editor, publisher, printer, and inventor of the lightning conductor, served his native state of Pennsylvania as diplomatic agent in London (1757–75), was a signatory of the Declaration of Independence (1776), brought about the alliance with France, and crowned his diplomatic activities by the peace of Paris (1783) which gave international recognition to the United States, and finally took a decisive part in the drafting of the Constitution of 1787.

The Hamburg publisher Friedrich Christoph Perthes (1772–1843) was instrumental at the Congress of Vienna (1813–15) in securing the re-establishment of the ancient Hanse towns of Bremen, Hamburg, and Lübeck as independent republics against the expansionist wishes of Prussia, Denmark, and Hanover. The Stuttgart bookseller Georg Friedrich Cotta (1764–1832), Goethe's and Schiller's publisher, was a champion of constitutional democracy in the Württemberg Diet and an untiring advocate of the German Customs Union which took effect a few months after his death.

One publisher has even exchanged the direction of his firm

for the highest office his country has to offer: Harold Macmillan, representing the third generation of his family house, entered the House of Commons in 1920 and, through a series of ministerial appointments including the Foreign Office and the Exchequer, reached No. 10 Downing Street in 1957.

The stability achieved at the beginning of the nineteenth century can be seen in the large number of firms which have survived to this day, in many cases even in the same family. Longman, Rivington, Constable, and Murray have already been mentioned; Blackwood (1804), Chambers, Nelson, Macmillan, Blackie, Black (1807), and Cassell (1848) may be added in England and Scotland. In the United States, Harper & Brothers (1817), Appleton, Little, Brown & Co.; in France, Garnier (1833) and Plon (1854) date back over a century. In Germany, the financial collapse of the country after the Kaiser's war and its moral collapse under the Nazi regime and the sovietization of eastern Germany have wiped out nearly every firm which throughout the nineteenth century had enjoyed international repute. Vandenhoeck & Ruprecht of Göttingen (1735), C. H. Beck of Munich (1763), Karl Baedeker (1827) of Leipzig (now Hamburg), F. A. Brockhaus (1805) of Leipzig (now Wiesbaden), and Herder of Freiburg (1801) are among the survivors.

The greater resilience and power of survival of English publishers compared with their German and French counterparts can partly be explained also by the difference of their publishing policies. By the middle of the nineteenth century a tendency towards specialization had become marked in Germany and France, whereas in England and America the general publisher had become the rule. A change of intellectual movements or literary fashions is therefore bound to affect adversely the fortunes of a firm which has identified itself with a particular group of writers or school of thought.

The cumulative advantages brought about by the stream of technical inventions and improvements were underpinned by the concomitant progress of improved organization and greater legal security on the part of the trade.

In the field of organizing the trade, pride of place must be assigned to the Börsenverein der deutschen Buchhändler. Founded in Leipzig in 1825, it soon united within its fold the publishers, wholesalers, and retailers of books throughout the German-speaking world. No organization of quite the same comprehensiveness and efficiency has been established in any other country. But associations of publishers and those of booksellers sprang up everywhere during the nineteenth century, leading up in some cases to international unions such as the International Publishers' Association.

Their work has uniformly benefited not only the trade itself but equally so the public and the authors. Among their greatest achievements are the fight against piracy and the establishment of uniform book prices.

The international regulation of copyright has put an end to the century-old twin-scandal of privileged and pirated editions – the former enriching publisher and author at the expense of the public, the latter ruining the respectable publisher and author with small benefit to the public. Piracy was as old as the printing trade itself. It was in vain that, as early as 1525, Luther attacked these literary 'highwaymen and thieves', for the sure gain to be extracted from the reprint of marketable books was stronger than moral scruples. The Signoria of Venice was the first in 1492 to safeguard a printer against unauthorized issues of his books by others. The snag lay in the impotence of every government to make its decrees effective beyond its frontiers and the lack of any inter-governmental understanding. The first effective dam against piracy was erected by the English Copyright Act of 1709. But as it did not apply to Ireland, Irish printers continued to rob English printers and authors, deodorizing their filthy lucre by the sweet perfume of patriotism; and in this they were stoutly supported by the Irish authorities until the Union of 1801 ended this scandal. Thus it came about that three pirated editions of Richardson's *Sir Charles Grandison* (1753) appeared in Dublin prior to the genuine London edition, as disloyal workmen had surreptitiously taken the proofs across St George's Channel.

The United States clung to this outworn creed of the mercantilist era right through the nineteenth century. The firm of Harper & Brothers, of New York, deserves honourable mention for voluntarily paying fairly substantial royalties to Dickens, Macaulay, and other authors unprotected by law.

The English Copyright Act of 1709 and the French copyright law of 1793 (which provided for a term of two years after the author's death) were the first enactments to secure the right of authors and publishers within large countries. The copyright law of the Grand Duchy of Saxe-Weimar, issued in 1839, was the first of its kind in Germany and the first to embody the thirty-year term of protection after the author's death. It took another half-century until at last the Berne Convention of 1886 established the principle of international reciprocity of rights. The Universal Copyright Convention of 1955, sponsored by UNESCO, has eventually provided a system of international copyright protection (from which only the Communist countries keep aloof), without impairing the International Copyright Union of Berne, brought up to date last by the Brussels Convention of 1948 (which, however, does not include either the U.S.S.R. or the U.S.A.).

The abolition of pirated editions exerted a great influence upon the calculation of book prices. Hitherto the publishers said, 'Books are expensive because they are pirated, and they are pirated because they are expensive.' Net price agreements, such as those established by the Börsenverein in 1887 and by the Publishers' Association in 1899, have saved the bookseller from being undercut and forced out of business by unscrupulous profiteers, provided some security for the honest publisher, and also assured the author of his fair share in the proceeds.

On the other hand, it must be admitted that the reading public derived certain advantages from the pirating of books. The cheapness of those pirated editions enticed many to purchase a book, the original edition of which would have been beyond their means. The original edition of the *Œuvres du philosophe de Sans-souci* (i.e. Frederick the Great of Prussia),

for instance, cost 27 fl.; a pirated edition published almost simultaneously was to be had at 12 fl. The publishers naturally desired to keep the 'right' to print from the author's 'copy' and to keep it for ever. The public were equally urgent for cheap books. In Britain the question was solved largely as a result of Scottish enterprise. Alexander Donaldson of Edinburgh led the way by breaking a ring of the London booksellers, and John Bell of the British Library followed. The technical innovations in the printing trade made at the turn of the eighteenth–nineteenth centuries, and the spectacular increase of the reading public throughout the nineteenth and twentieth centuries, rendered feasible larger editions at lower prices. This process continued until the outbreak of the First World War, since when taxation, inflation and, in their wake, the rising costs of raw materials and wages have reversed the trend.

The stability and respectability which individual publishers and the publishing trade as a whole achieved during the past 150 years has had its repercussions on the relations between authors and publishers. It has increasingly become the custom for an author to identify himself with a particular firm and for a firm to consider its authors an integral part of the business. There are, it is true, earlier examples of an author preferring one publisher to another – frequently on the basis of personal friendship, as with Erasmus and Froben – or of a publisher helping his author through a lean period. But as a rule there prevailed a latent and sometimes open antagonism between the two, and the relationship of mutual confidence and amity which is now the norm may justly be described as of recent growth. Was Thomas Campbell serious when he once drank a toast to Napoleon because the emperor had ordered a publisher to be court-martialled and shot? In a moment of irritation Goethe once expressed his belief that there must be a special place in hell reserved for publishers. When Byron gave John Murray a Bible with the playful alteration of St John xviii, 40, to 'Now Barabbas was a publisher', he made amends (if amends were needed) by addressing to him the lines:

To thee, with hope and terror dumb,
The unfledged MS authors come;
Thou printest all – and sellest some –
 My Murray.

The wayward genius of Walter Savage Landor entrusted his publications to no fewer than twenty-eight different publishers between 1795 and 1863. It is however far more frequent to find not only that an author stays with one publisher but also that a mere business relationship develops into lasting personal friendship. The histories of every publishing firm are full of examples.

A happy combination of good business instinct and good taste led to a revival of the printer's device in the middle of the nineteenth century. This proprietary mark of quality, proudly introduced by Peter Schöffer, had fallen into desuetude. In England, the Copyright Act of 1709 made the device superfluous, as the Act gave greater security to the property rights of the book-producer than could be obtained by the mere display of a legally unprotected trade-mark. Moreover, the shift of emphasis from the printer to the publisher militated against any special reference to the printer's share in the production. The publishers themselves showed no interest in what they, as children of the Age of Reason, probably considered a pointless survival of less enlightened times: and the congers were too loosely organized to create corporative devices for themselves.

Charles Whittingham the younger, nephew of the founder of the Chiswick Press, is credited with the reintroduction of the printer's device about 1850. The idea was taken up by R. & R. Clark of Edinburgh, T. & A. Constable, and William Morris, whose first publication was in fact printed for him at the Chiswick Press in 1889. The reason for this resumption of the old custom was artistic as well as economic. The printer's device was meant to serve typography as well as publicity. Publishers soon adopted devices of their own. The sailing-ship of the Insel-Verlag, La Belle Sauvage of Cassell & Co., the fountain of Collins, the Penguin, Pelican, and Puffin of Penguin Books

have undoubtedly impressed themselves upon the memory of millions of readers. It is somewhat surprising that so many English publishers still refrain from using this simple and memorable means of commercial heraldry and that some of them use their devices only occasionally, whereas virtually every German publisher 'shows the flag' on every book brought out over his imprint.

It is difficult, if not impossible, to obtain a fair estimate of the economic importance of the printing trade as such. Printers proper, compositors, type-founders, proof-readers, publishers, booksellers, stationers, literary agents, bookbinders, and many

Printer's device used by the Insel-Verlag
in various forms from 1902

more professions have become almost independent of each other. One ought to add the vast host of authors, ranging from the indefatigable manufacturer of shilling-shockers to the occasional writer of a letter to the editor of a provincial newspaper, the staffs of publicity agencies and many other professions in order to get a somewhat complete survey of all those connected with printer's ink. Among them, the 'waste-paper' stationers must not be left out, to whom John Dunton, the author of *Religio Bibliopolae* (1728), sold 'many hundred reams of books that my friends had forgot to ask for'.

Statistics about the annual output of books are almost valueless, as the basis of computation differs not only from country to country but even within the same country. Thus, the German publishers' association assessed the production in 1937 at 31,761 'units' whereas the national bibliography arrived at 69,002 'units'. And it may be doubted whether the

7,839 items claimed for Rumania and the 10,640 calculated for the United States of America in the year 1939 actually refer to even remotely comparable 'units'.

The number of English master printers was 103 in 1724, i.e. a generation after the lapse of the Licensing Act; of these, 75 were located in London and 28 in the provinces. In 1785 there were 124 printing offices in London, and by 1808 this number had increased to 216. From that time onward further statistics of printing establishments would be misleading. On the one hand, printers began to specialize as they had never done before. The newspaper compositors were the first to set themselves apart from book and jobbing printers: numerous firms applied themselves to some particular field of printing such as work for the theatres, the railways, colour printing, the printing of law books and so on. Thus, small presses have been able to maintain themselves in some distinct sphere. On the other hand, the vast expansion of the book-trade favoured the emergence of big firms which could command the capital needed for the installation of complex machinery, and the master printer of old has to some extent become part of the 'managerial' structure of modern economy.

As printers have necessarily always been one of the best educated and most intelligent group of artisans, the influence of their corporations and trade unions is far in excess of their numerical strength. As early as 1785 London master printers agreed with a compositors' trade union upon a negotiated scale of wages for composing work (which incidentally implied the lapse of the control of the trade hitherto exercised by the Stationers' Company), and it was again in the English printing trade that factory inspection was made compulsory as early as 1864. From 1890 onward the various English unions connected with the printing and allied trades moved towards a nation-wide federation. This was eventually founded in 1902 under the name of the Printing and Kindred Trades Federation. Its original membership was below 50,000; it now exceeds 320,000, and comprises virtually the whole trade. The relative importance of the member unions cannot be assessed by numbers,

for even the smallest – the Map and Chart Engravers' Association and the Society of Music Engravers, numbering together 82 – fulfil unique functions in their own specialized fields. However, it may perhaps be asserted that the compositors form the aristocracy of printing operatives, and that among them the Londoners take pride of place. The London Society of Compositors (after its amalgamation with another union in 1955 known as the London Typographical Society) numbered 722 members in 1809, 1,751 in 1845, 4,200 in 1875, 11,355 in 1900, and 20,014 in 1957. Before 1900, however, there were always several thousand non-union compositors in London; today there are very few. The introduction of mechanical typesetting eventually meant that practically the same labour force can now deal with a much greater volume of printing than that done fifty years previously.

The Second World War brought trials and triumphs on an unprecedented scale. German air-raids on London destroyed nearly all the publishing houses centred round the Stationers' Hall (which was severely damaged) and with them over twenty million books. Having thus sown the wind, the Germans reaped the whirlwind. A few allied bombing raids on Leipzig laid in ruins the whole centre of the German book-trade, and the subsequent inclusion of Leipzig in the Soviet zone of occupation forced the old publishing houses to rebuild from scratch in the dispersion of western Germany.

The war-time demand for reading-matter exceeded all previous records. The boredom of the long hours of waiting and inactivity between battles, on the high seas, in air-raid shelters, and hospitals intensified the value of the book as a never-failing friend to millions of readers and inculcated the habit of reading to millions of new-comers in the realm of letters. Thus the ordeal which, according to the Nazi press, should have extinguished the British book-trade, in fact filled it with new buoyancy. The public's desire for books – more books and cheaper books – gave publishers, booksellers, and authors additional strength in warding off the 'tax on knowledge' which a Chancellor of the Exchequer threatened to impose in

1940. Unable, as he declared himself, to distinguish between books and boots, he wanted to subject both these commodities to the same purchase-tax. The general outcry against this piece of obscurantism, led by Sir Geoffrey Faber, forced the Chancellor to abandon his scheme before incurring certain defeat in Parliament. This victory, which officially declared the book a vital necessity of life on a par with daily bread, is a singular tribute to the changed outlook brought about by 500 years of printing.

4. CENSORSHIP

PRINTERS, publishers, and booksellers were fortunate enough to escape the strict regulations that bound and often choked the older crafts. Their guilds and associations have always been based on voluntary agreement of the parties concerned and not on compulsory measures of the authorities. There has hardly ever been a limit to either the intensity or the extensiveness of the spreading of the printed word. The work considered dangerous or unprofitable by one printer might be taken on by another without breaking the code of honour of the trade; and any pedlar might sell books and thus bring instruction or pleasure to remote spots never reached by the ordinary bookseller. 'Since the book trade is the territory of the republic of letters, only a free constitution is suitable to the book-trading profession', declared the founders of the Börsenverein of the German booksellers in 1825.

The liberal outlook of the trade received great encouragement throughout the nineteenth century by the gradual disappearance of book and press censorship. Its abolition in Germany (in 1848) and France (definitely in 1872) was of particular importance in view of the high status these countries enjoyed in the republic of letters. However, 'fundamental rights' written into constitutions have always been expressive of the lofty ideals of constitution-makers rather than of administrative practice. With the help of emergency decrees and special

laws, governments have continuously and usually successfully tried to introduce some kind of censorship while shamefacedly avoiding the odious name.

The fight against heresy had by the nineteenth century seemed to be relegated to the efforts of the Roman Index, which moreover had become almost disregarded by the laity; but it was unexpectedly revived in the twentieth century in the guise of political censorship on ideological grounds. The Germans started in 1933 with the symbolic burning of books by Jewish, Marxist, pacifist, and other 'decadent' authors, whose works were also eliminated from libraries and bookshops. Authors, publishers, and booksellers were dragooned into organizations rigidly controlled by state and party, with the inevitable result that, for the duration of the Thousand-year Realm, universal darkness buried German literature and learning.

The harsh censorship the Germans imposed upon the conquered countries from 1940 to 1945 led to a revival of the dodges in which earlier generations of printers had found solace and delight. René Billoux, in his *Encyclopédie chronologique des arts graphiques* (Paris, 1943), reprinted on the back of the title-page the privilege granted in 1582 by Henri III to a Paris publisher and saluted the German censor for resuming a tradition hallowed by the '*bon vieux temps*'. The gallant Dutch publisher G. J. van der Woude (d. 1958) brought out an innocent *Boekje over het maken van boeken* (Utrecht, 1941), in which he explained the preparation of copy for the compositor by means of a text on 'Holland, land of our heart' including a stirring patriotic poem; showed, as an example of an effective combination of woodcut and letterpress, a drawing of seventeenth-century *Geusen* with the (strictly banned) national anthem 'Wilhelmus van Nassouwe' beside it; reproduced a magnificent Jewish rabbi of Rembrandt's as a specimen of line-block printing; and used the instructions on proof-marking for some more quiet fun at the expense of the German and Dutch Nazis.

But the Fascists, Nazis, and Falangists at least refrained from directly taking over publishing and printing firms; even the Franz Eher Verlag in Munich, which was Hitler's private

property, never attempted to obtain a monopoly even of Nazi writings. On the other hand, the Soviet Union and her satellites have imposed upon the printed word a uniformity more comprehensive and thoroughgoing than anything ever experienced in a more or less literate society. As the Soviet governments rigidly control every means of production and distribution, no private printing presses are allowed and only government-approved books can be printed, published, imported, sold, and read – the very antithesis of what printers and writers have been hoping to achieve for centuries.

There is at least one authenticated case in which political censorship has resorted to forgery rather than suppression. The 'definite' edition of Chekhov, published under the auspices of the Soviet Academy, purports to print the poet's writings as he wrote them. In reality, the text has been tampered with by the editors; and whole sections have been omitted altogether, such as his correspondence with revolutionaries who, or whose shades, are no longer acceptable to the rulers in the Kremlin. All Chekhov's occasional references – made, be it remembered, before 1904, the year of his death – to the superiority of European, especially British, institutions, standards or habits have ruthlessly been excised. Not the slightest indication reveals this transmogrification of a progressive Russian patriot into a herald of Soviet jingoism.

On the other hand, there are examples that censorship from below can be as dense and intolerant as censorship from above. Gerhart Hauptmann's fight against the banning of almost every one of his plays from 1889 to 1913 provides documentary evidence of this fact. The licensing authorities in Germany, France, Austria, Hungary, Italy, Russia, and the United States were mostly forced to intervene by private pressure groups which rushed to the defence of morality, teetotalism, militarism, religion, child-welfare, nationalism, and established authorities down to the village constable.

The non-theological sections of the Index of the Church of Rome continue to puzzle Catholic not less than non-Catholic students of literature. Its latest edition (which a decree of the

Second Vatican Council in June 1966 has made the last ever to appear) has, it is true, removed Boccaccio and Rabelais, but the list of banned authors still includes Francis Bacon, Sir Thomas Browne, Richardson, Gibbon, Locke, Hobbes, J. S. Mill, and Lord Acton among Englishmen, and Montaigne, Pascal, Stendhal, Balzac, Dumas, and Victor Hugo among Frenchmen.

Present-day conditions in this country are probably as puzzling to an outside observer as are English institutions in general. In theory, political censorship can hardly be more comprehensive than that provided for by the laws protecting the royal family, the Houses of Parliament, the government and constitution of the United Kingdom, or those forbidding to raise discontent among Her Majesty's subjects or to promote ill-will between different sections of the community, through, amongst other things, 'any printing or writing'.

In actual fact, however, most Englishmen are not only totally unaware of these restrictions – even to the extent that it is commonly held that there is no such thing as political censorship – but they are perfectly assured, and rightly, that every judge, jury, magistrate, or police officer will in practice protect the liberty of the subject whatever the theoretical powers of the authorities may be.

Where it is agreed among all peoples of the free world that political censorship, except in times of a national emergency, is bad in itself, opinions vary greatly as regards moral censorship – a term mainly applied to countering obscene publications. The main problem here arises from the fact that (to quote Mr Kenneth Ewart) 'the danger is so difficult to assess, and its assessment is itself constantly changing as the so-called "moral code" is itself subject to change'. There is the undisputed need for protecting children against exploitation by unscrupulous traffickers in moral corruption, and this aspect is fully covered by the classic definition of 'obscenity' by Chief Justice Cockburn in Regina *v.* Hicklin (1868): 'The test of obscenity is this, whether the tendency of the matter charged as obscenity is to deprave and corrupt those whose minds are open to such im-

moral influences, and into whose hands a publication of this sort may fall.' The Obscene Publications Act, 1959, has modified this test by providing that the tendency to deprave and corrupt must be considered 'as a whole', that 'the interests of science, literature, art or learning' may be adduced in defence, and that 'expert opinion' can be called in evidence. It is hard to imagine how any legal code can cope more satisfactorily with a subject that by its very nature defies any hard and fast definition. The test case of the new Act, Regina v. Penguin Books Ltd (1960), has fully vindicated the public's confidence in trial by jury.

Few and far between are the cases in which publishers have arrogated to themselves the combined role of prosecutor, judge, and executor in determining what the public should, or rather should not, read. The burning of Byron's memoirs which John Murray considered scandalous and libellous is perhaps the worst outrage of this kind, as it entailed an irrevocable loss to literature. On the other hand, the firm of Cotta have done a service to historical scholarship and political science when they went back on their undertaking not to publish the third volume of Bismarck's memoirs during the lifetime of William II. Its publication in 1919 was amply justified by the emperor's inglorious retirement from the political stage, which Bismarck's penetrating character sketch of the youthful monarch did much to explain to the world.

5. OFFICIAL AND PRIVATE PRESSES

THE governments of Revolutionary and Napoleonic France were the first authorities to use the printing press for large-scale, direct, and incessant appeals and orders to the masses. The occasional proclamation or regulation which the paternal rulers of the old dispensation addressed to their subjects could be set up and pulled as a casual job by any printer, and the titles of king's printer, *imprimeur du roi*, and so on did not imply any exclusiveness on either part. The spate of commandments to be instantly obeyed and of forms to be forthwith

returned, which has ever since been inundating government offices and private dwellings alike, made imperative the establishment of presses under the exclusive control and at the direct bidding of the central administration in every country.

The promulgation of authentic texts of laws and statutes and the prompt issue of forms affecting every aspect of civic life is the main concern of government presses. Thus, the functions of the United States Government Printing Office in Washington, which was set up by Congress on 23 June 1860, were defined as follows: 'All printing for the Congress, the judiciary, the executive departments, independent offices, and establishments of the Government, with specified exceptions, is required to be performed at the Government Printing Office.' The undreamt-of and still increasing expansion of the activities of all branches of the Federal administration has never permitted this press to venture into the field of literary production, even if the Congressional Committee on Printing were to connive at such trespassing on private enterprise.

Most official presses, however, have not been able to refrain from producing more attractive reading-matter. They have usually followed the precedent of the French Imprimerie Nationale and taken special interest either in fine printing with a view to providing national models of the highest standard, or in the publication of expensive works for which there is no commercial market. In this respect, the *Österreichische Staatsdruckerei* (founded 1804), the Prussian *Staatsdruckerei* (founded 1851) and the German *Reichsdruckerei*, in which the former was merged in 1879, have set good examples.

Less frequently, government presses have directly assumed the function of publishers. In the Swiss canton of Berne the publication of all school-books was a state monopoly from 1599 to 1831. The Austrian State Publishing House, which was originally set up in 1772, had a monopoly of all school-books until 1869; after the revolution of November 1918 it was re-endowed with certain privileges but has now to compete with other publishers. Only in the Soviet empire absolute control over all reading-matter is exercised by the state through the

central administration of printing, publishing, and bookselling, Glavpoligrafisdat. The association of state publishers, Ogis, comprises a number of firms which cater respectively for political writings, encyclopedias, agriculture, the non-Russian nationalities, juvenile literature, and other groups and subjects.

A remarkable development has taken place in the transformation of Her Majesty's Stationery Office into a state publisher. It was founded in 1786 merely to stop the waste of public money that occurred when each Government department bought its own paper, ink, sealing-wax, and the like as it pleased. It is still a supply service for all Government establishments for every kind of office equipment, including calculating machines, photographic materials, and many other things unknown as stationery in the eighteenth century. To the general public, however, H.M.S.O. is better known as the publisher of all official documents, including the daily record of Parliamentary proceedings. This is traditionally known as Hansard after the name of the original printer, Thomas Curson Hansard (1776–1833), who from 1803 printed the debates of the two Houses, first for William Cobbett and from 1811 under his own imprint.

In addition to the publication and sale of official documents, however, H.M.S.O. has gone a long way towards competing with private publishers. Especially since the beginning of the Second World War the Stationery Office has been producing books on topics which stretch the conception of official or government business to its utmost limit. Books and pamphlets on art and archaeology, cooking and husbandry, anthropology and geography, social and martial affairs, historical manuscripts, and the English language are represented in H.M.S.O.'s list of publications. Only fiction has not yet appeared in it, although the Opposition of the day may often be inclined to subsume Government White Papers in this category. It is no doubt a matter of concern for the British publishers to have their spheres of activity encroached upon by a firm which, able to draw on the taxpayers' money, need not pay undue regard to ordinary business calculations.

It was pleasure in fine printing, or at least in printing according to personal taste, rather than concern with commercial success that made kings and nobles set up private presses in the seventeenth and eighteenth centuries. With the collapse of the aristocratic style of life and the advent of the utilitarian age these private presses disappeared. The ducal press of Parma run by Bodoni was the last of its kind. Lacking the inspiration of connoisseurs and craftsmen of independent minds and means, the standard of printing rapidly declined. Mass-production and mass-literacy further favoured quantitative output at the expense of quality. The chief characteristic of Victorian book production, it has been said, was not so much its bad taste as the absence of any taste at all.

However, the undisputed sway Britain held in world trade cast an unmerited lustre on British printing. A redeeming feature was undoubtedly the technical perfection of the design, cutting, and adjustment of the dreary *Englische Antiqua* as the 'modern face' types were collectively called in Germany. An ambitious type-cutter such as Johann Christian Bauer (1802–1867), founder of the famous Frankfurt foundry which still bears his name, could do no better than cross the Channel and perfect himself in the Edinburgh foundry of A. & P. Wilson.

The printer Charles Whittingham the younger (1795–1876) and the publisher William Pickering (1796–1854) tried in vain to fight the general depravity. Pickering in 1830 boldly adopted the dolphin and anchor, and the motto ALDI DISCIP. ANGLUS, as the device for his edition of the English poets (in 53 vols); Whittingham in 1844 revived the 'old face' type of Caslon on the Chiswick Press which he had inherited in 1840 from his uncle Charles Whittingham the elder – but theirs were voices crying in the wilderness.

However, their labours eventually bore fruit. It was at the Chiswick Press that William Morris had the first books printed which inaugurated the revival of good printing. Although Morris's title to being called the father of modern printing cannot be questioned, it should not be forgotten that the actual impetus came from Emery Walker (1851–1933). The lecture

Printer's device used by
William Pickering from 1830:
adaptation of Aldus's dolphin and anchor;
motto 'Aldi discip[ulus] Anglus'
('Aldus's English disciple')

which he delivered at the Arts and Crafts Exhibition in London on 15 November 1888 marks the birth of the new movement. For it was Walker's clarion-call and the friendship with Walker that inspired Morris to put into practice his reforming ideas.

Two basic conceptions of Morris underlay his own work and have since remained the fundament of all good printing: the

Printer's device with lettering in the style of the
'Troy type' used by William Morris at the
Kelmscott Press from 1891

unity of type, ink, and paper manifested in imposition as well as impression, and his insistence on the opening (i.e. two opposite pages), and not the individual page, as the unit from which the typographic design of a book has to be conceived.

Morris put his ideas to the test in the works which he produced at the Kelmscott Press. Fifty-three books with a total of some 18,000 copies issued from it in 1890-8 (Morris himself died in 1896), and their impact upon every press in every part of the world can hardly be overstated. This influence, however, was indirect in that the Kelmscott Press first inspired the creation of a number of other private presses through which it gradually imparted its principles to the mass of printers.

For Morris himself, ardent socialist though he was, had in mind chiefly the enlightenment of the few by providing them with choice specimens of what a perfect book should be like. And it must be admitted that in almost every detail his particular preference stood in the way of general application and therefore had to be abandoned or modified. Morris's typography was romantic rather than historic (it is no mere coincidence that it was contemporary with the neo-romantic movement in literature), and his delight in gothic type – which posterity has mercilessly classified as pseudo-gothic – ran counter to the whole development of 400 years of western typography. Rightly abhorring the feeble greyishness of contemporary inking, Morris blackened his pages into a graphic pattern which made them all but illegible; disdainful of the cheap and ugly machine-made paper of his day, he employed hand-made paper which was too thick to be practical for everyday handling, as well as too expensive ever to become a business proposition for large-scale editions. The Kelmscott *Chaucer*, Morris's greatest achievement, shows the advantages and disadvantages of his method to the full.

After Morris had broken the sway of crude commercialism in book production, it became the task of his successors to adapt his principles to the needs and possibilities of ordinary printers, publishers, and book-lovers. The most important private presses which strove after this goal were the following:

I. THE TEMPLE

The Dedication.

Lord, my first fruits present themselves to thee ;
Yet not mine neither : for from thee they came,
And must return. Accept of them and me,
And make us strive, who shall sing best thy name.
 Turn their eyes hither, who shall make a gain
 Theirs, who shall hurt themselves or me, refrain.

1. The Church-porch.

Perirrhanterium.

HOU, whose sweet youth and early
 hopes inhance
 Thy rate and price, and mark thee for
 a treasure,
Hearken unto a Verser, who may chance
Ryme thee to good, and make a bait of pleasure
 A verse may finde him, who a sermon flies,
 And turn delight into a sacrifice.

Beware of lust ; it doth pollute and foul
Whom God in Baptisme washt with his own blood
It blots thy lesson written in thy soul ;
The holy lines cannot be understood.
 How dare those eyes upon a Bible look,
 Much lesse towards God, whose lust is all their book!

George Herbert, *The Temple*, originally published in 1633,
reprinted in Caslon's style by William Pickering,
London, 1850

the works of Geoffrey Chaucer now newly imprinted

Opening of the Kelmscott Press *Chaucer*, illustrated and ornamented by Sir

HERE BEGINNETH THE TALES OF CANTER-
BURY AND FIRST THE PROLOGUE THEREOF

WHAN THAT Aprille with his shoures soote
The droghte of March hath perced to the roote,
And bathed every veyne in swich licour,
Of which vertu engendred is the flour;
Whan Zephirus eek with his swete breeth
Inspired hath in every holt and heeth

The tendre croppes, and the yonge sonne
Hath in the Ram his halfe cours yronne,
And smale foweles maken melodye,
That slepen al the nyght with open eye,
So priketh hem nature in hir corages;
Thanne longen folk to goon on pilgrimages,
And palmeres for to seken straunge strondes,
To ferne halwes, kowthe in sondry londes;
And specially, from every shires ende
Of Engelond, to Caunterbury they wende,
The hooly blisful martir for to seke,
That hem hath holpen whan that they were
seeke.

BIFIL that in that seson on a day,
In Southwerk at the Tabard as
I lay,
Redy to wenden on my pilgrym-
age
To Caunterbury with ful devout
corage,
At nyght were come into that hostelrye
Wel nyne and twenty in a compaignye,
Of sondry folk, by aventure yfalle
In felaweshipe, and pilgrimes were they alle,
That toward Caunterbury wolden ryde.

Edward Burne-Jones, printed with the 'Chaucer type' by William Morris, 1896

1894–1935, Ashendene Press (C. H. St John Hornby); 1894–1914, Eragny Press, Hammersmith (Lucien Pissarro); 1896–1903, Vale Press (Charles Ricketts); 1898–1910, Essex House Press; 1900–17, Doves Press, Hammersmith (T. J. Cobden-Sanderson and Emery Walker). The Gregynog Press of the Misses Davies (1922–40) was a late, and very likely the last, major venture in the field of entirely non-commercial printing.

Although the cumulative effect of the movement as a whole was more important than that of any individual press or printer, St John Hornby may be said to have been the greatest single influence upon the trade. He was a partner of the firm of W. H. Smith & Son, the foundation of 'Sir Joseph Porter' of *Pinafore* fame, and was thus able directly and indirectly to bring pressure upon the publishers and printers who wished to sell their products through the agency of his thousands of railway bookstalls, lending libraries, and stationery shops. It was Hornby, too, who gave Eric Gill his first commission for lettering. The Doves Press deserves mentioning for their insistence on plain printing: none of their books, of which the 5-volume Bible is the greatest, was ever illustrated, and their return to Jenson was more judicious than Hornby's attempt to revive the Subiaco type of Sweynheym and Pannartz.

The first application of the revival of printing to mass-produced books was made by J. M. Dent. His Everyman's Library, of which the first volumes were issued in 1906, adopted William Morris's principles and – at least in its title-pages and end-papers – style; the latter was eventually abandoned in 1935 and replaced by Eric Ravilious's designs, which in themselves epitomize the progress of modern typography from Morris to Morison.

When the First World War interrupted the works of peace, Morris's teaching had borne fruit. The nine issues of Gerard Meynell's magazine *The Imprint* (Jan.–Nov. 1913) testify to the widespread interest which by this time had seized the trade: every one of its subscribers was an implicit propagandist of the editor's ideas which were, moreover, presented in a new type, called 'Imprint', that combined the best features

Florish. Enter Claudius, King of Denmarke, Ger-
trad the Queene, Counsaile: as Polonius,
and his Sonne Laertes, Hamlet,
Cum Alijs.

King. Though yet of Hamlet our deare brothers death
The memorie be greene, and that it vs befitted
To beare our harts in griefe, and our whole Kingdome
To be contracted in one browe of woe:
Yet so farre hath discretion fought with nature, ‾
That we with wisest sorrowe thinke on him
Together with remembrance of our selues:
Therefore our sometime Sister, now our Queene,
Th'imperiall ioyntresse to this warlike state,
Haue we as twere with a defeated ioy,
With an auspitious, and a dropping eye,
With mirth in funerall, and with dirdge in marriage,
In equall scale waighing delight and dole
Taken to wife: nor haue we heerein bard
Your better wisdomes, which haue freely gone
With this affaire along (for all our thankes).
Now followes that you knowe young Fortinbrasse,
Holding a weake supposall of our worth
Or thinking by our late deare brothers death
Our state to be disioynt, and out of frame,
Coleagued with this dreame of his aduantage
He hath not faild to pestur vs with message
Importing the surrender of those lands
Lost by his father, with all bands of lawe
14

of designs of van Dyck, Caslon, and Baskerville. The sudden collapse of the periodical remains a mystery.

After the war, commercial printing everywhere caught up with 'fine' printing. Joseph Thorp, Sir Francis Meynell, and Oliver Simon in this country, D. B. Updike, Bruce Rogers, and W. A. Dwiggins in the United States, and Rudolf Koch and Carl Ernst Poeschel in Germany successfully applied the lessons taught by the preceding generation to machine-made articles in the whole field of printing. Francis Meynell's Nonesuch Press (founded in 1923) showed the compatibility of the care which private presses bestow upon edition and production

Printer's device of Bruce Rogers

with the business success which commercial firms have to rely upon. It was the first publishing house to use machines to produce so-called fine books, and thus overcame the uninstructed prejudice of the 'hand-made' school of book-lovers. Oliver Simon, who joined the Curwen Press in 1920, bridged the gap between jobbing and book-printing by enlivening the latter with the former's verve, and quieting the former by the latter's dignity. Francis Meynell and Harry Carter, while connected with H.M.S.O., have made an unprecedented effort to raise the standard of official printing from the unlovely 'blue-book' style to something which can bear comparison with a product of any private press.

To the Monotype Corporation printing houses all over the world owe the wealth of founts with which texts are now being

Ich sage hinfort nicht, daß ihr Knechte seid; denn 15
ein Knecht weiß nicht, was sein Herr tut. Euch
aber habe ich gesagt, daß ihr Freunde seid; denn
alles, was ich habe von meinem Vater gehört, ha=
be ich euch kundgetan. Ihr habt mich nicht er= 16
wählt; sondern ich habe euch erwählt und gesetzt,
daß ihr hingehet und Frucht bringet und eure
Frucht bleibe, auf daß, so ihr den Vater bittet in
meinem Namen, er's euch gebe. Das gebiete ich 17
euch, daß ihr euch untereinander liebet.

✠ So euch die Welt haßt, so wisset, daß sie mich 18
vor euch gehaßt hat. Wäret ihr von der Welt, so 19
hätte die Welt das Ihre lieb; weil ihr aber nicht
von der Welt seid sondern ich habe euch von der
Welt erwählt, darum haßt euch die Welt. Ge= 20
denket an mein Wort, daß ich euch gesagt habe:
„Der Knecht ist nicht größer denn sein Herr." ha=
ben sie mich verfolgt, sie werden euch auch verfol=
gen; haben sie mein Wort gehalten, so werden
sie eures auch halten. Aber das alles werden sie 21
euch tun um meines Namens willen; denn sie

442

The Four Gospels, designed and printed by Rudolf Koch, 1926,
in one of his black-letter types, the last flowering of
gothic typography, all cast by the Klingspor
foundry in Offenbach

TALES

Grotesque and Arabesque

EDGAR ALLAN POE

ILLUSTRATED BY W. A. DWIGGINS

The Lakeside Press
R. R. DONNELLEY & SONS COMPANY
CHICAGO : 1927

Title-page of a book designed by W. A. Dwiggins,
the American creator of the Caledonia,
Electra, and other founts

A SPECIMEN
BOOK

OF TYPES & ORNAMENTS
IN USE AT
THE CURWEN PRESS
PLAISTOW · LONDON

PUBLISHED FOR THE CURWEN PRESS BY

THE FLEURON LTD

101 GREAT RUSSELL STREET, LONDON

1928

Title page designed by Oliver Simon

printed in every civilized language. In addition to the re-creation and adaptation of classical faces such as Baskerville, Bell, Bembo, Fournier, Garamond, Plantin, and Walbaum, the firm has been responsible for the introduction of Centaur by Bruce Rogers, Goudy Modern by Frederick Goudy (both especially for the American market), Perpetua and Gill Sans by Eric Gill. Above all, the Times New Roman has, since it was first used by *The Times* newspaper in 1932, become the most widely used of all type-faces: the book which the reader has before his eyes is printed with it, and so are many other Penguin and Pelican books.

It is not national prejudice that puts England first in a survey of modern printing, for during the present century Britain has achieved and maintained an almost undisputed lead in typography. American, German, Swiss, and Dutch printers have much beautiful work to their credit. The Leipzig printer Carl Ernst Poeschel (1874–1944) takes his place among the great printers of all ages, and the Officina Bodoni in Verona, operated by Giovanni Mardersteig, ranks among the best private presses in the world. But all these printers, no less than their English contemporaries, are but the disciples and heirs of the British pioneers who, at the turn of the century, rediscovered and re-established the art of printing.

6. THE READING PUBLIC

THE technical and organizational improvements of the nineteenth- and twentieth-century printing trade were called forth by the growing literacy of ever-widening classes. In turn, the reading public became larger and larger because it was offered more and cheaper reading-matter and greater facilities for obtaining it by loan, purchase, or subscription.

Compulsory and free education on the elementary-school level was achieved, at least on paper, in most civilized countries in the course of the nineteenth century. The fight against illiter-

acy of the backward peoples has become a growing concern of our own time.

At the same time there has become vocal an increasing concern with the results of this increasing literacy. On the one hand, there is the basic question of the purpose of educating the masses. What use is the knowledge of reading if it is applied to worthless or even debasing trash? The optimists of the nineteenth century had no such qualms. Tolstoy was a voice crying in the wilderness when, in 1866, he cursed 'that most powerful engine of ignorance, the diffusion of printed matter' (*War and Peace*, second epilogue). The utilitarians were confident that improved education would result in greater fitness for coping with the economic and technical advances of the time; liberal politicians predicted from it a better preparation for good citizenship and a growth of international understanding. We know the results. 'The penalty of universal literacy', as a writer in *The Times Literary Supplement* put it (30 October 1953), may well be our 'moving into an age when everyone will know how to read but none will turn his knowledge to good purpose'.

On the other hand, there is much doubt about the actual results of the compulsory school attendance which, in this country, was enforced by the Elementary Education Act, 1870. Statistics are invoked to show that semi-literacy or even downright illiteracy is prevalent among the products of our elementary schools. The situation, it is true, has changed from the time, beginning with the invention of script and lasting until the end of the eighteenth century, when the number of people who would read was more or less identical with those who could read. However, these complaints often result from disregarding the general rise of the standard of education as well as some of the principal agencies of modern literacy.

For the development of the past 150 years has dethroned the book and the pamphlet as the primary reading-matter. Their place has been taken by the newspaper and the periodical.

The transformation of the newspaper into an instrument of mass-information and mass-education, into the voice – often

shrill, but always unfettered – of democracy, is the major contribution of the United States of America to the history of the printed word. The American newspaper was perhaps the most influential single factor in converting the millions of immigrants from despotic Russia, authoritarian Germany, lawless Ireland, illiterate Italy into citizens of a democratic republic; in making them throw their national, social, religious differences into the 'melting-pot'; and in teaching them what became known as the American way of life. This process required a simple language, a forthright style, and a colourful presentation very different from what European journalists and readers were accustomed to; but it proved to be the medium proper to the spirit of the age of expanding democracy.

Unlike the American press, the English newspapers were, up to the middle of the nineteenth century, severely handicapped by the stamp duty. It was enacted in 1712 and its amount was successively raised from ½d. to 4d. per copy in 1815. This 'tax on knowledge' kept the price of English newspapers artifically high; that of The Times was 7d. from 1815 to 1836, when the duty was reduced to 1d., and still 5d. until 1855, when it was at last abolished. Moreover, the stamp duty forced the editors to make the utmost use of every square inch of the type area. This need for economy forbade any 'waste' of space through cross-heads, paragraphs, leading, and similar devices, and thus required from newspaper readers the closest attention line by line and put a heavy strain on their eyesight.

But even the abolition of the stamp duty did not greatly influence the make-up of the English newspaper. It was still mainly written for, and read by, the middle classes, to whom the newspaper was a means of information rather than relaxation. The change was brought about when American methods, labelled the New Journalism, reached England. This happened in 1888; that is to say, four years after the Country Franchise Act had nearly doubled the number of voters. It was chiefly these newly enfranchised masses to which the New Journalism addressed itself. Skilfully anglicized by the genius of journalists and business men of the calibre of W. T. Stead, Alfred

Harmsworth, George Newnes, and C. A. Pearson, the New Journalism did away with the solidity and stolidity of the Victorian newspaper. The signal success of the *Star*, the *Evening News*, the *Daily Express*, and the *Daily News* in the end forced even the 'high-class' papers, the *Daily Telegraph* and *The Times*, to admit such 'Americanisms' as banner headlines, signed articles, illustrations, crossword puzzles, and ready-made advertising displays that have not gone through the hands of the paper's compositors.

It can safely be assumed that at present every household (at least this side of the Iron Curtain) is served by at least one daily newspaper, and that every adult therefore consumes his or her daily ration of reading-matter. The cumulative effect must be prodigious – but in what direction does it extend? It is certainly not to be found in determining party allegiance. The support given by the vast majority of American newspapers to the Republican Party was not able to prevent the uninterrupted series of Democratic victories from 1933 to 1949. The nation-wide respect in which the (*Manchester*) *Guardian* is held by members of every party and of none has done nothing to stop the uninterrupted decline of the English Liberal Party of which it is the foremost champion. It is rather the constant reiteration of arguments on which the majority of newspapers are agreed that makes their influence most widely felt. It has been noted above how the American newspapers have been sponsoring the uniform 'American way of life'. It may equally be said of the English newspapers that they have been assiduous in inculcating and maintaining certain standards of our public life, such as refraining from criticizing the sovereign and the officers of the law, accepting the decisions of umpires and referees, the protection of children and animals – features which, though considered traditionally English, in fact go back no farther than the middle of the nineteenth century. The contribution made by Fleet Street to raising the tone of public controversy and to supporting the efforts of philanthropists and educationists still awaits its historian.

If America gave birth to the modern newspaper, Scotland

can claim the paternity of the modern periodical. The serious periodical, which addresses itself to the student of politics, literature, art and the arts, started with the quarterly *Edinburgh Review* (1802–1929); its publisher was Archibald Constable, its first editors Sydney Smith and Francis (Lord) Jeffrey. Its full-blooded Whiggism was counteracted by the Tory *Quarterly Review* (1809 to date), published by John Murray and first edited by William Gifford. Blackwood's monthly *Edinburgh Magazine* (1817 to date) eschewed the fierce partisanship of the two Reviews and put literature before politics. London caught up with the Scots in the 1820s, with the *London Magazine* (1820–9), the *Westminster Review* (1824–1914), the *Spectator* (1828 to date), and the *Athenaeum* (1828–1921). Among the most important later periodicals were the *Saturday Review* (1855–1938), the *Cornhill Magazine* (1860 to date), the *Fortnightly Review* (1865 to date), and the *Contemporary Review* (1866 to date). Their success was largely due to the cooperation of notable writers and politicians. Carlyle, Hazlitt, and Macaulay wrote for the *Edinburgh Review*, Scott, Canning, and Southey for the *Quarterly*, Lockhart, George Eliot, and Lord Lytton for *Blackwood's*, De Quincey, Hazlitt, and Lamb for the *London Magazine*; and Thackeray was the first editor of the *Cornhill*, which incidentally was the first periodical to reach a circulation of 100,000.

The quickening tempo of the present century seems to favour weekly magazines rather than the monthly and quarterly reviews. While *The Times Literary Supplement* (1902) has become a guide and oracle on matters of literature all over the English-reading world, periodicals such as the *Spectator*, the *New Statesman* (1913), *Time and Tide* (1920) strongly influence the formation of educated opinion on political, literary, and other cultural topics in this country. For the weekly paper of predominantly political colour has not caught on in any other country. The 'serious' French, German, and Italian magazines usually put discussions of literary and artistic affairs in the foreground. The *Revue des deux mondes* (1829–1944), the *Nouvelle Revue de Paris* (1866 to date), the *Nuova Antologia*

(1866 to date), *La Cultura* (1881–1935), the *Neue deutsche Rundschau* (1874 to date) have been, or are, the most notable in this field.

F. A. Brockhaus (1772–1823), perhaps the most enterprising German publisher, tried several times to found a periodical which, as he somewhat pathetically said when launching *Hermes* (1819–31), should 'emulate the *Edinburgh Review* in fighting for freedom of thought and against everything which impedes the progress of civilization and the emancipation of the nations that have attained maturity, as far as this is possible in view of the backwardness of political knowledge in Germany'. But all Brockhaus's ventures foundered on the rock of censorship – Goethe suppressed *Isis* in 1819 – or for lack of interest. His one great success, the *Literarisches Wochenblatt* (1820–98), shows in the very title its specialization; a curious feature of this 'weekly' is its appearance, until 1853, four to six times per week.

The fierce party struggle between the Whigs and Tories during the Napoleonic wars, accompanied by the equally fierce partisanship of rival schools of literature, gave the impetus to the earliest 'heavy' reviews. A generation later the struggle for parliamentary reform and the enfranchisement of a large new urban population, accompanied by the rising tide of middle-class moralism and scientific realism in philosophy and literature, was responsible for the genesis of the lighter kind of magazine. 'A cheap weekly periodical devoted to wholesome popular instruction, blended with original amusing matter', was the paper Robert and William Chambers wanted to create with their *Edinburgh Journal*; starting in 1832 with 30,000 copies, its circulation rose to 90,000 in 1845 and thus justified the brothers' bold enterprise. After an honourable career of more than 120 years *Chambers's Journal* ceased to appear after its Christmas number 1956, when its circulation stood at about 10,000. In Germany the *Gartenlaube* (1853–1916) tried in a similar vein to combine popular instruction with light entertainment; with 400,000 subscribers in the early 1870s, it can be said to have moulded the literary taste, the secularist

philosophy, and the pseudo-liberalism of the Protestant *bourgeoisie* of nineteenth-century Germany.

The penny magazines went farthest in bringing regular reading-matter to the masses. They started in the United States in the 1820s, came soon to England, and from here conquered the European continent. The Society for the Diffusion of Useful Knowledge, founded by Charles Knight in 1826, began the publication of the *Penny Cyclopaedia* in 1833; 75,000 copies were sold at weekly instalments of 1d. When, in 1834, the weekly rate was raised to 2d., the circulation dropped to 55,000, and when in 1843 the price went up to 4d. the number of subscribers fell to 20,000. The first German *Pfennigmagazin* began in 1833 with 35,000 subscribers and soon reached the 100,000. Its editor, the Swiss-born J. J. Weber (1803–80), continued this success with the *Leipziger Illustrierte Zeitung* which, modelled on the *Illustrated London News*, he brought out under his own imprint from 1843.

The effect upon the readers of these periodicals has been described by Charles Knight as follows: 'They took the patronage of men of letters out of the hands of the great and the fashionable, and confided it to the people. They might not create poets and philosophers, but they prevented Kings and Lords pretending to create them.'

The strain of moral improvement and scientific enlightenment has, from the 1880s, gradually disappeared from the general type of 'light' periodicals, and mere entertainment has become their watchword. Even writers on 'educational' features now try to present their subjects 'without tears' – including causeries on the atom bomb or the budget.

On the other hand, there has taken place an increasing specialization and multiplication of magazines, so that by now there is hardly any activity, interest, or hobby that is not being catered for by a weekly or monthly, with gardening probably leading in appeal to the largest group of readers.

Two classes in particular have, during the past hundred years, swelled the ranks of readers of light magazines – women and children; and the number of magazines specially

written for them has been legion. Fashion, cooking, society gossip, and trashy love stories may – with due deference to the fair sex – be considered the main ingredients of the average woman's magazine; their influence on western civilization can safely be rated as nil. On the other hand, there was a period, lasting roughly from 1870 to 1910, when children's periodicals exerted a great and wholesome influence in supplementing the school curriculum to which the Education Act of 1870 subjected millions of boys and girls. The *Boys' Own Paper* (1879 ff.) is the best known of these often excellent and never harmful magazines; they have unfortunately lost much ground in recent years to the 'comics'.

While it is undoubtedly true that newspapers and periodicals have obtained a firmer hold on the classes as well as the masses than the book has ever had, the relative decline of the book as the principal reading-matter has been paralleled by an absolute increase of book-production and book-circulation. In this respect, three institutions must be singled out for their influence upon the reading habits as well as the reading-matter of the masses: the lending library (rental library in American parlance), the public library, and the book club.

The German playwright and short-story writer, Heinrich von Kleist, gives a succinct description of the 'climate' which made the lending librarias prosper. 'Nowhere', he writes in 1800, 'can the civilization of a town and its prevalent taste be studied more quickly and incidentally more accurately than in its lending libraries.' Books by Wieland, Schiller, Goethe are not in stock, as 'nobody reads them'. – What, then, do you keep? – 'Gothick novels, only Gothick novels: here on the right, those with ghosts, there on the left, those without ghosts: take your choice.'

Wilhelm Hauff, the Swabian novelist, in 1825 wrote a sketch on 'Books and the reading public', which confirms Kleist's experience. The staple diet of the lending libraries consists of Gothick novels, trashy love stories, and – Walter Scott. The immense popularity of Scott's novels needs no explanation; their diffusion all over Europe was accelerated by the fact that,

in the days before the Berne Convention on copyright, neither copyright fees nor royalties had to be paid for translations; their place in the lending libraries was assured by the prohibitive price of the original editions.

For Walter Scott was, if not the inventor, at least the first popularizer of the 'three-decker' which dominated nineteenth-century fiction – the novel published in three volumes at the arbitrary and artificial price of 31s. 6d. the set. This price, more than any other factor, explains the dominating position of the circulating library in the English book market between 1820 and 1890.

The man who 'cashed in' on this trend and whose name has become almost synonymous with the term 'lending library', was Charles Edward Mudie (1810–90). 'Mudie's Lending Library' was opened in London in 1842; its annual subscription of one guinea guaranteed its success – being the equivalent of the retail price of two parts of one three-decker novel.

Within a short time Mudie came near to being the sole arbiter of literary taste in fiction. He certainly exerted a ruthless dictatorship over the authors and publishers of this kind of literature: keeping within the narrow confines of Victorian middle-class respectability was the surest way to find favour with Mudie. Charlotte Yonge, Rhoda Broughton, Ouida, Marie Corelli were the giants among the 'Queens of the Circulating Library': it needs little imagination to picture the level of the average and the pygmies. Anthony Trollope may be ranked among the few survivors of Mudie's deadening patronage. Meredith's *The Ordeal of Richard Feverel* and George Moore's *A Modern Lover* are typical examples of the kind of literature which Mudie excluded from his shelves as unsuitable for the great English public.

Authors and publishers who conformed to the literary, moral, and social standards set up by Mudie enjoyed the security of a steady sale of their products; and when they went on long enough to supply the prescribed fare, they achieved an outwardly impressive popularity.

However, their vogue was as artificial and mass-made as

their productions. They were successful only as types and cumulatively; no single work of any of them – perhaps with the exception of Miss Yonge's *The Heir of Redclyffe* (1853), which reaped the benefit of coinciding with the high-water mark of the Anglican High Church revival – achieved success on its own merits. But as not a few of these authors wrote up to or over a hundred books, they had little difficulty in passing the hundred thousand mark or a multiple of it. Mrs Henry Wood, for instance, bagged a total of over $2\frac{1}{2}$ million copies, including the 500,000 of *East Lynne* which two publishers had rejected before Bentley took it on with some misgivings.

Mudie's dominion came to an end in the 1890s when the one-volume novel had ousted the three-decker. Although lending libraries still continue to flourish, their heyday is no doubt over; the closing of W. H. Smith's huge library department in 1961 is an ominous sign. Their place has largely been taken by the public library.

It is in the English-speaking countries that public libraries have established themselves as an integral part of public instruction and recreation. Only in those countries which are akin to the Anglo-American political and cultural outlook has the public library movement taken roots: the Scandinavian countries, the Low Countries, and Switzerland. Germany, curiously enough, lags far behind; its biggest towns can hardly compete with an average English county library. This is perhaps the more remarkable as the usefulness of public libraries was recognized earlier in Germany than anywhere else. In 1524 Luther urged the municipal authorities to use the endowments and bequests invalidated by the dissolution of the monasteries for the establishment not only of grammar schools but also of 'good libraries or book-houses'.

The following figures show the immense lead of the United States: the public libraries of New York contain about ten million volumes and more than twenty other cities over a million each. The annual circulation of volumes is even more impressive: New York with thirty million, Los Angeles and Chicago with ten million each, and fifty more cities with over

a million each. More than a hundred cities apportion over $100,000 annually for their public library budgets, some twenty of them over $1 million, mounting to $17 million in the case of Greater New York. On the other hand, clear-sighted American observers deplore the unequal distribution of these huge stocks for, beside the concentrated agglomerations in New England, the Middle West, and California, there are immense tracts almost void of libraries and bookshops.

The Ewart Bill of 1850 gave the English public libraries the support of Parliament; and, although they cannot compete with their American sisters, their importance for the intellectual life of this country is undoubtedly still on the increase. In 1960 over 430 million books were lent to a reading public of nearly 40 million. Run as a public utility, the public libraries have never tried to impose their will upon either their customers or their suppliers. Tacitly excluding trash, they have taken their part in the educational system very seriously, in providing for special needs such as children's departments and reference libraries, in assisting the student through the publication of select lists on a variety of topics, and generally striking a happy balance between the demands of the low-brow and high-brow sections of the reading world. Their dependence on, and supervision by, democratically elected corporations has tended to even out political and denominational bias, while at the same time exposing the librarians to the fresh wind of public criticism – with the result that all classes of readers are, and know that they are, served well.

The idea of book clubs seems to have originated in about 1900 with the Swiss Cooperative Movement, which supplied its members with books on a non-profit-making or profit-sharing basis. The largest European book club, Büchergilde Gutenberg, was founded in 1924 by the educational section of the German printers' trade union. It started with 5,000 members and now comprises about 250,000. The first book offered to the members was a volume of Mark Twain's short stories. Despite its trade-union background, the Büchergilde Gutenberg steered clear of politics in the selection of its books,

contrary to the Left Book Club and Right Book Club in this country, both of which deservedly foundered after a short career.

Book clubs in England and America came into being mostly in the 1930s. Here as elsewhere (for book clubs have now spread virtually over the whole world) they have done valuable service by bringing books into households which, for some reason or other – such as distance from bookshops – had never troubled to build up a private library of their own. On the other hand, there is the obvious danger – as with the Mudie patronage – of canalizing public taste into more or less narrow channels and of puffing non-controversial mediocrity at the expense of provocative genius. The leading English book club, World Books, (which had the courage to launch its first volume in October 1939), seems, in this respect, to be happier with its non-fiction than with the choice of its fiction. Its 150,000 members are offered, for instance, Churchill's memoirs, the *Kon-Tiki* story, and Sir Osbert Sitwell's autobiography, whereas the best of its novels are well-tried classics such as Manzoni's *The Betrothed* and Galsworthy's *Forsyte Saga*.

Oddly enough, the publication of books at reduced prices to the tens of thousands of book-club members not only has no adverse influence upon the sales of the original publisher's stock but rather stimulates the latter. The result is that reputable publishers gladly cooperate with the book clubs and thereby help to keep up their average standard. Here, perhaps, may be detected the real service done to literature by book clubs: large new sections of the community become, for the first time, 'book-conscious', and gradually make the reading and ownership of books a habit and natural part of their lives.

The situation seems to be less satisfactory in the United States. The Book of the Month Club and the Literary Guild, both founded in 1926, each had more than a million members in 1946, and during these twenty years distributed something like 150 million books among them. This colossal spread of a handful of book clubs threatens to stifle the legitimate trade by making virtually unsaleable any book that has not been

proclaimed the Book of the Month, of the Week, or of the Day – incidentally condemning even these favourites to oblivion as soon as the next month, week, or day has arrived.

―――――

7. BEST-SELLERS AND STEADY-SELLERS

THERE have been best-sellers from the beginning of the history of printing, and we have frequently had occasion to refer to them. But the general increase of literacy in conjunction with the hold upon the literate public of lending libraries, public libraries, and book clubs has considerably changed the meaning of the word during the past 150 years. An initial sale of 10,000 copies constituted a best-seller in 1800; an advance order of 100,000 would be the equivalent in 1960. The disposal of 50,000 copies within a year was regarded as a tremendous success throughout the nineteenth century; not a few books top the 500,000 mark every year in the middle of the twentieth century.

This may therefore be the proper place for some general observations on the problem of best-sellers.

Its peculiar fascination for the historian derives from two facts. On the one hand, it touches upon literature, aesthetics, psychology (individual and national), education, taste, as well as the business acumen of publishers and their publicity agents, so that it can be approached from the most diverse angles. On the other hand, it has never been possible to explain the phenomenon to such an extent as to give future guidance to authors, publishers, and the reading public – in fact, your guess is as good as anybody else's, and every opinion can be contradicted by opposite examples.

It is, for instance, often maintained that best-sellers are usually second-rate (if not lower) from the literary and aesthetic point of view. Richard Monckton Milnes, a genuine lover and promoter of good books, thought that the 'enormous' success of Macaulay's *History* was in itself enough 'to convince one

his book cannot be good', and a bluestocking of the 1930s declared categorically that 'best-seller is an almost entirely derogatory epithet among the cultivated'. Undoubtedly this holds good for perhaps the greater part of fiction best-sellers, from the *Amadís* romances (which were only killed by *Don Quixote*), through Richardson's *Pamela* (which Fielding's *Joseph Andrews* emphatically did not oust), down to Margaret Mitchell's *Gone with the Wind* (which after a run of twenty-five years shows no sign of fatigue). But against those minor works there can be set Ariosto's *Orlando furioso*, Bunyan's *Pilgrim's Progress*, and Goethe's *Werther*, which were best-sellers as well as great literature.

The very definition of the term 'best-seller' is fraught with perplexity. Is the Bible to be counted a best-seller? Undoubtedly, if one goes by the criterion of an undiminished, hardly fluctuating sale over long periods. In fact, from the days of the 42-line and 36-line Bibles onward, the Bible has proved the best-selling book in the world – whether published as a whole or in parts, 'designed to be read as literature' or in scholarly editions, in the languages of the originals or in any of the nearly 1,000 translations, as an 'authorized version' or as the product of private devotion to a never-ending and ever-rewarding task.

But this kind of book is hardly meant when one speaks of a best-seller in the technical sense. Rather than diluting the term 'best-seller', one might describe this category as 'steady-sellers', for their main characteristic is a steady demand which is, to an astonishing degree, independent of the vagaries of literary movements and styles, and easily transcends linguistic and national barriers. This category of books is the backbone of series such as the World's Classics, the Penguin Classics, and so on, which are being dealt with elsewhere.

Above all, the Bible in the vernacular has, from Gutenberg's time onward, remained the most saleable 'steady-seller', and this despite the fact that it is usually produced and sold without regard to the profit motive.

The Bible Society which Baron von Canstein founded at

Halle in 1711 was the first press to organize and carry out a mass-production of cheap editions: within the first 30 years of its activity it printed 340,000 copies of the New Testament at 2 groschen (2½d.) apiece and 480,000 copies of the whole Scriptures at 9 groschen (1s.) apiece. The numbers of Bibles since printed, especially after the foundation in London of the British and Foreign Bible Society in 1804, amount to astronomical figures. During the one year, 1965, the last-named Society alone has issued some 77 million copies of the whole Bible in 1,253 different languages. Of the Revised New Testament, published in May 1881, the Oxford University Press alone sold a million copies on the day of issue; two American newspapers had the whole text wired to them and gave away the volume as a supplement to their ordinary daily editions.

These cheap editions, however, have at no time impeded the sale of expensive Bible editions of either a purely scholarly or an *édition de luxe* character. The eight volumes of the famous Polyglot Bible which Plantin published in 1568–73 could be printed in 1,200 copies, although its price varied from 70 to 200 fl. (£70 to £200). The Oxford Lectern Bible, designed by Bruce Rogers in 1929 and issued in 1935 at 50 guineas, was expected to last for some 50 years: by 1955 the stock was exhausted. The Oxford and Cambridge Presses estimated the demand for the new translation of the New Testament to be a possible million in the first year after publication day (14 March 1961) – it turned out to be nearly four million.

Next to the Bible the outstanding examples of 'steady-sellers' are Homer and Horace among the ancients, Dante's *Divina Commedia* and Thomas à Kempis's *Imitation of Christ* among medieval books, Shakespeare's plays and Cervantes's *Don Quixote* among the writers of the European baroque.

The greatest single author to spin money for publishers, booksellers, and other authors all over the world has been Shakespeare. The four folio editions of 1623, 1632, 1664, and 1685 testify to his continuous appreciation by the Caroline and Restoration gentry (who alone could afford the pretty stiff price). The twenty-odd editions which appeared between 1709

BEST-SELLERS AND STEADY-SELLERS

and 1790 prove that he had obtained a sure hold among the educated classes. At the end of the eighteenth century, John Bell's editions of *Shakspere* (1774) and *Shakespere* (1785) introduced him to a broader, if less critical, public. In the nineteenth century he reached virtually every home – and every schoolroom. Macmillan's one-volume *Globe Shakespeare* of 1864 (at 3s. 6d.) may be counted among the most imaginative strokes of a publisher's genius; Reclam's successful venture in popularizing 'Unser Shakespeare' is told of elsewhere in this book; but J. M. Dent's *Temple Shakespeare*, published in forty volumes between 1894 and 1896, has probably beaten all editions: by 1934, when it was replaced by the *New Temple Shakespeare*, over five million volumes had lifted up or depressed as many schoolboys.

With more recent authors, it seems that national barriers have prevented a similar unfettered popularity. Molière, Walter Scott, Dickens, Ibsen, Dostoyevsky, Tolstoy, and Shaw are perhaps the only writers who, since the eighteenth century, have become the common property of the whole world of the white man. Other writers whom the English, French, Germans, Italians, and so forth regard as stars of the first magnitude in their respective national literatures, do elsewhere not often penetrate more deeply than into the lecture-rooms of universities, the classrooms of grammar schools and esoteric circles of high-brows. We believe it to be incontestable that to Wordsworth and Tennyson, Balzac and Hugo, Goethe and Schiller, Alfieri and Manzoni, Lermontov and Pushkin, Calderón and Camões little more than lip-service is paid outside their national orbits.

An exception is to be found in the happy realm of children's books. The internationality which has so largely disappeared from the bookshelves of the grown-up has been fully preserved in the nursery. The Frenchman Perrault, the German Grimm brothers, the Dane Andersen, the American Mark Twain, the Italian Collodi, the Swiss Johanna Spyri, the Swede Selma Lagerlöf, the Englishmen Lewis Carroll and Kipling have become the common property of children all over the world.

Even more: adapted to the horizon of teenagers, some books have thus taken a new lease of life which have long disappeared from the libraries: Defoe's *Robinson Crusoe* and Swift's *Gulliver's Travels* are the examples that come most readily to mind. The same perhaps applies to *Don Quixote*, which is certainly more popular with children than with adults – though the simultaneous appearance in 1954 of four English translations of the unadulterated text makes one wonder whether the book has not come back to favour.

On the whole, however, it would seem preferable to set these 'steady-sellers' apart from best-sellers proper.

A genuine 'best-seller' may be defined as a book which, immediately on, or shortly after, its first publication, far outruns the demand of what at the time are considered good or even large sales; which thereafter sometimes lapses into obscurity, making people wonder why it ever came to the front; but which sometimes graduates into the ranks of 'steady-sellers'.

The steady spread of literacy and the extension of leisure for cultural pursuits could not fail to affect the size of an average edition as well as modify the concept of what constituted a best-seller. In 1587 the Stationers' Company fixed an edition at 1,250 or 1,500 copies. School-books, prayer-books, and catechisms were allowed four impressions of 2,500 or 3,000 each annually; statutes, proclamations, calendars, and almanacs were altogether free from these restrictions. In 1635 the number of copies was raised to '1,500 or 2,000 at the most', unless 'upon good reason shewed' special permission might be granted for 3,000. Although these regulations were meant to protect the workmen against exploitation and to prevent cut-throat competition among the publishers, they probably gauged accurately the normal demand. As late as 1786 the semi-official *Relation* of the Leipzig book fair stated that an edition of 600 copies was considered the saleable maximum of non-fiction.

But it was fiction, and popular instruction presented in entertaining shape, that from the seventeenth century onward took pride of place. In this field the first European best-seller

was John Bunyan's *Pilgrim's Progress*. The first edition appeared on 18 February 1678 in the normal size of 2,000 copies; by the end of the year 10,000 copies had been struck, 4,000 of them by a pirating rival. When the lawful publisher, Nathaniel Ponder, brought out his fourth edition on 3 February 1680, he knew already of six pirated editions. The first American edition was published in the following year by Samuel Green of Boston. At the time of Bunyan's death, ten years after the first publication (1688), eleven editions – each probably numbering 4,000 copies – had left Ponder's press. Since then, the Puritan tinker's dream allegory has spread to the remotest corners of the earth. Its popularity is only surpassed by that of the Bible. It has been translated into 147 languages, among them Eskimo, Malagasy, Tibetan, Fijian and dozens of African and Indian tongues.

Bunyan, however, would have felt uneasy in his conscience had he realized that the mundane aspect of his guide 'from this world to that which is to come' is probably the main motive for its undiminishing popularity. If *Pilgrim's Progress* is read today chiefly as a gripping novel full of dramatic incidents, it is only following the general trend. For, from the early eighteenth century onward, the vast majority of best-sellers has been in the realm of purely secular fiction.

This wave started with Defoe's *Robinson Crusoe*. It came out on 25 April 1719 (and the author received £10 for it); the second edition appeared on 8 May, the third on 6 June, and the fourth on 6 August, by which time at least two pirated editions had also been issued. In the following year it was translated into French, Dutch, and German; and when at the suggestion of Jean-Jacques Rousseau (1758) it was adapted to youthful readers, its popularity increased everywhere. The number of more or less good imitations produced all over the continent must be added to the success of the original *Robinson*. Before 1800, about a hundred imitations were published in Germany alone; there appeared Swiss, Russian, and Silesian 'Robinsons' and various professions had their Robinsons as well, among them a *Bookseller Robinson*.

341

The first edition of Swift's *Gulliver's Travels* (1726) was sold within a week, the third two months later, the three together comprising 10,000 copies. The biting political satire directed against the Whig administration and society, the savage fun poked at scientific quacks, and the pessimistic view taken of the human race as a whole were, one suspects, less powerful incitements to the public than the never-fading interest in travellers' tales and the brilliant rationalization of the primeval beliefs in dwarfs and giants. This is certainly the case today, when most of the personal and political insinuations have become devoid of interest if not incomprehensible.

Richardson's *Pamela* (1740), Voltaire's *Candide* (1759), Walpole's *The Castle of Otranto* (1764), Goldsmith's *The Vicar of Wakefield* (1766), and Goethe's *Werther* (1774) were the next books to capture Europe almost on the day of publication. Each of them reflected (and subsequently intensified) a particular facet of contemporary thought and feeling. The reward of virtue and the punishment of vice, the subtle analysis of the human heart and mind, belief and disbelief in '*le meilleur des mondes possibles*', the earthiness of utilitarian rationalism contrasted with the irrationalism of the subconscious and supernatural, the combination of moral instruction and exciting plots – all these aspects secured for these novels an immediate response in every class of society, from the sophisticated *salon* to the servants' hall.

The Castle of Otranto heads the unending list of shockers which flooded Europe in the next two generations. They were the *pièces de résistance* of the lending libraries which at that time came into vogue, and successfully displaced better authors in the public favour. Mrs Ann Radcliffe's novels, of which *The Mysteries of Udolpho* (1794) gained the widest circulation (and still makes surprisingly good reading), led up to a rational explanation of the piled-up improbabilities and thus satisfied curiosity by means similar to those which were to be exploited by the later writers of detective stories.

Goethe's *Werther*, published in 1774, presents a nice bibliographical problem in so far as the unauthorized editions and

translations by far transcend the genuine ones. Their biblio-
graphical details are almost impossible to unravel. Within two
years at least 16 German editions came out, and within twenty
years at least 15 French translations, 12 English, 3 Italian, and
1 each in Spanish, Dutch, Swedish, Danish, Russian, Polish,
Portuguese, and Magyar had flooded Europe. Napoleon, when
he met Goethe in 1808, told him that he had read *Werther*
seven times.

After the success of his *Werther* Goethe never again touched
the best-seller level; Scott and Byron, his younger contem-
poraries and admirers, never fell below it. Their position is
unique in that they are the only best-selling authors that ever
reached this status through the unpropitious medium of verse,
which occasionally with Scott, frequently with Byron, even
amounted to poetry. Of Scott's *Lay of the Last Minstrel* (1805),
Constable and Longman, who shared the copyright, sold
44,000 copies within twenty-five years. His *Lady of the Lake*
(1810) made the fortune – transient, alas! – of Constable,
Ballantyne, and Scott, and permanently enriched the catering
trade on the shores of Loch Katrine. It seems surprising to us
that Byron's publisher, John Murray, ventured only the 500
copies usual with a book of poetry when he brought out the
first two cantos of *Childe Harold* in 1812; it was sold within
three days and four large editions were issued during the next
nine months. *The Corsair* was therefore printed in a first edi-
tion of 10,000, and this was sold on the very day of publication
(1 February 1814).

These figures are the more remarkable as poetry has always
commanded a small market. When in 1800 Longman bought
up the stocks of Joseph Cottle, Wordsworth and Coleridge's
Lyrical Ballads were valued at nil. The ledgers of Messrs Long-
mans, Green & Co., as Wordsworth's publisher is now known,
hold much information on the attitude of the publisher and
the public towards the poet's production between the years
1800 and 1835. The *Lyrical Ballads* were reprinted in 1800,
1802, and 1805, and the sale of the (together) 1,750 and 2,000
copies of the two volumes respectively must have seemed

satisfactory to Longman, as he ventured to issue the *Poems* of 1807 in 1,000 copies. But this optimism was misplaced, for after seven years 230 copies were still unsold. Until 1827 Longman therefore stuck to the 'normal' size of poetry editions, namely 500. Even thus, neither the publisher nor the poet made much profit – for instance, of the *Thanksgiving Ode* of 1816, 220 copies were still in stock in 1834; and of the *Ecclesiastical Sketches* (1822), 203 were unsold in 1833. The only poem which had a steady sale was *The Excursion* (1814), and the exceptionally large edition of 1,500 of *Yarrow Revisited* (1835) sold in the year of publication. With the 5-volume edition of the *Poetical Works* in 1827, Longman's confidence in his author began to bear fruit; its 750 copies were exhausted in 1832 and Longman printed a 4-volume edition of 2,000 copies which was sold by 1836. In both these editions, the 'Excursion' volume was larger by 250 and 500 copies respectively.

One of the reasons for the 'sales resistance' on the part of the reading public must have been the price of these books: the first edition of *The Excursion* cost 42s.; the second (1820), 14s.; the ones included in the *Poetical Works* 10s. 6d. (1827) and 7s. (1832). The few pages of the *Thanksgiving Ode* cost 4s.; of *The Waggoner*, 4s. 6d.; of *The River Duddon*, 12s. This, of course, bears upon the publisher's age-old dilemma of a high price restricting the edition and a small edition requiring a high price.

Robert Burns was certainly more successful. His *Poems chiefly in the Scottish Dialect* were published in an edition of 600 in 1786 and reprinted three times during the next seven years, not counting two American editions, published in Philadelphia and New York in 1788 and allegedly exceeding 25,000 copies. But more common is the fate of William Johnson (Cory)'s *Ionica*; the publisher ventured the usual 500 in 1858, and of these 138 were still on his hands in 1872. Even of Palgrave's *Golden Treasury*, which was to become one of the safest steady-sellers, the publishers hazarded only 2,000 copies in July 1861; by December it had reached the ninth thousand in its fourth impression.

On the other side of the Atlantic, Longfellow's *Hiawatha* was, and has remained, the greatest hit in the field of poetry. Of the 5,000 copies Ticknor & Fields printed, 4,000 had been ordered in advance of publication (10 November 1855). On 15 December the eleventh edition went to press; eighteen months later 50,000 copies had been sold in the United States and about half that figure in England, not counting German, Swedish, Danish, French, Italian, Polish, and Latin translations.

The poets who achieved outward and visible success during their lifetime can be counted on the fingers of one hand. John Keble's *Christian Year*, of which some 150 reprints were called for between 1827 and the poet's death in 1866, is among the few that have stood the test of time. On the other hand, the volumes of poetry of Emanuel Geibel, J. V. von Scheffel, and Martin Tupper (if his rhythmical prose may be classified as verse), each of which poured from the presses in several hundred thousands between 1840 and 1880, are only remembered as monuments to the bad taste of the English and German middle classes of the Victorian era.

Scott's signal success as the creator of the historical novel even surpassed that of his verse romances. From the day the first volume of *Waverley* was on sale (7 July 1814) the presses were kept busy turning out one reprint after another. Even a minor story, such as *Rob Roy* (1818), sold 12,000 copies within a month. Robert Cadell, Constable's son-in-law, bought the copyright of the Waverley novels in 1827; by the time of his death in 1849 he had sold 78,270 complete sets of the series. But the sales in England and Scotland were nothing compared with those in Ireland and the United States where the pirates unscrupulously exploited the lack of copyright protection. Publishers in New York, Boston, and Philadelphia kept their compositors on the alert when a ship from England sailed in, with the copy – preferably advance sheets – of a new Scott novel on board. In 1822, *The Fortunes of Nigel* was received on a Thursday in the printing shop and was with the booksellers on the Saturday following; *Peveril of the Peak* was set,

printed, and bound within twenty-one hours, *Quentin Durward* (1823) within twenty-eight. Three days' undisputed sales of a 3,000-copy printing was the best the first pirate could hope for before others rushed into the racket. By 1830, about twenty American firms were pouring out the Waverley novels.

The same happened in Europe where, again owing to the absence of any legal safeguards, translators and publishers tried to crowd each other out. All these editions were cheap in every sense of the word – abominable translations, nasty press-work, undercut prices. One German publisher issued two complete editions of about eighty volumes each in one year (1825), the one series at 8 groschen (9d.) the other at 4 groschen (5d.) per volume; in the same year another German firm sold 30,000 copies of their edition, and two more editions went to press at the same time.

Once again, as in the days of Richardson and Goldsmith, the English novel set a literary fashion to the western world, and the canons of the historical novel established by Walter Scott have since guided his followers everywhere. A considerable number of historical novels after Scott have themselves turned out best-sellers of national and even international fame: Fenimore Cooper's *The Last of the Mohicans* (1826), Wilhelm Hauff's *Lichtenstein* (1826), Alessandro Manzoni's *I Promessi Sposi* (1827), Victor Hugo's *Notre-Dame de Paris* (1831), Alexandre Dumas's *Les Trois Mousquetaires* (1844), W. M. Thackeray's *Henry Esmond* (1852), L. N. Tolstoy's *War and Peace* (1862–9), C. F. Meyer's *Jürg Jenatsch* (1876), J. P. Jacobsen's *Fru Marie Grubbe* (1876) are some of the best-known examples of this genre in the literatures of America, Germany, Italy, France, England, Russia, Switzerland, and Denmark.

Throughout the nineteenth century a sale of 10,000 copies within a year seems to have been considered an outstanding success, and anything above that figure constituted a best-seller. The year 1859 was a veritable vintage-year of best-sellers, with Tennyson's *Idylls of the King*, Samuel Smiles's *Self-Help*, Mrs Beeton's *Book of Household Management*, and

George Eliot's *Adam Bede* all reaching 20,000 or so within a twelvemonth. Fitzgerald's *Rubáiyát of Omar Khayyám*, which was to become the best steady-seller of that year's publications, was a complete failure to begin with; even successive reductions of the original price of 5s. did not make the few hundred copies sell.

The adventurous side of publishing is most often exhibited in conspicuous failures to recognize a prospective successful author or book. Conan Doyle's *A Study in Scarlet* returned three times to its author before a fourth publisher somewhat reluctantly accepted it; G. B. Shaw's early work was refused the imprint of Macmillan (four times!), Murray, Chatto, Bentley, and half a dozen almost equally well-known firms. Not a literary but a political miscalculation made John Murray, in 1831, decline the publication of Disraeli's *The Young Duke*; the passing of the Reform Bill, which accidentally coincided with a transitory depression of the book-trade, presaged to the stout Tory the complete ruin of this country, in which there would be no more place for publishing ventures.

Macmillans (who can afford to let their historian, Charles Morgan, tell some good stories against themselves) were able to make a best-seller of J. H. Shorthouse's *John Inglesant* (1880), because their printers, R. & R. Clark of Edinburgh, had printed at their own risk 9,000 copies, vastly in excess of their order, having greater confidence in the success of the novel than the publishers. Macmillan also transferred H. G. Wells's *Kipps*, of which they had sold 180 copies within two years, to Nelson who, within a few months, sold 43,000 copies. Most amazing, Macmillans were so cautious as to limit the first English edition of Margaret Mitchell's *Gone with the Wind* to 3,000 copies (1936) although the novel had already proved a best-seller on the other side of the Atlantic, with over 100,000 copies ordered before publication. *Gone with the Wind* was, in fact, since Harriet Beecher Stowe's *Uncle Tom's Cabin* (1852) the first American book to make an equal sensation in both countries. Even after the story had begun to appear in a Washington weekly, a Boston publisher turned down its

publication in book form, and the publisher of the magazine had serious misgivings when he saw the short story for which he had bargained grow into a two-volume novel. Within six months after publication day, 20 March 1852, over 100,000 sets at $1.50 were sold, and a cheap one-volume edition at 37½ cents reached 200,000 before Christmas. As in 1852 American books were not protected by copyright in this country, about forty different English reprints came out in the same year. Their prices ranged from 6d. to 15s. Routledge seems to have been the most successful of the English pirates; he frequently dispatched as many as 10,000 copies per day to the booksellers, and all in all sold over half a million out of the million and a half produced by the English trade. In the same year 1852 *Uncle Tom's Cabin* was translated into French, Italian, Danish, Dutch, German, Magyar, Polish, and Swedish, to which later on came translations into some thirty more languages.

Such figures have, of course, to be judged by those of the average turnover. The concept of a best-seller therefore varies greatly from country to country. Italian publishers in 1955, for instance, regarded as a best-seller a novel selling 5,000 copies or more, whereas their American colleagues would consider 500,000 a proper yardstick. On the other hand, some of the mammoth figures beloved by American publishers and authors are open to reasonable doubt. The Congregational Minister Charles M. Sheldon let himself be persuaded – not unwillingly, one supposes – by an Australian bookseller that his missionary story *In His Steps* (1897) had sold 150,000 copies in this one shop and 'at least a million' throughout Australia. Sampling such encouraging figures, the Reverend finally credited himself with total sales of some twenty million.

Considering the range of potential appeal, non-fiction can hardly be expected to compete with fiction in the realm of best-sellers. But those critics who are inclined to equate best-sellers and light reading greatly underrate the public's taste, curiosity, assiduity, or whatever may create a best-seller.

Macaulay's *History of England* was meant by its author to outsell the best-selling novel of the day. It did so. The first two

volumes which appeared in 1849 sold 40,000 copies in England and 125,000 pirated copies in the United States before the third and fourth volumes came out. Of these, 25,000 were sold on publication day (17 December 1855), leaving 11,000 more applicants unsatisfied, and within a month 150,000 copies had been disposed of, including the unauthorized sales of 73,000 in New York and 25,000 in Philadelphia.

William Howard Russell expected that the publication in book form of his celebrated dispatches to *The Times* from the Crimean War theatre might sell 5,000 copies; his publisher, Routledge, was hoping for more. Neither of them foresaw that 200,000 copies would be sold in 1855–6. J. R. Green's *Short History of the English People* started with a sale of 35,000 copies in the first year of publication (1874) and ten times that figure next year in the United States; like Macaulay's *History* it continues to be in steady demand on both sides of the Atlantic.

Turning from history proper to the philosophy of history, Oswald Spengler's *Untergang des Abendlandes* and Count Keyserling's *Reisetagebuch eines Philosophen* went into the hundred thousands in the Germany of the 1920s; just as did, after the Second World War, A. J. Toynbee's *A Study of History* in this country, the United States, and (in translation) in Germany. Among biographies John Morley's *Life of Gladstone* was at the time an unheard-of success. Of its three volumes, 25,000 sets were sold in the year of publication (1903), and the first cheap edition (at 5s.) sold 50,000 copies in 1908–9 – an interesting reflection on the hold the Liberal Party had in those days on the mind of the English public, for fifty years later the book strikes anyone incautious enough to open it as singularly dull.

More easy to explain is the signal success of Sir Winston Churchill's *The Second World War*. Its six volumes appeared from 1948 to 1954, and each subsequent volume had to be printed in larger editions than the preceding one, necessitating constant reprints of the earlier volumes so that the whole work already presents a complicated bibliographical puzzle. The reason for this is, of course, given in the unique fact that here the greatest single story in the history of mankind is being told

by the greatest single participant in that story who, at the same time, happens to be one of the greatest living writers of the English language – a worthy recipient of the Nobel Prize for Literature.

Science, too, is represented among best-sellers. In the middle of the nineteenth century the Rev. John George Wood achieved tremendous successes with his popularizing books on natural history; of his *Common Objects of the Country* (1858) the first edition of 100,000 copies sold within a week. In our century Maeterlinck's *La Vie des abeilles* (1901), Sir James Jeans's *The Universe Around Us* (1929), Rachel Carson's *The Sea Around Us* (1951), and Thor Heyerdahl's *Kon-Tiki* (1951) have been outstanding.

One would hardly expect government publications to rank among best-sellers. But Her Majesty's Stationery Office can boast of at least four books which fall into this category. The sale of $4\frac{1}{2}$ million copies of *The Battle of Britain* is easiest to account for; the 700,000 copies of *The ABC of Cookery* owe perhaps a great deal to food rationing which made the British housewife look out for new recipes; the fact that Sir Ernest Gowers's *Plain Words* and *ABC of Plain Words* together exceeded 350,000 raises hope that Whitehallese and journalese may after all be kept within bounds. Finally there is Sir William (as he then was) Beveridge's famous *Report* of 1942, which, with 275,000 copies sold by 1954, surely constitutes a record of the sales of a government paper.

The growth of book clubs necessitates a further reappraisal of what constitutes a best-seller. The printing order by the American mail-order concern of Sears, Roebuck & Co. of one million copies of Lew Wallace's *Ben Hur*, in 1913, has so far remained a unique feature of book production. But the regular dumping of 100,000 copies upon as many members of several present-day book clubs, too, cannot correspond to a genuine demand; and 100,000, which earlier on was a dream realized by few authors, tends to become the normal output of any book that has found favour with a more or less anonymous board of selectors.

Best-sellers and steady-sellers also have a cultural function which is quite independent of their own literary merits. From the publisher's point of view, Dr Desmond Flower has neatly described the latter as 'money-spinners'. This financial aspect, which, of course, also applies to best-sellers, frequently causes the erroneous impression that a lot of people – chiefly publishers, but also printers, authors, and booksellers – are making fortunes out of them. As a matter of fact, the gains from best-sellers and steady-sellers, as far as they don't go straight to the Commissioners of Inland Revenue, are normally ploughed back into business. The greatest gain the general public derive from the very small number of best-sellers and the very small (though fairly assured) profits from steady-sellers consists in the fact that they allow a few authors to go on writing without distraction, and a few publishers to finance works of scholarship or of unrecognized literary promise and other unprofitable books that otherwise would not see the light of day.

If it were possible to separate the various components whose interplay produces a best-seller, it would appear that the general climate of opinion is the principal factor. The rising tide of abolitionism floated *Uncle Tom's Cabin*, the anti-Republican sentiment of the New Deal era responded to *Gone with the Wind*. On the other hand, an author's previous reputation has apparently no effect on turning a book into a best-seller. Byron's dictum, 'I awoke one morning and found myself famous', fairly reflects the experience of most writers of best-sellers. Neither did the failure of Byron's *Hours of Idleness* (1807) prevent the immediate success of *Childe Harold* (to which the above words referred); nor did the success of the earlier verse romances of Walter Scott pave the way for the rapturous acclamation of his prose novel *Waverley*, because this appeared anonymously. In fact, most best-sellers have been written by people 'without a name', i.e. a name previously known to the public; and not a few by people who, like Harriet Beecher Stowe and Margaret Mitchell, have remained one-book authors.

The contribution of the publisher and the reviewer towards

'boosting' a book is difficult to assess in any case; with rare exceptions, they seem to be quite ineffectual in spotting and making a best-seller. For the publisher's success largely depends on the cumulative effect of the regularity and repetition of his publicity, whereas the best-seller is more or less the outcome of a spontaneous ignition. As regards book-reviews, general experience has shown beyond reasonable doubt that their effect on the sales of books is infinitesimal and more gratifying to the author's self-esteem than to the publisher's account-book. Only a very virulent disparagement, if sufficiently long to catch the hurried reader's eye, may have the opposite consequence: Goethe's *Werther* throve on its almost unanimous condemnation by the literary critics of the day, and Dickens's *American Notes* and *Martin Chuzzlewit* – surely some of his minor works – owed their colossal sales in the United States mainly to the vituperation poured upon them by the American newspapers. But the vagaries of contemporary criticism of all ages is quite another matter.

8. POPULAR SERIES

'KNOWLEDGE is power' – this aphorism of Francis Bacon became, in the nineteenth century, the watchword of the rising middle classes to whom the extension of voluntary and compulsory schooling opened the world of letters. '*Bildung macht frei*' was the motto which Joseph Meyer put on the title-pages of his Groschen-Bibliothek (penny-library). It is easy – and not unjustified – to mock the semi-education of the half-literate masses of the nineteenth century (and after!), with their belief in 'progress', which only too often meant the blind acceptance of fashionable half-truths; but there was no doubt much earnest striving after deeper and wider knowledge. Among the popular institutions which catered for the new literate – such as evening classes, extension courses, etc. – the popular series of cheap books must rank very high.

As in so many other fields, John Bell was also the pioneer of cheap reprints in uniform editions at a uniform price. He refused to join the conger of London publishers who financed Dr Johnson's *British Poets*, and launched a series, under the same title, of 109 volumes at the price of 6s. (1777–82). Apart from Johnson's prefatory *Lives of the Poets*, which have remained a glory of English literary criticism, his series failed, whereas Bell's succeeded. The reason may be found in the different attitude of the editors. Bell passionately believed in the educational value of his enterprise, whereas Johnson was sceptical about all cheap editions, whose publishers he described as 'no better than Robin Hood who robbed the rich in order to give to the poor'. It may safely be contended that no publisher or editor will ever be successful who does not believe in his mission.

The advance on the political scene of a public of less wealth and leisure than heretofore about 1830, and the enforced idleness in comparative comfort which railway travelling afforded from about 1840, were two important stimuli to turn the minds of publishers to the production of cheap literature. Archibald Constable was the first to speak of 'literature for the millions'. Printed on the newly invented machine-made and wood-pulp paper, issued in paper boards or inexpensive publishers' cloth, and sold by stationers and railway bookstalls, these books could be, and were meant to be, discarded after perusal with little regret on the part of the buyer.

Archibald Constable's Miscellany (1827–35), John Murray's Family Library (1829–34), Colburn and Bentley's Novels (1831–54) were the first of these series. They stressed the educational rather than the entertaining side of reading. Constable's series consisted chiefly of writings on travel and history, most of which were specially commissioned for it. Of Colburn and Bentley's series the *Spectator* wrote: 'When classical and highly priced standard works are thus placed within the reach of humble means, assuredly before the lapse of many years there will not be a house which gives the occupier a right to vote that has not also its little library.' Their prices were mostly

6s. per volume, a figure which has to be set against the standard price of 31s. 6d. for a nineteenth-century novel.

A further advance in mass-production and cheapness was made with the Irish Parlour Library, launched by Simms and McIntyre (1847–63; some 300 vols), and with George Routledge's Railway Library (1848–98; 1,300 vols). Both limited themselves to fiction and sold at 1s. each volume. Their instantaneous success was partly due to their display in the railway bookstalls of the firm of W. H. Smith, the first of which was opened in 1848 at Euston Station. Smith also procured for this venture special railway editions of the standard 'three-decker' novels, made up in one volume at the price of 6s.

The first popular series in Europe which made use of the new inventions of cheap mass-production clearly show their indebtedness to English models. The 'Pocket-Novelists' which the Frankfurt publisher Carl Jügel issued in the 1830s show their Englishness by their very title; they were aimed chiefly at the numerous English travellers who visited the romantic Rhine valley and thronged the fashionable spas and casinos of the Taunus mountains. This somewhat ephemeral series was followed by the 'Collection of British (later: and American) Authors' with which the Leipzig printer Christian Bernhard Tauchnitz (1816–95) in 1842 raised his small publishing department to the rank of a house of international fame. With eventually (1939) more than 5,400 titles the Tauchnitz series was, for nearly a century, the cherished companion of English-speaking travellers in central Europe and the royal road for foreign students to the treasures of English and American literature. Tauchnitz secured the good-will of the English writers and publishers by an unprecedented step. Although not obliged to do so under the then conditions of international copyright, he asked for the 'authority and sanction' of the authors and voluntarily paid them royalties on his reprints; at the same time he pledged himself not to sell these reprints in England and the Empire, while raising no objections to the sale of the original editions in Germany. Macaulay and Thackeray were among the largest beneficiaries of Tauchnitz's liberalism;

and when he once apologized for his deficient English, Thackeray replied that Tauchnitz should not worry as 'a letter accompanied by £50 is always in good style'. For a long time the Tauchnitz collection took no notice of the revival of good typography, but in the 1930s Giovanni Mardersteig carried out a thorough typographical reform. However, the entire stock was destroyed during the war, and the post-war attempt to revive the firm in Stuttgart failed because of the unlimited imports of English and American pocket-books.

William Shakespeare is the author who eventually stabilized the era of popular editions of good literature at bargain prices. Or rather it was 'Unser Shakespeare' who thus became 'a jewel well worth a poor man's taking'. For, preceding Macmillan's *Globe Shakespeare* of 1864 which, at 3s. 6d., sold 20,000 copies within a few months, the Leipzig publisher Anton Philipp Reclam brought out, in 1858, a 12-volume edition at 1½ taler (4s. 6d.) which, at half the price of the next-cheapest German edition, reached its sixth edition within a year. Moreover, this tremendous success encouraged Reclam to issue in 1865 the twenty-five individual plays at the equivalent of 3d. (from 1871, 2½d.) each.

By way of parenthesis it may be noted that in those same years the study of textual problems of printed texts also grew out of research work done on Shakespeare. Critical bibliography, as it is now called, was inaugurated in 1855 by Tycho Mommsen, brother of the great historian, and its outstanding achievements – by A. W. Pollard, R. B. McKerrow, Sir W. W. Greg, F. P. Wilson, and Fredson Bowers – still derive mainly from the scrutiny of texts of the age of Shakespeare.

The signal success of the Shakespeare edition suggested to Reclam the launching of a uniform series of similar booklets of literary quality at the same low price; each volume to be sold separately. Thus was born Reclam's Universal-Bibliothek, the model of popular series all over the world. It began in 1867 with the first part of Goethe's *Faust*; and although plays continued for a long time to be the backbone of the series, the advertisement of the first forty numbers already contains short

stories, poems, and essays. The price of 20 pfennigs (2½d.) remained unaltered until 1917. After seventy-five years, in 1942, it comprised about 8,000 numbers, printed in about 275 million copies. After the destruction of the stocks during the war and the subsequent sovietization of the firm, Reclam began its reconstruction in Stuttgart in 1947. By 1967, over 2,100 titles had been reissued, totalling over 118 million copies; the list is headed by Schiller's *Tell* with 2,100,000.

Among the most remarkable successes of the Universal-Bibliothek must be counted the Norwegian playwright, Ibsen. Between 1877 and 1942, Reclam sold over 6 million copies of the German translations of nineteen of his works; *Peer Gynt* leads with 719,000 copies, followed by *The Doll's House* (584,000) and *Ghosts* (544,000), and even his poems reached the 100,000 mark. Some may consider it even more remarkable that Plato and Kant each achieved a sale of over 930,000 copies, followed by Schopenhauer with 860,000 – of whose first book only 140 copies had been sold in twenty-five years. Of interest to the English reader is the order of precedence accorded by the German public to British and American writers in this series: Shakespeare (6·4 million copies), Dickens (1·5 million), Mark Twain (776,000), E. A. Poe (455,000), Bellamy (434,000; the (retranslated) German title of his socialist utopia was *Everything Nationalized*), Walter Scott (424,000), Oscar Wilde (401,000), Byron (312,000), with Darwin and Faraday as close runners-up. The post-war series includes translations of *Beowulf, Gulliver, Robinson Crusoe,* nineteen Shakespeare plays, and writings by Pearl S. Buck, Joseph Conrad, Dickens, Theodore Dreiser, Faraday, William Faulkner, E. M. Forster, Galsworthy, Graham Greene, Hemingway, Aldous Huxley, Kipling, T. E. Lawrence, Jack London, Somerset Maugham, Herman Melville, E. A. Poe, J. B. Priestley, Shaw (*Pygmalion*), R. L. Stevenson, Oscar Wilde, and Thomas Wolfe. Students of literary taste and of national psychology may find food for thought in these lists.

If Reclam's Universal-Bibliothek has been treated at some length, the reason is not only that it is the oldest and still

2 Silbergr. 7 Kr. rhein.

Universal-Bibliothek

2

Fauſt.

—

Eine Tragödie

von

Goethe.

Zweiter Theil.

———

Leipzig.

Verlag von Philipp Reclam jun.

Title-page of No. 2 of Reclam's Universal-Bibliothek (1867);
the design, described as 'elegant' in the first prospectus,
was retained until 1917

357

extant series of popular books, but also that it is the only one about which its historian has been permitted to give exact figures of printing, costs, and sales.

The mass-production of good, cheap reading-matter on the model of Reclam was taken up by more than one German publisher. All of them were moderately successful, though none could achieve the popularity and distinction of their rival until the Insel-Verlag launched its Insel-Bücherei in 1912. This new venture appealed to a more sophisticated public than that which Reclam chiefly catered for, and was therefore more restricted in the choice of its titles. But it applied to mass-produced books, at the price of 6d., the standards of typography and make-up which the revival of typography had up to then devoted only or mainly to *éditions de luxe*. Considering the somewhat high-brow fare, the success of the Insel-Bücherei must be regarded as a high compliment to the educated classes in Germany. After twenty-five years, in 1937, some 500 titles had sold 25 million copies, the three leading books being Rudolf Binding's *Opfergang*, Rilke's *Cornet* (with about 900,000 each), and Stefan Zweig's *Sternstunden* (about 500,000); but even an anthology of Carossa's poems, selected by the poet himself, sold 170,000 copies between 1937 and 1961, in addition to the 50,000 of the large edition. Very soon the Insel-Verlag began to include illustrated volumes containing up to fifty pictures in woodcut, half-tone, and colour. Here, as with Reclam, the exigencies of the inter-war period caused a rise of the original price, without however adversely affecting either production or sales: Rilke's *Cornet* has passed the million mark.

Popular series at such low prices as Reclam and Insel were not attempted in this country for a long time. In fact, when Mr (as he then was) Allen Lane in 1935 planned a series which, in his own words, was to supply good literature in attractive form at the price of a packet of Players, the highest authorities of the English publishing world were not slow in predicting its speedy and unavoidable failure. They were quickly proved wrong and in a short time Penguins were not merely reprinting well-known

fiction and biographies – the first ten titles had included books by André Maurois, Ernest Hemingway, and Mary Webb – but also serious non-fiction, such as Sir Leonard Woolley's *Digging Up the Past* and Sir James Jeans's *The Mysterious Universe*. In 1946, just over ten years after the first Penguin was published, E. V. Rieu's translation of *The Odyssey* – specially commissioned by Allen Lane as the first of a new series of translations of world classics – came out and by 1960 had sold more than a million copies. Of Penguin's sister series, Pelican Books, most of them specially written for this cheap form of publication, the sales in some instances reached several hundred thousand copies; even books on fairly limited aspects of archaeology, individual studies of philosophers and psychologists, and history textbooks occasionally sell in similar quantities: in the first twenty-five years of existence, Penguin Books have published over 3,250 titles and sold more than 250 million books.

Up to that time the 'Shilling Series' – the self-explanatory title of the series launched by H. G. Bohn in 1850 – was regarded by most English publishers as the minimum the English book-trade could afford for any 'Standard Library' or 'Classics' – the titles of the first and last cheap series launched in 1846 and 1853 respectively by the indefatigable Bohn. Neither Nelson's Sevenpennies nor The Reader's Library at sixpence did outlast their initial successes.

The one exception to this rule was Cassell's National Library. Its editor, Henry Morley (1822–94), had previously edited a Universal Library, published by Routledge at the customary price of 1s. The National Library was started in 1886 and within four years issued 209 volumes in weekly intervals at the price of 3d. each paper-bound and 6d. cloth-bound. Morley wrote an introduction to each volume, and the series covered practically the whole range of English literature. Standard non-copyright fiction was included, but with a strictly moral outlook, and such works as the *Decameron* and *Tom Jones* were carefully eschewed. The Library was a great success, and the average sale of the titles was 30,000 each; amounting

to nearly 7 million in all. Among the untold number of readers to whom it gave 'particular delight' was a poor little schoolboy in a Welsh village who was to become Professor Sir Ernest Barker. The price was raised to 6d. some time later, but the books were selling for many years. Later on, in 1907–8, Cassells undertook a similar series, called People's Library; of its 85 titles 900,000 copies were sold at 8d. a title. These were mostly fiction, tempered with Bacon's *Essays*, Marcus Aurelius's *Meditations*, and the inevitable Macaulay's *Essays*.

The isolated position of these two ventures of Cassell's may be ascribed to two factors. One is the high cost of production in this country owing to the high wages of British compositors and printers, compared with those abroad. The other, the attitude of the Victorian reading public. It seems to have wanted a more substantial fare to get its teeth into, at least as regards size; and it therefore asked for larger volumes, which in Reclam's Universal-Bibliothek would occupy three, four, or more 'numbers', and these in solid binding, for which Reclam would ask an extra charge.

The growth of Reclam's Universal-Bibliothek was greatly facilitated by the expiration, in 1867, of the exclusive copyright privileges which the German Confederation had bestowed upon certain authors and publishers. Henceforth, thirty years after the death of an author, his writings became 'free'. This at once released Goethe, Schiller, Lessing, Kleist, E. T. A. Hoffmann, Jean Paul and other classical and romantic writers for inclusion in cheap reprint series.

A similar effect on the English market was produced by the Copyright Act of 1842. This stipulated that copyright should cease seven years after an author's death or forty-two years from the publication of a book. The result was that, round about the year 1900, all or most of the writings of Dickens, Thackeray, Disraeli, Lytton, George Eliot, the Brontës, Carlyle, Ruskin – in brief, all the great Victorians – would become available.

It is therefore no accident that all the famous series of cheap reprints which have survived to this day originated within a

THE LIFE OF
SAMUEL
JOHNSON LLD
BY JAMES
BOSWELL Esq
VOLVME · I

LONDON : PUBLISHED
by J · M · DENT · & · CO
AND IN NEW YORK
BY E · P · DUTTON & CO

Title-page of No. 1 of Dent's Everyman's Library (1906);
the design was retained until 1935

few years: Nelson's New Century Library in 1900 transformed into Nelson's Classics in 1905; the World's Classics, started by Grant Richards in 1901, and taken over by the Oxford University Press in 1905; Collins's Pocket Classics in 1903; and Dent's Everyman's Library in 1906. These series are bound to have in common a great many features, as they serve the need of virtually the same classes and categories of readers, as understood and anticipated by publishers and editors of virtually the same commercial and scholarly standing. None of them, to begin with the most mercurial and, to the buyer, most painful aspect, has been able to maintain the initial price, nor even a uniform price. By way of compensation, both Collins in their reset and re-edited New Classics and Dent in their new large-format Everyman's Library have thoroughly recast the layout, typography, and binding in accordance with the more exacting demands of modern book-design. Collins and Nelson have concentrated mainly on novels, short stories, and other works of prose fiction; whereas World's Classics and Everyman's Library have cast their nets wider and included poetry and drama, history and biography, theology and philosophy with an appeal, as J. M. Dent put it, 'to every kind of reader: the worker, the student, the cultured man, the child, the man and the woman'.

The success of the four series was immediate and has been lasting. After half a century Nelson has passed 50 million copies; Collins has sold some 29 million copies of about 300 titles, 2·6 million of them since 1953 when their new series came into circulation. Dent, with over 1,000 volumes of Everyman's Library, have reached a total sale of over 43 million, and the World's Classics with 550 titles, about 12·5 million.

An examination of the best-selling titles of these popular series provides ample food for thought. Only 4 titles of Collins's series have maintained themselves among the 12 best-sellers over the past twenty years: *David Copperfield*, always keeping the first or second place, *Oliver Twist*, *A Tale of Two Cities*, and *Treasure Island*, with *Lorna Doone*, *Pride and Prejudice*, and *Jane Eyre* as close followers-up; after them, Dickens

appears again with *Great Expectations, Pickwick Papers*, and *Nicholas Nickleby*. It would appear that the serialization of some of these stories by the B.B.C. and the filming of others have given additional stimulus to the sales – a television serial of *Jane Eyre* in 1956 doubled the sales of the Collins edition in that year. This is something to be kept in mind when discussing the influence of broadcasting and the screen upon the book market.

Most of Collins's 24 best-sellers are also listed among the 70 best-selling Everyman books. The latter include 10 non-fiction titles, among which deserve notice 2 volumes of Plato (as with Reclam), Descartes, J. S. Mill, Karl Marx's *Das Kapital*, the Koran (included on the suggestion of G. B. Shaw), the *Anglo-Saxon Chronicle*, and, less surprising, Pepys, Boswell, and Gibbon. Sir Walter Scott is represented only once (with *Kenilworth*) in Collins's, and not at all in Dent's top list – in fact, Collins's New Classics now contains only 8 Scott novels, compared with 21 in their old series.

Of the best-sellers of the World's Classics, Palgrave's *Golden Treasury* figures also in the van of Collins and Everyman, and *Lorna Doone* in that of Collins. Otherwise the Oxford series numbers among its half-dozen most successful books *Twenty-three Tales* by Tolstoy, two volumes of *English Short Stories*, and a collection of *English Essays*.

The historian of literature may be interested in the choice of the first half-dozen titles with which these series started. The World's Classics began with *Jane Eyre*, Tennyson's *Poems*, *The Vicar of Wakefield*, Hazlitt's *Table-Talk*, Keats's *Poems*, *Oliver Twist*, *The Essays of Elia*, and *Wuthering Heights*. Everyman essayed first Boswell's *Life of Johnson* (2 vols), J. G. Lockhart's *Life of Napoleon*, Andersen's *Fairy Tales*, and Hawthorne's *Wonder Book and Tanglewood Tales*. Collins started with *David Copperfield, Kenilworth, Adam Bede, Two Years Ago, John Halifax Gentleman*, and *Westward Ho!* These titles are a remarkable testimony to the discrimination and taste of the editors of these series. Ernest Rhys (1859–1946), who edited Everyman's Library from its inception to his

death, was perhaps the most influential personality among them.

It has been suggested that the prodigious sales of these 'classics' series are largely 'spurious' because so many of their titles are among the books more or less frequently set for school examinations. *Force majeure* rather than spontaneous interest in literature would thus account for the popularity of *Pride and Prejudice* or *David Copperfield*. No doubt compulsory reading may stimulate the sales of certain authors; and in one case Collins definitely ascribe to its adoption as a set-book the sudden rise of a book to the fifth and later even to the third place of their series: H. G. Wells's *The History of Mr Polly*. But it is difficult to believe that the rise of O. Henry's *Short Stories* into the best-selling group of Collins's New Classics is in any way due to the dictates of the examination boards. Moreover, *David Copperfield* also heads all English prose writers in Reclam's library – and it is seldom read in German schools. Moreover, whereas Goethe's *Faust I*, which is a German school-book, had by 1942 sold 1·89 million copies, *Faust II*, which is not read in schools, had sold 1·46 million copies – a difference of only 400,000 copies over seventy-five years.

Much less can the signal success of the works of Tolstoy in the World's Classics and Everyman be ascribed to any compulsory reading in schools or colleges. His *War and Peace* had its largest sales during the Second World War, when its subject-matter and the prevailing uncritical admiration of everything Russian may have been contributing factors. But Tolstoy's essays, letters, and short stories were popular before the war, and his great compatriots Dostoyevsky, Turgenev, Gogol, and Chekhov had found entry in Everyman, which even lists *Crime and Punishment* and *The Brothers Karamazov* among its best-sellers.

The paper-back or soft-cover editions – of which Penguin Books (1935) was the pioneer in England and Robert de Graaf's Pocket Books (1939) in America – have now become the backbone of book production and book-selling. Their

popular appeal has had noteworthy repercussions. Originally these series were published by houses which entirely specialized in their production, and there are still a number – though steadily decreasing – of pure paper-back firms. But from 1945 more and more hard-cover publishers went over to issuing paper-backs as a profitable side-line. At the same time the programme of these series has been undergoing a change. All of them started with reprints, and mostly reprints of fiction. Now, entertainment and instruction nearly balance each other: in 1958, there appeared in America some 900 fictional and some 800 instructional soft-cover titles. Moreover, from 1940 onwards – Sir Allen Lane leading – publishers began to commission books specially written for these series, and some of these titles have been a boon for serious students as well as the common reader.

Finally, the wheel has turned full circle. One of the advantages of paper-backs is the ease with which they can be thrown away after reading without making the reader feel either his purse too much lightened or his conscience too much burdened. However, quite a few of the specially commissioned paper-backs appealed so strongly to their readers that they wished to keep them on their shelves in a more permanent form. In response to this demand it has now come about that hard-cover publishers acquire the copyright of paper-backs and reprint them in solidly bound library editions.

Conclusion

RIVALS of the printed word have sprung up in films, broadcasting, and television. The printing press has made it possible for millions of people to read the same text at the same moment: wireless, television, and the cinema enable millions of people to hear the same text spoken and to see the same performance acted at the same moment. To what extent are these new means of mass communication going to affect the future of the printed word?

Certainly the number of people who rely upon the cinema and the B.B.C. for entertainment and instruction is steadily increasing. Yet is the number of readers decreasing? Statistics have proved the contrary. When newspapers took up reviewing books, they did not divert the interest of their readers from newspapers to books. An increase in the sale of books was by no means damaging to the circulation of newspapers: both could thrive very well side by side without their respective spheres overlapping. The same forecast may be ventured as regards the competition for the favour of the public between broadcast and book. Publishers, booksellers, teachers, and librarians can testify to the fact that a good many people are currently being induced to read books after having listened to literary broadcasts (such as reviews of new publications, recitals from poetry, or serialized adaptations of novels) or after having watched on the screen the filmed version of a play or story.

The peaceful coexistence of print, sound, and vision is to a large extent guaranteed by the psycho-physiological make-up of the human race. The basic division into visual, auditory,

and motorial types means that the primary and strongest impulses are conveyed through the eyes, the ears, and the muscles respectively. These types, though of course not clear-cut, are sufficiently differentiated to ensure the permanence, side by side, of three groups of people who derive the deepest impression and greatest satisfaction from either reading words printed, or listening to words spoken, or watching words acted.

Before the days of Edison and Marconi the printer was the sole distributor of the word by means of large and uniform publication. After the loss of this monopoly the printer will have to reconsider his position, which may be said (with a grain of salt) to have remained unchanged since the time of Gutenberg. However, as this open competition will certainly result in further improving the printer's craft it is all to the good. In the long run the general public, the last judge of the printer's endeavours, will benefit by it, and the printer will continue to hold the proud position of a man – as Gutenberg's epitaph puts it – 'well-deserving of all nations and languages'.

BIBLIOGRAPHY
NOTES
INDEX

The publishers wish to thank the Prestel-Verlag of Munich for making available to them, in this edition, the blocks for most of the illustrations. They were first used in *Die Schwarze Kunst*, the German translation of this book, published in 1958 (Second Edition, 1961). Thanks are also due to Faber & Faber for the loan of prints and for making available a number of blocks.

Bibliography

THE material for a history of printing, if conceived as a history of civilization reflected in print, is not to be found in one or two comprehensive reference-books. Almost any historical, sociological, and bibliographical dissertation, if used with discrimination, will yield some relevant information. Much material is, of course, contained in the histories of individual firms of printers and publishers and in the biographies and autobiographies of leading booksellers.

The following list is limited to some indispensable standard books. Further bibliographical aids on special topics are given in the Notes.

Membership of the Printing Historical Society and use of the technical library at the Saint Bride Foundation Institute (both at Bride Lane, London, EC4) should be regarded as obligatory by any student of the history, theory, and practice of printing.

GENERAL BOOKS

Harry G. Aldis, *The Printed Book*. 3rd ed. rev. by John Carter and Brooke Crutchley (C.U.P., 1951)

> Excellent summary, useful for the beginner as well as the expert

Stanley Morison, *The Typographic Arts* (Sylvan Press, London, 1949)

> Reprint of lectures on 'The Typographic Arts' and 'The Art of Printing', with new (and more) illustrations and a revised (and augmented) appendix

K. Bauer, *Aventur und Kunst: eine Chronik des Buchdruckgewerbes* (Bauersche Giesserei, Frankfurt, 1940)

> Annalistic history of printing; well illustrated

BIBLIOGRAPHY

D. Greenhood and H. Gentry, *Chronology of Books and Printing*. Rev. ed. (Macmillan, New York, 1936)

> Shorter and less scholarly than Bauer, but convenient to English readers

F. Kapp and J. Goldfriedrich, *Geschichte des deutschen Buchhandels*. 4 vols. (Börsenverein, Leipzig, 1886–1923)

> A mine of information on the German printing and book trades, with numerous references to other countries as well

H. Widmann, *Geschichte des Buchhandels vom Altertum bis zur Gegenwart* (Harrassowitz, Wiesbaden, 1952)

F. A. Mumby, *Publishing and Bookselling from the earliest times to the present day*. 3rd ed. (Cape, London, 1954)

> Both books contain extensive bibliographies, that in Mumby by W. H. Peet

R. B. McKerrow, *An Introduction to Bibliography for Literary Students* (O.U.P., 1928)

> The standard book on the subject

A. Esdaile, *A Student's Manual of Bibliography*. 3rd ed. rev. by Roy Stokes (Allen & Unwin, London, 1954)

> A 'beginner's McKerrow', with some good and some less good points of its own

J. Ryder, *Printing for Pleasure* (English Universities Press, London, 1957)

> A useful introduction to the technique of composing and printing

James Moran, *The Composition of Reading Matter* (Ernest Benn, originally Wace, London, 1965)

> A history of typesetting machines

James Moran, *Printing Presses – History and Development from the Fifteenth Century to Modern Times* (Faber & Faber, London, 1973)

> The most comprehensive history of the relief printing press

BIBLIOGRAPHIES

E. C. Bigmore and C. W. H. Wyman, *A Bibliography of Printing*. 3 vols. (B. Quaritch, London, 1880–86); reprint 2 vols. (P. C. Duschnes, New York, 1945)

> Unsurpassed as a mine of information up to 1800

BIBLIOGRAPHY

Douglas C. McMurtrie, *The Invention of Printing: a Bibliography* (Chicago Club of Printing House Craftsmen, 1942)

> More than 3,200 titles, covering every aspect of the subject

Catalogue of the Technical Reference Library of Works on Printing and the Allied Arts of the St Bride Institute (London, 1919)

Catalogue of the Periodicals relating to Printing and Allied Subjects in the Technical Library of the St Bride Institute (London, 1951)

> These two lists are particularly useful for students working in London

PERIODICALS

The Fleuron, vols. 1–4, ed. Oliver Simon; 5–7, ed. Stanley Morison (1923–30)

Signature, ed. Oliver Simon (1935–54)

The Library. Transactions of the Bibliographical Society (1899 ff.)

Gutenberg-Jahrbuch (Mainz, 1926 ff.)

Penrose Annual (London, 1895 ff.)

The Monotype Recorder (London, 1902 ff.)

Typographica, ed. Herbert Spencer (1950–67)

Motif, ed. Ruari McLean (1958–67)

Journal of the Printing Historical Society (London, 1965 ff.)

TYPE DESIGN

Stanley Morison, *First Principles of Typography* (first published in *The Fleuron*, vii, 1930; numerous revised reprints); *On Type Designs, Past and Present* (Ernest Benn, London, 1962)

Oliver Simon, *Introduction to Typography* (Penguin Books, Harmondsworth, 1954; rev. ed. by David Bland, Faber & Faber, London, 1963)

> These two books provide the yardstick by which all modern printing should be measured, without slavish adherence to the authors' every pronouncement

Daniel B. Updike, *Printing Types: Their History, Forms and Use: A Study in Survivals* (3rd ed., Oxford University Press, 1952)

> Standard work for historians and master printers

Notes

p. 17 GUTENBERG: Aloys Ruppel, *Johan Gutenberg, sein Leben und Werk* (2nd ed., Gebr. Mann, Berlin, 1947), standard biography, to be supplemented by Rudolf Blum, *Der Prozess Fust gegen Gutenberg* (Harrassowitz, Wiesbaden, 1954). H. Lehmann-Haupt, *Gutenberg and the Master of the Playing Cards* (Yale University Press, 1966), an unconvincing attempt to attribute to Gutenberg the invention of copper engraving.

p. 18 SCHÖFFER: Helmut Lehmann-Haupt, *Peter Schoeffer* (Rochester, N.Y., Printer's Valhalla, 1950).

p. 26 DÜRER'S DRAWING: Ray Nash, *Dürer's Drawing of a Press* (Harvard University Library, 1947).

p. 27 TYPE DESIGN: W. G. Hellinga, *The 15th-century Printing Types of the Low Countries* (2 vols, Amsterdam, 1966); H. D. L. Vervliet, *16th-century Printing Types of the Low Countries* (Amsterdam, 1967).

p. 31 ROMAN TYPE: W. Turner Berry, A. F. Johnson, W. P. Jaspert, *The Encyclopaedia of Type Faces* (Blandford Press, London, 1958), deals with about 1,400 type-faces, exclusive of Black Letter.

p. 38, 86, 87 AUGEREAU: Jeanne Veyrin-Forrer, *Antoine Augereau, graveur des lettres et imprimeur parisien* (Paris et Île-de-France, Mémoires, VIII, 1956, 103–56).
CIVILITÉ: H. Carter and H. D. L. Vervliet, *Civilité Types* (Oxford, 1967).

p. 40 GOTHIC TYPE: Albert Kapr, *Deutsche Schriftkunst* (Verlag der Kunst, Dresden, 1955), a general history of script and print, with special emphasis on the development in Germany; interesting as a first attempt to interpret typography from the Marxist point of view.

NEUDÖRFFER: Albert Kapr, *Johann Neudörffer d. Ä.* (Harrassowitz, Leipzig, 1956); Wilhelm Doede, *Johann Neudörffer und seine Schule* (Prestel, Munich, 1956) – the two books are complementary.

p. 50 ZURICH: J. Staedtke, *Anfänge und erste Blütezeit des Zürcher Buchdrucks* (Orell Füssli, Zurich, 1965).

p. 56 EMBLEM BOOKS: Rosemary Freeman, *English Emblem Books* (Chatto & Windus, London, 1948), fundamental for the social and intellectual background of baroque literature. A. Henkel and A. Schöne, *Emblemata . . . des 16. und 17. Jahrhunderts* (Stuttgart, 1968).

p. 58 KOBERGER: O. Hase, *Die Koberger* (2nd ed., Leipzig, 1885; reprint Amsterdam, 1966).

p. 60 MÜNZER: E. P. Goldschmidt, *Hieronymus Münzer und seine Bibliothek* (Warburg Institute, London, 1938).

p. 62 COLOGNE: Wolfgang Reuter, *Zur Wirtschafts- und Sozial-geschichte des Buchdruckgewerbes im Rheinland bis 1800: Köln - Bonn - Düsseldorf* (*Börsenblatt f.d. deutschen Buch-handel*, Sondernummer M, 1958).

p. 64 GOTHAN: H. Raab, 'Zu einigen niederdeutschen Quellen des altrussischen Schrifttums' (*Zeitschrift für Slawistik*, iii, 1958, 323–35).

p. 65 ITALY: F. J. Norton, *Italian Printers 1501–20* (Cambridge Bibliographical Society, Monograph 3, 1958), covers virtually all Italian printing from 1465 to 1520 and thus breaks the incunabula barrier of 1500 (see p. 16).

p. 67 WALTER MAP: E. Ph. Goldschmidt, *Medieval Texts and their first appearance in print* (Bibliographical Society, London, 1943, pp. 39–40).

MUSIC PRINTING: K. Meyer-Baer, *Liturgical Music Incunabula* (Bibliographical Society, London, 1962).

p. 72 COLOPHONS: A. W. Pollard, *Essay on Colophons* (Caxton Club, Chicago, 1905): the translations are Pollard's.

p. 78 MAKARIOS: D. S. Radojičič, 'Die erste walachische Druckerei' (*Gutenberg-Jahrbuch* 35, 1960, pp. 167–71).

p. 84 ROBERT ESTIENNE: Elizabeth Armstrong, *Robert Estienne, Royal Printer* (Cambridge University Press, 1954).

p. 90 CHARLES ESTIENNE: Abraham Horodisch, 'Die Geburt des Kinderbuches im 16. Jh.' (*Gutenberg-Jahrbuch* 35, 1960, pp. 211–22), shows Estienne as the precursor of Comenius (see p. 238).

p. 92 RABELAIS: Prologue of the Second Book (Penguin ed. p. 168).

p. 95 'It exhibits three very Spanish features: (1) an heraldic design (2) in white on black (3) above very little text; and shows what is meant by 'Spanish' better than any words can do.' D. B. Updike (see p. 373), p. 111.

p. 102 ENGLAND: W. L. Heilbronner, *Printing and the Book in 15th-century England* (Charlottesville University Press, 1967).

p. 104 READING-MATTER: H. S. Bennett, *English Books and Readers, 1475–1603* (C.U.P., 2 vols. 1952, 1965), a model of social history centred round the printer's shop.

p. 106 LONDON: P. M. Handover, *Printing in London from 1476 to Modern Times* (Allen & Unwin, London, 1960), with special chapters on the book trade, the Bible patent, the periodical press, and jobbing.

p. 110 SIBERCH: E. Ph. Goldschmidt, *The First Cambridge Press in its European Setting* (Cambridge University Press, 1954); O. Treptow, *Johann Lair von Siegburg* (Respublica, Siegburg, 1964), covers Siberch's whole life, 1476–1554.

p. 112 GREEK PRINTING: V. Scholderer, *Greek Printing Types, 1465–1927* (London, 1927).

p. 114 HEBREW PRINTING: Ellic Howe, 'An Introduction to Hebrew Typography' (*Signature* 5, 1937).

p. 116 LE BÉ: Ellic Howe, 'The Le Bé Family' (*Signature* 8, 1938); Stanley Morison, *L'Inventaire de la fonderie Le Bé* (A. Jammes, Paris, 1957) and *Les Notes de Guillaume II Le Bé sur les fondeurs français du XVIème siècle* (A. Jammes, Paris, 1958).

p. 121 IRISH FOUNT: Bruce Dickins, 'The Irish Broadside of 1571 and Queen Elizabeth's Types' (*Trans. Cambridge Bibliographical Society*, 1, 1949, pp. 48–60).

p. 122 ESTONIAN, etc.: P. Johansen, 'Gedruckte . . . Messen für Riga 1525' (*Zeitschrift für Ostforschung*, 8, 1959, pp. 523–532).
FINLAND: C. R. Gardberg, *Bogtrycket i Finland intill Freden i Nystad* (Helsingfors, 1948), an exemplary history of printing in a small (and bilingual) country.

p. 128 PROOF-READING: Percy Simpson, *Proofreading in the 16th–18th Centuries* (Oxford University Press, 1935).

p. 129 PERUGIA: Heinrich Reincke, *Forschungen und Skizzen*

zur Geschichte Hamburgs (Hoffmann & Campe, Hamburg, 1951, pp. 253–61).

p. 130 COLOPHON: see note for p. 72.

p. 132 DEVICES: H. W. Davies, *Devices of the Early Printers, 1457–1560* (Grafton, London, 1935); H. Grimm, *Deutsche Buchdrucker-Signete des 16. Jh.* (Mainz, 1965).

p. 133 ADVERTISEMENTS: K. Burger, *Buchhändleranzeigen des 15. Jh.* (Leipzig, 1907); Ernst Vouillème, *Nachträge . . .* (Festgabe Konrad Haebler, Leipzig, 1901, pp. 1ff.).

p. 136 SORG: Adolf Schmidt, 'Bücheranzeige von Anton Sorg' (*Gutenberg-Jahrbuch*, 1930, pp. 119ff.).

p. 138 POSTER: Caxton printed three service books in this *lettre de forme* which was later also used by Wynkyn de Worde; size of the original 14·6 × 7·8 cm.

p. 144 ARIOSTO: Barbara Reynolds, *Cassell's Encyclopaedia of Literature* (London, 1953), s.v. Ariosto.

p. 145 TITLE-PAGE: A. F. Johnson, *One-hundred Title-pages* (Bodley Head, London, 1928).

p. 146 ANONYMITY: see note for p. 67.

p. 150 ORNAMENTS: John Ryder, *A Suite of Fleurons* (Phoenix House, London, 1956); Stanley Morison, *Venice and the Arabesque Ornament* (Oxford University Bibliophiles, 1955).

p. 155 COSTER: see Ruppel (note for p. 17), pp. 204–8.

p. 157 The Holy Sepulchre, here shown, was visited by the Mainz canon, Breydenbach, and the Utrecht painter, Reuwich, on 16 July 1483. Some copies are printed on vellum and have all the pictures coloured by hand (e.g. British Museum, 7202).

p. 158 ILLUSTRATIONS: David Bland, *The Illustration of Books* (Faber & Faber, London, 1951) and *A History of Book Illustration* (Faber & Faber, London, 2nd ed., 1963); E. Ph. Goldschmidt, *The Printed Book of the Renaissance: Type, Illustration, Ornament* (C.U.P., 1950); James Strachan, *Early Bible Illustration* (C.U.P., 1957).

p. 159 HYPNEROTOMACHIA [The Battle of Love in a Dream]: Size of the type area 22 × 13 cm. A comparison of Aldus's edition with that printed by Louis Blaubloom in Paris, 1546, in types cut by Jacques Kerver (1535–96; son of the printer Thielmann Kerver), is highly instructive as to the difference of Italian and French printing styles at their

respective best. Sir Robert Dallington, Master of Charter-house, brought out an English translation in 1592. Biography, edition, and commentary: M. T. Casella and G. Pozzi, *Francesco Colonna* (4 vols., Stamperia Valdonega, Verona, 1955–62); facsimile edition with introduction by G. Painter (Eugrammia Press, London, 1963).

p. 166 TYPES: A. Jammes, 'Académisme et Typographie: the making of the Romains du Roi' (*Journal of the Printing Historical Society*, i, 1965, pp. 71–95); *Campionari di caratteri nella tipografia del settocento*, ed. J. Veyrin-Forrer (Milan, 1963).

p. 168 FELL: Stanley Morison, *John Fell* (O.U.P., 1967).

p. 172 GENEVA: On the importance of Geneva as the centre of Calvinist book production see P. Chaix, A. Dufour, G. Moeckli, 'Les Livres imprimés à Genève de 1550 à 1600' (*Genava*, N.S. VII, 1959, pp. 235–395), including some 30 titles in English. See also John R. Kleinschmidt, *Les Imprimeurs et libraires de la république de Genève 1700–98* (Université de Genève, thèse 127, 1948), interesting for the predominance of the two families of Cramer and De Tournes.

BRITISH FOUNDRIES: T. B. Reed, *History of the Old English Letter Foundries*. Rev. and enlarged ed. by A. F. Johnson (Faber & Faber, London, 1952); W. Turner Berry and A. F. Johnson, *Catalogue of Specimens of Printing Types by English and Scottish Printers and Founders 1665–1830*. With introduction by Stanley Morison (Oxford University Press, 1935).

p. 173 BASKERVILLE: J. Dreyfus, 'The Baskerville Punches, 1750–1950' (*The Library*, 5th series, v, 1951, pp. 26–48); Philip Gaskell, *John Baskerville: a Bibliography* (Cambridge University Press, 1959); L. W. Hanson, review and additional notes (*The Library*, 5th series, xv, 1960, pp. 135–43 and 201–6).

p. 179 ANGLO-SAXON TYPE: J. Bromwich, 'The first book printed in Anglo-Saxon types' (*Trans. Cambridge Bibliographical Society*, III, 1962, pp. 265–91); G. Wakeman, 'The design of Day's Saxon' (*The Library*, 5th series, XXII, 1967, pp. 283–98).

PLANTIN: Colin Clair, *Christopher Plantin* (Cassell, London, 1960); Léon Voet, 'The Printers' Chapel in the

Plantinian House' (*The Library*, 5th series, XVI, 1961, pp. 1–14).

p. 182 ELZEVIR: S. L. Hartz, *The Elseviers and their Contemporaries*, translated by A. F. Johnson (Cleaver-Hume Press, London, 1955); D. W. Davies, *The World of the Elseviers, 1580–1712* (M. Nijhoff, The Hague, 1954).

p. 186 EMBLEM BOOKS: see note for p. 56.

p. 189 FRANCE: David T. Pottinger, *The French Book Trade in the Ancient Régime* (Harvard University Press, 1958).

p. 192 KEHL EDITION: P. H. Muir, 'The Kehl Edition of Voltaire' (*The Library*, 5th series, III, 1949, pp. 85–100).

p. 194 HERDER: A. M. Weiss and E. Krebs, *Im Dienst am Buch* (Herder, Freiburg, 1951).

p. 196 STERN: H. Dumrese and F. C. Schilling, *Lüneberg und die Offizin der Sterne* (Stern, Lüneburg, 1955).

p. 203 EMBLEM BOOKS: see note for p. 56.

p. 204 WICKED BIBLE: [P. M. Handover] *The 'Wicked Bible' and the King's Printing House Blackfriars* (*The Times*, London, 1958) gives a plausible explanation of the how and why.

p. 206 BASILICON DORON: James Craigie, 'The Basilicon Doron of King James I' (*The Library*, 5th series, III, 1949, pp. 22–32).

p. 208 FOULIS: Philip Gaskell, *A Bibliography of the Foulis Press* (Soho Bibliographies, 1964).

p. 220 MOXON: Reprinted, with introduction, notes, index and additional illustrations by Herbert Davis and Harry Carter (Oxford University Press, 2nd ed., 1962).

SERIAL PUBLICATIONS: R. McK. Wiles, *Serial Publication in England before 1750* (Cambridge University Press, 1955).

p. 221 DEDICATIONS: Franklin B. Williams, Jr, *An Index of Dedications and Commendatory Verses* (Bibliographical Society, London, 1962).

LEICESTER: Eleanor Rosenberg, *Leicester, Patron of Letters* (Columbia and Oxford University Presses, 1956), an inquiry into the meaning of sixteenth-century patronage.

p. 222 PATRONAGE: A. S. Collins, *Authorship in the Days of Johnson: being a study of the relation between author, patron, publisher and public, 1726–80* (Routledge, London, 1927) and *The Profession of Letters: a study of the relations*

of author to patron, publisher and public, 1780–1832 (Routledge, London, 1928).

p. 229 BELL: Stanley Morison, *A Memoir of John Bell* (Cambridge University Press, 1930).

p. 235 UNIVERSITY PRESSES: J. Johnson and S. Gibson, *Print and Privilege at Oxford to the Year 1700* (Oxford University Press, 1946); S. C. Roberts, *A History of the Cambridge University Press, 1521–1921* (Cambridge University Press, 1921) and *The Evolution of Cambridge Publishing* (Cambridge University Press, 1956); *The University as Publisher*, ed. E. Harman (University of Toronto Press, 1962).

p. 236 PRIVATE PRESSES: Desmond Flower in *Cassell's Encyclopaedia of Literature* (1953) s.v. Private Presses; *The Book of the Private Press*, ed. Thomas Rae and Geoffrey Handley-Taylor, with foreword by John Ryder (Signet Press, Greenock, 1958).

p. 240 TREWE ENCOUNTRE: J. C. T. Oates in *Trans. Cambridge Bibliographical Society*, I, 1950, pp. 126–9, full of instructive and interesting information.

p. 243 WOLFENBÜTTEL AVISO: R. Engelsing, *Der Aviso von 1609* (Bremen, 1960).

ENGLISH NEWSPAPERS: Folke Dahl, *A Bibliography of English Corantos and Periodical Newsbooks, 1620–42* (Bibliographical Society, London, 1952); Stanley Morison, *The English Newspaper, 1622–1932* (C.U.P., 1932) and *The Origins of the Newspaper* (St Bride Foundation, 1954); R. P. Bond, *Studies of the Early English Periodicals* (University of North Carolina, 1958); K. K. Weed and R. P. Bond, *Studies in British Newspapers and Perodicals from the Beginning to 1800* (University of North Carolina, 1946); G. A. Cranfield, *A Hand-list of English Provincial Newspapers and Periodicals, 1700–60* (Cambridge Bibliographical Society, Monograph 2, 1952) and 'Additions and Corrections' (*Trans. Camb. Bib. Soc.* II, 1956, pp. 269–74; 1958, pp. 385–9).

p. 254 LIBRARIES: Arundell Esdaile, *National Libraries of the World* (Grafton, London, 1934); Francis Wormald and C. F. Wright (eds), *The English Library before 1700* (Athlone Press, London, 1958); Peter Karstedt, *Studien zur Soziologie der Bibliothek* (Harrassowitz, Wiesbaden, 1954).

p. 262 TRATTATO UTILISSIMO DEL BENEFICIO DI GIESU

CHRISTO (Venice, 1543): V. Vinay, 'Domenico Antonio Ferrari' (*Studi di letteratura . . . in onore di Bruno Revel.* Olschki, Florence, 1965, pp. 597–615). Professor G. Potter, of Sheffield University, and Mr A. G. Lee, of St John's College, Cambridge, first drew the author's attention to the unique copy in St John's.

p. 266 AREOPAGITICA: Best modern edition, with a brilliant introduction and copious notes, by Olivier Lutaud (Collection bilingue des classiques étrangers, Éditions Montaigne, Paris, 1956).

p. 278 GED: John Carter, 'William Ged and the Invention of Stereotype' (*The Library*, 5th series, XV, 1960, pp. 161–92).

p. 280 THE TIMES: *Printing the Times, 1785–1953* (1953).

p. 293 HITLER: The decree was for the first time reproduced, with translation and comment by S. H. S., in *Printing News* (9 May 1957).

p. 297 PUBLISHING HOUSES: Some recent histories of value beyond business publicity: F. D. Tredrey, *The House of Blackwood, 1804–1954* (1954); S. Nowell-Smith, *The House of Cassell, 1848–1958* (1958; the model of an impartial account).

p. 301 LANDOR: R. H. Super, *The Publication of Landor's Works* (Bibliographical Society, London, 1954).

p. 303 COMPOSITORS: Ellic Howe, *The London Compositor 1785–1900* (Bibliographical Society, London, 1947).

p. 308 CENSORSHIP: K. Ewart in *Cassell's Encyclopaedia of Literature* (1953) s.v. Censorship and Law; N. St John Stevas, *Obscenity and the Law* (1956; Roman Catholic viewpoint); A. L. Haight, *Banned Books* (R. R. Bowker, New York, 1955); A. Craig, *The Banned Books of England* (Allen & Unwin, London, 1962).

p. 309 TEST CASE: C. H. Rolph, *The Trial of Lady Chatterley* (Penguin Books, Harmondsworth, 1960).

p. 312 MORRIS: F. A. Schmidt-Künsemüller, *William Morris und di neuere Buckhunst* [in England, America, and Germany] (Harrassowitz, Wiesbaden, 1955).

p. 314 PRIVATE PRESSES: see note for p. 236.

p. 318 IMPRINT: see *Monotype Newsletter* 71 (October 1963).

p. 324 MODERN PRINTING: Julius Rodenberg, *Grösse und Grenzen der Typographie* (Poeschel, Stuttgart, 1959).

p. 324 READING PUBLIC: Michael Sadleir, *XIXth-century Fiction, a bibliographical record* (2 vols, Constable, London, 1951); R. K. Webb, *The British Working-class Reader, 1790–1848: literary and social tension* (Allen & Unwin, London, 1955); R. D. Altick, *The English Common Reader. A Social History of the Mass-reading Public, 1800–1900* (University of Chicago Press, 1957).

p. 339 CHILDREN'S BOOKS: Bettina Hürlimann, *Three Centuries of Children's Books in Europe* (Oxford, 1967).

p. 348 BESTSELLERS IN AMERICA: F. L. Mott, *Golden Multitudes: the story of best sellers in the United States* (Macmillan, New York, 1947), defines a best-seller as a book selling the equivalent of one per cent of the population at the time of publication: at first sight a plausible theory, but wholly misleading in practical application.

p. 349 CHURCHILL: F. Woods, *A Bibliography of the Works of Sir Winston Churchill* (Nicholas Vane, London, 1963), with the review by Desmond Flower (*The Library*, 5th series, xx, 1965, pp. 161–2).

p. 351 MONEY-SPINNERS: Desmond Flower in *Cassell's Encyclopaedia of Literature* (1953) s.v. Bestseller.

p. 353 CHEAP REPRINTS: R. D. Altick, *Cheap Reprint Series of the English Classics, 1830–1906* (University of Virginia Press, 1958).

p. 356 RECLAM: A. Meiner, *Reclam, eine Geschichte der Universal-Bibliothek* (Reclam, Leipzig, 1942); the new edition, *Reclam, Geschichte eines Verlages* (Reclam, Stuttgart, 1958) omits the valuable statistics.

p. 358 PENGUINS: W. E. Williams, *The Penguin Story* (Penguin Books, Harmondsworth, 1956); *Penguins Progress 1935–1960* (Penguin Books, 1960).

p. 364 PAPERBACKS: Desmond Flower, *The Paper-Back, its Past, Present and Future* (Arborfield, London, 1959).

SUPPLEMENTARY NOTE

PADUA. The seat of the Venetian state university deserves mention among the incunabula places because of the singular survival of a number of documents which give us a unique insight into the actual running of a printer's workshop.* Printing in Padua began in 1471; the first printers were natives of Italy, Prussia, Harlem, Basel, and Stendal. In 1474 they were joined by the Frenchman, Pierre Maufer of Rouen, who italianized his name as Piero Fransoso. Born about 1452, he went to Padua with his father, acquired the title of *magister* and established a printing shop of his own. He was obviously a shrewd and enterprising business-manager, though his ambitious publishing programme involved him in constant litigation with his numerous creditors. From these notarial instruments, court decisions, articles of association, etc., we learn a mass of details unavailable elsewhere. We have a complete inventory of Maufer's workshop with its five handpresses. We know exactly the wages of his compositors and pressmen as well as the remunerations of his academic editors and proofreaders. His compositors worked from twelve to fourteen hours daily, during which each of them had to set up two folio pages with double columns. We hear of a strike and lockout of compositors and pressmen, which forced Maufer to hire new men from abroad at higher wages. He was connected with Johann Rauchfass, a Frankfurt bookseller who lived in Padua, acted as agent for German firms in Venice, specialized in the export of Italian books to the Frankfurt book fair, and financed the printing of Maufer's most important book, Gentile da Foligno's commentary on the third book of Avicenna's *Canone di medicina*. For this enterprise Rauchfass commissioned two new gothic type-faces, one for the text, the other for the glossary, from the great punchcutter, Francisco Griffo, on the model of a type used by Nicolas Jenson; this incidentally led Rauchfass and another Frankfurt businessman to form with Jenson a partnership in Padua, 'Nicolò Jenson e Compagni'. The next step was the enlistment of two academic editors and a scholarly proofreader. Finally, a sufficient supply of high-quality paper was secured from a mill in Battaglia. Between June

* See G. Mardersteig, *The remarkable story of a book made in Padua in 1477*, translated by H. Schmoller (London, 1967).

and November 1477 six hundred copies of 1,062 pages each came off Maufer's four presses, 'an impressive performance which could hardly be repeated today'. Surprisingly, only three copies have survived.

The later career of Maufer and his various partnerships is of no less interest, although less well-documented. Like other early printers Maufer was restless: in 1479 he left Padua and printed successively in Verona, Venice, Modena, and Mantua. Bartolo de Sassoferrato's commentaries on the *Corpus juris* (7 vols, 1479–85) is perhaps his most massive publication.

Index

Italic numbers refer to pages with illustrations